Stranger on the earth

A PSYCHOLOGICAL BIOGRAPHY
OF VINCENT VAN GOGH

Albert J. Lubin

DA CAPO PRESS

Library of Congress Cataloging in Publication Data

Lubin, Albert J.
 Stranger on the earth: a psychological biography of Vincent van
Gogh / Albert J. Lubin.
 p. cm.
 1st Da Capo Press ed.
 Originally published: New York: Holt and Co., 1972.
 Includes bibliographical references and index.
 ISBN 0-306-80726-2 (alk. paper)
 1. Gogh, Vincent van, 1853–1890–Psychology. 2. Artists–
Netherlands–Biography. I. Title.
N6953.G63L82 1996
759.9492–dc20 96-14082
[B] CIP

First Da Capo Press edition 1996

This Da Capo Press paperback edition of *Stranger on the Earth*
is an unabridged republication of the edition first published in
New York in 1972. It is reprinted by arrangement with
Henry Holt and Co.

Published by Da Capo Press
A Member of the Perseus Books Group
http://www.dacapopress.com

To Dr. V. W. van Gogh
and his late wife,
Nelly van Gogh-van der Goot

. . . in general, and more especially with artists, I pay as much attention to the man who does the work, as to the work itself.

[LETTER R6, FROM VINCENT TO VAN RAPPARD, 1881]

There certainly is an affinity between a person and his work, but it is not easy to define what this affinity is, and on that question many judge quite wrongly.

[LETTER 187, FROM VINCENT TO THEO, 1882]

. . . I do not consider my studies are things made for their sake, but am always thinking of my work as a whole.

[LETTER 309, FROM VINCENT TO THEO, 1883]

. . . art is something which, although produced by human hands, is not created by these hands alone, but something which wells up from a deeper source in our souls.

[LETTER R43, FROM VINCENT TO VAN RAPPARD, 1884]

Contents

Thirty-two pages of illustrations follow page 108

List of illustrations

xi

xii List of illustrations

Preface

⋀⋀⋀ A YOUTHFUL interest in Vincent van Gogh was rekindled during the late 1950s when I was studying the influences of religion on identity formation. In pursuing van Gogh from this point of view, I was exposed to a wealth of information, unknown in the case of any other great artist, that seemed to afford the basis for a broad study of the relation between his psychological development and his art. In spite of the vast literature about him, I was surprised to find that such a study had never been carried out. In addition, I felt that such an approach to van Gogh, a nineteenth-century combination of dropout, rebel, and genius, might shed some light on today's dropouts and rebels as well as on extraordinary men of this century, such as Churchill and Hemingway, whose attempts to master depression also seem to have been powerful stimuli to their creative processes.

The psychoanalysis of the living who freely submit to the procedure is difficult enough, and often impossible. It is not surprising, therefore, that even analysts doubt the value of attempting to psychoanalyze the dead. The data that van Gogh has left us, however, provide special resources for this task; a creative genius of extra-

ordinary sensitivity, he was better able to look at himself than most ordinary men, and he described his thoughts and feelings in hundreds of expressive letters, often with great skill and frankness. Indeed, in an early letter to his brother Theo he wrote that he would be "telling you the thoughts that come into my mind, without being afraid of letting myself go, without keeping back my thoughts or censoring them," [1]—a statement remarkably similar to that made by analysts in describing the technique of free association. And while I could not obtain the responses to interpretations that analysts rely on for verification in therapeutic work, his expressive pictures could be compared with his letters as a check on the accuracy of interpretations.

As a psychiatrist involved in the study of van Gogh, the question I meet most frequently is, "What was the matter with him?" Although it is a question that fascinates psychopathologists, professional and amateur alike, it is not very important. Countless human beings with similar frailties have long since been forgotten, and such frailties can be better studied among the living. It is more pertinent to question what made it possible for him to accomplish such outstanding things. Therefore, while I have inevitably been concerned with van Gogh's problems, the stress has been put on his ability to transform them into incredible achievements. I have tried to depict him not as a strange and mysterious combination of sick eccentric and great artist, but as a complete man whose psychological conflicts entered into all aspects of his development and whose creative use of them in his fight against suffering was essential to his artistic success. The end result was a phenomenal body of work, in which all of us can sense the enormous struggle that made it possible. By identifying ourselves with this dynamic process, perhaps we can share in his triumph.

Simple explanations of human behavior often seem convincing, but creative activity is far more complex than the reflex salivation of a laboratory animal. For instance, intense psychological conflicts may motivate the talented novice to become a great artist, and a causative relationship may be clearly demonstrated between specific conflicts and specific characteristics of the creative process—as in the case of van Gogh. But the nature and intensity of the conflict do not in themselves determine the artist's greatness. The same conflict that influenced Leonardo to paint the *Mona Lisa* may have influenced another to become a Bluebeard. A fuller understanding of the creative process requires the use of other disciplines, from his-

tory and cultural anthropology to physiology and heredity. Accordingly, while physiology and heredity are outside the ken of a study such as this, I have attempted to trace the historical and cultural forces that molded him and to show how these forces were modified by his conflicts and by the distorted images he had of himself.

With this in mind, my wife and I have followed Vincent's path from his birthplace in Zundert to his grave in Auvers-sur-Oise and talked with many helpful people. Every year since 1959, Dr. V. W. van Gogh, Vincent's nephew, has devoted time and effort to checking, criticizing, and broadening my observations and to taking us on field trips into the Dutch countryside. Most of all, he has been a repeated source of encouragement and stimulation, even though he has not always agreed with my conclusions. His wife, Mrs. Nelly van Gogh-van der Goot, was an equally strong support until her death in 1967. Dr. Marc Edo Tralbaut, an enthusiastic student of van Gogh for almost 50 years, has given freely of his prodigious fund of knowledge; he has also, occasionally with a bulky catalogue of Vincent's works under his arm, led us to the actual scenes of many van Gogh pictures in both Holland and Provence—some of them in obscure places known only to Tralbaut himself. Before their deaths in the mid-1960s, we had the good fortune to discuss the subject of van Gogh with two citizens of Saint-Rémy-de-Provence. One was Dr. Charles Mauron, mayor of Saint-Rémy for many years, professor at Aix-en-Provence, and a scholar versed in psychoanalysis, who has written some of the most sensitive psychological studies on van Gogh. The other was Dr. Edgar Leroy, director for many years of Saint-Paul-de-Mausole, the sanitarium in Saint-Rémy where Vincent incarcerated himself, who discussed Vincent's illness and showed us the original hospital records.

I have also obtained the invaluable help of the Dutch psychoanalyst, Dr. Jacob Spanjaard, who not only reviewed my writing but compared all of the translated quotations in the manuscript with the original sentences from Vincent's own hand and suggested many changes—a task beyond the call of duty. Among many others who have helped, I should like to mention five who have read and criticized the entire manuscript: Professor Daniel Mendelowitz, Dr. Stanley Leavy, Dr. Martin Grotjahn, Patricia Zelver, and Richard Lubin. Dr. Mortimer Ostow reviewed portions of chapter 9 with me. As editor, Joseph Cunneen has done an exceptional job of making the manuscript more readable. Finally, the help of my wife, Helen Almeida Lubin, has been so essential to every phase of

the project that it would be difficult to conceive of it without her.

Because the human mind is an inordinately complicated apparatus, human activity can be seen from many different points of view. For this reason I was forced to restrict myself to those perspectives that seemed particularly relevant. It should also be kept in mind that the evaluation of the plausibility of interpretations differs widely even among trained observers. Among those interpretations I have included, some impress me as highly plausible while others seem dubious but interesting. I hope that the reader's final assessment, however, will not be derived from his perception of individual implausibilities but from an overall view.

This book grows out of an interest—more and more widely shared—in understanding the creative person in the context of his time, influenced by his personal and cultural past and his wishes for the future. While it is not primarily intended to be an exercise in art appreciation, some may find that another dimension has been added to their enjoyment. I hope it will illuminate new paths for those who have previously contented themselves in having a one-to-one relationship with the picture, and reason-bound people who cannot respond aesthetically may find their intellectual interests have been aroused.

Following his own preference, I have usually called our protagonist simply Vincent.

Woodside, California

Chronology

	Amsterdam	May: Studies for theological school
1878	Etten	July: Quits studies, returns to father's parsonage
	Brussels	August: Enters missionary school
1879	The Borinage	January: Begins work as evangelist
		July: Dismissed; begins "moulting period"
1880		July: Decides to become an artist
	Brussels	September: Registers at Royal Academy of Fine Arts; meets van Rappard
1881	Etten	April: Returns to parsonage; falls in love with Kee Vos-Stricher
		December 31: Leaves parsonage following argument with father
1882	The Hague	Studies with Mauve; lives with Sien; hospitalized in June; Sien's boy born in July
1883	Drenthe	September: Arrives
		December: Leaves for parsonage in Nuenen
1884	Nuenen	January: Vincent cares for injured mother
		July, August: Affair with Margot Begemann
		November: Begins teaching art to three men
1885		March 27: Father dies
		April: Works on *The Potato Eaters*
1886	Antwerp	January 18: Enrolls in Academy of Art
	Paris	February 27: Moves in with Theo
		March: Attends classes at Cormon's studio
		Meets Toulouse-Lautrec, Bernard, Gauguin, Pissaro, Signac, Degas, Guillaumin
1888	Arles	February 21: Arrives
		June: Visits Saintes-Maries-de-la-Mer
		September 18: Moves into Yellow House
		October 20: Gauguin arrives
		December 23, 24: Cuts off ear, taken to hospital; Gauguin leaves; Theo announces engagement
1889		January 7: Leaves hospital
		February 9: Returns to hospital for ten days
		February 27: Forcibly put in hospital again
		April 17: Theo marries Johanna Bonger
	Saint-Rémy	May 8: Arrives at Saint-Paul-de-Mausole
1890		January: Albert Aurier praises Vincent's art in the *Mercure de France*
		February: Exhibits works in Brussels; sells painting
	Paris	May 17: Visits Theo, Jo, and nephew
	Auvers	May 21: Arrives; meets Dr. Gachet
		June 8: Theo, Jo, and nephew visit Auvers
		July 6: Vincent visits Paris
		July 27: Shoots self
		July 29: Dies

1 Vincent's sermon

IT WAS a clear autumn Sunday in 1876; Vincent van Gogh, twenty-three years old, left the English boarding school where he was teaching to give a sermon at a small Methodist church in Richmond, a humble London suburb. Standing in front of the lectern, he felt like a lost soul emerging from the dark cave in which he had been buried.[1]

The sermon, which survives among Vincent's collected letters, reiterates universal ideas and is not an outstanding example of the art of homiletics. Nevertheless, his words grew out of his tormented life and had an intense emotional charge. Preaching to the congregation, he was also preaching to himself—and of himself. The images he used were the same as those that were to be given powerful expression in his pictures.

The text chosen for the sermon was Psalm 119:19, "I am a stranger on the earth, hide not Thy commandments from me." The young preacher then went on: "It is an old faith and it is a good faith, that our life is a pilgrim's progress—that we are strangers on the earth, but that though this be so yet we are not alone for our Father is with us." The psalm's text is an affirmation of isolation

1

and loneliness, but they are summarily eliminated; for the community of the faithful, "I" becomes "we," and "we are not alone."

The theme of sorrow is woven through the sermon and seen as an inherent human trait: "Our nature is sorrowful." But painful as it may be, sorrow is a blessing in disguise, a quality to be cultivated: "Sorrow is better than joy," he asserts, and "by the sadness of the countenance the heart is made better"; hence one is "sorrowful yet always rejoicing."

The sermon shows Vincent freely accepting the existence of grief, loneliness, and death, but through the vehicle of religious faith he is able to glorify them as prerequisites for joy, acceptance, and immortality. Catalyzed by suffering, sorrow leads to joy, loneliness to togetherness, death to rebirth, darkness to light, and earth to heaven.

Like the figure in the sermon, Vincent was a stranger on the earth. From the remote Drenthe country of Holland he had bemoaned the fate that made him "wander and wander forever like a tramp, finding neither rest nor food nor covering anywhere"; later, at Arles, he was to describe himself as a traveler going to a destination that did not exist.[2]

His tormenting loneliness and sense of being an outcast were reflections of an omnipresent, though sometimes hidden, depression; they erected a barrier that isolated him from human companionship. Being in a crowd and becoming aware of the closeness of happier people in it intensified the loneliness and drove him further back into himself. He longed for intimacy with others, yet sought out solitude: it was the lesser of two evils. When he felt rejected or unsuccessful in a task, the self-doubt and self-depreciation of depression were intensified. Feeling guilty and doubting his own worth, he often thought that others regarded him as bad and worthless; human intimacy therefore threatened him with punishment and shame. As one biographer has written, the fact that he was self-taught enabled him "to comply with the promptings of his own impulses, to preserve the primal vigour of his instincts and the plenitude of his own resources";[3] but first of all, it was a necessity that grew out of his need for isolation.

The story of Vincent van Gogh is a never-ending struggle to control, modify, glorify, or deny a deep-rooted melancholy and loneliness. Religion and art were simply different means he employed for this purpose. The struggle with these feelings not only helped to shape his personality but stimulated his creative urge and

did much to determine the content and style of his work. The young man's sermon and his later pictures deal with the same themes, revealing both his problems and his efforts to solve them. As he himself wrote, "I tackle things seriously, and will not let myself be forced to give to the world work that does not show my own character." [4] The themes are the predictable responses of a sensitive man to ubiquitous fears of life and death. A confluence of forces, however, caused Vincent to be particularly motivated and particularly able to give expression to these fears. Few artists have been as persistent and as talented in devising techniques for doing so.

The two broad phases of Vincent's artistic life follow the antithetical themes of the sermon. The works of the first phase, executed in Holland and Belgium between 1880 and 1885, tend to be somber and dark, with the emphasis on sorrow and isolation. Those of the second phase, executed in Paris, Provence, and Auvers between 1886 and 1890, tend to be bright, colorful, and joyous. Some have tried to explain this transition from darkness to light in terms of his encounter with the French Impressionists and the southern sun, but it was his own needs that led him to seek them out.

From beginning to end, the depression that permeated Vincent's life cast an indelible stamp on his art. From The Hague in July 1882, for instance, he wrote, "In either figure or landscape I should wish to express not sentimental melancholy but serious sorrow," and from Saint-Rémy-de-Provence in February 1890 he described his pictures as "a cry of anguish." [5] By becoming the recorder of sad people rather than one of them, he disclosed his sadness, but at the same time kept it at a distance. In one of his earliest pictures, *Miners*, drawn in the Borinage soon after he decided to become an artist, he tried to reveal "something touching and almost sad in these poor, obscure laborers—of the lowest order, so to speak, and the most despised." [6] Seeing himself in the same light, the work was a self-portrait as well as an exposé of society.

Unfortunates with bowed heads often appear in van Gogh's paintings, especially those from Holland and Belgium; they may be seen, for instance, in *Worn Out: At Eternity's Gate* and *Sorrow*. But Provence did not turn out to be the cheerful haven that Vincent had hoped for, and depression hid behind the stimulating colors and patterns of the bright period. Two months before he killed himself, he painted the same old man of *Worn Out: At*

Eternity's Gate, this time in bright oils. Despite the vividness of its colors, however, the painting conveys the same deep sense of grief.

Dr. Gachet is only one of the sad, rigid, suffering, or frightened faces that Vincent portrayed in France. Dr. Gachet was as unhappy as he was, he said, no doubt projecting his feelings about himself into this helper who could not help. Vincent told his sister Wil that the portrait had "an expression of melancholy that would seem like a grimace to many. . . . Sad yet gentle, but clear and intelligent— this is how one ought to paint many portraits. . . . Perhaps people will mourn over [them] after 100 years." [7] Vincent's death was imminent as he worked on this painting, and it expressed the wish to be remembered long after he was gone.

Sadness was also expressed in Vincent's northern landscapes, with their gloomy atmosphere, writhing trees, and thorn bushes. *The Roots,* for instance, was for him the equivalent of the unhappy figure of Sien, the sickly prostitute whom he cared for in The Hague and whom he sketched in *Sorrow.* He tried, he explained, "to put the same sentiment into the landscape as I put into the figure, the convulsive, passionate clinging to earth and yet being half torn up by the storm." [8] A dead willow trunk, "alone and melancholic" [9] on a road outside The Hague, attracted his attention, and he returned to make a watercolor of it.

Vincent equated storm in nature with sorrow in humans. Preoccupied with Sien's melancholy in the winter of 1883, he described her as "withered—literally like a tree which had been blasted by a cold, dry wind, its young green shoots withering." [10] Soon after, he portrayed such a tree. Sien's melancholy was a reflection of his own, and the blasted tree represented both of them. Convinced he had failed her, Vincent sought consolation by walking in the countryside. He noticed a clump of trees that had been bent by the wind: "Those trees were superb; there was drama in each *figure* I was going to say, but I mean in each tree. . . . Yes, for me, the drama of storm in nature, the drama of sorrow in life, is indeed the best." [11] A sketch of these bowed trees, expressing the same feeling he poured into the drawings of humans bowed by sorrow, is included in letter 307 of Vincent's collected letters. (See *Trees.*)

When Vincent went to live with his family in Nuenen, he continued to portray his gloomy view of the world in somber landscapes of the dreary fields. The houses and the people, he observed, were "quite in harmony"; [12] his grim, dark peasant huts reflected what he saw in the faces of those who lived in them. The house of a man called "the mourning peasant" [13] became a painting of a

house of mourning. He wrote that he saw the peasant's melancholic mien in old cab horses,[14] and his sketches of tired, bowed horses caught this expression. A painting of three pollard oaks was among the last works from Nuenen; its combination of colors created a "soft melancholic peace."[15]

The bright palette that emerged when Vincent moved to Antwerp, and that became increasingly vivid in Paris and Provence, produced many lively, ecstatic landscapes, but the sadness of the North often reappeared in them. For example, *The Iron Bridge at Trinquetaille* was painted in the summer of 1888, when he was composing the resplendent fields and glorifying the sun of the Midi. "I am seeking," he wrote of it, "something utterly heartbroken and therefore utterly heartbreaking."[16] About to leave Arles for the sanitarium in Saint-Rémy, he made a drawing that "turned out very dark and rather melancholic for one of spring."[17] From Saint-Rémy he wrote that *Entrance to a Quarry* has "something sad in it that is healthy."[18] Trees again became melancholic objects, such as the familiar "funeral cypress."[19] Behind the sanitarium he painted "the mournful pines with their silhouettes standing out in relief against [the sky] with exquisite black lace effects,"[20] (See *Pine Woods.*) Some landscapes from Auvers, painted shortly before he killed himself, seem calm and peaceful. Others, like three paintings of wheatfields "under troubled skies," disclosed his anguish: "I did not need to go out of my way to express sadness and extreme lone-liness." But they also revealed "the healthy and restorative force that I see in the country."[21] Again we are reminded of Vincent's belief that eternal bliss is achieved through sadness and suffering.

The many solitary figures in van Gogh's work correspond to the lonely outcast—the stranger, the prisoner, and the vagabond—he saw himself to be. In some of his pictures each figure seems to have a private space around it that keeps others at a distance. *Landscape with Pollard Willows* shows a lonely figure standing in the center of a large expanse, neither in the immediate world of the viewer nor in the heavens beyond; in *Mending the Nets* each washerwoman is alone, alienated from the others; in *A Factory* a single man is seen in the midst of a barren, snow-covered field with a dreary factory in the distance; and in *Willows with Shepherd and Peasant Woman,* the lone peasant woman on the left is insulated from the lone shepherd on the right by three rows of trees.

Girl in the Woods, an 1882 oil depicting a girl dwarfed by

giant oak trees, recalls young Vincent's solitary walks in the Zundert woods, where he escaped from his family. In *View from the Artist's Studio Window* two women are separated from each other by clotheslines, and they, in turn, are barricaded from the workmen beyond by tall fences. A man in the right upper corner pushing a wheelbarrow is enclosed in a tree-lined road, remote from all the others, heading toward the distant horizon. *View from the Studio Window in the Snow* shows a laborer digging in the snow; the figure is sandwiched between two fences, while someone in the distance disappears down the same tree-lined road. The rigidity and remoteness of Vincent's early figures might be attributed to defective technique if his work as a whole during the same period did not belie this. In fact, the same "fault" remains visible even at the peak of his technical development, as witness the mother and child in *Madame Roulin with Her Baby* from Arles; the mother holds the stiff, awkward child at a distance, as if she were afraid to cuddle him. Perhaps Vincent's fear of closeness made it difficult for him to portray tender relationships between people, even though he wished to do so.

Vincent compared himself to "a prisoner who is condemned to loneliness." [22] He gave this description artistic expression in *The Prison Courtyard,* after Doré. *The Weaver* was also a prisoner, one who spends "whole seasons alone." [23] Like jail bars, the bars of the loom isolated the weaver from society; the weaver was "imprisoned in some cage," [24] just as Vincent saw himself.

Sometimes he heightened the alienation of the solitary person by contrasting him with couples. In *Third-Class Waiting Room,* reminiscent of Daumier, a man and a woman on the left sit at a discreet distance from each other, further separated by a vertical member of the window frame; in contrast, the two women on the right face each other, engaged in friendly conversation, and another holds a baby. The estranged man and woman gaze in unison toward them, attracted by the intimacy they themselves lack. Couples are seated tête-à-tête in *La Guingette,* an inn on the outskirts of Paris, while—like a standing corpse—a stiff waiter is entombed by the narrow wall behind and the lamppost beside him, forms that add to his alienation from the couples. In the watercolor *Montmartre* a ghostly figure sits by herself on the right side, separated from the couple on the left by the porch posts and from the couple above by the porch floor. The estrangement is accentuated by placing the solitary woman at the extreme edge of the picture, while

the closeness of the couples is strengthened by superimposing one figure over another. In an oil from Auvers, *The Stairs,* two women and two girls stroll toward the stairs as a solitary man descends them, heading in the opposite direction. *The White House at Night,* also from Auvers, recalls the parsonage of Vincent's father in Nuenen. Two women enter the house together, while a solitary woman in the foreground walks away from it. She reminds one of the artist himself, who always yearned to return to his parents' house, but whose discomfort in their presence compelled him to stay away.

Plagued by loneliness, Vincent never ceased to yearn for closeness with another human being. But closeness meant for him a merger that was both mental and physical, and his fierce, almost mystical determination to achieve this goal was so powerful that it threatened his intended partner. It frightened parents, relatives, women, artists, and even his brother Theo, contributing to the failure of every attempt at intimacy. Learning to expect these failures, he substituted nature, art, and books for friends, marriage, and children.

When he visited the Rijksmuseum in Amsterdam, he told his pupil Kerssemakers that he would give ten years of his life if he could go on gazing at Rembrandt's *The Jewish Bride,* a portrait of a man embracing a young woman.[25] To be united with a woman in love was the most pressing desire of Vincent's adult life, even though this desire was doomed to frustration. "[A] man and wife can be one," he wrote, "that is to say, one whole and not two halves."[26] Deeply in love with Kee Vos, he felt exalted by his fantasy of being with her, even though she rejected him: "[T]here is a feeling of deliverance within me and it is as if she and I had stopped being two, and were united forever and ever."[27] When he was criticized for living with the prostitute Sien, he replied that he preferred "certain death" to separation.[28]

Vincent told his brother Theo, "Being friends, being brothers, love, that is what opens the prison. . . ."[29] If the two of them could "combine," he wrote, "some of those ten years which I seem to have spent in prison will disappear."[30] To "combine" meant total understanding, total sharing, total commitment. He claimed that Theo was as responsible for "their" art as he. The fulfillment of this fantasied union was vital, yet impossible to achieve. It seemed that

the relation between them could succeed only when carried on by mail or during brief visits.

Similar frustrations marked Vincent's attempts to form working alliances with fellow-artists, such as Anthon van Rappard in the North and Paul Gauguin in Arles. These alliances were to be more than working arrangements, as Vincent told van Rappard: "The truth is that whenever different people love the same thing and work at it together, their union makes strength; combined, they can do more than if their separate energies were each striving in a different direction. By working together one becomes stronger and a whole is formed. . . ." [31] When isolated from other artists in Nuenen and Arles, unfulfilled yearnings for human ties led him to formulate plans for an artists' cooperative, plans that were never consummated. And actual involvement in a community of artists— as in Antwerp and Paris—failed to bring him the satisfaction he sought.

Fantasies of closeness and union were diverted into art. Vincent not only portrayed the sad, lonely person he felt himself to be, but also the companion he wished to be. The desire for intimacy in life was paralleled by an obsession with it in his art. He was forever sketching pairs of people—companions and lovers who stood together, walked together, sat together, worked together, grieved together, and lay together. Typically, one partner is close to the other: they are arm in arm, they embrace, or their bodies touch. In the characteristic van Gogh pair, one figure overlaps the other, as if merged with it.

Since Vincent sometimes mentioned these couples in his letters, it is clear that they had special significance for him. Of one proposed drawing, similar to *The Old Couple*, he wrote from The Hague in 1883: "[T]he couple, arm in arm against the hedge of beeches, are the type of man and woman who have grown old together and where love and faith remain." [32] This drawing had its Provençal counterparts in *The Rhone River at Night*, *The Lovers*, and *The Poet's Garden*. The first, Vincent wrote, shows "two colorful little figures of lovers in the foreground"; [33] the second, "two lovers, the man in pale blue with a yellow hat, the woman with a pink bodice and a black skirt"; [34] and the last "two figures of lovers in the shade of the great tree." [35] The old lovers from The Hague are in a simple somber setting, reinforcing the pathos of ago, while the setting for the young lovers, from France, are vibrant and alive, with trees that are tall and lush.

Vincent's gift for seeing nature in terms of human form and feeling provided solace for living and a constant enrichment of his art. "The worse I get along with people," he wrote, "the more I learn to have faith in nature and concentrate on her." [36] The expressive trunks and limbs of trees were easily translated in terms of youth and age, strength and weakness, beauty and ugliness, sorrow and joy, death and rebirth. As we have seen, he equated a lone tree with a lonely person, and he paired trees in the same way that he paired humans. He noted that *The Vicarage Garden*, in addition to its human pairs, has three other "couples": "to the right, two trees—orange and yellow; in the center, two bushes of grey-green; to the left, two trees of brownish yellow." [37] Each of the paired trees of *Park Along the Fence* and *Two Pines* gently touches its partner. *Souvenir de Mauve*, "probably the best landscape I have done," shows "two pink peach trees against a sky of glorious blue and white"; [38] their limbs intertwine.

Cypresses are popular in Provence, where they are planted in hedgerows as windbreaks in the face of the powerful mistral. Paired cypresses are not common, but Vincent's personal vision led him to paint many of them, such as cypress couples standing side by side in *The Drawbridge* or overlapping in *Wheatfield with Cypresses*. In *Road with Cypress and Star*—the title its owner, the Kröller-Müller National Museum gives it—the "cypress" turns out to be two cypresses when one discovers the two trunks at the base; the two trees have almost fused.

Other objects were also turned into symbolic human couples, with one partner touching or merging with the other. Vincent drew a pair of cottages, fully conscious of his intent: "The subject struck me very much. Those two half-mouldered cottages under one and the same thatched roof reminded me of an old couple, worn with age, who have grown into one being, are seen leaning on each other. For you see there are two cottages and a double chimney." [39] Similar twinned structures in *Barns and Houses at Scheveningen* complement the human couple to their left; like Siamese twins, the buildings are bound together by a connecting structure, the couple by the woman's arm. *The Yellow House*, from Arles, is also one of a pair; its partner on the left is structurally identical. They are tied together by a common segment, similar to the wall in *Barns and Houses at Scheveningen*. Vincent made several paintings of pairs of worn shoes; conceived in human terms, he called them "a pair of decrepit ancients." "Couples" are also pictured in *Two Rats Eating*,

Two Sunflowers, and *Sandbarges Unloading,* showing a pair of river barges lying side by side along the quay at Arles.

The Bedroom is a painting of Vincent's bedroom in the Yellow House. He had purchased two "country beds, big double ones" [40] for the house, and the bed in the painting—with its two pillows side by side—is undoubtedly one of them. By creating an illusion of depth in the picture which increases the bed's length, he makes the double bed look like a single bed. Similar to overlapping couples, merged trees, and cottages that "have grown into one," the two would-be occupants of the bed are brought together to occupy the space of one. There are a pair of paintings on the wall above the bed (one a man, the other a woman), a pair of chairs, a pair of bottles on the table, and a pair of windows above the table. This pairing, repeated over and over again, expressed Vincent's wish that the Yellow House would end his isolation and become "a home of my own, which frees the mind from the melancholy of being out on the streets." [41]

Vincent wrote that *Tree with Ivy and Stone Bench,* a painting of the garden of the sanitarium at Saint-Rémy, represented "eternal nests of greenery for lovers. Some thick tree trunks covered with ivy. . . ." [42] Both the bench, where people sat together, and the ivy encircling the tree trunk represented closeness and love. But the ivy also stood for his fear of being engulfed and destroyed by love, as witness the words he had written six weeks before, while still in Arles: "The ivy loves the old branchless willow—every spring the ivy loves the trunk of the old oak tree—and in the same way cancer, that mysterious plant, so often fastens on people whose lives were nothing but ardent love and devotion." [43]

The paired portraits above the bed in *The Bedroom* exemplify another means Vincent used to bring people (or people substitutes) together. Especially during the last year of his life, he conceived of many of his paintings in terms of pairs. Those of round, golden sunflowers and of tall, dark, flame-shaped cypresses are examples. "When I had done those sunflowers, I looked for the opposite and yet the equivalent, and I said—it is the cypress." [44] The olive trees with a pink sky, Vincent wrote, "would go well as a pendant to those with the yellow sky." [45] "[A] canvas . . . of wheat fields and one which is a pendant to it, of undergrowth, lilac poplar trunks and at their foot, grass with flowers, pink, yellow, white and various greens," [46] formed another pair. The portrait of Dr. Gachet's daughter went well with the landscape of a wheatfield: the portrait

was vertical and in pinkish tones while the landscape was horizontal and in "pale green and greenish-yellow, the complement of pink." These two "fragments of nature," he added, "explain each other and enhance each other." [47] In earlier days he had said the same thing about human beings.

The use of complementary colors, by itself, was still another means by which he symbolized the union of two human beings: "[T]here are colors which cause each other to shine brilliantly, which form a *couple,* which complete each other like man and woman." [48] He reaffirmed this idea in declaring that he wished "to express the love of two lovers by a wedding of two complementary colors, their mingling and their opposition, the mysterious vibration of kindred tones." [49] The orange background complementing the blue of the cap in *Self-Portrait with Bandaged Ear* is one example of such a "wedding." From the standpoint of technique and style, Rembrandt's chiaroscuro painting, *The Jewish Bride* (which had so fascinated Vincent in Amsterdam), and this strange Provençal work with its raw complementary colors side by side were poles apart. In the former, the message—"the love of two lovers"—was carried by its expressive content; in the latter, by the "wedding" of colors. To Vincent van Gogh, they were psychological equivalents.

In his sermon Vincent told his congregation, "There is sorrow in the hour of death, but there is also joy unspeakable. . . ." For this reason death is not to be feared but anticipated.

Vincent was attracted to and stimulated by death, and he seized many opportunities to discuss it, especially during the years before he turned to art. For example, the sudden death of the sister of his English friend, Harry Gladwell, in August 1876, a few months before his sermon, impelled him to embark on a six-hour hike to visit the grieving family. He "felt a kind of shyness and shame on witnessing the great respectable sorrow," and the desire to partake of the family's experience stimulated him to put himself into his friend's skin. "[Gladwell's] work was my work," he continued, ". . . his life was my life." [50] The following year he rushed back to Zundert on hearing that a family friend was dying. By the time he arrived, however, he could only visit the bereaved family, sharing their grief as completely as he had with the Gladwells. Vincent wrote admiringly of "that noble head lying on the pillow." [51] The expression of peaceful suffering and a "certain holiness" transformed

the corpse into an object of beauty. Later, while living in Amster-
dam with his uncle, Admiral Johannes van Gogh, an unknown boy
drowned in the harbor. Vincent followed the boy's body as it was
carried home, and he returned in the evening to observe the grieving
family and admire the corpse: "The little body was lying so still on
a bed in the little parlor—he was such a pretty little boy. The
impression remained with me the whole evening while I took a long
walk." [52]

He continued to admire the corpse even during the exciting
Arlesian summer of 1888 when he was at the peak of his vitality and
achievement. After one of his uncles died, Vincent asked, "Why
was . . . the face of the deceased calm, peaceful, and grave, when
it is a fact that he was rarely that way while living, either in youth
or age? I have often observed a similar effect as I looked on the
dead as though to question them." [53] The conviction that the corpse
experienced such feelings proved to him the existence of "life
beyond the grave" and justified anticipating death with pleasure
rather than with fear. "Illness or death," he affirmed, "holds no
terrors for me." [54]

Vincent's view of "the almost smiling death," as he once called
it, arose from a passionate faith in rebirth and immortality. This
faith was at the heart of his sermon, in which he reminded the
congregation that "there is not [sic] death and no sorrow that is not
mixed with hope—no despair—there is only a constantly being
born again."

Although Vincent gave up church religion in favor of art, ideas
of rebirth and immortality continued to fill his mind, and he ex-
pressed them in unusual ways. When Kee Vos refused his love and
Sien took her place, for example, he wrote that his love "had liter-
ally been *killed*. But after death one rises from the dead. Resurgam.
Then I found Christine." Even prior to becoming an artist, he
responded to the death of the French artist, Daubigny, by saying
that it must be good to die if one knows he will live through his
work.[55] Hoping for the same immortality he bestowed on Millet and
Delacroix, he told his pupil Anton Kerssemakers, "They will surely
recognize my work later on, and write about me when I'm dead and
gone." [56]

Vincent viewed his emergence as an artist as a rebirth, made
possible by adversity and misfortune. He concluded a gestating
silence of nine months by informing Theo that he was emerging
renewed, like a bird after molting time.[57] Painting itself was a

magical means of inducing this rebirth; defining art as "re-creation" rather than imitation, he thought it would give him "a second youth." [58] But even if this did not happen, "even though my own youth is one of the things I have lost," there would be "youth and freshness" in his pictures.[59]

Vincent's love of drawing, which began in childhood, disappeared in 1874 following his rebuff by Ursula Loyer,[60] but the death of his landlady's thirteen-year-old daughter in April 1875 revived it. On the Sunday morning after she died, he made the first drawing mentioned in *The Complete Letters*, "a large grassy plain with oak trees and gorse. It had been raining overnight; the ground was soaked and the young spring grass was fresh and green." [61] Here he was not depicting death itself, but its complement, rebirth. Later he sketched corpses in The Hague. The bowed old man in *Worn Out: At Eternity's Gate*, one of many withered ancients whom he drew in The Hague, was a more indirect way of portraying death; although the old men will soon die, they "cannot be destined for the worms." [62] He drew one of them standing near a coffin, "in what they call the 'corpses den.' " [63] Vincent was also enthusiastic about a drawing by Luke Fildes, *The Empty Chair*, which commemorated the death of Charles Dickens.[64] There are many empty chairs among Vincent's works—*The Window at Bataille's, Vincent's Chair, Gauguin's Chair;* they reminded him of absences caused by death: "Empty chairs—there are many of them, there will be even more, and sooner or later there will be nothing but empty chairs. . . ." [65]

Sickness, like old age, also represented death for Vincent, except that it meant a fast death rather than a slow one: "[C]holera, gravel, tuberculosis and cancer are the celestial means of locomotion just as steamboats, buses and railways are the terrestrial means. To die quietly of old age would be to go there on foot." [66] He perceived ivy encircling an old willow as a cancerous growth, and his pictures of such scenes, such as *Tree with Ivy and Stone Bench*, were representations of the fast death. Bodily injury represented partial death, and among Vincent's works are sketches of *Man with Bandage over Left Eye, Blind Man Begging,* and *The One-eyed Man*, as well as paintings of a ward of sick people in the hospital at Arles and a sick inmate of the Saint-Rémy sanitarium. He also painted his own mutilated head in bandages in *Self-Portrait with Bandaged Ear*, and the injured traveler, similarly bandaged, in *The Good Samaritan.*

The reaper, a familiar symbol of death, is another of Vincent's

favorite subjects. His early reapers are dark, in tune with the melancholic nature of his northern works, but the reapers of the Midi are full of sun or color, portraying the happy death. Of one of them, he writes, "I see in him the image of death, in the sense that humanity might be the wheat he is reaping. . . . But there is nothing sad in this death; it goes its way in broad daylight with a sun flooding everything with a light of pure gold. . . . [It] is an image of death as the great book of nature speaks of it—but what I have sought is 'the almost smiling.' " [67] The reaped autumn wheat, Vincent points out in this passage, is a symbol of dead humanity. The golden landscapes of cut wheat from Arles, Saint-Rémy, and Auvers, also depict the "almost smiling" death.

As an artist, Vincent portrayed the fantastic roots and gnarled leafless trees that had earlier reminded him of the old twisted trees and stumps in Dürer's etching, *The Knight, Death, and the Devil.*[68] *The Roots,* the drawing that Vincent had equated with *Sorrow,* and *Pollard Willow by the Side of the Road,* a watercolor of a dead tree, are examples; they expressed not only sorrow but death as well, like a poem that had once struck him: "I, sad and alone, am standing like a dead tree. . . ." [69] Cut down (dead) trees were the subject of other works, from *The Woodcutters* of 1883 to *The Woodcutter* of 1889, after Millet. As for the cypress, which he painted so often in the Midi, it has, of course, been a symbol of death since pagan times.

In the watercolor of the dead willow, he used mutually reinforcing symbols: "that dead tree near a stagnant pool," "black smoke-stained buildings," and a "sky with scudding clouds." [70] In Nuenen the winter countryside was a similar scene of sad death: "It is dreary outside, the fields a marble of lumps of black earth . . . crows, withered grass, and faded, rotting, green, black shrubs, and the branches of the poplars and willows angry, like wire against the dismal sky." [71] At another time and in a different mood, Vincent equated the dead leaves of autumn with a happy, joyous death. *The Garden of Saint-Paul's Hospital* is a quintuplet of death in nature: "an enormous trunk, struck by lightning and sawed off," "the pale smile of a last rose on the fading bush," "empty stone benches," "the last ray of daylight," and "the sickly green-pink smile of the last flower of autumn." [72] His sunsets and twilights, subjects of especial interest to Vincent, may also be seen as reflections about death. In describing an autumn sunset in Arles, he again combined several such representations: "an extraordinarily beautiful sunset of a mysterious, *sickly* citron color—Prussian blue *cypresses* against

trees with *dead* leaves [italics added]. . . ." [73] A scene resembling this is pictured in *The Sower* (October 1888), a painting mentioned in the same letter.

Vincent saw "something deeper, more infinite, more eternal than the ocean in the expression of the eyes of a little baby when it wakes in the morning." [74] The presence of babies, who represented rebirth and immortality, relieved his sadness, and numerous drawings and paintings of babies attest to his fascination with re-creating them. Some are being held or nursed, and others, seen or unseen, lie in cradles. Vincent was attracted to Sien by her pregnancy, and was quick to take artistic advantage of the newborn baby boy.[75] Similarly, when Madame Roulin's daughter Marcelle was born in August 1888, Vincent could hardly wait to get the baby on canvas, and he again accomplished his mission with dispatch. Although she is not seen in it, *The Cradle* also concerned Marcelle: Mother Roulin is pulling a cord that rocks the cradle in which she lies. In drawings from The Hague, old age and childhood—death and rebirth—sometimes coexist. In *Old Man with a Child*, for example, a seated old man holds the hands of the little girl who stands facing him, and in *Old Man Holding an Infant* a bald old man with long white sideburns holds an infant in his arms. The old man nears death but the child will carry on in his place.

The Raising of Lazarus, based on an etching by Rembrandt, was Vincent's only direct artistic representation of human rebirth. For the most part, however, he looked to nature for evidence of rebirth, and his search provided material for many famous works. When the death of his landlady's daughter stimulated young Vincent to draw the fresh spring grass, he brought her back to life symbolically, in this way easing his grief.

References to rebirth in nature appear frequently in letters written long before he became an artist, and they present the same message that was expressed later in his pictures: "Who is there to see when the first years of life . . . will perforce wither, and they shall wither even as the blossom falls from the tree, and new life shoots up vigorously, the life of love unto Christ?" [76] Predictably, there are many pruned trees with fresh growth springing from their bare crowns among his Dutch landscapes. Though such scenes were commonplace in the Dutch countryside, they had deep meaning for him; they were not selected merely because of their availability. During these early years as an artist, however, his view of nature was dominated by death and depression; the ebullient, colorful new

growth that for Vincent was a manifestation of joyous rebirth would displace it only later on.

Vincent often brought the old and the new—the dead and the reborn—together in one landscape, just as he brought them together in the drawing of the old man and the child. In *Sorrow*, Vincent wanted to express "the struggle of life in that pale, slender woman's figure." [77] She is sick and wasted and "would die if she had to walk the streets again." [78] But at the same time she is filled with new life, as her swollen belly testifies. The coexistence of death and rebirth is echoed in the plant life around her. She sits on a sawed-off dead stump, surrounded by new spring growth. The young tree in the background is about to burst into bloom; flowering plants grow beneath it and in the foreground as well. Later at Arles Vincent portrayed a colorful variation on the same idea in *The Blossoming Pear Tree*. As in *Sorrow*, a cut-off stump is seen on the far right, and a tree has burst into bloom on the left. But now the young tree is in the foreground, dominating the scene with its fresh new shoots and colorful blossoms, while the dead stump is relegated to the background, small and barely noticeable.

Souvenir de Mauve, the brilliant painting of two young, pink peach trees glowing in the sky was painted in memory of Vincent's relative and teacher. With Mauve's death fresh in mind, Vincent recalled that Corot dreamed on his death bed of "landscapes with skies all pink," [79] and Corot's dream may have influenced Vincent's choice of color for this commemorative work. Painted during the same spring as *The Blossoming Pear Tree*, it carried the same message. There was no dead stump, only the reborn trees, but the thought of death remained in its inscription.

Earlier, in the dismal atmosphere of Drenthe, Vincent had noted that a gnarled old apple tree "at a certain moment bears blossoms that are among the most delicate and virginal things under the sun." [80] He reiterated a similar idea while enduring the pangs of his Provençal rebirth: "The more I am spent, ill, a broken pitcher, by so much more am I an artist—a creative artist—in this great renaissance of art of which we speak." [81] He called this renaissance of "eternally living art" a "green shoot springing from the roots of an old, felled trunk." The following year, after suffering several psychotic attacks, he was indeed a "felled trunk," immured in an asylum. There, he painted *The Garden of Saint-Paul's Hospital* with its symbols of death, but from this sawed-off, "defeated" giant, he wrote, "a side branch shoots up very high." [82]

As he had equated the harvest with old age and death, Vincent

also equated new growth in nature with the newborn infant and rebirth. Long before painting the young wheat in Provence, he had written, "Young wheat has something inexpressibly pure and tender about it, which awakens the same emotion as the expression of a sleeping baby." [83] He combined these equivalents in word pictures just as he combined them in art: "I think there is no better place for meditation than by a rustic hearth and an old cradle with a baby in it, with the window overlooking a delicate green wheat-field. . . ." [84] Toward the end of his life, he called paintings of "a field of young wheat at sunrise" and an "orchard in bloom"—regarded by him as the most delicate things he had ever done—his "babies." [85]

While the reaper portrayed the withering of life, the sower was the herald of rebirth and, as Vincent said, a symbol of the infinite. He was one of Vincent's favorite subjects.

Like *The Garden of Saint-Paul's Hospital, The Sower* (October 1888), with a fall sunset and other representations of death, also depicts rebirth: The sun is setting but it will arise; the leaves on the tree are dead but new leaves will replace them; the wheat has been cut, but the sower insures its return. Like sowers, the Crau and the Camargue, vast plains of the Midi, were also "nothing but infinity—eternity," and the Crau was "as beautiful and as infinite as the sea." [86] Vincent also painted the infinite sea many times, both in Holland and Provence.

To Vincent, death and rebirth were opposite and complementary, but they were also the same—a point of view identical to the "union beyond the opposites" of Hinduism. Like the old man and the child, the cut sheaf and the new wheat, as well as the reaper and the sower, were paired symbols of death and rebirth; but each pair was also a symbol of infinity and eternity. Similarly, he noted that both his tortuous old olive trees and his Provençal harvest scenes contrasted and formed a unity with the paintings of colorful spring growth.

A fireplace was another favorite subject and its anthropomorphized flames stood at once for death and rebirth. One of his letters quotes a passage from his reading that makes this clear: "to see the flames be born, rise, flicker and supplant one another as if craving to lick the pot with their tongues of fire, and to think that such is human life: to be born, to work, to love, to grow, to disappear." This was not the end, however, for the smoke rose to a star in heaven, "a star that sends its rays through the opening in the chimney as if to call me." [87]

Vincent's *Oleanders* also spoke of the drama of death and re-
birth. He described them as "raving mad"—even as he had been not
long before painting them. They were "flowering in a way they may
well catch locomotor ataxia"—one of the diseases that, according to
Vincent, facilitated death. But the oleanders "are loaded with fresh
flowers and faded flowers as well, and their green is continuously re-
newing itself in fresh, strong shoots, apparently inexhaustibly. A
funeral cypress is standing over them." [88] Vincent's paintings of sun-
flowers also depicted ecstatic growth. There are fourteen oil paint-
ings of them in the de la Faille catalogue. These flowers are abun-
dant in Provence, where Vincent's most popular portrayals of them
originated, but his fascination with them predated his stay there;
there are almost as many still lifes of sunflowers from Paris as from
Provence. He planned to hang *The Cradle* in the guest bedroom of
the Yellow House with still lifes of sunflowers on each side of it.[89]
They would have reinforced the idea of exuberant, happy growth—
an idea already implicit in the unseen baby and the colorful flowers
studding the background of *The Cradle*.

Vincent compared himself to the lowly caterpillar that is
miraculously reborn as a butterfly, a common symbol of Christ's
Resurrection.[90] The remarkable transformation of his art repre-
sented his own wished-for metamorphosis. During his first year as
an artist, his work—like the caterpillar—was close to the earth, and
it portrayed the low and ugly. Later it emerged in bright canvases
that stressed the beauties of nature and was more of the sky than the
earth, suggesting "the existence of [a] painter-butterfly." [91] The
series of butterflies that he painted in Saint-Rémy might be called
self-portraits. (See *Death's-Head Moth*.)

Since beetles are transformed grubs, as Vincent noted,[92] the
paintings he did of them were still another representation of him-
self as newborn. Consoling himself on the death of Mauve, he ob-
served that man may also become transformed after death, for he
cannot know about this any more than the grub knows it will
change into a beetle.[93] (See *Roses and a Beetle*.) Vincent too had
been a grub, working in mines and experiencing the darkness of
depression, but he too would emerge transformed—in the sunny
painter's paradise of the Midi.

"There is only a constantly being born again," Vincent said in
his sermon. He then repeated the idea using different terms: "a

constantly going from darkness into light." He reenacted this alter-
nation between darkness and light in his life, and he depicted it in
his art. Born and raised in dark Holland, he traveled south seeking
light in France and died in its bright summer sun. His art began in
darkness and ended in brilliance. Darkness itself did not interest
him. Rather he was driven to seek light arising out of darkness, and
he was forever enthralled when he could find it and gaze at it.
References to the theme of light emerging out of darkness are not
confined to his sermon; there are hundreds of them in his letters.

Descriptions of light effects poured forth as abundantly in the
letters he wrote before choosing an artistic career as after—descrip-
tions of twilights, lights in homes and churches, streetlights, bon-
fires, ships at night, lighthouses, lightning, glowing pipes, night
snow scenes, and the night sky with its celestial bodies. His fascina-
tion with the play between darkness and light was not the result of
training in art, then, but was an important factor in determining his
choice of an artistic career.

As a young teacher in London, Vincent loved to stand on the
embankment of the Thames in the evening in order to gaze at the
city's lights. His fondness for light arising out of darkness also
helped to draw him to the coal-mining region of Belgium and kept
him there for two years. He was fascinated by the lights on the
miners' caps that sparkled in the black depths, and he enjoyed
gazing at the miners when they emerged from the pits into the light
of day. In the same way, he enjoyed watching the sun come into
view at dawn, or remained awake during the night, gazing by the
hour at a candle glowing in the dark.[94]

The theme of light in darkness manifested itself as much in
Vincent's art as in his letters. He arose while it was still dark in
order to paint the sunrise. His depictions of the cavelike interiors
of the wretched huts of Dutch peasants and weavers always contain
a source of bright light—sunlight pouring through a window or
the glow of a suspended lantern. Two well-known paintings, *The
Potato Eaters* of 1885, and the mysterious *The Night Café* of 1888,
are among the many van Gogh interiors that illuminate dark
scenes with glowing lanterns hung in prominent positions. His pic-
tures of the starry skies in Provence transpose the same idea into
the heavens; he painted them in the darkness with a halo of candles
on his cap.

To Vincent, the glowing lights of a house spoke of warmth and
happiness within. Stars twinkling in the sky revealed the acceptance

of the dead in heaven, a glorious rebirth into a life of love and joy. Many of his youthful statements of religious faith equated darkness with death, sorrow, and rejection and light with rebirth, joy, and acceptance. He pointed repeatedly to the need to sit in darkness—that is, to face sorrow, rejection, and death—patiently awaiting the light of ultimate happiness. Man, he said, must cast himself into the depths of darkness on the road toward light. Part of his mind took this idea literally, and he cast his body as well as his mind into the depths. From the dark mines and the dark North, as well as from the darkness of self-imposed isolation, he emerged to seek the light of Provence and, finally, the light of heaven.

2 The assets
of melancholy

MM "The only true wisdom lives far from mankind, out in the great loneliness, and it can be reached only by suffering. Privation and suffering alone can open the mind to all that is hidden in others." So spoke a primitive Eskimo shaman named Igjugarjuk, recorded by the Arctic explorer-scholar Knud Rasmussen and quoted by Joseph Campbell in *The Masks of God*. "The 'grave and constant' in human suffering, then," Campbell writes, "leads—or *may* lead—to an experience that is regarded by those who know it as the apogee of their lives and which is yet ineffable." He believes that this experience "is the ultimate aim of all religion, the ultimate reference of all myth and rite." "But all, certainly, will not be suffering," Campbell concludes, ". . . for the paramount theme of mythology is not the agony of the quest but the rapture of a revelation, not death but the resurrection: Hallelujah." [1]

Change the words "religion" and "mythology" to "artistic creativity" and these quotations might have been written by—or about—Vincent van Gogh. By reason of childhood experience, parental teaching, and religious conviction, he thoroughly believed in the value of suffering, sorrow, and loneliness. In his sermon at

Richmond he had observed, "Passing through great tribulation leads to greater joy." Staying with a difficult person like Sien, Vincent insisted, helped him maintain the "melancholic view of life" that he prized. "I prefer feeling my sorrow to forgetting it or becoming indifferent," he explained, and told Theo that he found his serenity was " 'put in *worship* of sorrow' and not in illusions." ² On the death of a cousin, he wrote, "This is one of those things which, as time goes on, makes us 'sorrowful yet always rejoicing'; this is what we must become." ³ On another occasion, when Theo remarked that being ill was no misfortune, Vincent replied, "No, for 'Sorrow is better than laughter.' No, being ill when God's arm supports us is not bad, especially when we get new ideas and new intentions that would not have come to us if we had not been ill, and we achieve clearer faith and stronger trust." ⁴ Even before he became an artist, when his father told him, "Sadness does no harm, but makes us see things with a holier eye," Vincent remarked, "*This* is the true 'still sadness,' the pure gold." ⁵ Neither of them could have guessed at that time that this sadness would be transformed by Vincent's hand into the pure gold of art.

The desire to rid himself of depression—and the loneliness, the despair, and the fears that were part of it—was the most powerful force that motivated Vincent to become an artist and incited the intense energy that was so vital to this end. His pictures became his companions, his mistresses, and his children. "The work is an absolute necessity for me," he wrote. "I can't put it off, I don't care for anything but the work; that is to say, the pleasure in something else ceases at once, and I become melancholic when I can't go on with my work." ⁶ He observed at another time that hard work was the way to avoid "that melancholic staring into the abyss." ⁷ "I feel inexpressibly melancholic without my work to distract me, as you will understand, and I *must* work and work with *facility. I must forget myself in my work,* otherwise it will crush me." ⁸

It was not simply that art made his suffering more tolerable, but Vincent regarded suffering itself as a virtue that contributed to his success as an artist. From The Hague he wrote, "If momentarily I feel rising within me the desire for a life without care, for *prosperity,* each time I go fondly back to the trouble and the cares, to a *life full of hardship,* and think, it is better this way; I learn more from it. . . ." ⁹ Hardship would help a flourishing artist friend, Theophile de Bock, with his work, just as it helped his own: "I should be sorry for him if he did not land more in the thorns than in the flowers—that's all." ¹⁰

Suffering—and the desire to allay it—stimulated Vincent's development in various ways. His fight against loneliness and his fear of intimacy, for example, set up opposing strivings that functioned alternately in activating his creative processes. On the one hand, he wanted to join hands with other painters "because everyone who paints would almost sink down under it if alone." [11] On the other, he gave credit for his accomplishments to the self-isolation that arose from his fear: "I agree with what I recently read in Zola: 'If at present I am worth something, it is because I am alone, and I hate fools, the impotent, cynics, idiotic and stupid scoffers.'" [12] Like a Zen Roshi, Vincent could tolerate mutually opposing ideas and managed to combine them to the benefit of his work, at one time having relations with other artists who provided him with new ideas, and at another time the isolation in which his mind could function without outside interference.

Art was the one activity that enabled him to turn loneliness into solitude, the solitude that provided necessary time for fantasy, reflection, study, and reading. In his first letter to Theo after deciding to become an artist in 1880, he stressed the importance of his self-isolating proclivities, an explanation that was both a rationalization and an insight: His shocking appearance and his life of poverty and neglect, he said, "was a good way to assure the solitude necessary for concentrating on whatever study preoccupies one." [13]

His position as a lonely outsider also made it easier for him to create a new and unique style. Just as Freud praised his Jewishness as a valuable source of energy that helped to give him a "readiness to accept a situation of solitary opposition," [14] Vincent praised his alienation as a necessary part of his creative life. Ignored in The Hague by his cousin-in-law Mauve, an established artist, and Tersteeg, the manager of the art gallery where he had once worked, he emphasized the advantages of being an outcast: "And though some people may damn me irrevocably and forever, in the nature of things my profession and my work will open new relations to me, that much fresher for not having been frozen, hardened and made sterile by old prejudices." [15] He missed Mauve and wished he could work with experienced painters, but it was "not exactly a misfortune to struggle on alone. What one learns from personal experience is not learned so quickly, but it is imprinted more deeply on the mind." [16] It is also more apt to represent genuine, deeply rooted ideas and feelings.

Although he inevitably became an outcast wherever he went, he continued his search for an accepting environment: during his

ten years as an artist he lived in eleven different places. This exposed him to a wide variety of people, ideas, and landscapes, thereby greatly increasing the perceptions that he could put to use in art. His self-alienating behavior, however, made it inevitable that his relations with people would be short-lasting, and that he would never be so thoroughly attached to anyone or anyone's ideas as to become an imitator rather than an innovator.

Like many people on the threshold of depression, Vincent tried to find solace in an inner world of fantasy. He recognized that this tendency grew out of his emotional problems but was also aware that it enabled him to become an artist. Months of silence and contemplation, with his imagination given free rein, brought him a clear vision of his future, which he then proceeded to turn into action. "It is true that there may be moments when one becomes absent-minded, somewhat visionary; some become too absent-minded, too visionary," he wrote in 1880, when he announced his intention to become an artist. "This is perhaps the case with me, but it is my own fault; maybe there is some excuse after all—I was absorbed, preoccupied, troubled, for some reason—but one overcomes this. The dreamer sometimes falls into the well, but is said to get out of it afterward. . . . [A] man who has seemed good-for-nothing and incapable of any employment, any function, ends in finding one and becoming active and capable of action—he shows himself quite different from what he seemed at first." [17]

In addition to helping him find his way toward art, Vincent's dreaming also provided the inner perceptions that made it possible to be creative. The truly creative artist must see and depict something that has never been seen or depicted before, and fantasy is essential to this. E. H. Gombrich writes, "It is the impractical man, the dreamer whose response may be less rigid and less sure than that of his more sufficient fellow, who taught us the possibility of seeing a rock as a bull and perhaps a bull as a rock." [18]

But Vincent was also frightened by his fantasy world and tried to counter it in his art by being a realist. With few exceptions, he did not express himself in visionary, fantastic, or overtly symbolic ways; indeed, he derided such an approach to art—"à la Redon," he called it.[19] His pictures are closely tied to the topographical realities of his subject; where they can still be compared, his landscapes—down to individual trees and rocks—are often remarkably similar to the original setting. In this he followed both his inner needs and Dutch tradition. This is not to say that fantasies are not present

in his work, but they receive indirect expression in his technique, his color, and the hidden symbolism of realistic scenes.

His readiness to acknowledge depression—indeed, to be proud of it—was another important asset in pursuing his artistic goals. He was thus enabled to examine this depression, depict it, and with the aid of his fantasies, transform it. In contrast, constant denial of one's depression often contributes to a psychological rigor mortis. In transforming his depression, however, Vincent reconstructed his inner life; projected the reconstruction into his environment, and used it in his art. The darkness of the world disappeared, and he saw it in a brighter light. This form of mental activity usually goes on at an unconscious level, and the person often remains unaware of its existence. Vincent's remarks, however, suggest that he had some conscious control over it or understood it when it happened. For example, when he felt like an outcast in Arles, he was determined to avoid feeling miserable; he explained that he would rather fool himself than feel alone. "And I think I should feel depressed if I did not fool myself about everything." (In an apparently unrelated statement concerning an event in Paris, he then added: "It wasn't a bad idea, that journalist advising General Boulanger to wear rose-colored spectacles, so as to put the secret police on the wrong scent.") [20] Vincent's perception of Provence was among the ways he "fooled" himself. He too wore rose-colored glasses—not to put off the police but to dispel depression, and his paintings there evolved out of a rose-colored view of the world. He threw himself into painting Provençal orchards "of astonishing gaiety" in order to make himself feel gay, however deceptive and short-lived this feeling was.

Much of the strength of Vincent's tendency to fuse his internal and external perceptions—so vital for his art—had its source in his depressive origins. It is natural to perceive the environment in terms of the images and fantasies of one's inner world, but in Vincent this was an extraordinarily powerful tendency with both pathological and creative aspects. Vincent's ability to differentiate between himself and the people and objects around him was quite weak and unstable, due, as I shall try to explain later, to problems in his childhood that laid the basis for his depressive character. To put the situation in a way that better expresses its creative aspects, his tendency to fuse self-perceptions and external perceptions was strong. This was an asset when he was confronted with external objects that stirred his fantasies; it contributed to moments of awe

and wonder. Except during the psychotic episodes of his last years, he could distinguish intellectually between internal and external, yet use the perceptual fusion in the service of art. He projected his internalized images into models, still lifes, and landscapes and then depicted them as psychologically reborn.

When Vincent said sorrow was better than joy, he was not talking about the deep depression that leads to stagnation and paralysis of action—"that desperate suffering that makes one despair." Rather, he was referring to what he called "active melancholy" [21] or "healthy melancholy," a state that contributed to creative work. Throwing himself into work was his salvation. On one occasion, when Theo expressed a "hope for better times," he replied, underlining each word, *"To hope for better times must not be a feeling but an action in the present."* [22]

When he tried to avoid a "fatal" melancholy after being disillusioned with Sien, he deliberately sought out a melancholic environment in Drenthe. Though depressed, he was able to go to work at once, since the "melancholy that things in general have here is of a healthy kind, like in Millet's drawing." [23] He meant, of course, that the surroundings produced a "healthy" effect on him, that it transformed a paralyzing depression into an "active melancholy."

What made this transformation possible? The answer to this question may be beyond our knowledge, but the biographical material of the remaining chapters will offer evidence that several interrelated, overlapping factors contributed to it. For example, he had a need to be productive, originating in his Dutch culture and encouraged by family example and childhood training. To work was to be "good," and it provided him a sense of goodness that mollified the guilt and shame of depression. The advent of depression signaled him to turn to work as a means of alleviating it. In addition, his ability to shift from unsuccessful human relations that precipitated depression to substitute relations with nature and fantasied objects permitted him to function beyond the point where depression would have otherwise paralyzed his actions. His identifications with Christ and immortal artists of the past generated a secondary self-confidence in him. (A "secondary" self-confidence is intended to contrast with the more solid self-confidence built on a satisfactory parent-child relationship.) These grandiose identifica-

tions also justified the expression of a self-righteous anger that helped neutralize depression. He was also able to replace depression with a hyperactive, hypersensitive state, similar in some ways to the manic phase of a manic-depressive state.

Finally, he had the ability to convert the nonfunctioning misery of depression into the "active" suffering of masochism, an alternative way of having relations with other people.

The masochist can be seen as a depressed person who has attempted to preserve or restore hope through a display of suffering that appeals for love.[24] I have suggested that a continuum exists between theoretically "pure" depression and "pure" masochism:

> Broadly speaking, the depressive suffers and the masochist exhibits suffering. Though he complains bitterly of his misery, the masochist tends to minimize or deny to himself the affect of depression. The emotion is distilled out of the depressive mixture, leaving behind a residue of depressive ideation. Depression is infectious; gloom spreads in its wake. But, partly because of this dissociation between affect and thought, masochism stirs resentment and recrimination, and the masochist is sometimes condemned as a fraud who exaggerates his woes. Analysis, however, discloses profound unhappiness.
>
> The depressive feels the misery inside himself and blames himself for it. Using provocative behavior, the masochist manages to cause others to bring it on him. This helps him to deny the inner unhappiness. Through externalizing it, he can exhibitionistically appeal for help and sympathy, righteously express anger toward his persecutors and absolve himself of guilt. These safety valves are not available to the depressive.[25]

Vincent is a good example of this relationship between depression and masochism. He took the suffering of depression and, instead of being crushed by it, glorified it—first in the name of Christ and then in the name of art. He exhibited it to his parents, his brother, and to all the world. He swung back and forth between paralyzing depressive states of relatively short duration and productive masochistic-creative states. In his identification with the crucified Jesus, the masochistic use of depression enabled him to accept unhappiness as a means of obtaining the approbation of his fellow man as well as eternal joy in heaven. With the glorification of suffering, the thought of suffering remained but the feeling diminished. He

appeared to accept the cruel demands of the rejecting, punishing, shaming world by rejecting, punishing, and shaming himself; but, at the same time, he rejected this world and asserted his intimacy with God and heaven. He made a compact with the sadists, but he also defied them. By becoming a martyred hero, he turned guilt into innocence and shame into pride.

Vincent was overtly masochistic. This can be seen in the humiliation and physical abuse that he brought on himself, his ascetic habits of eating and dressing, his fear of success, and his self-mutilation. His parents had some awareness of this tendency. His mother feared "that wherever Vincent may be or whatever he may do he will spoil everything," and his father remarked, "It seems as if he deliberately chooses the most difficult path." [26] His eccentricity made him the butt of jokes, and his sad face stirred a sympathetic response. In part, such behavior revealed his deep unhappiness; in part, it was an exhibitionistic demand for attention and love intended to appeal to an audience that would enjoy mocking him or would be attracted to his misery.

When Vincent wrote, "I resign myself to everything and put up with everything," [27] he was following a childhood pattern of appeasing a mother whom he experienced as unloving and cruel. Having learned early that acceptance was more readily obtained by being the victim than by being the victor, he could testify as an adult, "[I]t is better to be a sheep than a wolf, better to be slain than to slay—better to be Abel than Cain. . . . better to be ruined than to do the ruining." [28] And he added not long after, "*I consciously* choose *the dog's path.*" [29]

He had found that his childhood anger, as frightening as only that of a rejected child can be, could not be unleashed without fear of a frightening retribution from people much larger and stronger than he. Hoping to appease them through suffering, he turned their expected anger as well as his own against himself. By provoking their anger, he encouraged them to be angry with him, so that he would not be angry with them. In adulthood such thinking enabled Vincent to pride himself on being "chained to misfortune and failure." "I do not envy the so-called fortunates and the ever successful, as I can see through it too much," he wrote. "Take 'The Prisoner' by Gérôme—the man lying fettered is most certainly in an unpleasant situation, but to my way of thinking it is better to be him than that other fellow who has the upper hand and is nagging him." [30]

Adding to the value placed on hard work by Dutch tradition, his masochism forced him to spend endless hours learning and practicing his art. While he often accused himself of being a burden to others, art was his own burden, as he wrote in 1886: "And do you realize *how heavy* are my burdens which the work demands every day, how difficult it is to get models, how expensive the painting materials are? Do you realize that sometimes it is almost literally impossible for me to keep going?" [31] Soon after, he complained that he was "worn out" from excess work,[32] work that his inner demons forced upon him; *Worn Out* was the title he had previously given to a sketch of an old bent man.

In Arles he referred to the "atrocious hardships" of his craft, and in announcing Gauguin's arrival, he told his brother that "the pains of producing pictures will have taken my whole life from me, and it will seem to me then that I have not lived." [33] It is not surprising that after mutilating his ear he would blame it on his work; his pictures, he lamented, cost him "an extraordinary amount, perhaps even in blood and brains." [34] The anger that Vincent was unable to vent openly was not entirely directed toward himself, however. Much of it went into the aggressive task of creating pictures, especially apparent in his last years when he attacked the canvas with a fury.

Feeling unloved and deprived, he was convinced that his parents and their psychological successors owed him his due, and did not hesitate to demand the help that ordinarily is only given to a child. Throughout his career as an artist he expected his father and then Theo to supply his needs, and he also expected other father substitutes—Mauve in The Hague, Tanguy in Paris, Roulin in Arles, and Dr. Gachet in Auvers—to provide for him, each in his own way. It could be assumed from Vincent's frequent complaints about his financial plight that he was on an extremely meager allowance. Charles Mauron, however, has pointed out that the 150 francs per month that Theo gave him was twice the starting salary of a French school teacher before the first World War.[35] If Vincent had not been as demanding, and his father and Theo as giving, he would not have been able to follow the single-minded course that permitted his talents to evolve. He could well afford to have contempt for those whose goal was to make money; although he sometimes gave lip-service to the idea that he should pay his own way, he expected his wants to be supplied by others.

Vincent craved understanding and recognition for himself and

his pictures. "It does me so much good when people are enjoying my work a bit," he wrote. "For it is so discouraging and dispiriting and acts like a damper, when one never hears, This or that is right, and full of sentiment and character." [36] Yet he was able to transcend these wishes, sometimes defiantly, so that they did not interfere with his creative endeavors. He could rationalize his dependency, for instance, by convincing himself that Theo and he were partners, with Theo supplying money and encouragement and he supplying the pictures. He could even deny that he wished others to approve of his work, for he convinced himself—rightly as it turned out—that future generations would recognize him. Without this ability, he would have been unable to discover and depict his new vision of the world.

When Vincent agreed with Millet's assertion that he *"would never do away with suffering, for it often is what makes artists express themselves almost energetically."* [37] he knew his own mind. His masochistically oriented "active melancholy," like the suffering of the Eskimo shaman, led to wisdom and revelation—an artistic revelation that has given many others the joy that was denied to him.

3 Molting time

M THE REVEREND Theodorus van Gogh and his wife Anna—conscientious, austere middle-class Dutch—were married in 1851. Their first child, Vincent, died at birth in 1852. Vincent Willem, the future artist, was born in 1853. Following the second Vincent came Anna (1855), Theo (1857), Elizabeth (1859), Wilhelmina (1862), and Cornelius (1867).

At the time of Vincent's birth, his father was thirty-one and the minister of the Dutch Reformed Church in Zundert, a town in the province of North Brabant, close to the Belgian border. Pastor van Gogh had been called there in 1849, when he was twenty-seven years old. His wages were modest, and his family could afford no luxuries. Although a handsome man of great religious faith and devotion, his sermons were uninspired and his speech halting; probably as a result, he never escaped the insignificant parishes of Brabant.

Anna Cornelia van Gogh-Carbentus,* Vincent's mother, was a strong woman with a plain face. She was industrious and talented,

* By Dutch custom the wife's maiden name comes after her husband's name.

proficient in writing, drawing, painting watercolors, and sewing. Her father was a bookbinder and had been awarded the title "Bookbinder to the King." Thirty-two years old, Anna was well on her way to spinsterhood when she married Theodorus van Gogh, then twenty-nine. She was the last of three sisters to marry: the eldest was the wife of a well-known Amsterdam clergyman, Pastor Stricker; the youngest was married to Theodorus' wealthy brother Vincent.

The paternal grandfather, the Reverend Vincent van Gogh, had been the Protestant minister in nearby Breda since 1822. The family described him in glowing terms: as a youth he set an example of "good behavior and persistent zeal" for his fellow students and "won many prizes and testimonials"; as an adult he became a "distinguished" man of "great intellect" with "an extraordinary sense of duty." Such emphasis on achievement and eminence gave notice to young Vincent that the same performance was expected of him, and he once complained, "I wish we only strove for peace in our home, and stinted ourselves rather than strive after a high position." [1]

The Reverend Vincent van Gogh had six sons. Only Theodorus followed him into the ministry. The others, however, surpassed Theodorus in terms of prominence and prosperity. Three became successful art dealers: Hendrik Vincent ("Hein"), Cornelius Marinis ("C.M."), and Vincent ("Cent"). Johannes became a vice-admiral, the highest rank in the Dutch navy, and Willem was a civil servant. There were also five sisters; two of them married generals and three remained single. Most of the van Goghs lived more elegant lives than the small town minister's family, lives that the young Vincent admired and, no doubt, envied.

Vincent resembled his plain mother rather than his handsome father. He was medium in height and stocky in build, his eyes were blue, and he was adorned with red hair and freckles that did not vanish with his youth. His mother claimed that he had the only strong body in the family. Vincent recalled his youth as unhappy; he was often singled out by his parents for "unruly behavior," and the discipline in his moralistic environment was strict. In their early years, the children were forbidden to leave the parsonage garden. According to his sister Elizabeth, "Brothers and sisters were strangers to him as well as his own youth." [2] In contrast to Vincent, his younger brother Theo inherited the refined, handsome features of his father and was regarded as a model child.

North Brabant had scarcely been assimilated into the Nether-lands during Vincent's childhood. Before the Dutch rebellion against Spanish rule in the sixteenth century, it had been part of the Duchy of Brabant, an area that extended south of Brussels. It was cut off from the Duchy and ceded to the newly formed Dutch Republic by the Peace of Münster in 1648. But unlike the principal seven provinces, it was controlled by the States-General rather than its own citizens. North Brabant became the country's cheap labor market and did not attain equal political status with the rest of the country until early in the nineteenth century. Even during van Gogh's youth it continued to have a lower standard of living than the northern provinces.

Because of its historical tie to the old Duchy of Brabant, North Brabant, unlike the rest of Holland, was overwhelmingly Catholic. Only a few could have squeezed into Pastor van Gogh's tiny church; the others attended the large Roman Catholic church that domi-nated the town. Animosity between the two groups was not absent, and as a withdrawn son of the Protestant minister, Vincent prob-ably suffered more than most the humiliating jibes due a distrusted minority.

The Brabant countryside around Zundert was a land of small farms, unsalvaged moors, and pine forests. Although economically dependent on agricultural staples like potatoes, rye, and buckwheat, its soil was not especially fertile; only the extreme density of popu-lation caused it to be used at all. Its inhabitants were peasants who existed on marginal diets and lived in dark hovels. Young Vincent escaped from the estrangement he felt in his home and his town by turning to this land and its people. He always admired this envi-ronment of his childhood, and he never ceased to be influenced by it. He once quoted a passage about Cromwell that applied to himself as well: "The soul of a land seems to enter into that of a man. Often a lively, ardent and profound faith seems to emanate from a poor and dismal country; like country, like man." [3] He was proud that there would always remain something of the Brabant fields and heaths within him; there he could be alone without feeling lonely.[4] His longing for love transformed the peaceful countryside into a loving, nurturing mother; quoting Souvestre, he called it "every-thing that has brought you up and nourished you, everything you have loved." [5] He delighted in hiking through it, studying its trees and flowers, its birds and insects, and acquiring an intimacy with them that years later he would put to use in his art.

The country people fascinated Vincent as much as the land. "[O]ne's native land is not nature alone," he wrote, "there must also be human hearts who search for and feel the same things. And only then is the native land complete, only then does one feel at home." [6] He found these human hearts in "the simple Brabant types" [7]—the poor, malnourished peasants who tilled the soil, worked its looms and spinning wheels, and lived in its dark huts. They were not beautiful or handsome people, perhaps due to long hours of work and poor diets, and their faces showed signs of suffering. On viewing the face of a dead friend of his father, he remarked, "Oh! it was so beautiful, to me it was characteristic of all the peculiar charm of the country and the life of the Brabant people." [8] Perhaps it was in such people that he first began to see beauty where others saw ugliness, a perception that influenced the style and content of his art. He identified himself with these rough, unhappy outsiders, and in seeing them as beautiful, he felt more acceptable and praiseworthy himself.

Mrs. van Gogh's own interest no doubt stimulated Vincent to paint, while his Uncle Vincent's knowledge of art as well as his personal collection stimulated him to look at paintings and to learn about the artists who painted them. The family regarded Uncle Vincent as the most gifted of the van Gogh brothers, and they boasted he was responsible for developing Goupil and Company into the largest chain of art stores in Europe. Wealthy and retired, Uncle Vincent lived close to Zundert, in Princenhage, a well-to-do suburb of Breda. The nephew visited him frequently, and Uncle Vincent became the youngster's favorite relative. The Princenhage house contained an excellent art gallery. "It was there," wrote Mrs. van Gogh-Bonger, Vincent's sister-in-law, "that Vincent and Theo received their first impressions of the world of art." [9]

Uncle Cornelius and Uncle Hein probably also influenced Vincent's interest in art. Cornelius headed a reputable art business in Amsterdam that bore his name, and Vincent once remarked that he had "pictures and prints that you can never see at [Goupil's in] The Hague." [10] Uncle Hein had an art business in Rotterdam and later became head of the branch of Goupil and Company in Brussels.

Vincent's earliest known sketches were drawn between his eighth and eleventh years. They include carefully executed studies of flowers, leaves, a bridge, a dog, a milk can, and a Corinthian capital. A drawing of a farm house and a watercolor of a landscape reveal some of the qualities found in his adult works. This evidence

of childhood talent no doubt brought him the approval of his distinguished art-loving uncles as well as his parents.

Fostered by the father's devotion to study, by Bible reading, and by the quiet isolation of the parsonage, sons of Dutch ministers often became men of learning and intellect. Vincent's formal education at the public school began three months before his eighth birthday. Fearing that "intercourse with the peasant boys made him too rough," he was soon withdrawn and tutored at home. When he was eleven, his parents sent him to Jan Provily's boarding school in Zevenbergen, fourteen miles from Zundert. Two years later he was transferred to another boarding school in the city of Tilburg, seventeen miles from Zundert, where he remained for eighteen months, leaving just before his fifteenth birthday. Like many men of great talent, he claimed he learned "absolutely nothing" in school.[11] Whatever the limits of his formal education, Vincent's love of reading and intellectual curosity helped him become well-informed in languages, literature, world events, and art history. His ability to express himself in writing, said to have been acquired from his mother, has made his collected letters almost as famous as his art. His self-imposed isolation aided his acquisition of knowledge, for books—like nature—were substitutes for human relations.

The van Goghs' economic status obliged Vincent to go to work at sixteen; with the help of Uncle Vincent, he was hired by Goupil and Company. Goupil's had branches in Paris, London, Brussels, The Hague, and New York; in addition to selling paintings, it manufactured and distributed art reproductions. Young Vincent was first assigned to the branch in The Hague, where H. G. Tersteeg was manager. During most of the seven years he remained with the firm, he was a diligent worker whose behavior and dress were conventional. In London, where he was transferred in May 1873, he even bought himself a top hat, the mark of a conforming businessman of the times.

During that fateful year in London, his twentieth, he fell passionately in love with Ursula Loyer, the daughter of his London landlady. Following the death of her father, she and her mother had moved to London from the south of France. They set up a day school and took in lodgers; Vincent moved there in August 1873. Not yet twenty-one, he was profoundly impressed by the close relationship between daughter and mother, a closeness that he longed to experience himself. "I never saw or dreamed of anything like the love between her and her mother," he wrote. After

months of silent devotion, he finally told Ursula of his love, only to
discover that she was already engaged. Refused, he "tried every-
thing" to convince her to give up her fiancé in favor of himself
but failed. The extreme sensitivity to rejection that heretofore pre-
vented him from approaching her now precipitated a prolonged
state of melancholy. This experience, he wrote later, caused him
"many years of humiliation." [12]

Although he continued to live with the Loyers, he lost interest
in his job, argued with his employers, and became increasingly
eccentric. He diverted his anger from Ursula to the art business,
proclaiming that he resented selling worthless pictures to unsus-
pecting customers. He turned increasingly to religion, and devoted
much time to reading the Bible and drawing. Hoping that a tem-
porary change would prove beneficial, his employers transferred
him to the Paris branch in October 1874. There he found a com-
panion, an Englishman named Harry Gladwell, who shared his in-
terest in the Bible. Vincent returned to London in January 1875,
but his attitude was unchanged, and he was again transferred to
Paris in May. In December he went to Holland to spend Christmas
with his parents, even though his employers disapproved of his
absence during this busy time. In 1876 the situation deteriorated
further. His unhappiness, his withdrawal, and his obsession with
religion forced his employers to dismiss him from the company on
April 1, two days after his twenty-third birthday.

Having secured a job assisting a Mr. Stokes at a school for boys
in Ramsgate, on the Kentish coast, Vincent returned to England—
still longing to be near, but afraid to be too near, Ursula. He
received no salary, only room and board. The school was soon
moved to London, where one of his duties was to collect tuition fees
from parents who lived in the slums. This experience extended his
interest in the poor and oppressed with whom he already identified
himself. From then on, he also saw himself as their benefactor, a
self-image that would color all of his subsequent activities.

In July 1876 Vincent moved to a similar position in a boys'
school in Isleworth, a London suburb which was directed by the
Reverend Mr. Jones, a Methodist minister. Vincent's preoccupation
with religion, his desire to help others, and the example of Mr.
Jones led him to consider becoming a minister himself, and it was
at this time that he delivered the sermon described in Chapter 1.

As usual, Vincent returned to his parents' home at Christmas.
After a family parley, he decided to remain in Holland. From

January to April, he worked as a clerk in Blussé and van Braam's Bookstore in Dordrecht, where he nurtured his guilt-laden melancholy and devoted his energies more to the study of religion than to selling books. A Mr. Braat, who worked by his side in the bookstore at that time, has written, "[H]e led an absolutely solitary life. He took many walks on the island but always alone. . . . In the shop he hardly spoke a word. In short, he was a recluse." [13] Attributing his "heavy depression" to constant failure,[14] Vincent did not see that it was the underlying depression that caused him to fail. Because he felt like a failure, he cultivated failure, and then castigated himself.

Vincent had entered Goupil and Company fascinated with the subject of art, pushed by the pressure of making a living, and encouraged by his favorite relative, Uncle Vincent. But he was not suited to business. The self-defeating behavior that finally led to his dismissal enabled him to get out of an existence that he detested. As an outsider who felt alienated from his own class and who identified himself with the oppressed, he felt out of place catering to prosperous clients. As one who regarded himself as ugly, a feeling aggravated by Ursula's rejection, he was uncomfortable wearing the clothes and assuming the manners of the well-to-do. As one who loved to commune with nature, working all day in a city store was like confinement in prison. And the inexhaustible supply of nervous energy that needed an outlet in physical and mental activity was stifled by sedentary work.

The distrust that accompanied his depression made him suspicious of the motives of both his employers and his clients. "The exhibitions, the picture stores, everything, everything," he wrote, "are in the clutches of fellows who intercept all the money." [15] Moreover, he complained, most people who bought expensive pictures were speculators. "There are real, serious connoisseurs, yes, but it is perhaps one-tenth of all the business that is transacted . . . that is really done out of belief in art." [16] Eventually, this resentment extended to his uncles who had become wealthy from dealing in art. When Vincent became an artist himself, for instance, he proclaimed that he "would rather live from hand to mouth . . . than fall into the hands of Messrs. Van Gogh." [17]

He decided to abandon the art business and follow in his father's footsteps as a minister. As one who helped others while

looking down on them from the pulpit, perhaps he would feel less guilty, less inferior, and less ugly. And as one who related to people in a spirit of Christian love, his distrust and anger could be attenuated. His father became an idealized model in this venture; such a man was "more beautiful than the sea." Not even the greatest artist was permitted to outshine such a guide; his father's life resembled that of his favorite artists, Rembrandt and Millet, but was even more valuable.[18] By trying to be like this kind of father as well as his other religious antecedents, he could carry on their work. "As far as one can see," he wrote, ". . . there has always been someone in our family who preached the Gospel. . . . It is my fervent prayer and earnest desire that the spirit of my father and grandfather may also rest upon me . . . and that my life may resemble more and more [their] lives." [19]

Idealization of one's father is ubiquitous among children, and nowhere is this stronger than among ministers' children. The minister is a holy father endowed with magical qualities found in no one else. Set off from other parents by special dress and special demeanor, he carries on elaborate rituals, during which he becomes the intermediary between a mysterious God in heaven and the ordinary members of the congregation. Idealization is usually replaced with a more realistic appraisal, or turns into outright antagonism, during adolescence. This disillusioning experience, painful though it is, serves a useful function. Part of the price of independence, the youth creates a gulf between himself and those who tie him to his dependent childhood. This no doubt happened to Vincent. But now, in his mid-twenties, a melancholic hunger for love and a desperate search for a better life caused him to return once again to an early awe-inspiring image.

The twenty-four-year-old Vincent went to Amsterdam on May 9, 1877, in order to prepare for the entrance examination given by the theological school of the University of Amsterdam. He studied Latin and Greek with Dr. Mendes da Costa, a scholarly Jew, and lived with Uncle Johannes, the vice-admiral, who was then in charge of the naval establishment at Amsterdam. He began his studies with high hope of success, but by the end of May depression flared anew, and he had difficulty in concentrating on his lessons. Again he berated himself, claiming that his "evil self" caused him to be a disgrace who brought misery on others. Mendes da Costa

wrote a description of his forlorn pupil: he pulled his mouth down at the corners, producing an "indescribable haze of sad despair," [20] and he spoke with a deep melancholic voice.

Within six months Vincent had become disenchanted with his studies, considering them a needless waste of time for a student who wished to become an honest pastor. The study of Latin and Greek would not help him in his principal task, the relief of human misery, and the Church's emphasis on such subjects exemplified for him its lack of humanity. After a year in Amsterdam he recognized that he would be unable to qualify for admission. His family excused this failure by claiming he had been away from school too long and therefore could not be expected to succeed as a student. In view of Vincent's breadth of learning and the facility in French and English that he demonstrated in his correspondence (perhaps in German, too, for he taught it to the schoolboys in England), this explanation seems inadequate. More likely, his inability to study effectively resulted from melancholy and lack of motivation. As he came closer to the realities of the ministry he saw a vast gap between his vision of helping suffering mankind and the successful ministers the theological school produced. Dealing in religion, he concluded, was no different from dealing in art or in tulip bulbs.[21]

Vincent returned to the parsonage, now in Etten, and decided to become a simple evangelist who helped the poor and taught the Bible. In this role he hoped to avoid close contact with the powerful hierarchy of the Church, whose presence made him feel unworthy, and to cultivate a relation with the poor and oppressed, with whom he felt worthwhile.

His father and the Reverend Mr. Jones, who was visiting the van Goghs from England, accompanied Vincent to Brussels in July 1878 to assist him in evaluating the local school for evangelists. Vincent applied for admission and was accepted. He returned in August to begin a three years' course. At the end of a three months' period of probation, however, the committee on evangelization refused to give him a regular appointment because he did not comply with the requirements. A fellow pupil said, "He did not know what submission was." [22]

Nevertheless Vincent received a trial as an evangelist in the Borinage, a poor region that could not be too strict about the formal qualifications of its spiritual advisors. The Borinage was a shabby, desolate coal-mining area in the southwest of Belgium, close to Mons, a region of barren flat lands dominated by hills of coal

waste. It was an ideal post for the moment. His sadness and despair were swallowed up in the grim lives of the people and the dark countryside. The brooding scene became beautiful in his eyes, stimulating him to action. The land seemed like his own Dutch heath, and the "simple and good-natured" [23] people no doubt recalled his beloved Brabant peasants.

After a brief stay at the village of Pâturages, Vincent was given an appointment of six months at nearby Wasmes. There he taught the Scriptures, but most of his plentiful energies were directed toward aiding the poor and the sick. Instead of enduring existence in isolation, he was now the nurse and teacher of the miners and their families, and was accepted by them.

When he arrived in Pâturages, the local minister noted that "he was well-dressed, had excellent manners, and showed in his personal appearance all the characteristics of Dutch cleanliness." [24] Soon, however, he left his lodgings, moved into a dirty hovel, and "his face was usually dirtier than that of the miners." When the miners rebelled against their ruthless employers and were tempted to violence, Vincent is said to have used his moral authority to help them regain self-control. In caring for these mistreated men and women, he gave away his possessions, his money, and his clothes and became sick and emaciated himself. He was accused of displaying "an excess of zeal bordering on the scandalous." This display and his unkempt appearance may have contributed to his dismissal, though he was merely accused of lacking a talent for speaking when in July 1879 the Synodal Board refused to reappoint him.

The board's explanation was partly true, and Vincent was undoubtedly aware of his limitations, since, like his father, he sermonized with a halting speech. At any rate, he was now convinced that success as an evangelist, like success as a minister, required him to be "respectable," like the other van Goghs, a respectability that he condemned as false and hypocritical. "Failure" would permit him to give it up and seek a more satisfying way of life, one that better suited his talents. At least partly as a result of such views, he became disillusioned with his father at the same time that he became disillusioned with the church. Needing to undermine the identification with his father in order to go on to other pursuits, Vincent now found only evil in him.

Vincent moved next to nearby Cuesmes, where he lived with an evangelist named Frank. Although no longer sanctioned by church

officials, he continued for a while to minister to the townsfolk. Religious doubts increasingly challenged him, however, and he read Dickens and Harriet Beecher Stowe instead of the Bible. Within a few months he dropped his evangelistic work, withdrew from the world, and spent almost a year in deep and silent misery. His usually active pen did not produce a single letter from October 1879 until the following July. Finally, in July 1880, he suddenly announced his intention to become an artist.

During the long period of depression, while this decision was germinating, Theo apparently accused him of being idle. Vincent objected, knowing this was the only way he could find a place for himself in the world; "[T]his is a strange sort of 'idleness.' . . . But I am not sure it would be right to combat such an accusation by becoming a baker, for instance. It would indeed be a decisive answer . . . but at the same time it would be a foolish answer." [25] The psychopathologist might be content to diagnose this period of inactivity as a depressive reaction with psychotic features, but this would ignore the constructive contribution it made toward his future and the future of art. For it was a time in which the creative forces activated by his melancholy could unify the various elements of his character and enable him finally to emerge in a new identity as Vincent the Peasant Painter. Erik Erikson has called such a period of hibernation a psychosocial moratorium, a time where an individual "may find a niche in some section of his society, a niche which is firmly defined and yet seems uniquely made for him. In finding it the young adult gains an assured sense of inner continuity and social sameness which will bridge what he *was* as a child and what he is *about to become,* and will reconcile his *conception of himself* and his *community's recognition* of him." [26]

Vincent described this period in his own way: "As molting time —when they change their feathers—is for birds, so adversity or misfortune is the difficult time for us human beings. One can stay in it—in that time of molting—one can also emerge renewed; but anyhow it must not be done in public and it is hardly amusing, therefore the only thing to do is to hide oneself. Well, so be it." *

How did a little boy who regarded himself as an ugly, unloved, lonely outsider become transformed in the course of his hibernation into a painter with a mission, confident of his potential for greatness? At least part of the answer is to be found in the way the

* This letter [133] in which he emerged "renewed" was the first one written in French—perhaps a manifestation of his transformation.

various facets of his youthful personality were progressively modified and became integrated in this new identity.

To a considerable degree, Vincent's struggle was over the incompatibility between his own self-image and his view of what he was supposed to be as a Dutchman and a van Gogh. Yet one can hardly overemphasize the fact that only in a Dutch setting with a Dutch inheritance of morality and art was a Vincent van Gogh possible.

The Netherlands consists mainly of a delta formed by the discharge of the Rhine, the Maas, and the Schelde into the North Sea. It is so flat and low that it has been called a sinking ship and an oozing patch of ground. As a result, it is a man-made country that has required enormous toil and patience to build and maintain its complicated system of dikes, canals, polders, locks, reservoirs, and pumping stations. People have had to be alert to the danger of rising tides, and the large amount of water lying in Holland's rivers, canals, and lakes results in a humid atmosphere in which the sky is rarely clear and rain falls more than two hundred days a year. These hard facts of Dutch life have produced a people who have made a virtue out of the necessity of working hard and paying attention to duty.

A small open country vulnerable to invasion, Holland was for a long time under foreign domination, but the Dutchman eventually succeeded in freeing himself and maintaining his own identity. In addition, a combination of Dutch geography and Dutch character made Holland a prosperous trading, shipping, industrial, and banking center. As a result, it became a nation ruled by a middle class that placed a high value on the accumulation of wealth. Its agricultural and dairy land was divided into small parcels requiring the exertion of a large peasant class that remained poor in spite of its incessant labor.

To surmount such geographical, historical, and social limitations required the cooperative efforts of people with common goals and shared traits. Only in this way could the citizens of a densely populated country work together without stepping on each other's toes and protect themselves from being swallowed by their foreign rulers. Children were indoctrinated with a faith in cultural traditions, a spirit of pride in industry, and a satisfaction in accomplishment that outranked the need for sensual pleasure.

Maintaining the land required a toughness and seriousness that discouraged frivolity; the expression of emotions was restrained, and a certain rigidity of behavior was promoted. In a land of mud, cleanliness and tidiness became a necessity for a conscientious people, and Dutch women prized neatness and primness. The immaculate state of windows and thresholds has not, however, always been extended to bodies—a point that the Dutch themselves joke about.

With few exceptions Dutch children have conformed to Dutch precept early in life. They have, of course, often rebelled in adolescence, but learned once again to accept it as adults, urged by practical necessities and the virtues that were instilled in childhood. Van Gogh's rebellion came later (or, to put it another way, his adolescence was delayed), but it persisted to the end.

The word "Dutchman" has come to suggest a hard worker who believes in action and is inclined to be taciturn; a realist who prides himself on seeing things as they are, and is perseverant, patient, and efficient; a man whose performance is based on careful observation and prudent deliberation rather than on impulse. The incessant battle with the ever-recurring rhythms of the sea, the great rivers, the fields and dairy animals has demanded an endless supply of preparedness, conscientiousness, industriousness, and punctiliousness.

The Dutchman is pictured as a man who disbelieves assertions without proof. He avoids fantasy, leaving it to the French, whom he envies for such freedom. "There is always room for one more docile sheep" is a proverb that expresses the Dutch need to cooperate with each other. Nevertheless, he is independent and individualistic, preferring to seclude himself in the privacy of his family than seek his pleasure in public. His strong sense of realism, however, forces him to cooperate in practical and important measures. His countless regulations suggest that he feels the need for external sanctions if he is to have the order he cherishes.

An intense curiosity leads him to poke his nose into his neighbor's affairs—a characteristic that may have helped the Dutch to keep each other in line and thus contribute to the cooperative efforts required for their self-survival. Self-critical and even humble, he frowns upon self-glorification but takes a quiet pride in his country, a pride that is based on a sense of accomplishment as well as a reaction against feeling small and vulnerable. At the same time he suspects that things may be better elsewhere, and he

listens to foreigners, managing to assimilate foreign ideas without losing his own Dutchness.

Although the burgher is *deftig*, combining dignity with humility, the Dutch image also has a more negative aspect. Hard work and perseverance may emerge as obstinancy and narrow-mindedness. Action-oriented responses in which emotions and imagination are stultified may contribute to dullness and didacticism; stolid fortitude may be a poor substitute for the joys of play and sensual gratification; interest in detail may become a preoccupation with trifles; and cleanliness and tidiness may evolve into an absurd and aggressive fussiness. The burgher's feeling of rightness about himself may become mere self-righteousness; his dignity and humility may not prevent him from keeping his head in the air while the head of the peasant remains bowed to the earth. Van Gogh came to see the negative aspects of these dichotomies in his parents, his relatives, and his countrymen in general, and he tried desperately to eliminate them from himself.

Regardless of whether this characterization, including both its positive and negative sides, accurately describes many Dutch people, Dutch literature testifies that it constitutes a national self-image. More important to the understanding of Vincent van Gogh, he himself held this view of Dutchmen, and it was with this image that he identified his family and himself. But the impact of the unusual events of his childhood, reinforced by the social ferment in Holland in the second half of the nineteenth century, made it impossible for him to accept such an image; neither could he completely reject it. It was, in part, a struggle between his Dutchness and opposing reactive forces that enabled him to become a great artist.

Vincent's Dutch rearing provided him with traits that were essential to his success. He was a hard worker intent on developing his skills; genius itself (whatever that may mean) would not have enabled him to telescope so much into a period of ten years. Dutch persistence in the face of rejection was another source of strength. Like the typical Dutchman, Vincent was a realist (although appearances sometimes belied it), and he decried excessive use of the imagination. He was humble, ascetic, and taciturn, and disliked ostentation and publicity about himself. He was self-critical, although he recognized his merits when not overly depressed, and he felt a strong need for cooperative effort.

These Dutch traits grew out of exposure to his parents and his

culture. But their reinforcement by accidental events in his child-
hood exaggerated some of them to the point of caricature.

As a youth, he was proud of his native land and his country-
men. But as he grew older, he became increasingly sensitive and
critical of them. He harangued against their narrow-mindedness,
hypocrisy, self-righteousness, greed, and academism. In his artistic
life, he followed a similar though more subtle course. His early
work was Dutch in character, while later he reacted against this
style, a reflection of the rebellion against his compatriots.

It is hardly necessary to underline the importance of Calvin-
ism as an influence on the son of a Dutch Reformed minister.
The introduction of Calvinism to Holland strengthened national
traits that had already developed as a result of Holland's geo-
graphical and historical position. Although John Calvin was a reli-
gious genius with a first-rate mind, he lived by cold reason and a
strict creed. The relative inflexibility of the Reformed Church that
followed his teaching was especially suited to the political and eco-
nomic needs of a people who needed to be discouraged from vola-
tile flights into fantasy that might distract them from their duties.
The religious images, elaborate rituals, and mystical trends of its
predecessor, the Roman Catholic Church, were less suited to pro-
duce the cooperative action required in this difficult geographical
setting. Catholicism stimulated emotionally charged, fantasy-stimu-
lating modes of behavior in which work could become secondary
to the sensual, pleasurable aspects of living, an attitude that was
more acceptable to the balmier lands to the south. In contrast,
Calvinism, by its insistence on God's will, encouraged asceticism
and hard work.

Calvinism, according to Max Weber,[27] also favored those who
pursued industry, commerce, and trade. Making money became a
religious act, providing the money was reinvested in business, put
into savings, or given to support institutionalized philanthropies.
The "best" Calvinists were often the richest. Calvin's doctrine of
predestination was used to justify the wide discrepancies between
Holland's wealthy middle class and its impoverished peasants and
laborers (as their South African descendants, the Boers, now ra-
tionalize their relations with the black man). The burgher's ac-
cumulation of wealth indicated a state of grace; if a man was poor,
it was God's will. Sloth was discouraged by the threat of God's

wrath and by shaming. In giving God's approval to social inequities, the church's tenets stirred a smoldering resentment in the poor peasant as well as in those, like van Gogh, who identified themselves with the peasant.

Many would wish to modify Weber's thesis or even challenge it directly. Wealthy burghers, for example, are often said to have been more tolerant than the ministers and the common people. In terms of an influence on young Vincent van Gogh, however, these are comparative matters. The dominant Dutch Reformed Church, the *Hervormde*, to which most of the burghers belonged, may not have been as rigidly Calvinistic as its small rival, the *Gereformeerde*, but it was hardly a pleasure-loving sect. Such an attitude inevitably encouraged guilt-laden submission to a powerful God rather than the pleasures of a mystical union with a loving God. Van Gogh repudiated this church at the same time that he repudiated his Reformed parents because it failed to satisfy his strong desire for such a union, and this repudiation provoked him to find an outlet for these desires in art.

When Vincent emerged as an artist, he had dissociated himself from the van Gogh name—he was simply "Vincent." Not a single drawing or painting of his adulthood bears the family name. He explained that foreigners could not pronounce "van Gogh," [28] but even his earliest Dutch sketches, hardly intended for foreigners, are also signed "Vincent." In this practice he followed Rembrandt van Rijn, his beloved Rembrandt, but it was also a means of cutting off his psychological ties to his father, the other van Goghs, and the Dutch Reformed Church—a necessary step to finding his own way in art. Calling his father obstinate, unintelligent, icy cold, and narrow-minded, Vincent asserted, "I am *not* a 'Van Gogh.'" [29] The other money-grubbing "Messrs. Van Gogh & Co.," [30] were equally deplorable. When he intended to become a minister, his father and grandfather were the apotheoses of good. When he became an artist, he saw them differently: "they have something gloomy, dull, stale, so much so that it makes one sick." [31]

At the same time that Vincent cut his psychological ties to his father, he strengthened those with his brother Theo. Theo, who had joined Goupil and Company in 1873, came to be Vincent's chief link to the world of human beings, serving him not only as the brother and companion of earlier days but as father, mother,

mirror image, family, audience, mentor, patient, and psychother-
apist. Vincent could carry on this relationship because in his eyes
Theo was not a despicable businessman or one of the treacherous
Messrs. van Gogh. "Are you a 'Van Gogh' too?" [32] Vincent asked
his brother. Vincent himself answered in the negative: "I have al-
ways looked upon you as 'Theo.' " He excused Theo's position in
the art business by attributing it to their father's influence. [33] In
the mutual interplay between the two brothers, they shared com-
mon interests and advanced each other's knowledge of the art
world while avoiding the hazards of competition and rivalry. As
a member of a hated class, Theo purged his own guilt by caring
for Vincent. Although Vincent occasionally offered apologies for
his demands, he not only accepted the help, but insisted on it,
complaining bitterly when payments were delayed. Theo's largesse
made it possible for him to be an artist; without it, Vincent would
have had to find another Theo or abandon his career for one that
provided a living wage.

The rejection of his father and his church also permitted Vin-
cent to turn from them to idealized fathers in the world of art—
among them the great names of Holland's Golden Age in the seven-
teenth century, when the country reached its peak of wealth, in-
fluence, power, and creativity. Encouraged by the burghers who
wanted portraits of themselves and their possessions, hordes of
painters began to depict the Dutch scene. The style of life that
went into building Holland also went into their work. Living in
a democracy that lacked royal figures—before Holland became a
kingdom—and guided by a church that discouraged religious por-
traiture, they depicted the everyday Dutchman, commonplace ob-
jects, and the countryside. In rejecting Catholic Spanish rule, they
also rejected the elaborate pageant art of Catholic countries, and
tended to avoid historical, abstract, and mystical subjects. Like the
Dutchman himself, Dutch pictures tended to be unostentatious,
their trademark realism and meticulosity. The artist absorbed
every detail of his subject and his surroundings. In contrast to the
romantics who eliminated or obscured irrelevant surroundings, the
Dutch artist treated subject and background alike. Perhaps the flat
land stimulated the eye; not hemmed in by hills or mountains, it
was trained to seek out objects in the distance—like the sailor
searching the distant horizons to find objects that would break the

monotony. Keen observation also was demanded of the artist by his ambitious patrons who wished every detail of their lives recorded for posterity.

Above all, the Dutch artist was a master of light. The paucity of sunshine led him to prize the sun's rays and to make the most of them in his work. The design of modern Dutch museums, even the small ones, illustrates the value the Dutch place on light and their ability to harness it effectively. Although the sky is often somber, the moving clouds and the shifting rays of the sun give rise to a remarkable range of atmospheric effects that are not seen in sunnier climates. This feature became all the more significant in view of the scarcity of unusual visual attractions in the simple landscape.

Like the burghers, artists of the Golden Age tended to avoid emotional display and fantasy in their work. Among the exceptions were landscape painters like the Ruysdaels, whose skies, fields, and non-Dutch hills partook of the romanticism that the figure painters avoided. Many Dutch paintings of the Golden Age, exemplified in the neat interiors of Vermeer, seem as antiseptic as Dutch thresholds and windows. However, a few artists like Jan Steen reacted against their hard-working, well-controlled society by painting boisterous, fun-loving Dutchmen engaged in eating, drinking, and philandering.

Antony van Leeuwenhoek and Christiaan Huygens, the two pre-eminent scientists of the Golden Age, expressed these same characteristics in their work. They too combined superb craftsmanship, a search for detail and form, and a preoccupation with light and vision. Van Leeuwenhoek perfected the microscope and by careful observation revealed a whole new world of microorganisms. Huygens improved the telescope through new techniques of lens making, detected new bodies in outer space, and developed the wave theory of light at a time when Dutch painters were depicting light as it had never been depicted before. The same Dutch fascination in seeking out visual impressions would appear in a Vincent van Gogh two centuries later.

The work of Rembrandt van Rijn climaxed the art of the Golden Age. Rembrandt was a revolutionary who defied Dutch tradition, especially in the art of his later years. While he too excelled in the use of light effects, human nature and human emotions were more important to him than microscopic details. Unlike

his peers, he ignored background effects and treated ancillary sub-
jects in an impressionistic way—the better to emphasize the heart
of his subject. Ignoring the Calvinist's objection to religious por-
trayal, he borrowed many of his subjects from the Bible. Neverthe-
less, these subjects were not icons for the religious but portrayals
of human relations that provoked emotional responses in all men.
Defying Dutch precept, Rembrandt was the only artist of the
Golden Age to paint numerous self-portraits. Not until van Gogh
did another Dutchman follow his lead, and van Gogh's self-por-
traits were painted after he abandoned Holland. Yet in the very
act of defying tradition, both Rembrandt and van Gogh followed
it. Their self-portraits are highly critical rather than flattering, and
no one could find them guilty of self-glorification.

Frans Hals, the other great portrait painter of the Golden Age,
shared some of Rembrandt's revolutionary tendencies. For their
own psychological reasons, Rembrandt and Hals defied the Dutch
code in both their life and their art—as van Gogh did later. They
accepted their emotions and then revealed them to the world. These
same emotions, however, marred their personal lives, and both spent
their last years in relative poverty and misery. Hals became desti-
tute and his meager belongings were seized for debt, although he
managed to subsist on a small pension from the city of Haarlem.
Rembrandt became bankrupt not long after.

Rembrandt and Hals were not the only great Dutchmen—
whether artists, scientists or public figures—to end their days poor
or in exile. Erasmus, known as the greatest humanist of the Renais-
sance, spent most of his life in France, England, and Italy and died
in Basel. Vondel, Holland's greatest poet, suffered for his political
and religious views and was impoverished as an old man; he ended
his days as a pensioned government clerk. De Groot (Grotius), the
founder of international law, was sentenced to life imprisonment
and his property confiscated because of his political views; he
managed to escape from prison and wrote his principal works in
France. Christiaan Huygens spent a large part of his life in Paris
and regarded himself as citizen of the world rather than a Dutch-
man. Neither of the two great Dutch biologists was accepted by
his academic peers: van Leeuwenhoek was an outsider to his home
town University of Leiden; Swammerdam, the naturalist and

anatomist, died of privation because he turned down his father's demand to give up his science and practice medicine. Van Gogh followed the tradition of these great Dutchmen.

Vincent van Gogh was born at the beginning of intensified social development and artistic renewal in the Netherlands—a time ripe for another Dutchman to make himself famous in the world of art. There had been a long period of decline in Dutch power, prestige, and inventiveness, beginning in the latter half of the seventeenth century with the rise of English military might and the prolonged war with France. The eighteenth century had been marred by decadence among the rich and the country's internal affairs became stagnant. Napoleon's domination at the close of the eighteenth century and a war with England resulted in the loss of many of its overseas possessions, and its shipping and foreign trade were cut off.

Holland began to revive in 1813, when the present constitutional monarchy was formed after Napoleon's defeat. The revival did not get into full swing, however, until the middle of the century—about the time of van Gogh's birth. More progressive political forces began to hold positions of power. Thorbecke, the leading liberal politician of his time, was able to modernize legislation, improve the educational system, and extend the vote. Prosperity returned and the country's spirit was reborn. But this prosperity did not extend to the peasant and laborer; even Thorbecke did nothing for them. Many eked out an existence on a diet of potatoes and salt pork. Men, women, and children worked long hours, day and night. It was not until 1889, one year before van Gogh died, that children from twelve to sixteen were prohibited from working more than eleven hours a day.

Pressure was building up against these injustices. Writing under the pseudonym of Multatuli, Eduard Douwes Dekker wrote *Max Havelaar*. Published in 1860, when van Gogh was seven years old, it exposed the abuse of the natives of the East Indies by their Dutch rulers. Dekker's criticism was easily transferred to conditions at home. After *Max Havelaar*, he published collections of biting satire on the ministers of the Reformed Church, who were especially powerful during van Gogh's youth, and on the bourgeoisie. He became the most discussed writer of the day and had considerable influence among Dutch freethinkers like van Gogh, who

mentions *Max Havelaar* in one of his letters. After publishing his essays, Dekker left Holland to spend his remaining days in Germany.

Although painting continued to be fashionable and painters technically competent, Holland did not produce a single great artist during the eighteenth century and the first half of the nineteenth century. Johan Jongkind emerged around 1850, working in the tradition of Dutch landscapists. He and Boudin are regarded as the immediate precursors of the Impressionists, and some critics consider him to be one of the great painters of his time. Like van Gogh after him, he had severe psychological problems and deserted Holland for France. Beginning about 1870, a group known as the Hague School [34] also made a Dutch contribution to the arts; among them, Vincent especially admired Josef Israëls, pre-eminently a painter of humanity. Taking their lead from the French Barbizon School, English landscapists, and the seventeenth century Dutch, these artists returned to nature and the everyday subjects of the Golden Age, but added a modern idiom. Anton Mauve, whose paintings are still valued in Holland, was a distinguished member of the Hague School. But his chief claim to fame may rest on the fact that Vincent van Gogh, a cousin-by-marriage, was his student.

Vincent revered his elders in the Hague School, as well as other artists of the mid-nineteenth century who painted the common man and the countryside. Millet, the peasant painter from the Barbizon forest, was a particularly important model during these early years as an artist: "Millet is *Father Millet*—that is, a guide and counselor in all things for the younger painters." [35] His real father forced false values on him, like the duty of earning money, while Father Millet could "best teach us to see, and get a 'faith.' " [36] There were also "Father De Groux," who painted the Brabant peasant, "Father Corot," [37] and other artistic fathers still to come. These revered artists helped him establish the basis of his new life, and his deep attachment to them facilitated his own growth as a creative artist.

The displacement of Vincent's attachment to his father to father-artists who loved the land and the peasants permitted Vincent to retain his attachment to his native country while disowning those Dutch characteristics he detested, characteristics that would not serve him as an artist. As a painter of peasants and land-

scapes Vincent could isolate himself from the Dutch bourgeoisie whose presence embarrassed him. Because he defied bourgeois standards of dress and behavior, he was regarded as an eccentric. What better profession than art for an eccentric, as long as one was talented and worked hard? Like a phrase he applied to the French artist Lhermitte, Vincent saw himself as *"a peasant who could paint."* [38] Uncomfortable among his own class, he was "content with the food, drink, clothes and bed which the peasants content themselves with." [39] This identification was an essential component of his identity as a painter. "When I call myself a peasant-painter, it is a real fact . . . that I feel at home there," he wrote. "And it has not been in vain that I spent so many evenings at the houses of the miners and peat cutters and weavers and farmers. . . ." [40]

As a man with an urgent need to help others, he asked, "How can I be of use in the world? Can't I serve some purpose and be of any good?" Having failed to accomplish his mission in formal religion, he transferred the task to art, confident that great art leads to God. "One man wrote or told it in a book [the Bible], another, in a picture," he asserted: ". . . there is something of Rembrandt in the Gospel, or something of the Gospel in Rembrandt." [41] He could thus continue to preach, using art as his medium, without being bound to those values of the Church that he detested. Art also provided an ideal outlet for his passionate love of nature. In art he carried on his youthful romance with nature, seeing her various aspects in terms of human equivalents.

In the course of knowing the Brabant peasant, the London slum dweller, and the miner from the Borinage, Vincent acquired a revolutionary spirit. The nucleus of this identity element was present when he was a childhood rebel; it submerged in his youth and reemerged transformed in early adulthood. He read avidly about the French Revolution during his stay in the Borinage; this extended his ideas of revolution to all who lacked equality and freedom. Shyness probably made concrete political action impossible, for this would have required direct contact with other people. But in art the revolutionary in Vincent van Gogh could find a place.

Other aspects of his personality also discovered a haven in Vincent the Peasant Painter. For instance, he was impetuous and emotional, entirely lacking in the Dutch virtue of stolidity. "I am a man of passions, capable of and subject to doing more or less

foolish things. . . . But the problem," he wrote, "is to try every means to put those selfsame passions to good use." [42] They could not be put to good use in the art business nor were they acceptable in the church. But painting was an ideal mode in which to express them, one that eventually made him the prototype expressionist. Painting also enabled him to indulge his intense urge to gaze at the world and to mold it on canvas with his hands so that it became his own, thus expressing intimacies that were substitutes for human relations.

Vincent was an ambitious man who had been indoctrinated as a child into the importance of being eminent. But there was no better way of achieving this goal in Holland—"the land of pictures," he called it—than in the profession of art. More of a problem was the fact that he was a potential mystic in a country that prized practicality. While his Dutch conscience led him to criticize himself for being "too visionary," he also knew that this tendency, which could not be realized in the straight-laced Dutch world of business and religion, could find an outlet in art. He retained the Dutch tradition of realism in his pictures; but his realistic forms had symbolic meanings, and art served him well as an outlet for his fantasies and mystical longings.

It is not surprising that the pictures van Gogh drew in Holland had Dutch qualities, for he was thoroughly saturated in his youth with knowledge of Dutch artists of the past and the present. This early work consisted of realistic depictions of peasants at work, peasant homes, the fields, portraits of common people, street scenes, churches, and still lifes. Much of it resembled the old Dutch genre paintings that had "a touch of the curious and a moral to be learned." Like most Dutch artists, he was an excellent draftsman with a strong visual sense. And like his Dutch predecessors, his pictures were intended for the general public, not the connoisseur.

Vincent was a talented portrayer of human emotions in these early works. But if nothing else of his remained to us, if he had not reacted against this style, he would not have become the greatest Dutch artist of the nineteenth century. The pictures he painted in France, pictures that are distinctively "van Gogh," seem removed in spirit from traditional Dutch art, no more resembling the works of the Hague School than those of the Golden Age. They were intuitive and rapidly executed, not the meticulous work of his typical Dutch predecessors. He was more interested in

stirring emotions than in respecting natural colors and natural proportions, although his proportions were often surprisingly accurate. No artist, and no Dutch artist in particular, had ever been so brash with colors, and light effects—the soul of Dutch art—were subordinated in his work to color effects. He infused his pictures with a non-Dutch glare, so different from the subtle light prized by his artistic ancestors. While Rembrandt, Hals, Josef Israëls, and the early van Gogh expressed deep emotions, they were exhibited with Dutch constraint; in comparison, Vincent's late paintings were often shocking.

Yet both his approach to art and the art itself retained Dutch qualities. Hard work, persistence, and careful observation were essential to his task. So was craftsmanship; without it, the intuitive, slapdash technique would have failed. He still depicted the common man, scenes from everyday life, and nature, although these depictions were often distorted. And the moral lessons of Dutch genre and his own Dutch art persisted, hidden behind the brilliant colors and the tempestuous style.

4 A rough dog with
wet paws

HAVING ANNOUNCED from the Borinage in July 1880 that he had decided once and for all to become an artist, Vincent moved into the house of a miner named Decrucq. There he set up his first studio, one that doubled as a bedroom for himself and the Decrucq children, and spent these last months in the Borinage sketching dark scenes of the bleak region and its dismal inhabitants, displacing sorrow into melancholic art. In October he moved to Brussels, where he met a wealthy artist named Anthon van Rappard, five years his junior. The two encouraged each other in their work, and their friendship established the basis for a long correspondence. Bound by a mutual interest in depicting the common man, they worked together for several months. To van Rappard, Vincent was "the struggling and wrestling, fanatic, gloomy Vincent, who used to flare up so often and was so irritable, but who still deserved friendship and admiration for his noble mind and high artistic qualities." [1]

After six months in Brussels, Vincent returned to the parsonage in Etten, where his new occupation as an artist kept him hard at work. Continuing the sketching he had begun in the Borinage,

he drew sowers, diggers, laborers, seamstresses, landscapes, and street scenes. There, too, he fell in love again.

The object of his love was Kee Vos-Stricker, who had been recently widowed, and was a cousin on his mother's side; Kee's mother was the eldest sister of Vincent's mother, and her father was Pastor Stricker, a minister in Amsterdam. She and her four-year-old son spent the summer of 1881 with the van Goghs. Vincent had been attracted by her before. During a visit with Kee and her husband in 1877, he wrote a glowing description of their marriage, one that resembled his earlier description of the relation between Ursula and her mother: "I spent Monday evening with Vos and Kee; they love each other truly. . . . When one sees them sitting side by side in the evening, in the kindly lamplight of the little living room quite close to the bedroom of their boy, who wakes up every now and then and asks his mother for something, it is an idyll." [2]

When Vincent proclaimed his love to Kee and proposed marriage, she flatly refused him. To accentuate her negative feelings, Kee left at once for her home in Amsterdam. Vincent broke the news to Theo in September: "I want to tell you that this summer a deep love has grown in my heart for Kee; but when I told her this, she answered me that to her, past and future remained one, so she could never return my feelings." Repeating the ordeal with Ursula, he tried desperately to change Kee's mind. "[T]o keep melancholy and depression far from me," [3] he refused to take the rebuff seriously, preferring to believe she was ill and would change her mind when she recovered. "But she has loved another and her thoughts are always in the past," he wrote, "and her conscience seems to bother her even at the thought of a possible new love." [4] He resolved to stay by her for her own good and hoped to have "touched the core of the fatal disease of burying herself too much in the past," [5] the very "disease" from which Vincent himself suffered.

Vincent did not accept Kee's refusal gracefully; his implacable attitude led to quarrels with both her family and his own. The Strickers censured him for pressing so untimely and indelicate a love, and Vincent's parents sided with them. The fury that this stirred in him assuaged his despair, yet the desperate pleas in his letters sometimes gave way to wish-fulfilling fantasies: "Theo, I love her—her, and no other—her, forever. . . . there is a feeling of deliverance within me and it is as if she and I had stopped being two, and were united forever and forever." [6]

In December he attempted to visit Kee, who was then living with her parents in Amsterdam. Pastor Stricker ordered him to leave and demanded that he never see her again; Kee kept out of sight. Vincent later told the rest of the dramatic story: "I put my hand in the flame of the lamp and said, 'Let me see her for as long as I can keep my hand in the flame.' But I think they blew out the lamp and said, *'You will not see her.'* " * [7] His passion for art, however, prevented a repetition of the severe depression that followed his rejection by Ursula in London. He proclaimed almost defiantly that he would not let melancholy strike him down, now that he had found his lifework.

On Christmas day of 1881 he provoked a violent argument with his father, which ended in the angry demand that Vincent leave. He headed for The Hague on the same day, and this abrupt departure had significant implications for his future. Vincent needed to free himself of parental restrictions and find a freer environment; most of all, he needed talented and experienced artists to guide and to stimulate the growth of his own talent. The Hague suited this purpose for it was then the center of the most vital movement in Dutch art, and Anton Mauve, a respected artist and the husband of one of his mother's nieces, had promised to help. At first the relations between Mauve and his pupil went well, and through Mauve he met other talented artists of the Hague School. But Vincent could remain no one's intimate and, even more, no one's pupil for long. Mauve soon had enough and refused to see him. Although Vincent attributed the breakup to Mauve's narrow-mindedness, his own irascible behavior must surely have provoked it. But by then he had gotten his fill of Mauve's teaching and was ready to proceed on his own, free of the restrictions imposed by a teacher.

Vincent's love of art and his relationship with Mauve did not dissipate his longing for a woman; even before coming to The Hague, he had written that he could not live without one.[8] So it is not surprising, therefore, that he found Clasina Maria Hoornik —whom he called Christine or Sien—and formed a liaison with her. A forlorn woman with a five-year-old daughter, Sien was an unmarried, pregnant prostitute, and Vincent was convinced that

* In doing this Vincent followed the legendary Roman, Scaevola, who is mentioned in Multatuli's *Max Havelaar*, a book well known to Vincent. Scaevola saved himself from execution and made himself a hero by thrusting his hand into a sacrificial fire until the flames consumed it. Multatuli (Eduard Douwes Dekker), *Max Havelaar or The Coffee Auction of the Dutch Trading Company* (New York: London House & Maxwell, 1967), p. 30.

she needed him as Kee never could. Besides, he wrote later on, "I hated being alone so much that I preferred being with a bad whore to being alone." [9]

Vincent has left a vivid description of Sien, a woman in poor health, with "one foot in the grave when I met her, and whose mind and nervous system were also upset and unbalanced." [10] She was disgusting to other people and had fits of anger; her speech was ugly; "Nobody cared for her or wanted her, she was alone and forsaken like a worthless rag. . . ." [11] She was a "whore, already pock-marked, already withered and prematurely old," yet Vincent perceived her in terms of his own needs: "In my eyes she is beautiful, and I find in her exactly what I want; her life has been rough, and sorrow and adversity have put their marks upon her—now I can do something with her." [12]

The fact that Sien was pregnant appealed to his altruism, his love of babies, and his desire for family life. After the birth, he brought Sien, her daughter, and the newborn infant into his house. Sien became his mistress and model, and with her he had his only prolonged, intimate relation with a woman. He freely accepted her physical and mental weaknesses and took over the household chores; as he noted, he had often done that for sick people. [13] At the same time he praised her lavishly whenever he detected the faintest sign of motherliness.

Sien's similarity to Vincent's view of himself helped draw him to her. A sad, ugly, despised, prematurely old outsider, she, too, had a mother who did not care. Sharing his problems with her, he felt less unhappy, less despised, and less aged himself. In perceiving Sien as beautiful, he felt better about his own ugliness; in caring for her, he served notice that he expected others to do the same for him. Humiliated by Ursula and Kee, he had said, "I know that what I have to do is retire from the sphere of my own class." [14] A sinner like Sien, moreover, humiliated and despised by society, was in no position to look down on him.

As might be expected, this affair further alienated Vincent from Mauve, his parents, his relatives, and his former chief, Tersteeg, the branch manager of Goupil and Company. Although their aversion distressed him, it also provoked his righteous indignation. Choked with grief, he blamed his misery on Mauve, while imploring the painter to see him. [15] At the same time he encouraged these "superior" people to neglect him, for their presence made him feel uncomfortable. Occasionally, however, he recognized his

own culpability. It was irritating and tiring to have people close by, he complained, and painful to talk to others because he made such an unfavorable impression on them.[16] With considerable insight, he observed that when he was melancholic and hungering for sympathy, his behavior often repelled those he wished to attract: "I try to act indifferently, speak sharply, and often even pour oil on the fire." [17]

In June 1882, aggravated by an attack of gonorrhea that sent him to the City Hospital for several weeks, his depression was at its worst since coming to The Hague. While recuperating in a ward for poor patients, he noted that the doctors treated him abruptly and inserted the catheter into his bladder "without 'ceremony' or fuss." [18] Oddly, he seemed to find some gratification in this approach to treatment—one that must have produced needless distress—for he commented favorably on it. In November he complained of "more and more a kind of void" that could not be filled. The following February he said that melancholy prevented him from doing anything properly and made life "the color of dishwater . . . an ash heap." [19] Yet in spite of these complaints he was not incapacitated. He worked hard and was productive; his letters were reasonable and perceptive, and demands on Theo were not as pressing as at other times.

As the winter of 1883 wore on, his depression subsided. He cared for Sien through pregnancy and illness and put up with her family's nastiness. Helping someone else in misery relieved his own distress. The "heavy cares" [20] he mentioned concerned Sien, not himself. Work came easier. "[M]y good spirits with regard to my work and the confidence that it will come out all right after all are beginning to return." [21]

Predictably, Sien failed him. She relapsed into her old ways in spite of his care and entreaties. As he reluctantly accepted his inability to heal her soul, the depression returned, and he suffered from the physical reactions that often accompany depression—stomach trouble, loss of appetite, dizziness, and headache.[22] But whereas formerly he praised his unhappiness on religious grounds, now he conceived of it as a necessary adjunct to an artistic career. Why should he give it up? After all, he explained, "the history of great men is tragic. . . . For a long time during their lives they are under a kind of depression because of the opposition and difficulties of struggling through life." [23] Relating himself to creative men, he felt less hopeless.

During his stay in The Hague, Vincent's interest in depicting peasants extended to their city relatives—the laborers and the slum dwellers. "Being a laborer," he wrote, "I feel at home in the laboring class. . . ." [24] He was more comfortable in dirty places than in clean places, for the latter reminded him of his own family, rekindling past frustrations and anger. In addition to this irascible behavior, his relations with Sien had cut him off from his past and from contemporaries whom he associated with it. But he rationalized this alienation in another way: "As a painter, one must *drop* other social ambitions," [25] he insisted. This "decision," made after the fact, helped him reject any residual temptation to seek the help of his well-to-do, socially prominent relatives or to return to his middle-class inheritance. Not being obligated to the "Messrs. van Gogh" and their allies, his art could remain true to his own values, and he could fight the despised bourgeoisie in his own way.

Rejection by family and friends, his plight with Sien, and nagging depression did not slow Vincent's progress as an artist. On the contrary, adversity reinforced some of his Dutch virtues, and he toiled incessantly, improving his skills and training his eye. There are approximately 200 drawings, watercolors, and lithographs from The Hague listed in Bart de la Faille's *The Works of Vincent Van Gogh: His Paintings and Drawings*. Of these, more than 60 are pencil drawings and about 30 are watercolors. Among the others are drawings with pen, black crayon, india ink, charcoal, and chalk. These media are combined in many ways, and colored washes are often added to them. There are also 23 oil paintings from The Hague in the de la Faille catalogue.

Continuing the task that he had set out for himself, Vincent drew peasants digging in the soil and sowing in the fields, as well as laborers, woodsmen, miners, carpenters, blacksmiths, the sick, and the aged. Some performed simple everyday activities such as reading, writing, drinking, praying, and warming themselves before a fire. Women were pictured walking, sewing, darning, sweeping, pushing wheelbarrows, and carrying sacks of coal. Others were dressed in widow's habits. He drew views of shabby dwellings in the Schenkweg, the district in which he lived, as well as factories, parks, gas tanks, railroad stations, churches, the lottery, and the local dumps. These landscapes convey the same impression of suffering, poverty, and toil as do his portraits of human beings. He

also depicted the beach and the sand dunes of nearby Scheveningen, fields of flowers, expressive trees, and the woods.

During his first six months in The Hague, he devoted himself almost exclusively to drawing, "which," he wrote, "everything depends on." His work had, until now, been stiff and motionless, and he was trying "to get some action and structure into it." [26] He also improved his ability to depict proportion and perspective. He made a complicated machine after a description in a book by Dürer, a machine, he claimed, that the old Dutch masters used. In concentrating on proportion, perspective, and detail, he also followed his Dutch antecedents. "They are landscapes with complicated perspective, very difficult to draw," he wrote, "but for that very reason there is a real Dutch character and sentiment in them."

In the middle of 1882 he returned to painting watercolors, which he had begun in Etten, and soon after painted his first oil. Although he followed Dutch tradition, he utilized materials and techniques that best expressed his own feelings. For instance, he liked the "rough" graphite of a carpenter's pencil. "I prefer the graphite in its natural form," he wrote, "to that sawed so fine in those expensive Fabers." [27] Similarly, he preferred a "rough" paper to the popular smooth type.[28] He limited himself, he wrote, to "simple colors" and avoided "nice" colors. Since he was not a "nice" person—that is, a hypocrite—he did not choose to use nice colors or be a nice painter. In describing the "coarse form and rough technique" of his work, he was not accusing himself of faulty craftsmanship but pointing with pride to honest work that revealed his own character.

Until now, Vincent had begun each picture with a sharp outline of his subject and paid little attention to modeling or to light effects. During the latter half of 1882, however, he began to experiment with chiaroscuro—the art of depicting light and shade by variation in tones, exemplified above all by Rembrandt and Israëls. Having begun to use oils, his interest in color was emerging. "While painting recently," he wrote at the end of his stay in The Hague, "I have felt a certain power of color awakening in me, stronger and different than what I have felt till now." [29]

Vincent realized that he needed to leave Sien and the unfriendly atmosphere of The Hague. A story he read in an English magazine about a painter whose health, like his own, suffered during a time

of trouble, may have led him to a solution. The man "went to a lonely place in the peat fields, and there, in that melancholic scenery, found himself again, and began to paint nature as he felt and saw it." [30] So, too, Vincent finally resolved to leave The Hague for a more isolated region and to be dead to everything but his work—"to live with a peasant for a time, far, far away in the country—far away, alone with nature." [31] In his last letter from The Hague, Vincent announced that his work was more important than Sien, knowing full well that he could expect nothing more from her than disappointment. [32]

Like the artist in the story, he went to "a lonely place in the peat fields"—the remote Drenthe district in northeast Holland. He arrived there in September 1883. Drenthe was a poor dreary country of desolate heaths, peat bogs, and rain—an emotional counterpart of the Borinage. Its thatched huts, with roofs that almost touched the ground, were shared equally by men and animals.

For a brief moment Vincent seemed to find what he was seeking. The first letters from Drenthe were optimistic; expressing sorrow in pictures of the gloomy heath, somber peasant huts, and workers in the peat fields provided an outlet that helped him keep his emotional balance. Anticipating a bright future, he even pleaded with Theo to quit his job as an art dealer and become a fellow painter. Before long, however, he was describing his self-imposed solitude as "bitterly, bitterly sad," and complained that he almost lacked the courage to go on alone. [33] He pinned the blame for his melancholy on "certain developments in the past," on Theo, or on other convenient targets. [34] When Theo's letter failed to arrive on time, he felt "absolutely cut off from the outer world." [35] Sometimes he blamed his loneliness on his work, contending that a painter has to accept being looked upon as a lunatic, a murderer, a tramp, and an outcast.

Though loath to do so, after three months at Drenthe Vincent returned to the house of his parents. His father was then the pastor in Nuenen, a Brabant village near Eindhoven, and Vincent remained there from December 1883 to November 1885.

With his parents' help, he set up a studio in the laundry room of the parsonage and went to work. But soon he was accusing them of being blind, ignorant, and unhappy. His father received the brunt of the attack, Vincent complaining that he was cold as iron, despite his outward gentleness, while simultaneously deriding his

violent passion.[36] Vincent's behavior, no doubt, would have tried the patience of the most stoical parent, and if his father did show passion, it is not surprising. For example, Vincent again threatened to marry Sien, even though he had definitely decided that such a marriage was impossible.[37]

He even accused Theo of being cruel, claiming that refusal to understand his relationship with Sien had split them apart. He expressed a suspicion that Theo, then an art dealer in Paris, made no effort to sell his paintings and enjoyed seeing him fail.[38] When Theo tried to excuse Vincent's venom by suggesting it was expressed in haste, Vincent retorted that this only proved that Theo did not understand him, that their relationship was hopeless, and that they should have nothing to do with each other. Marvelously inconsistent while in these resentful moods, he also feared that Theo wanted to get rid of him. He blamed Theo for being self-righteous while being self-righteous himself.[39] His claim that he was indifferent to Theo's criticism was blatantly false, for he was exceedingly sensitive to it.

Vincent also attacked his uncles whose wealth came from the art business. Their commercial values, he insisted, would destroy his art, and he would *"rather toil and live from hand to mouth"* [40] than fall into their hands. He charged them, as he had charged Theo, with self-righteousness, and described Theo's self-righteousness as "a dear little van Goghish trick." [41] This contempt for the proud van Goghs quieted the painful conviction that he was an inferior among them. Vincent's humanistic, egalitarian values were partly determined by this need to improve the belittled view he had of himself. Like him, the peasants and weavers of the region, the miners in the Borinage, and the poor prostitute in The Hague, were prisoners within the confines of their small world. The truth was that he felt more at ease with such humble people than with van Goghs and others like them.

Less than a month after his arrival at Nuenen, his mother seriously injured her hip and became bedridden. Accusations ceased, and he cared for her with tenderness and devotion. Her pain and helplessness brought forth an outpouring of love that can be found no place else in his letters.[42] Sufferers always aroused his compassion, and he nursed his mother with the same intensity with which he had previously nursed sick miners and Sien.

Another tragic incident occurred later in the year. Vincent had become attached to Margot Begemann, a lonely spinster who

lived next to the parsonage and helped nurse his mother. Margot was the youngest of three sisters but ten years older than Vincent; she was described as "neither beautiful nor gifted," [43] and their mutual attraction seems to have been based on shared unhappiness. They discussed marriage, and she, at least, was eager for it. Vincent, ready to respond with a consoling interest toward an unhappy woman, would have married her, but out of a love that was based on pity.

Vincent's description of Margot suggests that he was seeing his own past in hers: "[I]n her youth she let herself be crushed by disappointments, c. ushed in the sense that the orthodox religious family *thought they had to suppress* the *active*, aye, *brilliant* quality in her, and have made her utterly passive." Like her, he too "used to be very passive and very soft-hearted and quiet; I'm not anymore. . . ." [44] In Margot, Vincent became attached to an externalized image of himself, a sad person who was misunderstood and mistreated by an intolerant family, suffering what he had so often suffered. Saving her was like saving himself.

Not wishing to part with a useful helper, Margot's family strenuously objected to her relations with this strange fellow. Unfortunately, Margot was a woman with formidable emotional difficulties, extremely vulnerable to her family's disapproval, and she became *"excessively melancholic"* and "felt deserted by everybody and everything." [45] When she told Vincent she wanted to die, he tried in vain to rescue her from her family, but this only stirred up more trouble. The drama reached its climax when Margot attempted suicide by swallowing strychnine; she had a convulsion while walking in the fields with her controversial friend. Finally, she was sent off to a sanitarium in Utrecht, and the relationship seems to have terminated.

Constantly frustrated in his yearnings for human ties, Vincent formulated plans for an artists' cooperative in May 1885, following up ideas he first expressed in 1882. The members could work together and produce inexpensive pictures for the lower classes. Earlier he had met three men from Eindhoven who wanted to learn to paint: a sixty-year-old ex-goldsmith named Hermans, a forty-year-old tanner named Kerssemakers, and a telegraphist named van der Wakker. He volunteered to be their mentor and began to instruct them late in 1884, apparently to the considerable satisfaction of students and teacher alike.

During the first part of 1885, Vincent also spent much time

at the home of a peasant family, the de Groots, who posed for him. Unfortunately, the unmarried daughter, Gordina, became pregnant while he worked there, and Vincent was an easy target for suspicion. The local Catholic priest even issued an edict forbidding Catholics to pose for him, thus cutting off his chief source of models. Vincent vigorously denied the accusation, and the whole incident only increased his conviction that he was misunderstood and victimized.

Involved in all these hectic events, Vincent seldom complained of melancholy during his stay in Nuenen. Work, abundance of targets for his anger, concern for his injured mother and the unhappy Margot, friendly relations with the peasants, and his teaching duties absorbed his misery. When he did succumb to depression, it was short-lived and tempered with hope. The first spell of depression was in the autumn of 1884. He could neither eat nor sleep.[46] But, unlike former times, he immediately reassured himself that he would get over it and, "in spite of much old and new sorrow," [47] was hopeful about his future. As usual, the darkness of mid-winter was hard on him; early in 1885 he complained that he had hardly ever begun a year in a gloomier mood and pessimistically prophesied a future of strife.[48] But this spell soon passed.

His father died unexpectedly on March 27, but Vincent's letters give little evidence of personal grief. Shortly after, Mrs. van Gogh made plans to move to Breda, while Vincent moved out of the parsonage and slept in his studio at the home of the sexton of the Catholic Church, reflecting his continued bitterness toward his mother.

The period in Nuenen, shorter than two years, was probably the most prolific in Vincent's career as an artist. Almost one quarter of his total known output originated there: There remain about 225 drawings, 25 watercolors, 185 oils, and a few lithographs. Oils became his principal preoccupation, and his drawings were often merely preliminary studies for them.

As his first task, Vincent made many drawings and paintings of weavers working at their looms. He saw them as victims of an outmoded system that could not compete with modern industry, anxious and restless because of low wages and scarce work. Like the coal miner imprisoned in his cramped tunnel, the weaver was a prisoner confined in his loom, "a monstrous black thing of grimed

oak." "A sort of sigh or lament," Vincent wrote, "must issue now and then from that contraption of sticks." [49]

Soon after, he began to paint peasants at work—sowing, plowing, digging, reaping, chopping wood, making baskets, and eating potatoes. As in the past, peasant women were depicted at their own chores. Although he followed Millet, Israëls, Breton, and Lhermitte in these portraits, Vincent's peasants were uniquely his own, deformed by the desperate self-image that he projected into them. Unlike the proud peasants of Millet, for instance, Vincent's peasants reflected his view of himself as coarse, ugly, and prematurely aged. In contrast to Millet's peasants who were masters of the dirt they tilled, Vincent's often merged with the dirt or resembled the animals who were forced to till it, characteristics derived from feeling dirty, awkward, and bestial. Living in the same house with his parents no doubt exaggerated this feeling, perhaps stirring up old memories of situations in which he was shamed by them for some childhood indiscretion concerned with cleanliness. His analysis of what his parents thought about him epitomizes the kind of person who would be intolerable to a tidy Dutch mother for whom cleanliness was next to godliness: "They feel the same dread of taking me in the house," he wrote, "as they would about taking in a big rough dog. He would run into the room with wet paws— and he is so rough. He will be in everybody's way. *And he barks so loud.* In short, he is a foul beast." [50]

Despite the painful realism of Vincent's peasants, there is also a heroic aspect in these pictures. Since he was steeped in the idea that God's grace is obtained through toil and suffering, when he pictured toiling, suffering peasants, he glorified both them and himself.

An old church tower with the cemetery surrounding it was the locale of Vincent's first landscapes in Nuenen; he made studies of the wheat harvest, the parsonage, an old watermill, tree-lined roads, snow scenes, his father's church, thatched huts, ditches, and farm scenes. He also painted autumn landscapes, sunsets, twilights, and many still lifes.

In May 1885, he reached the peak of his artistic development in the North when he painted *The Potato Eaters*, a somber portrayal of a peasant family of five seated around a bowl of steaming potatoes. "I have tried to emphasize," Vincent wrote, "that these people, eating their potatoes in the lamplight, have dug the earth with those very hands they put in the dish, and so it speaks of

manual labor, and how they have *honestly* earned their food." [51]
The gloomy atmosphere, the coarseness of the human features, and
the melancholic interplay between the inhabitants of this "grimy
cottage," [52] as Vincent called it, reveal their poverty, their suffering,
and their despair.

As in *The Potato Eaters,* Vincent projected himself into the
content, the forms, the strokes, the textures, the colors, the move-
ment, even the materials of his pictures. While he borrowed stylistic
elements from other artists, he used, or adapted for his use, those
that helped him reveal himself; only in this way could his work
be so distinctive. His self-perceptions—those physical and psy-
chological qualities that he attributed to himself, those he felt
others attributed to him, and those he wished to have—were among
the basic tools of his craft. In putting them on canvas, he displayed
his struggles and his desires, and gradually learned techniques
for transforming himself and the world around him.

When working for Goupil and Company in London, Vincent
was a well-dressed businessman who wore a top hat; after the
disillusionment with Ursula, however, he changed. He brought his
top hat to Dordrecht in 1877, but used it to caricature his former
self; a fellow employee at the bookstore wrote, "[S]uch a hat—you
were afraid you might tear its brim off if you took hold of it." [53]
When he arrived in the Borinage in 1878, he reverted to his former
respectability; he was "well-dressed, had excellent manners, and
showed in his appearance all the characteristics of Dutch clean-
liness." [54] Suddenly he changed once again. He began to wear "an
old soldier's tunic and a shabby cap"; "his Dutch cleanliness was
singularly abandoned; soap was banished as a wicked luxury; and
when our evangelist was not wholly covered with a layer of coal
dust, his face was usually dirtier than that of the miners."

From this point on Vincent saw himself—and was seen by
others—as rough, dirty, and shabby. Early during his stay in The
Hague he wrote "I shall have to suffer much, especially from those
peculiarities which I *cannot* change. First, my appearance and my
way of speaking and my clothes." He even managed to find reasons
for prizing his peculiarities. "For my profession it is better that I
am as I am than that I squeeze myself into forms that do not fit
me. I, who did not feel at ease in a fine coat in a fine store . . .
am quite a different person when I am at work on the Geest or on

the heath or in the dunes. Then my ugly face and shabby coat harmonize perfectly with the surroundings and I am myself and I work with pleasure. . . . When I wear a fine coat, the working people that I want for models are afraid of me or distrust me as a devil, or they want more money from me." [55]

He used this self-image in carrying on his work as an artist which he described variously as "rough work, even dirty work at times," "messing around," and "a dirty and hard profession." [56] According to visitors, his studio was "very disorderly and untidy" [57] and his clothes were smeared with paint. During his stay in Nuenen he developed an unfinished earthy quality, and he learned to paint with thick unsmoothed strokes, a style that produced effects that fascinated him while simultaneously expressing his rough ways.

When he wrote from Nuenen that his parents regarded him as "a foul beast" and "a big rough dog [who] would run into the room with wet paws," he was reaffirming his view of himself as an uncouth person whose presence was intolerable to them. Yet the young man who felt his parents detested him for soiling their house would make these same wet paws create admirable pictures. Remaining dirty, his dirtiness would become acceptable, even praiseworthy. The thick, deep brown paints that covered his canvases were like the abundant Dutch mud that was not to be tracked inside the house or, to put it in the framework of an earlier period of his life, like feces that were not to be smeared willy-nilly on his surroundings; now, however, he was mastering techniques for diverting this soiling into channels that would be admirable rather than disgusting. When he smeared his canvas with his brush or palette knife, he was symbolically defying parental authority. And when, later on, he gave up his dark browns and grays for brilliant yellows and blues, he would transform the repulsive dross into a heavenly glory.

It would be a mistake, however, to imply that Vincent's molded forms and rough textures were motivated solely, or even mainly, by such "anal" factors. They were also efforts to make contact with other people. His pictures appeal not only to the eye but to the sense of touch. He wished them to appear like solid living substance, a substance that asks to be handled. When he depicted a tree in terms of its "convulsive, passionate clinging to the earth, and yet being half torn up by the storm," [58] he was attempting to create the illusion of an active physical state. The tree grasps the earth while it also becomes something to grasp. Appealing to the

viewer's own body image, it invites him to fuse with it in an act of identification.

Vincent's view of himself as a repulsive, untouchable, rootless, "dead" outsider motivated him to create such forms. Feeling worthless, without a solid sense of definition about himself, he tried to produce art that was touchable, solid, and alive. As he wished to be held, he wished the viewer to touch and hold this extension of himself, hoping in this roundabout way both to define himself and make contact with others. He steered clear of visionary subjects that might precipitate latent feelings of unreality and depersonalization. His rejection of the customary practice of beginning the painting with the contour may have been based on similar fears. Perhaps the spaces within the contour lines reminded him of the emptiness that he felt inside himself, for he called such pictures "dead." [59] Beginning the painting from the inside emphasized the life and substance of the portrayed object and, indirectly, of himself.

Vincent was a short square man with a strong muscular body and a mind that goaded his body to function with unflagging energy.[60] In Dordrecht, for instance, a flood that endangered the warehouse at the bookstore aroused him to such a display of strength and endurance that years later a fellow employee spoke with admiration of his performance.[61] Vincent himself remarked that he had the appearance and the strength of a bargeman or an iron worker.[62] This muscular energy is essential to his art, displayed in the bold vigorous strokes and forms that emerged during his last years in Holland and became increasingly prominent later on.

He was also an emotional and impulsive man, and he needed to find an outlet for these qualities in his work. In Nuenen his continued development of chiaroscuro improved his ability to express emotions, although he would find more characteristic ways in the bright colors and the restless movement of his French pictures. He did, however, solve the problem of his impulsiveness by acquiring a great proficiency with his tools, and began to praise the merits of painting rapidly. "To paint in one rush, as much as possible in one rush," [63] best expressed the impulsive, passionate style of life that came natural to him. If we accept an eyewitness report from Antwerp, his impulsiveness and his messiness found common ground in art: "Van Gogh started painting feverishly, furiously, with a rapidity that stupefied his fellow students. 'He

laid on his paint so thickly,' Mr. Hageman told us, 'that his colors literally dripped from his canvas onto the floor.' " [64] In painting rapidly, he discovered that he was following in the path of his artist ancestors: "What struck me most on seeing the old Dutch pictures again was that most of them *were painted quickly,* that these great masters—such as a Frans Hals, a Rembrandt, a Ruysdael, and so many others—dashed off a thing from the first stroke and did not retouch it very much." [65] He also observed that the "real artists" of his own time—Israëls, Maris, and Mauve, for instance—"just dash it on." [66] This discovery permitted him to go ahead with the same dash, reassured that he need not fear his natural inclinations.

Vincent was an eccentric character, mentally and physically distorted by inner strains. People said, for example, that he made a "queer impression," and described him as "an ugly creature," and "a rare specimen out of a collection of freaks." [67] He himself recognized his bizarre aspects, but hoped that his pictures would help others perceive that there was more to him than the impression he gave: ". . . I should want my work to show what is in the heart of such an eccentric, of such a nobody." [68] He had already demonstrated in The Hague that he was an expert draftsman who could produce photographic likenesses. In Nuenen he went beyond this, deliberately distorting images, projecting his distorted view of himself into his style. As was his custom, he managed to find precedents for this in literature as well as in art. "Zola creates, but does not hold up a mirror to things," he wrote, "he creates *wonderfully,* but *creates,* poetizes. . . ." [69] He pointed out that anatomy and structure are often incorrect in the art of Michelangelo, Daumier, Millet, Lhermitte, and Israëls. *"I should be desperate if my figures were correct,"* he added. ". . . Millet and Lhermitte are the real artists for the very reason that they do not paint things as they are, traced in a dry analytical way, but as *they* feel them. . . . [M]y great longing is to learn to make those very incorrectnesses, those deviations, remodelings, changes in reality, so that they may become, yes, lies if you like—but truer than the literal truth." [70]

Vincent repeatedly complained that he was ugly, coarse, and aged beyond his years; once he wrote that he looked "as thick-skinned as a wild boar." [71] At the age of thirty he described himself as a man "with wrinkles on my forehead and lines on my face as if I were forty, and my hands are deeply furrowed." [72] At this same

time he was making many drawings of gnarled, wrinkled old people. Consistent as always in equating man and nature, he often emphasized the gnarls on trees, just as he emphasized the gnarls on the hands of the peasants in *The Potato Eaters*. Perhaps he also projected his appearance into the texture of his paintings; the coarse furrowing characteristic of many of them resembles the wrinkled skin of old age.

Some have assumed that Vincent's awkward, sometimes eccentric use of the French language was due to his foreign birth. Jacob Spanjaard, however, has pointed out to me that his Dutch shares a similar character. It is often clumsy but at the same time poetic, with great literary quality. Indeed, Dr. Spanjaard says that one can recognize Vincent's paintings in his "queer and angular" sentence structures. He suspects that van Gogh's literary style, and, perhaps, his artistic style as well, were influenced by a trend that is found in the Dutch literature of the time. The "tachtigers," for example, were a group of Dutch poets and writers that—beginning about 1880—revolted against rigid scholastic usage; like Vincent, some of them used unorthodox syntax to increase expressivity.

Compared with the refined features of his father and Theo, Vincent was not a handsome man. But without the melancholic conviction that he was unloved and therefore unlovable, he would not have been so certain he was ugly. Yet, while he readily acknowledged his ugliness, he instinctively knew the meaning of the aphorism in Robert Burton's *The Anatomy of Melancholy:* "Beauty alone is a sovereign remedy against fear, grief, and melancholic fits." It was in the struggle to relieve melancholy that he developed his concept of beauty.

The word ugly originally meant horrible, dreadful, or loathsome; a person who feels ugly feels repulsive, and, like Vincent, he will be cautious of making close ties. Part of Vincent's artistic task— as well as a remedy for "melancholic fits"—was to transform the feeling of being ugly and repulsive into being beautiful and attractive. To accomplish this he used the masochistic device of glorifying this negative aspect of himself. Just as he was convinced that a show of suffering would bring him love, he was convinced that a show of ugliness would bring him admiration.

Michelangelo, small in stature and deformed of face, made monumental figures of classic beauty; Toulouse-Lautrec, partially

immobilized by deformity, produced grace in motion. Vincent did it differently. While he was well aware of contemporary standards of beauty—a cultural phenomenon that varies in time and place— he refused to be hampered by them; ever since the depression that followed Ursula Loyer's rejection, he had admired the ugly, the poor, the aged, and the mutilated. And as soon as he began to draw, he drew them, doing it with a pathos that would stimulate compassion toward them and indirectly toward him. Michelangelo was encouraged in his direction by the classic aesthetic values of his Catholic Renaissance environment. Vincent's masochistic glorification of ugliness was backed up by his Dutch artistic forebears; the self-portraits Rembrandt painted as he grew older, poorer, and uglier, for example, are commonly admired more than those painted when he was younger, wealthier, and handsomer.[73]

Vincent once wrote, "I do not want the beauty to come from the material, but from within myself." [74] Later in referring to the classic example of ugliness, Victor Hugo's Quasimodo, he thought of a saying: "In my soul I am beautiful." [75] He saw Sien, "this ugly???, faded woman" in the same light: "In my eyes she is beautiful. . . ." [76] In Drenthe he became fascinated with "the most wonderful types of Nonconformist clergymen with pigs' faces and three-cornered hats. Also adorable Jews, who look uncommonly ugly." [77] And he wrote from Antwerp: "There were several very handsome girls, the most beautiful of whom was plain-faced. I mean a figure . . . with an ugly and irregular face, but lively and piquant à la Frans Hals." [78]

He extended this paradoxical view of ugly as beautiful to non-human objects. In The Hague, for example, he saw "beautiful things: building plots being dug up or leveled, sheds, wooden huts," and in Nuenen he described some "beautiful hovels." [79] When he painted the gnarled flowering trees in Arles, he was putting into visual form a statement he made in Nuenen three years earlier: *"When a rough man bears blossoms like a flowering plant,* yes, that is beautiful to see." [80]

Death, suffering, old age, poverty, and dirtiness—concepts that are allied to ugliness—partook of the same beauty. When he saw the distress of a cow in labor and tears of compassion in a little girl standing nearby, he called it "pure, wonderful, beautiful," and he found stories like *Les Miserables* "beautiful." After drawing "an old man sitting with his elbows on his knees and his head in his hands," Vincent remarked: "How beautiful such an old workman

is, with his patched fustian clothes and his bald head." [81] He once described himself as a ruin, but he also noted that "some ruins of physiognomies . . . are full of expression." [82] Shipwrecks and wrecked buildings were also objects of beauty, and he preferred a woman "who was ugly or old or poor or in some way unhappy, but who, through experience and sorrow, had gained a mind and a soul" [83] to a beautiful woman.

The Dutch word *schoon* means both clean and beautiful, illustrating the importance the Dutch place on cleanliness, but Vincent defied this idea, proving in his art that dirty can also be beautiful. He "saw drawings and pictures in the poorest huts, in the dirtiest corner. And my mind is drawn toward these things by an irresistible force." [84] He liked to paint scenes "that people would pass by . . . even figure painters [would say] 'Oh, those dirty people.' " [85] A view of The Hague in which men were "all white with lime dust" was "beautiful" even though "most people think the city ugly." [86] He once exclaimed, "How beautiful the mud is, and the withering grass." [87]

These ideas may also be applied to *The Potato Eaters*. Vincent put himself into its gnarled ugly peasants, the "grimy cottage," the unsmoothed brush strokes, the muddy colors, and the energetic rapid execution. For others to accept its ugliness as beautiful was to accept him. When van Rappard criticized the painting on aesthetic grounds, he was, in effect, reminding Vincent that he was ugly and repulsive. No wonder Vincent was so indignant and let the friendship die. But although *The Potato Eaters* is one of Vincent's most widely recognized paintings, some are repulsed by it. Probably more are disconcerted, as if the conflict that raged within Vincent about his own worth had been shifted into them.

Beneath the continued portrayal of somber people in somber settings was the silent work of preparation for the bright paintings to come. Even before he painted *The Potato Eaters,* he had begun to consider other styles than the dark tonal effects of chiaroscuro. In 1884, for instance, he mentioned Eugène Delacroix's ideas about colors. But he was not yet ready, so he pushed them aside at once in praise of the dark tones of Josef Israëls. [88] He did not even question Theo about Impressionism, even though his brother was well acquainted with this movement in his capacity as an art dealer in Paris. He once mentioned that he had talked with van Rappard

about it,[89] but there is no other reference to this new colorful approach to art in the letters from Holland. Indeed, no sooner had Vincent mentioned it than he surmised that his painting would become darker rather than brighter in the future. Perhaps he was denying his growing interest in bright colors in order to protect himself from premature action.

At the same time, when he proposed to depict the four seasons by means of complementary colors, his description sounds like a forecast of paintings that were to come several years later: "But now, if summer is the contrast of blues with an element of orange in the golden bronze of the wheat, one could paint a picture which expressed the mood of the seasons in each of the contrasts of the complementary colors. . . ." [90]

Having painted *The Potato Eaters* in May 1885, the first half of his career had come to a natural conclusion, and he was then freer to seek new solutions to his life problems and new approaches to art. Vincent's chief psychological task between May and his departure from Nuenen six months later was to weaken his attachment to Holland and to find other attachments that would facilitate his move to a brighter, more friendly land. Holland had become for him a dark, antagonistic place that was an extension of his antagonistic family. He still felt like an outsider in his own country and in its world of art—"banished because of my wooden shoes." [91] He warded off feelings of neglect and loneliness, however, by convincing himself that he had no need for these ostentatious hypocrites. "The real thing that makes one happy," he wrote, ". . . does not exist here." [92]

His artistic task paralleled this psychological task. It was to find the technical means to express not only sorrow but other intense emotions, including the joy he was unable to experience in life. The dark tones of Dutch chiaroscuro could not do this. In July he announced that he had seen too much gray in his life: "Painting gray as a *system* is becoming intolerable and we shall certainly get to see the *other side of the coin*." [93] He was tempted by the idea of brightness but saw insipid, cold qualities in many bright pictures: ". . . I hate more and more those pictures which are light all over." [94] This condemnation did not result in the preservation of his dark style but stimulated him to learn to use bright, contrasting colors in exuberant ways, to express, like Delacroix, an "enormous variety of moods in symphonies of color." [95] Vincent was a colorful man who clashed rather than harmonized with other people, and he

could not find satisfaction in the smooth harmonies of tonal effects. By the time he left Nuenen he was beginning to orient himself toward an impetuous, imaginative, colorful art that suited him much better.

In giving up chiaroscuro, Vincent loosened his ties to Rembrandt, Millet, and Israëls. While he would continue to be influenced by them, he needed to turn to other idealized artist-fathers for the inspiration that would help him discover the secrets of using bright colors. Eugène Delacroix was the first source of this inspiration. When he was looking at works of the old Dutch masters on a visit to Amsterdam museums, for instance, he wrote that he "was thinking continually of Delacroix." [96] In the following letter he mentioned the "colorists" Hals, Veronese, Rubens, Delacroix, and Velasquez, and then admitted to himself that his beloved Rembrandt, Millet, and Israëls were "more harmonists than colorists." [97] He noted that his palette was thawing,[98] and henceforth his paintings became progressively brighter. *Autumn Landscape* painted in November, was his most colorful Dutch work.

The isolation Vincent felt in Nuenen was not the only reason for leaving it. He was also motivated by his developing needs as an artist. He had been "working absolutely alone for years . . . completely outside the world of painters and pictures," [99] and he longed to visit museums, mingle with other painters, and paint from the nude. Besides, the freezing weather in late November made it impossible to paint outside, and he could no longer obtain the models he needed to paint inside. To accomplish his aims he had to live in a city, where—he reassured Theo—he would also have a better opportunity to sell his pictures. Too, he had enough of Holland, even from the standpoint of art. Contemporary Dutch artists were like "tepid water," he said, lacking enthusiasm or daring. They had destroyed the talented Thijs Maris,[100] and he would not permit them to do the same to him. Once Vincent turned to art, the vicissitudes of life never drove him into a prolonged state of paralysis as they had previously. Rather they stimulated him into actions that benefited his progress as an artist.

He decided to go south, an idea that symbolized his search for light and joy and his intent to change from an art of dark tones to one of bright contrasts. One of his last Dutch paintings was a still life with a large dark Bible and a small bright yellow copy of Zola's

The Joy of Life. The Bible is open to Isaiah, in which the description of the suffering Messiah resembles Vincent's own self-image: "One who grew up like a root out of dry ground . . . [who] had no beauty. . . . He was despised and rejected by men; a man of sorrows, acquainted with grief." This was the Vincent of the dark North. The Bible, his father's, suggests the suffering he associated with his rigid Calvinistic parents, their church, and their country. *The Joy of Life* suggests the acceptance he hoped to find in France. There in the bright light his sorrow would disappear and be transformed into joy. But the message is ambiguous, for the Bible also expresses his hope for a joyous future, and the title on the cover of Zola's book is an ironical one, as there is no joy at all inside it. (See *The Bible and the Joy of Life.*)

Antwerp was to be his first stop, and he anticipated seeing the works of the famous citizen of Antwerp and master colorist, Rubens, "the very man who tries to express, and really succeeds in expressing, a mood of cheerfulness, of serenity, of sorrow, by the combination of colors. . . ." [101] As he was leaving, he wrote, "I am looking forward to him very much." [102]

5 The first Vincent
and the sad mother

VINCENT'S DEEP MISERY seems to have been present from his earliest years. "My youth," he wrote, "was gloomy and cold and sterile. . . ." Even then, as his sister Elizabeth noted, he was a stranger to his family, even as he was a stranger to the world later on. Although he sometimes fancied that his childhood was happy, second thoughts caused him to suspect that he only imagined it.[1]

He had a theory about the origins of his chronic unhappiness, and he voiced it in a language that came easily to him—the pictorial language of nature: "The germinating seed must not be exposed to a frosty wind—that was the case with me in the beginning."[2] He was saying, in effect, that during his earliest years he was deprived of those ingredients that comprise the mysterious entity called mother-love: the freely-given, cuddling, cooing, nourishing, protecting, reassuring behavior of a maternal figure. He was like a scraggy, stunted, deformed plant, constantly struggling for its life because it had been neglected by an unfriendly Mother Nature when it was beginning to root and grow.

Depression, to be sure, is a psychological reaction familiar to everyone. But the study of children and the psychoanalysis of

adults indicates, as Vincent's explanation suggests, that extreme vulnerability to it may arise out of a defect in the nurture of the young child: the seed has been exposed to a frosty wind.

When the infant first opens his eyes, he cannot differentiate between himself and the people and things that surround him—a state that Freud called an "oceanic feeling." Gradually, the infant becomes aware that the most vital thing in his existence, his mother, is separate from himself. Then, one by one, he perceives the differences between himself and other people and objects around him. During the course of this learning experience, he builds a discrete mental image of himself. This image is composed in part of what he sees, feels, and hears about himself, in part of what others think about him, and in part by identifying himself with certain aspects of those close to him.

This process of self-differentiation is facilitated by a mutually close, trusting relationship between mother and child. The relationship may be deficient due to emotional distress in the mother, to her absence at crucial times, or to a stifling overprotectiveness. Anything that causes discomfort in the child, such as illness or feeding problems, may also impair the relationship. This impairment impedes the infant's development into a stable, integrated, self-respecting, self-sufficient human being. Instead he tends to feel inferior, unloved, lonely, hopeless, and hypersensitive to all kinds of stimuli. The mere possibility of unloving behavior from the outside world causes anxiety, and relatively mild displays of rejection cause depression, a predisposition that persists into adulthood.

This vulnerability is intensified when the child has been taught to believe that he is expected to become an eminently successful adult. As we have seen, this was a factor in Vincent's rearing. The combination of low self-esteem and high expectation is most apt to produce adults who are highly susceptible to depressed states.

The fate of other offspring in the family as well as Vincent's may reflect deficiencies in Mrs. van Gogh's child-rearing practices, although it would be fallacious to draw definite conclusions from this evidence. Like Vincent, Theo also suffered from severe attacks of depression and anxiety. Wil, the only one of his three sisters with whom Vincent had friendly relations, developed an incapacitating psychosis, probably schizophrenia, and was confined in a mental hospital until her death in 1941. Cor, the youngest brother, died in South Africa at the age of thirty-three; an acquaintance claimed that he committed suicide.[3]

The oblique references recorded by Vincent and his sister Elizabeth are all that is known of his childhood relationship with his mother, but the relationship is better documented during the period of his published correspondence, from the age of nineteen until his death at thirty-seven. Of course, a grown man's relations with his mother do not openly reveal the childhood situation. Indeed, feelings and actions sometimes become reversed during the course of development. Still, they may supply valuable clues, especially when they form part of a larger pattern of behavior; for the compulsion to repeat earlier patterns, while it may be modified, is one of the deepest and most ineradicable processes in human nature—even if the pattern is detrimental to adult living.

One looks in vain through hundreds of Vincent's revealing letters to find a spontaneous, affectionate reference to his mother. Only on a special occasion, such as her birthday, did he express his devotion, and this was routine and strained. Tender feelings for her were awakened only when she was bedridden as the result of a painful injury. It is true that he seldom criticized her, but his defensive silence was no less eloquent than freely expressed anger.

The most flagrant breach in this wall of silence occurred during the stay with his parents in the parsonage at Etten in 1881. Overwhelmed by Kee Vos-Stricker's rejection, he protested that his mother cut off every opportunity for him to discuss the unhappy situation with her; like his father, she did not understand him. Indeed, she took Kee's side rather than his own. His bitterness finally burst into the open: He complained that "a man who wants to act cannot approve of the fact that his mother prays for his resignation." [4] This was followed by a shotgun blast in her direction: "There really are no more unbelieving and hard-hearted and worldly people than clergymen and especially clergymen's wives." [5]

When he left the parsonage for The Hague, the resentment soon vanished from sight. He rarely mentioned her; and when he did, a spirit of sadness and a willingness to share the blame permeated his thoughts. ". . . the disharmony between Father, Mother and me," he wrote, "has become a chronic evil because there has been misunderstanding and estrangement between us for too long"; as a result, he felt like a "half-strange, half-tiresome person." [6]

The last volley against his mother was fired in the Nuenen parsonage, soon after the death of his father in March 1885. He protested that his mother selfishly wanted the whole inheritance transferred to herself. Pointing to her (and to his three sisters who

backed her), he added, "I think those . . . at home very far, very far from sincere." [7] Then his complaints vanished once again.

But by November, he had become convinced that his mother was soon going to die, suddenly and unexpectedly, although the ostensible reasons he gave for being thus alarmed were tenuous.[8] She had been overwrought immediately after her husband's death, he recalled, but now she was calm and resolute. Indeed, he added, she appeared to be *"particularly well."* He saw this as evidence of her precarious state, and he fearfully predicted she would breathe her last in a few days. (In fact, she lived a vigorous life up to her death in 1907, twenty-two years later, having outlived all three of her sons). This phobia appeared at a time when Vincent had particular reason to be angry with his mother, yet was unable to vent it. Most likely it was generated by an unconscious wish for her death, a wish that his conscious mind would not tolerate.

In the letter that followed these remarks, his certainty of her imminent death persisted. But he was also able to express some resentment: Her mental life was so complicated, he wrote, that she could not talk about her "deep thoughts"; she was so "chary of speech" that he knew little about her. He felt that her remoteness and lack of understanding were his intolerable burden, even as he was hers.[9]

That same month he left Nuenen and his mother, protesting that "she had neglected him for a long time." Complaining that they had become "more estranged . . . than if they were strangers," [10] he swore he would no longer write to her. Soon after he interjected a poem that echoed these feelings, but added to them the opposing feelings of love:

> *All evil has come from woman—Obscured reason, appetite for lucre,*
> * treachery . . .*
> *Golden cups in which the wine is mixed with lees,*
> *Every crime, every happy lie, every folly*
> *Comes from her. Yet adore her, as the gods*
> *Made her . . . and it is still the best thing they did.*[11]

When, a few months later, he described Xanthippe as "a woman of a soured love," [12] he may have been describing the dangerous, untrustworthy nature of woman as he learned it from his mother.

Later, when far away in France, open resentment toward her almost disappeared from his letters, if not from his mind. Once while in Arles, however, he received her photograph; the confronta-

tion stimulated him to paint two canvases. The words he chose to describe the first, based on a memory of the parsonage at Etten, indicate that Vincent saw his mother as depressed and angry: "[T]he deliberate choice of color, the *somber* violet *violently* blotched with the citron yellow of the dahlias, suggested Mother's personality to me [italics added]." [13] The second, a portrait of his mother, was painted "ashen grey," as deadly a color as might be imagined. It brought to his mind a poem about a man's longing for a woman who, being cold and sad, cannot return his love. He included the poem in a letter to Wil:

Who is the maid my spirits seek
Through cold reproof and slanders blight?
. . . wan and sunken with midnight prayer
Are the pale looks of her I love . . .[14]

Mrs. van Gogh-Bonger, Theo's wife and Vincent's biographer, has pointed out that Theo's correspondence with the family was "preserved in full," but Vincent's was "unfortunately destroyed." [15] Similarly, the way in which Vincent's mother dealt with his art reinforces the suspicion that his sense of rejection was not based simply on figments of his imagination. It appears that when Vincent quit Nuenen in November 1885, he left almost all the drawings and paintings that remained to him in the Catholic sexton's house, where earlier he had rented a room in order to get away from his family. When his mother moved to Breda in May 1886, they were brought there with the family furniture, packed in cases, and left with a carpenter. Upon hearing that "traces of woodworm" had been found in the packing cases, she developed a "fear of infection"; this "fear" gave her leave to abandon her son's work—estimated at "60 paintings on stretchers, 150 loose canvases, two portfolios with approximately 90 pen drawings, and some 100 or 200 crayon drawings." This large collection eventually fell into the hands of a junk dealer, who destroyed some of them and sold others for pennies from a pushcart.

But if Mother van Gogh did indeed reject her son, was it his own antagonistic behavior that drove her to it? Or did she first reject him and thus turn him into a rejected and therefore rejecting son? Vincent was sometimes quite willing to bear the responsibility for the unhappy relationship. He once described Theo as one "who comforts his mother and who is worthy to be comforted by his mother"; in contrast, he compared himself with a leper who brings

only sorrow and loss and should be quarantined in order to save others from harm.[16]

But while Vincent's behavior provoked disharmony, it originated in an aversion to his family that was present in his childhood and was conditioned by childhood experience.

Vincent van Gogh was born, and died, on March 30, 1852. The baby was buried in the graveyard of the Dutch Reformed church in Zundert, where his tombstone can still be seen. Exactly one year later, on March 30, 1853, another boy was born to the van Goghs. He was also named Vincent, and he lived his early years just around the corner from his dead brother's grave.

Dr. V. W. van Gogh, Theo's son and Vincent's nephew, has remarked, "Until he left the parental home, Vincent saw this little grave at least once a week when he went to church, but he also saw it when he came home on weekends, holidays, etc. Besides it is certain that he heard the little boy mentioned continually." He wrote to the late Charles Mauron, an esteemed student of van Gogh, that the artist, "conceived and carried by a mother who was in deep mourning, was able to see the tomb of the one he was to replace every day from the time he was old enough to perceive." Dr. Mauron added, "The psychological importance of this detail is difficult to evaluate." [17]

Vincent nowhere mentions his dead brother or his mother's reaction to the death. As an adult he probably had no conscious memories of her reaction and its consequences, yet the thoughts that preoccupied his mind—repetitiously expressed in his sermon, letters, and art—suggest that the first Vincent influenced the psychological development of the second, and that the latter's life was dominated by the idea that he was unloved and ignored by a mother who continued to grieve for her beloved dead son.

Such an idea, of course, is a hypothetical reconstruction of a childhood situation, the memory of which, it is assumed, was buried in Vincent's unconscious mind and became manifest later in life through the emergence of distorted repetitions of the original situation. Reconstructions that are based on such repetitious patterns are often used in the practice of psychoanalysis.[18] Tentatively proposed, a reconstruction is verified or discarded on the basis of further information obtained from free associations, dreams, and the "transference"—the latter referring to the transfer to the analyst of

thoughts, feelings, and actions that once concerned significant early figures. Ordinarily, a reconstruction cannot be substantiated without these techniques of psychoanalysis, but Vincent's case may come close to being an exception. His numerous letters often resemble the free associations of psychoanalysis, and his pictures and the thoughts at the time he made them, may be used in place of dreams and dream associations. The complicated relationship with his brother Theo, documented in hundreds of emotion-packed letters, can be compared to the transference situation in psychoanalysis; (it has been suggested that Freud's relationship with Wilhelm Fliess, similarly expressed in a long correspondence, served as a transference situation in his own self-analysis).[19] The probability of this hypothesis rests on information that will accumulate throughout the book.

As Mrs. Nelly van Gogh-van der Goot, the wife of Vincent's nephew, has suggested, the grief that Vincent's mother suffered following the death of the first Vincent may have persisted through the second Vincent's early years, for the transformation of mourning into a chronic state of melancholy is not rare among women whose children have died. This would make it difficult for her to satisfy the boy's needs for the warmth and intimacy that come from a happy mother's loving care; he, in turn, would have suffered from the deprivation and become depressed himself. Sharing the brother's name, he constantly reminded the mother of her loss. A dead child easily becomes an idealized child. The first Vincent did not live long enough to be bad, and a child who continued to live would inevitably fail in comparison. The mother's own guilt about the death would then be displaced to the next child: he became the guilty one. The depression the little boy suffered from this experience may have laid the foundation for the depressive tendencies he was to bear later in life.*

His brother's example taught Vincent that being dead meant being loved and cherished, while being alive meant being rejected. Referring to another family with a similar tragedy, Erik Erikson has written, "For example, a mother whose firstborn son dies and who (because of complicated guilt feelings) has never been able to attach to her later surviving children the same amount of religious devo-

* Dr. Jacob Spanjaard has found that the mother's inability to attach herself to the living child is often determined by the wish to keep the dead child alive in fantasy; a firm attachment to the live child is equated with abandoning the dead one. Because of this, the former may become a malevolent temptation.

tion that she bestows on the memory of her dead child, may well arouse in one of her sons the conviction that to be sick or to be dead is a better assurance of being 'recognized' than to be healthy and about." [20] Such a pattern is in keeping with Vincent's preoccupation with the partial deaths of sickness and mutilation and with the anticipation and glorification of death. "It is better to go to the house of mourning," he preached at Richmond in 1876, "than to the house of feasts."

Of course, Vincent's unconscious fixation concerning the circumstances of his earliest years may not have been based on fact. His mother may not have been depressed and unloving, and her mind may not have constantly dwelled on the first Vincent during the second's early years. The idea could have been reconstructed retrospectively in order to rationalize later childhood conflicts that caused him to hate his mother and, in turn, feel hated by her. For our purposes, however, the question of fact or fantasy is not crucial, since fantasy may influence development as much as reality.

Additional light may be cast on Vincent's early relationship with his mother by reviewing his relations with other women. Because of the powerful tendency to repeat behavior patterns, a man's feelings about women reflect in some measure his attitude toward the first woman in his life. The mate he chooses, the tendency toward success or failure in love, the kind of love relations he seeks, all bear the stamp of this first love, both in its sweet and its bitter components. As we have seen, Vincent's relations with women ended in disaster. Ursula Loyer and Kee Vos-Stricker refused his love and caused him intense suffering. His association with Sien disrupted his relations with his own family; she herself proved to be completely untrustworthy, and he was forced to abandon both her and her children. His attempts to help Margot in her distress only increased the turmoil in her family and finally led to her attempted suicide. With Ursula and Kee he was in the position of a child demanding the love of an unloving mother, and with Sien and Margot he reversed this role, becoming a parent whose child could not accept the loving care he offered. In all these relationships the evidence suggests that Vincent unconsciously sought out situations that would result in disappointment and humiliation.

Although little is known about them, Vincent's unhappy alliances with women continued after he went to France. He wrote

in 1887 that he went on having "the most impossible, and not very seemly, love affairs, from which I emerge as a rule damaged and shamed and little else." [21]

One reason for Ursula and Kee becoming substitutes for his mother may have been due to the fact that, like her, they both had close ties to church religion: Ursula's father was a curate, and Kee's father and dead husband were both ministers. Kee, being his mother's niece, also shared her blood. The resemblance between Kee and his mother is intimated in the painting from Arles that was based on a memory of the garden of the parsonage at Etten; in it Vincent's mother and a younger woman are walking side by side in a garden. Although Vincent hinted that the younger woman is his sister Wil, M. E. Tralbaut has shown that she is, in fact, a good likeness of Kee, who had spent the summer in Etten with him seven years before.[22] It is remarkable that Vincent was able to recall the details of her features even though he had not seen her since then. The similarity in the appearance of the two women and the overlapping representation of their figures suggests that Vincent saw a close psychological kinship between them.

In falling in love with Ursula and Kee, Vincent was choosing partners who had committed their love to someone else, a situation reminiscent of his mother's attachment to her bereaved son. Ursula intended to marry the man she loved; Kee continued to love her dead husband. As an intruder into these loves, Vincent reexperienced the childhood situation. When he complained that Kee's love for her husband caused her to bury herself in the past and that her guilt made it impossible to transfer this love to another person, he might have been paraphrasing an explanation of his mother's attachment to the first Vincent.[23] And when he fantasied that he was united with Kee "forever and ever," [24] he was repeating an unfulfilled childhood wish to be united with a loving mother.

Meeting a sad, pitiful woman like Sien, Vincent wrote, was like meeting an apparition from his own past; it "will take your thoughts back to the period some ten or even twenty years ago, and even further back. . . . you will rediscover yourself in her, a phase of your own life you had nearly forgotten. . . ." [25] This cryptic statement may have referred to the dimly awakened memory of the unhappy mother of his childhood, characterized in the drawings of the pregnant Sien that he labeled *Sorrow*. As an adult with Sien, however, he was the rescuer, not the helpless, unloved, ignored child. The hopelessness that followed his failure with two women

who represented the "good" aspects of his religious mother provoked him to turn to a social outcast.

Sien was not the first "despised" woman "marked by fear and poverty" who had appealed to Vincent. He said that he had an old, deeply rooted feeling toward such women and recalled that even as a boy he had been attracted by one who resembled her, on whose "half-faded" face "life in its reality had left its mark." [26] In identifying such women with his mother, he could excuse her failure. She failed because she was unable to do more, not because she did not love him; the burden life had imposed on her made it impossible. This helped him repress opposing thoughts about a hateful and hated mother who resented his existence. On the other hand, his interest in women like Sien also enabled him to deride and mock his mother, as he did when he facetiously labeled a nude drawing of the bedraggled prostitute *The Great Lady*.

Sien also reminded Vincent of his childhood nurse: "Do you remember our old nurse at Zundert, Leen Veerman?" he asked Theo. "If my memory does not deceive me, Sien is that kind of person." [27] Both the nurse and the prostitute were depreciated, paid substitutes, with analogous functions. During childhood, a nurse is paid to give the child the care a mother would otherwise give freely. During adulthood, a prostitute is paid to give the sexual satisfaction that a wife would otherwise give freely. Vincent learned to accept a second-best substitute early in life, even though he longed for the original. As an adult, his longing for a mothering wife encouraged him to repeat an unhappy childhood experience with the forlorn hope of transforming it into a happy experience. When he failed with a woman who resembled his mother, he turned to one who resembled her paid substitute.

By the time he met Margot, he had accepted his fate as a man who could not even succeed in having a permanent relationship with a wretched stand-in. Margot, not he, was the one who longed to be married. And after Margot, Vincent no longer seriously ruminated about marriage. Women became incidents in his life, and art his real wife.

The contrasting themes in this art—sorrow and joy, isolation and togetherness, death and rebirth, darkness and light, earth and heaven—arose, I suggest, out of the persistant but buried memory of his childhood. He was the unhappy outsider, ignored and rejected by a grieving mother whose affection lay with the dead brother who was buried in the earth but had ascended into heaven.

In defense, the second Vincent developed an envious identification with the first, made almost inevitable by the mysterious coincidence of name and birthdate. In the fantasy of his artistic life, he alternated between depicting the depressed, unloved outsider, living in darkness, whose salvation lay in death, and the adored child, reborn on the earth or ascended into the light of heaven.

Most of the women depicted in Vincent's work are marked by sadness and tragedy, so deeply were these features of a woman ingrained into his mind. Early portraits, from The Hague, Drenthe, and Nuenen, show women with bowed heads and downcast eyes, women made ugly by the cares and sorrows of a fruitless existence. These include the two drawings and a lithograph of *Sorrow*, *Woman Weeping*, *Head of Woman: Full Face*, and *Woman with Dark Cap*. A. M. Hammacher has pointed out that many of these portraits combine features of the grieving Kee and the miserable Sien.[28]

In Antwerp, having come to terms with his inability to be intimate with a woman, he declared that he preferred painting a woman's figure to possessing it.[29] Painting her did not threaten him with the disillusionment and depression that would surely have resulted from attempting to possess her. Nevertheless her tragic countenance persisted in his canvases, as in two portraits of an Antwerp café singer (*Head of Woman: Nearly Full Face*), in which, he explained, "I tried to express something voluptuous and at the same time sad." [30]

With a few exceptions, the women he portrayed later, in France, appear to be sad, worn-out, or ugly (*An Old Arlesian Woman* and *Adeline Ravoux*), although the bright colors and the exciting background of the Provençal portraits may distract the viewer from these unhappy features. His studies of nude figures from Paris (like *Nude Woman Reclining*) must be among the ugliest and least desirable women in the history of art. At Arles he noted that the portraits of Madame Roulin (*Madame Roulin with Her Baby*, and *The Cradle*) evolved from his Dutch heads, and her face partakes of the same sadness. The portrait of the wife of the superintendent of the asylum in Saint-Rémy, he wrote, depicts "a faded woman, an unhappy, resigned creature of small account." [31] These pictures of Madame Roulin and the superintendent's wife were intended to represent middle-class women who reminded him

of suffering saints and holy women. Because "the emotions which that rouses are too strong," however, he lacked the strength to continue painting them.

Vincent perceived himself as a burden his depressed mother was forced to tolerate. His unsatisfied craving for maternal care continued to make him feel like a burden for the rest of his life, and he was forever divided between attempts to satisfy this craving and contradictory attempts to free himself from it or to take on other people's burdens. After he became an artist, his brother Theo took his mother's place as the one who tolerated him, and Vincent repeatedly accused himself of being a burden to his brother: "[I]t often makes me sad to think that I must be a burden to you again and again," he wrote from The Hague. "But who knows, in time you may be able to find someone who takes an interest in my work, who will take from your shoulders the burden which you took upon yourself at the most difficult time." [32]

Vincent drew *Bearers of the Burden* soon after he decided to become an artist. Each woman in the procession carried a heavy sack of coal on her bent back. A figure of the crucified Christ hangs from a tree in the foreground, and a spade leans against the tree, objects that recall the dead Vincent, the acme of perfection who was buried in the earth and ascended into heaven. The women bent by their heavy loads recall Mother van Gogh, who bore the second Vincent in spite of her grief, and the second Vincent himself, who became a heavy burden to her.

Vincent was attracted to women bearing burdens. The pastor, M. Bonte, saw this preoccupation in action in the Borinage: "He would squat in the mine fields and draw the women picking up pieces of coal and going away laden with sacks." [33] Vincent continued to ponder upon these women and their burdens long after he departed from the coal country. After two years of absence from the scene, he wrote, "Not without some trouble I have at last discovered how the miners' wives in the Borinage carry their sacks. . . . I often made a woman with such a sack pose for me, but it never turned out right." [34] He included a sketch of one of these sacks in the same letter and made at least twelve other studies of burdened women. (See *Miners' Wives Carrying Sacks of Coal.*)

The Vicarage Garden in Winter is one of a group of drawings in which a solemn woman garbed in black stands in a garden facing a church steeple, a steeple that is set in the midst of a cemetery; Vincent annotated it *Mélancolie.* It shows a woman with a melancholic closeness to the earth who nevertheless is preoccupied with

heaven, recalling the mother's grief for the dead son who is buried in the earth but is now in heaven.

Though Vincent does not mention it, *Peasant Burning Weeds,* a lithograph of 1883, was undoubtedly influenced by Millet's *The Angelus,* a painting that Vincent had copied three years before. The burning of weeds was the immediate stimulus for Vincent's revision of *The Angelus.* (Vincent had more than a passing interest in weed burning, for he returned to it in Drenthe.) Both *The Angelus* and the lithograph depict a man, a woman, and a wheelbarrow in a field. Considering that the lithograph is reversed from the original sketch from which it was printed, the three elements are in similar positions in both works. But there are significant differences: In *The Angelus,* the two people are standing; their heads are bowed in prayer; and the wheelbarrow is behind the woman. In the lithograph, the man is stooped over, tending the burning weeds; the woman is seated on the wheelbarrow, and her bowed head is supported by her hand. Another figure has been added to the lithograph: a youngster stands alone in the distance. The mood of thankful prayer in Millet's scene has been changed to one of quiet desperation. It is in keeping with Vincent's unconscious fixation: A woman is grieving for her dead son, ignoring the remote, isolated child. Like the first Vincent, the dead burnt weeds unite with the earth, but the fire and smoke arising from them carry their immortal spirits to heaven.

It has been found that psychiatric patients who have been reared as replacements for a dead child tend, like Vincent, to be preoccupied with death, illness, and body-mutilating accidents.[35] Like Vincent, too, they are apt to believe that they will die at an early age and have an inordinate interest in cemeteries.

When Vincent returned home in 1877 because an old friend of the family was dying, he went directly to the cemetery: "It was very early [Sunday morning] when I arrived in the graveyard in Zundert: everything was so quiet. I went over all the dear old spots, and the little paths, and waited for the sunrise there. You know the story of the Resurrection—everything reminded me of it that morning in the quiet graveyard." [36] Here, during the meditative hours of this early Sunday morning—under the sway of dawn, when the sun is reborn—he could become his brother, a reborn beloved Vincent.

No wonder, too, that cemeteries were the goal of many of his

walks and that he saw them not as receptacles for rotting bodies
but as beautiful places where living things grow out of the ground.
For example, his favorite walk in Amsterdam was to the Ooster-
begraafplaats [East Cemetery], where he would pick snowdrops,
"preferably from under the snow." [37] When his affair with Sien
in The Hague alienated him from Theo, and he wanted to arrange
a meeting to mend their differences, Vincent thought of getting
together with him in the old village graveyard.[38] A graveyard was
an ideal place for a reunion from Vincent's point of view, for it had
long stirred thoughts of reunion with another brother.

Later, in Drenthe, he found one of "the most curious ceme-
teries" he had ever seen: "Imagine a patch of heath surrounded by
a hedge of thickly grown little pine trees, so that one would think
it just an ordinary little pine wood. . . . It is very beautiful to see
the real heather on the graves. The smell of turpentine has some-
thing mystical about it, the dark stretch of pine wood border sepa-
rates a sparkling sky from the rugged earth. . . ." [39] From Drenthe,
he also reiterated the idea that everyone is equal in a cemetery:
"Like you, I have visited Père Lachaise [a famous cemetery in
Paris]. I have seen there graves of marble, for which I have an in-
describable respect. I feel the same respect before the humble
tombstone of Béranger's mistress. . . ." [40] In Nuenen not long after,
he took an opposite point of view: "And then you will say that it
is also rather tragic when a painter breathes his last in a hospital
and is buried along with the whores in a common grave. . . ." [41]
The first statement denied that he was less acceptable than the
adored first Vincent; the second faced head-on the tragedy of being
a rejected outsider.

Vincent perceived the abandoned cemetery in Nuenen as
symbolic of the unity of man and nature as well as death and re-
birth. Describing a painting he had just made of it that he called
Peasant Cemetery, he wrote: "I wanted to express what a simple
thing death and burial is, just as simple as the falling of an autumn
leaf—just a bit of earth dug up—a wooden cross. . . . And now
those ruins tell me . . . how the life and the death of the peasants
also remain forever the same, budding and withering regularly,
like the grass and the flowers growing there in that graveyard." [42]

Vincent depicted burial places even before he decided to be-
come an artist. While in Amsterdam preparing for the theological
school, he drew Sarah's tomb: "Last week I got as far as Gen. 23,
Abraham's purchase of the field around the cave of Machpelah and

the cave itself, for Sarah's burial. Involuntarily, I made a little drawing of how the place appeared to me." [43] His drawing, *Graveyard Sketch*, depicted the "curious" cemetery in Drenthe; the sketch was included in letter 325. This was followed by a series of drawings and paintings of the old graveyard in Nuenen, the same place he had wished to meet Theo to reconcile their differences. He had become obsessed with the idea of painting it two years before, while he was still in The Hague. [44]

Vincent arrived in Nuenen early in the winter of 1883–1884 and within two months informed van Rappard that a period of mild weather had enabled him to spend several days painting "the little country graveyard." [45] He returned to it again during the spring of 1885, when the old tower in the graveyard was being dismantled. [46] The de la Faille catalogue [47] contains eleven drawings and paintings of this scene (see *The Churchyard and Old Tower at Nuenen*). One is a drawing of a funeral procession.

In Paris Vincent made two drawings, almost identical to each other, of a common grave in a public burial place (see *The Graveyard*), the kind of grave he had mentioned in Nuenen, where a painter is buried with whores. These drawings are in the style of Brabant and were probably drawn early in his stay. After this, as his work brightened, the rare graveyard scenes that appear are not readily recognizable as such. The cemetery in a pen sketch of 1888 that is annotated *Cimetières de Saintes-Maries* is so far removed from the viewer that is is barely discernible. The colorful oils of *Les Alyscamps* (or Elysian Fields) in Arles depict the ancient burial ground that had been revered by the Romans and the early Christians; by 1888, however, it had long since been transformed into a place for strollers. Vincent's paintings of the Alyscamps stress life rather than death; only the empty tombs that border the path betray their kinship to the graveyard.

These direct portrayals represent only a fragment of the fascination with burial grounds that Vincent diverted into art. More significant to his work as a whole, this fascination evolved into a generalized artistic commitment to the earth. Using a variety of symbols, he elaborated the fantasies associated with his dead brother, both as a body buried in the earth and as a beloved child resurrected out of it. He was obsessed with digging, cultivating, and sowing the earth, and this obsession was translated into art. It was responsible, in part at least, not only for these subjects but for his love affair with the rich exuberance of the earth's soil, the

things inside it, and the life growing out of it. It even extended to coal mines.

While he went to the Belgian Borinage in 1878 to express his religious devotion to poor suffering people, the mines themselves and the people who inhabit them also pulled him there. Indeed, he had applied for a position as an evangelist in an English coal mine several years earlier but had been turned down because of his youth. He was attracted to this underground world "in which daylight does not exist" and to the pale, melancholic, tired, emaciated miners who worked in tiny cells, bent over or lying on their backs. These cells reminded him of "an underground prison" or "the partitions in a crypt," and, as he observed, people were buried alive in them. Nevertheless, the "pale, dim light" [48] of the miners' lamps revealed that life continued to go on there. Vincent himself risked the danger of being buried alive; once, for instance, he spent six hours 2300 feet below the surface in "the oldest and most dangerous mine in the neighborhood." He left the mines and the miners in 1880, but continued to recall them in letters from The Hague, Nuenen, Arles, and Saint-Rémy.[49]

The cellar, another place dug out of the earth where people work, also intrigued him. Once during his stay in Amsterdam, at a time when the impulse to peer into the dark interior of buildings was especially strong, he came across one: "This morning I saw a big dark wine cellar and warehouse with the doors standing open. For a minute, I had an awful vision in my mind's eye—you know what I mean—men with lights running back and forth in the dark vault. It is true that you can see this daily, but there are moments when the common every day things make an extraordinary impression and have *a deep significance and a different aspect* [italics added]." [50]

Four other remarks in the same short letter are relevant to understanding this observation: He was busy copying the whole of *The Imitation of Christ*, he had purchased some funeral orations, he referred to his "dead" friendship with the Englishman Gladwell, and he admired Rembrandt's *Men of Emmaus*. Of his friendship with Gladwell, Vincent wrote, " '[I]t is dead, but it sleepeth' and it would be good to see each other again, to wake and bring it to life again." Rembrandt's painting depicts the scene in the New Testament when Christ—his tomb now open—appeared at Emmaus arisen from the dead. Death, burial, and rebirth were then prominent in his mind, stimulated by his deep involvement with the

story of Christ. Perhaps the dark wine cellar, open like Christ's tomb and filled with life, made a profound impression on him because of this involvement. But there may be an earlier source in fantasies regarding the entombment of his brother.

Ditches and diggers were also prominent in Vincent's art (see *Peasant Digging*, and *The Diggers*, after Millet). An 1882 watercolor from The Hague, *Diggers in a Trench*, illustrates "where they are digging the sewer or water pipes." [51] Early in 1883, while searching for subjects, he found "beautiful things of workmen . . . digging a cellar and laying the foundation of a house." [52]

In *The Yellow House*, from Arles, the road in front was depicted at a time when it was disfigured by a long trench; in both the drawing and the oil he deliberately chose a perspective that exaggerated the trench. In Saint-Rémy he painted a similar trench, similarly exaggerated, in a view of the Boulevard Victor Hugo in Saint-Rémy (*The Road Menders*). In all of these scenes, the trenches are in the foreground, thrusting themselves into the viewer's gaze; this emphasis suggests that they are neither incidental nor accidental features of the composition. *Montmartre Quarry* and *Entrance to a Quarry*, from Saint-Rémy, illustrate other man-made excavations.

Shovels are found not only in Vincent's digging scenes but in other works as well; for example, a shovel leaning against the wall shares the spotlight with a melancholic human figure in *Bowed Man*. Like so many of his subjects, shovels symbolize the toil of the peasant; but they also relate to the Zundert graveyard and to the gravediggers he must have seen there.

Nonhuman objects buried in the earth also attracted his eye. In Drenthe, for instance, he discovered "some decayed oak roots, so-called bog trunks (that is, oak trees that have perhaps been buried for a century under the bog, from which new peat has been formed; when digging it up these bog trunks come to light). . . . That pool in the mud with those rotten roots was completely melancholic and dramatic. . . ." [53] *Landscape with Bog Trunks* illustrates one of these bogs, and *The Peat Boat* shows peat being transported from it. Here were living objects that had died, were buried, and then came back to light; transfigured, they now had a life of their own, like the metamorphosis of the beetles and worms he wrote about and like his own fantasied rebirth.

The cultivation of the potato, another object that is buried in the earth, was a frequent subject of Vincent's Dutch works, and he portrayed the potato in still-lifes. (See *Still Life: Potatoes*.) In

The Potato Eaters, the potato and the poor peasants who live off it almost merge into one; indeed, he wrote that the painting itself was "like the color of a very dusty potato."

His fascination for the buried dead encompassed man-made objects, too. He was fond of some broken street lamps and other discarded objects that he recovered from a "beautiful" garbage dump in The Hague, and got them, as he put it, "to pose for me." [54] He brought them out of their burial place "rusted and twisted," endowed them with human attributes, and gave them a new useful life.

The 1883 sketch of the Drenthe graveyard contrasts with a landscape from Auvers, *View Across the Oise.* The graveyard sketch is dark, its scale is small, and its mood is melancholic. In contrast, the Auvers' landscape is colorful, its scale is grand, and its mood is joyous. But the two works also share some similarities: Both contain plots of land—burial plots in one and farm plots in the other. Both have tall trees in the distance, similarly placed. A church steeple rises in the center beyond the trees in the dark cemetery sketch, while the colorful landscape contains a red vertical spire in the same area, tenuously related to the long low building with a red-striped roof. These similarities suggest that Vincent's French landscapes, especially those of the plains of La Crau (*La Crau Seen from Montmajour* and *Harvest*) and the fields near Auvers (*View Across the Oise*) are transformed graveyards.[55] If true, they are the most eloquent transformations in his work. By magic, Vincent transformed a dark, unhappy scene based on dark, unhappy memories into a bright, happy one.

Comparing drawings of de Groux and Boughton, Vincent remarked, "I was struck by the resemblance, as of two brothers who had never met and who were yet of one mind." Without knowing it, he had discovered ready-made in the depths of his own mental processes the material for this comparison. For in his fantasy he was a reembodiment of his buried brother; the two were, indeed, "of one mind." Vincent once wrote, "In these days, I believe, Jesus himself would say to those who sit down in a state of melancholy, 'It is not here, get up and go forth. Why do you seek the living among the dead?' " [56] He was not only referring to the need for modern man to find new ways, but was also thinking of his own attempts to rid himself of melancholy. Feeling dead and alone, while his buried

brother seemed alive and adored, Vincent had sought love and happiness by becoming one with him.

Vincent's writings themselves hint that he retained an image of his dead brother. Although he probably was not aware of it, it sometimes pressed close to consciousness, as during the period surrounding his ear mutilation. In December 1888, immediately preceding this episode, he and Gauguin visited the Fabre Museum in Montpellier, fifty miles west of Arles. There he was struck by a portrait of Alfred Bruyas by Delacroix, painted in 1853, the year of Vincent's birth. Like Vincent and Theo, Bruyas had red hair and a red beard, and Vincent saw an extraordinary resemblance between Bruyas and them. He informed Theo that "one must boldly believe that *that what is is,* and Delacroix's portrait of Brias [sic] resembles you and me as if he were a new brother." [57] The portrait made him think of a poem by de Musset: "Partout où j'ai touché la terre—un malheureux vêtu de noir, au près de nous venait s'asseoir, qui nous regardait comme un frère. [Wherever I have touched the earth— an unfortunate man dressed in black would sit down close to us, one who looked upon us as a brother.]" He also told his doctors about this likeness, adding that he was merely continuing in the South the work that Bruyas had begun—a cryptic observation considering that Bruyas was a collector of art, not an artist. [58] Vincent continued periodically during the rest of his life to refer to the importance of Bruyas to him and to art.

The Delacroix portrait, still hanging in the Montpellier museum, shares the red hair, maybe even the facial features of the van Gogh brothers. But Bruyas is not "dressed in black" nor does he appear to be an "unfortunate." Rather, he is elegantly garbed, his appearance is congruous with Vincent's description of him as a "benefactor of artists," and his reserve suggests he is not about to sit close to anyone. Vincent's associations to the portrait, while stirred by a cursory resemblance and, perhaps, his brotherly association with the older Gauguin, had their basis in old unconscious ideas about the real other brother who was dead and buried—"un malheureux vêtu de noir."

When he was hospitalized following the self-mutilation, he thought of his childhood home in Zundert and of the nearby cemetery where his brother was buried—the place that had previously reminded him of the Resurrection. He ended his recollection with a seemingly insignificant childhood memory: "a magpie's nest in a tall acacia tree in the graveyard." [59] This kind of clearly per-

ceived detail has the earmarks of a screen memory, that is, a memory selected because of its proximity or its resemblance to a significant memory that is too painful to recall. The magpie is a cousin of the crow, the symbol of death that Vincent painted shortly before he killed himself and—unlike Bruyas—is "dressed in black." Perhaps the magpie high in the tree refers to the dead body that is buried beneath it, now risen into the sky; later I shall suggest that it also refers to another painful memory.

Vincent added, "It's because I still have the most primitive recollections of those first days than any of the rest of you. There is no one left who remembers all this but Mother and me. I say no more about it, since I had better not try to recover all that passed through my head then." These early memories—disturbing thoughts associated with the cemetery and the Vincent van Gogh who was buried in it—seem to have pressed toward consciousness during his psychotic state, and now he wished they would remain in limbo.

The cemetery in Zundert reminded Vincent of the Resurrection because in fantasy he was the resurrected Vincent. Like his perception of Bruyas, he felt he was of one mind with a brother he had never seen. Becoming the resurrected Vincent was an attempt to replace the other Vincent—the repulsive, bad, ugly Vincent, responsible for his brother's death and his mother's grief. Having defensively taken in this goodness and made it a part of his own self-image, he (or part of him) became good, beloved, and beautiful, even though the original image remained with him too. While Vincent's propensity to depict pairs grew out of his frustrated longing for closeness, it had another source in this double self-image. The countless human couples, tree couples, and object couples in his work reflected it; many of them fuse with each other, just as Vincent wished to fuse with his brother.

Vincent made three copies ("translating them into another tongue," [60] he wrote) of a painting of Millet, *The Diggers;* the first two were drawings from his artistic beginnings, and the third was an oil from near the end of his life. While all of Millet's peasant paintings appealed to him, this one had a special significance. It depicts two men who are similar in appearance, side by side, digging a ditch; the double image is joined with a symbol of the grave that linked one Vincent to the other.

The frequency of such twinning and of fused pairs suggest that

they were (among other things) an artist's way of depicting the "double"—the German *Doppelgänger*. The double, a phenomenon known from ancient times, is a ghostly replica, something like a mirror image or shadow that exists as a transient hallucination, an abstract idea, or a fantasied companion.[61] Its existence may be confined to the unconscious, revealing itself only indirectly—in dreams, in creative works, or in the free associations of psychoanalysis. The magical thinking that is common to children and the unconscious mind constructs the double as a means of denying fears of being destroyed and of dying. It becomes equated with ideas of immortality and the soul. Going through life conceiving of oneself as a combination of body and soul has as its goal a final fusion in death and immortality. The mysterious circumstances of Vincent's birth no doubt reinforced this kind of magical thinking.

Road with Cypress and Star has three pairs of doubles. Two people are seated in the cab of a horse-drawn vehicle in the distance, two are walking shoulder to shoulder in the foreground, and two tall cypresses alongside the road disappear into the sky between the "slender crescent" of the moon and a star of "exaggerated brilliance." The two trees fuse into one; only the base of the trunks reveals they are two. The scene of the road and the people on it resemble some other pictures from Saint-Rémy that represent a solitary pilgrim on his way from earth to heaven. But in *Road with Cypress and Star* there are two instead of one. Together, the two Vincents form a unity endowed with magical qualities and immortality. Vincent and his double travel through life's journey together, and in death—symbolized by the cypress trees—ascend to a distant star. Vincent's own remarks indicate he knowingly depicted heaven in this way: "Why, I say to myself, should the shining dots of the sky be less accessible than the black dots on the map of France? Just as we take the train to get to Tarascon or Rouen, we take death to reach a star." [62]

In *The Drawbridge*, a woman holding an umbrella stands in the center of the bridge. The canal beneath it is analogous to the road in *Road with Cypress and Star*. Like the fused cypresses on the side of the road in the latter, a pair of cypresses reaches into the sky from the canal bank. Too, the curve of the umbrella repeats the curve of the cab roof in *Road with Cypress and Star*. Viewed from the standpoint of his unconscious fixation, both paintings symbolize Vincent and his double, born from the same womb and the same birth canal, united as they will be in heaven.

Vincent had a special interest in Dickens' two Christmas ghost stories, *A Christmas Carol* and *The Haunted Man*. He pointed out that he had "reread these two 'children's tales' nearly every year since I was a boy, and they are new to me again every time." [63] Both Marley's ghost who appeared to Scrooge in *A Christmas Carol* and the ghost who appeared to Redlow in *The Haunted Man* were doubles, and both were responsible for rejuvenating these melancholic men. This is what Vincent desired from his own double.

As an outgrowth of the magical thinking associated with the double, Vincent developed an affinity for ghosts. In *The Vicarage Garden*, mentioned in Chapter 1, the human pairs have a ghostly quality, similar to many other works of his dark period (e.g., *Miners*). He perceived a woman like Sien as an "apparition" with a "pale face." [64] The people spreading or repairing nets on the beach at Scheveningen in *Mending the Nets* were "sitting or standing or walking around like dark fantastic ghosts." [65] In a drawing of a weaver at the loom from Nuenen, he called the weaver a "goblin or spook." "When I had finished drawing the apparatus pretty carefully, I thought it was so disgusting that I couldn't hear it rattle that I let the spook appear in it," an addition that made the picture "more haunting." [66] Conceiving of portraits as a means of rendering himself and his subjects immortal, he wrote, "I should like to paint portraits which would appear after a century as apparitions to the people living there." [67]

If we are to believe Paul Gauguin, Vincent called himself a ghost shortly before he mutilated his ear—perhaps in jest, more likely during a psychotic state. Gauguin reported that Vincent wrote on the wall of the Yellow House:

> *Je suis Saint Esprit.*
> *Je suis sain d'esprit.*
>
> [*I am the Holy Ghost.*
> *I am healthy of spirit.*]

Perhaps the tie between the two Vincents is represented in a different way in *Vincent's Chair*. The chair, "my own empty chair," stood for himself as well as for death. The yellow planting box in the corner of the room inscribed with the signature "Vincent" may represent the buried Vincent. Boxes in other works, such as the half-buried box in *Boats on the Beach* that are also signed "Vincent," may refer to the same idea. If this is true, the flowers growing out of the box represent his rebirth. The legs of the

chair are placed on the mortar lines of the floor that connect it to the yellow box. In this way the two Vincents are tied together in a mutual interplay of death, burial, and resurrection.

Vincent's work in the North had culminated in *The Potato Eaters*, a "composition of those peasants around a dish of potatoes." [68] More study went into this painting than any other in his career. After a long series of preliminary studies of heads and hands, he made a rough sketch in March 1885, a preliminary oil in April, and the definitive version in May. He had mastered the model and the scene so well that he painted this last version from memory; "[T]he thing is so fixed in my mind," he wrote, "that I can literally dream it." In contrast to Vincent's usual humility about his work, he had no qualms about praising *The Potato Eaters*. Looking back on his achievements more than two years later, he called it "the best one after all." The scene so fascinated him that he returned to it again in Provence. *The Potato Eaters* was the focus of all his energy, talent, and hope—a situation suggesting that it depicted a central issue in his life.

The painting was a sermon on the unjust treatment of the peasant by the Dutch ruling class and an ode to the former's endurance. It was a stirring commentary on the difficult role of the peasant, a man like himself who suffered, lived in darkness, bore heavy burdens, and received few rewards on earth. While the painting depicts a family group seated around a small table united by the rays of a single lamp above them, their closeness is only physical. Emotionally, they are remote from each other, unable to communicate. Vincent identified himself with these coarse peasants, with their suffering and their isolation. Meyer Schapiro observes that "each figure retains a thought of its own and two of them seem to be on the brink of an unspoken loneliness." [69] He attributes this effect to the difficulties involved in copying the heads from earlier portrait studies. Yet this same sense of isolation is common to many of Vincent's Dutch works, where it cannot be explained away solely on technical grounds. A wall separates the woman on the right from the rest of the family—Professor Schapiro says that it "creates a strange partition of the inner space"; I have suggested that Vincent often used such partitions to portray a feeling of isolation.

Such are a few of the messages conveyed by *The Potato Eaters*.

But these same messages are contained in other van Gogh pictures; they do not account for the elaborate detail. Preliminary studies were sketched at the hut of the de Groot family, and the family posed for them. The painting itself, however, was done in his studio, using his memory and imagination. The sketches drawn directly from the models were "food for one's imagination," he wrote, "but in the painting I give free scope to my own head." [70] Such freely elaborated thinking, like the content of dreams, has roots both in the present and in the distant past, and is derived from conscious as well as unconscious thoughts. Vincent began his work on the painting immediately after his father's death.* While he spent the winter preparing for a peasant picture, he nowhere indicated that he had chosen the subject of the potato eaters until this time. Perhaps the renewed confrontation with his mother's grief reactivated memories of the childhood situation.

If we look at *The Potato Eaters* from this point of view, the younger man on the left represents Vincent: the name "Vincent" is inscribed on the top slat of the back of his chair, although it is difficult to make out. The older woman on the right represents his mother. Her head is bowed, seemingly because she is intent on pouring coffee. But it is modeled from the melancholic heads that Vincent had been drawing in preparation for the painting. The act of pouring coffee diverts attention from her downcast expression; at a deeper level, melancholy accounts for her inability to show interest in those around her. The goggle-eyed "Vincent" gazes at her, vainly trying to make contact.

The enigmatic figure of a child in the foreground—faceless and ethereal—stands between Vincent and his mother. No chair is visible, and the child—a ghostly presence, not a flesh and blood human being—is obviously not partaking of the meal. Curiously, steam arises from only one side of the plate, forming an aureole that envelops the child's head and shoulders. It would seem that Vincent was portraying the grieving mother who could not mother him; her spirit remained with the dead but perfect child who stood between them, separating them in the painting as in life.

The two other members of the family, seated in the rear, are secondary figures, not essential to the theme, perhaps added to focus

* The first letter to Theo after the father's death is numbered 397. Vincent first mentions "those peasants around a dish of potatoes" in the following letter, which begins, "I am still greatly under the impression of what has just happened. . . ."

attention on the two protagonists on whom their attention is fixed. Indeed, only the three foreground figures are present in a preliminary sketch. In a preliminary version in oil the younger woman is omitted and the father is but a disembodied head. In the definitive version the younger woman, gazing toward Vincent, is on his side; perhaps she represents his sister Wil, for Wil was the only sister who was on his side. The father is on the mother's side (indeed, Vincent often saw them on the same side), although he is isolated from her by the partition and his own vague remoteness in the background; he is making her an offering that she cannot acknowledge.

The situation is sad and apparently hopeless. But a crucifix, similar to the one in *Bearers of the Burden*, hangs in the murky atmosphere above Vincent's head. Hope lies here, in this hint of his identification with Christ. Indeed, the iconography of *The Potato Eaters* may have been influenced by Vincent's frequently expressed admiration for Rembrandt's *Christ in Emmaus*. In it, the risen Christ sits at a table; the others gaze with awe upon him. Vincent praised the "deeply mysterious" quality of Rembrandt's painting. In it he saw a "soul in a body," and a "tenderness of gaze," [71] and these are the qualities that he carried into his own picture.

It is interesting to compare *The Pietà* of 1889 with *The Potato Eaters* of 1885. *The Pietà*, based on a painting of Delacroix, depicts the dead Christ lying in the entrance of a cave. His grieving mother stretches out her arms toward him in a "large gesture of despair";[72] because he has suffered and died, she shows him her love. The contrast between the two heads causes them "to seem like one somber-hued flower and one pale flower, arranged in such a way as to intensify the effect." Death and grief were on Vincent's mind at the time he painted *The Pietà*. He had just painted *The Reaper*, the one in yellow that he called "the image of death," and a self-portrait in which he pictured himself "thin and pale as a ghost." [73] He was also concerned about his mother's grief, then occasioned by the loss of her last son, Cor, who had gone off to South Africa.

The red-headed, red-bearded Christ of *The Pietà* shares the same brilliant colors, the same pathos, the same shadow effects as the ghostly self-portrait. While the crucifix above Vincent's head only hints at his identification with Christ in *The Potato Eaters,* he has become Christ in *The Pietà*. Even as the somber hues of *The Potato Eaters* have been replaced by the brilliant blues and yellows, the

downcast rejecting mother has been replaced by the adoring mother and the live rejected son had been replaced by the dead adored son. A haloed self-portrait painted shortly before *The Pietà* reveals that the red-haired Christ is also Vincent. Anticipating the death he is soon to bring upon himself, Vincent proclaims once again that it is better to be dead than alive, for death is the prerequisite for a state of perpetual bliss in which a good mother loves her adored child.

The unconscious, according to psychoanalysts, conceives of death as the "good sleep" of a baby following a satisfying feeding or as a state of happiness in which the dead one is united with a good mother.[74] Martin Grotjahn writes, "The unconscious may not know death but it knows peace and sleep and longs for reunion with mother." [75] This is the latent meaning behind much of Vincent's art, perhaps most obvious during the last year of his life when his brush strokes move ecstatically into the heavens. For it is in heaven where this happy reunion will occur. *Landscape with Olive Trees,* for instance, painted at about the same time as *The Reaper* and *The Pietà,* continues the theme of death and a mother's love: The cloud in the sky, toward which anguished trees are reaching, resembles "a wraith-like mother and child," [76] according to Professor Schapiro. In a picture sketched just before Vincent killed himself, a man stands on a roof-top as a breast-shaped cloud formation awaits him in the sky above. (See *Thatched Roof with Man on Top.*)

6 Our mother who
art in heaven

VINCENT'S NEED FOR love had found no satisfactory response in his mother; his rejection by Ursula Loyer shortly before visiting his parents in July 1874 repeated the childhood situation and provoked a return of his childhood depression. Mrs. van Gogh-Bonger described the change observed by the family: "With this first great sorrow his character changed; when he came home for the holidays he was thin, silent, dejected—a different being." [1] Upon returning to London, he moved away from the Loyers, lived by himself, and saw no one. From his seclusion, he vented the grievance of many bewildered men who have been disappointed in love: "That a woman is 'a totally different being' from a man, and a being we do not know yet, at least only quite superficially. . . ." He had not given up hope, however, for he also observed that "a man and a woman can be one," [2] a wish he later expressed in pictures of overlapping, fusing couples.

For a while he clung to the French historian, Jules Michelet—romantic revolutionary, critic of clergy and Church, champion of the oppressed, lover of nature, and self-appointed expert on the art of handling women. Michelet became a deity whose writings were "a revelation and a Gospel" [3] that could heal his wounds. But Vin-

cent soon turned against his idol, although he still agreed with Michelet's liberal political and social views. The latter's interest in women had become incompatible with the young man's newly found solution to his sadness: The inordinate intensity of feeling that had sought an outlet in the unrequited love of Ursula Loyer was now transformed into a fanatical preoccupation with God.

On May 8, 1875, in the conclusion of his last letter from London before being transferred to the Paris branch of Goupil and Company, he quoted the French philosopher and historian, Renan: "To act well in this world one must sacrifice all personal desire. . . . Man is not on earth only to be happy nor even to be simply honest. He is there to realize great things for humanity, to attain nobility and to surmount the vulgarity of nearly every individual."[4] He thus transformed his loss into a benefit, a variety of mental gymnastic that he put to use later in his art. Besides, in giving up the idea of personal happiness on earth, he was sustained by the faith that asceticism and ministering to unfortunate humanity would qualify him for the joys of heaven.

Religious asceticism and martyrdom formed the theme of much of his correspondence from this time until 1880, when he decided to become an artist. Exercising a selective vision for Bible passages concerned with sorrow, suffering, and self-denial, he wrote, "Let us ask of Him that He teach us to deny ourselves, to take our cross every day and follow after Him; to be gentle, long-suffering and lowly of heart."[5] Vincent had hoped to achieve a relationship with Ursula that had been denied him by his mother; when she failed him, he renounced worldly desires and displaced his frustrated longings to God. Through helping the unfortunate and directing his suffering into the service of God, he hoped that God in turn would make up for the failure.

Vincent followed Christian tradition when he referred to God as the Father, but the image of God he portrayed in his letters (and in his art as well) was more often that of an idealized, loving mother who, through devoted care, brought joy to humanity. To obtain this love, however, earthly pleasures had to be disowned and suffering glorified. These ideas grew out of his unhappy childhood, which, coupled with his Calvinistic heritage, helped set the pattern for his personal understanding of The New Testament. A rambling letter, written at the height of his religious fervor, shows how God became Mother: "This Charity is Life in Christ, this charity is our Mother; all the good things of the earth belong to Her, for all is

good if enjoyed with thankfulness, but She extends much further than those good things of the earth. To her belongs the draught of water from a brook on a hike or from a fountain in the hot streets of London or Paris, to Her belong also 'I shall make thy bed in sickness,' 'as one whom his mother comforteth, so I will comfort you,' and to Her belongs: 'Constancy unto death toward Christ, who giveth us the strength to do all.' " When the real mother has failed to do her job, the Mother God takes her place: " 'Can a woman forget her suckling child, that she should not have compassion on the son of her womb? Yea, they may forget, yet I will not forget thee.' " The Lord also takes the place of those later loves who have disappointed him: " 'All thy lovers have forgotten thee. I shall restore health unto thee, and take the plagues away from thee.' " He repeated for the second, and then for the third time: " 'As one whom his Mother comforteth, so I will comfort you, saith the Lord.' " [6]

Vincent was not merely a passive worshipper, appealing to God through an exhibition of helpless suffering: he actively helped the poor, the oppressed, and the sick. In this way he treated others as he wished he had been treated in the past and as he wished God to treat him in the future. He became, in effect, a loving mother who nursed, fed, and brought happiness to unhappy children in spite of her own suffering. Like his good Mother God, he cared for suffering humanity, with whom he also identified himself; but at the same time he found an outlet for his compulsion to punish and debase himself.

A story from George Eliot's *Scenes from Clerical Life*, called "Janet's Repentance," may have helped Vincent to tie together some of these ideas. The story, which touched him deeply, as he related in a letter dated February 19, 1876, concerned a clergyman who lived in squalid surroundings, had little to eat, and died at the age of thirty-four. He was nursed by a drunken woman who, through his teaching and ministrations, had "conquered her weakness and found rest for her soul." "At his burial," Vincent wrote, "they read the chapter which says, 'I am the resurrection and the life; he that believeth in Me, though he were dead, yet shall he live.' " [7] The life that Vincent was to lead followed a similar pattern. The squalid surroundings, the lack of food, the debauched woman whom he tried to rehabilitate and who in turn was expected to care for him, the early death, and the preoccupation with resurrection—all were in it. In itself, of course, the story did not cause Vincent to

live this kind of life, but it may have given form to a latent mental configuration in the same way that contemporary events give form to dreams that have their roots in childhood.

There was another reason for Vincent to become a missionary who helped unfortunate people: It enabled him to carry out an identification with Christ.

Vincent, like many Christians, saw Christ in himself and himself in Christ. His identification with Christ became apparent after he was rejected by Ursula, but its component parts were already present, waiting only the pressure of fate to assemble them into a functional unit. As the son, the grandson, and the nephew of Christian ministers, he was forever admonished to lead the life of Christ. From his earliest years he must have perceived that suffering was a characteristic they both shared. But there was a difference in the results of their suffering. Vincent's suffering was ignored by a grieving mother, while Christ's brought him the love of a grieving mother as well as the Christian world. Another aspect of his life made it easy for Vincent to find a resonant chord in the story of Christ: As the second Vincent, he regarded himself as a special person, miraculously resurrected from the dead. It should be noted that this kind of "imitation" takes place mainly in the unconscious, and that to be Christlike from the standpoint of the unconscious may be altogether different from knowingly imitating Christ.[8] Some aspects of Vincent's identification with Christ will be obvious enough, while others may seem anything but Christlike to the casual observer.

Vincent's perception of Christ reflected the kind of person he himself wished to be and, in large part, was. In 1875 he said, "Let us ask of [Christ] . . . that He teach us to deny ourselves, to take our cross every day and follow after Him; to be gentle, long-suffering and lowly of heart."[9] Under a print hanging in his room in Dordrecht, he wrote, "Take my yoke upon you, and learn of me; for I am meek and lowly in heart. . . . if any man will come after me, let him deny himself and take up my cross and follow me—in the Kingdom of Heaven they neither marry, nor are given in marriage."[10] Most of all Vincent saw himself as the Christ who was "the man of sorrows, and acquainted with grief."[11] He appealed to God by exhibiting himself in another guise of Christ: "[Y]ea, if we could make ourselves a crown of the thorns of life,

wearing it before men and so that God may see us wearing it, we should do well." [12] He wanted to follow the advice he gave the poor Belgian coal miners: "In imitation of Christ man should live humbly . . . learning from the Gospel to be meek and simple of heart." [13]

An identification restricted merely to Christ's suffering and self-denial would have served no useful purpose in Vincent's psychic economy: Only the love that the suffering Christ received from his mother and the admiration he received from mankind could relieve his hopelessness. Through Christ, for example, he could resolve the problems that lay behind the contrasting themes of his youthful sermon. He could remain aloof from his fellows, yet feel loved by all. This minimized the discomfort of loneliness and avoided the taint of being a rejected outsider. As an awesome figure, he was alone, but alone on a pedestal; he became an outsider because of strength, not weakness. Out of sorrow Christ brought joy to the world—and, through the love of the *mater dolorosa* and the "Angels of God" [14]—to himself as well. So could Vincent. As another Christ, death became a passing event that heralded a joyful resurrection. Darkness was eliminated: Christ was "the light of the world," and Vincent could bask in his glory.

The identification with Christ took on different forms at different times to fit the needs of the moment. Chronic sadness and the compulsion to seek punishment could be justified internally and exploited externally, for Christ suffered and was crucified for the good of mankind, and he was in turn loved by mankind. In this way, masochism was converted into martyrdom, and his feared sexual and destructive impulses could be diverted into righteous paths. The lack of appetite associated with depression and the self-imposed dietary restrictions that may have arisen from fears of angry cannibalistic impulses were transformed into the response of a saintly ascetic. Failure in sexual fulfillment could be pushed aside, since Christ was seen as sexless. The figure of Christ was a ready-made mask of goodness behind which he could hide the badness he felt inside, thereby appeasing a conscience steeped in the ways of Calvinistic orthodoxy. As Christ, Vincent not only could compete with his dead brother; he could outdo him. When he became disillusioned with his father, he could consider his father a Pharisee and surpass him as a man of God. The figure of Christ both helped to shape his symptoms and became a blueprint for shaping his life's work.

Vincent led the Christ life (or, rather, his own perception of it) in England as a teacher (1876), in Dordrecht as a bookseller (1877), in Amsterdam as a student (1877–1878), and in the Borinage as an evangelist (1878–1879); its manifestations have been discussed by the Dutch psychoanalyst, Westerman Holstijn,[15] as well as others. In preparation for this life he renewed his acquaintance with Christ by reading the New Testament over and over again, even translating it into various languages. Beginning with his return to London in 1875, his letters were filled with references to it.

His second most treasured book at the time was *The Imitation of Christ,* a product of the German-Dutch mystical school of the fifteenth century that focuses on the renunciation of worldly desires and the need to suffer, rather than on the active aspects of Christ's life. He gave copies of it to his brothers and sisters, even to his Jewish teacher, Mendes da Costa. He pointed to II Corinthians 5:17: "Therefore if any man be in Christ, he is a new creature; old things are passed away; behold, all things have become new." [16]

While teaching in England, Vincent never skipped a day without praying, speaking about God, and reading the Bible with his students.[17] He sought to become a combination of teacher, clergyman, and missionary who helped the poor and the oppressed; like Christ he, too, could tolerate "the thorns which have pricked me." [18]

In Dordrecht, where he had been hired to help in a bookstore, his energy was devoted to working through the entire story of Christ, "in all places and circumstances," [19] and these thoughts made his loneliness and suffering more tolerable. As Christ, Vincent could take pride in his strange behavior, for Christ, he pointed out, was also accused of being a strange man.

In Amsterdam, according to Mendes da Costa, Vincent belabored his back with a cudgel whenever he felt he had neglected his duty; [20] it seems as if he was reenacting the beatings suffered by Christ on the way to Calvary. More relevant to his future as a creative person who did not have to cling to convention, Vincent came to regard the theological faculty of the University of Amsterdam as a group of Pharisees and himself as Jesus pointing the finger of scorn at their sin and hypocrisy. Disillusioned and discouraged, he became convinced that the preparatory studies required of students bore no relationship to their goal of ministering to humanity and were foisted on them by the antichrists of Dutch theology. Because his courses came to symbolize all that he opposed, it is not surprising that he failed them.

Plate 1

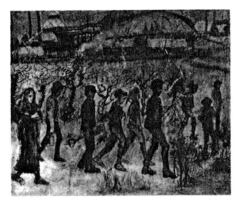

MINERS

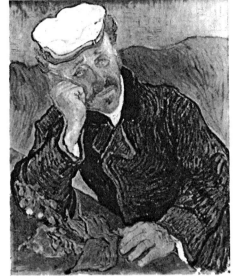

DR. GACHET

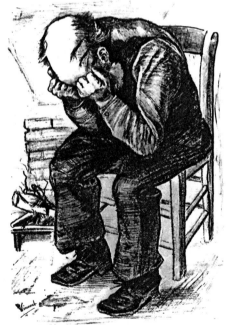

WORN OUT: AT ETERNITY'S GATE

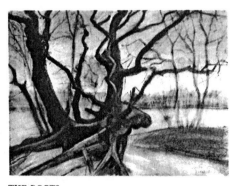

THE ROOTS

Plate 2

POLLARD WILLOW BY THE SIDE OF THE ROAD

THE WHITE HORSE

TREES

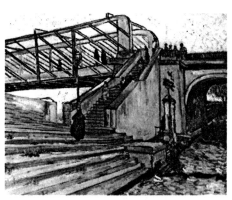

THE IRON BRIDGE AT TRINQUETAILLE

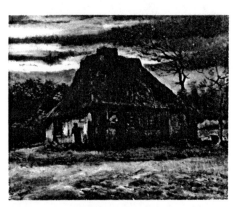

THATCHED COTTAGE AT NIGHTFALL

Plate 3

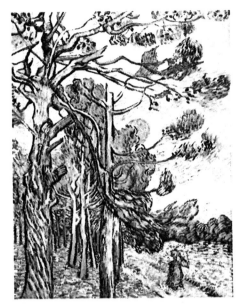

PINE WOODS

MENDING THE NETS

A FACTORY

LANDSCAPE WITH POLLARD WILLOWS

WILLOWS WITH SHEPHERD
AND PEASANT WOMAN

Plate 4

GIRL IN THE WOODS

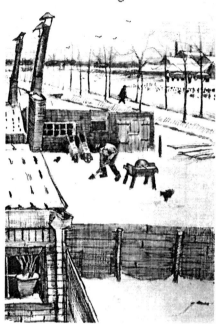

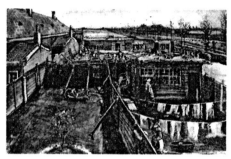

VIEW FROM THE ARTIST'S STUDIO WINDOW

VIEW FROM THE STUDIO WINDOW
IN THE SNOW

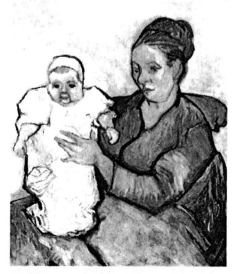

MADAME ROULIN WITH HER BABY

Plate 5

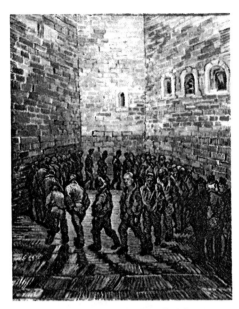

THE PRISON COURTYARD (*after Doré*)

THIRD-CLASS WAITING ROOM

LA GUINGETTE

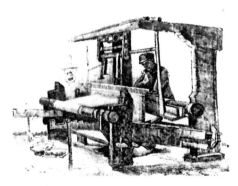

THE WEAVER

Plate 6

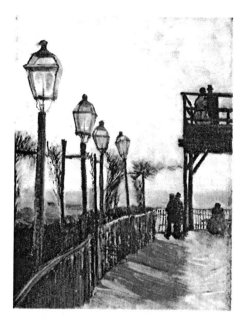

MONTMARTRE

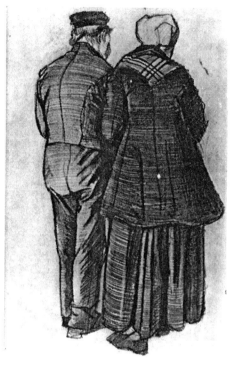

THE OLD COUPLE

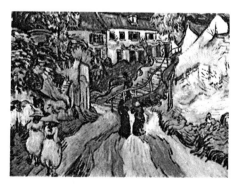

THE STAIRS

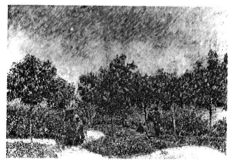

PARK AT ASNIÈRES

Plate 7

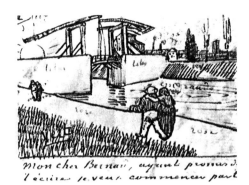

SKETCH OF DRAWBRIDGE

THE LOVERS

NOON: REST FROM WORK (*after Millet*)

THE POET'S GARDEN

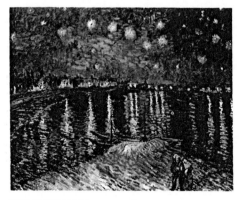

THE RHONE RIVER AT NIGHT

THE VICARAGE GARDEN

Plate 8

PARK ALONG THE FENCE

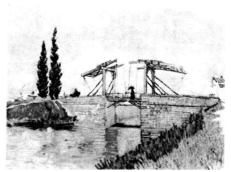

THE DRAWBRIDGE

ROAD WITH CYPRESS AND STAR

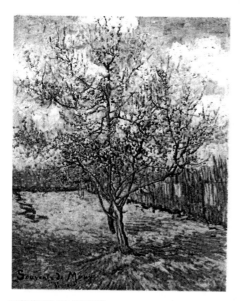

SOUVENIR DE MAUVE

Plate 9

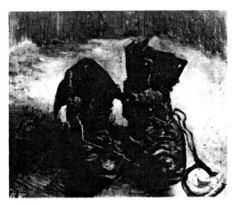

A PAIR OF SHOES

TWO RATS EATING

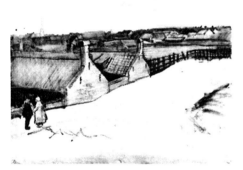

BARNS AND HOUSES AT SCHEVENINGEN

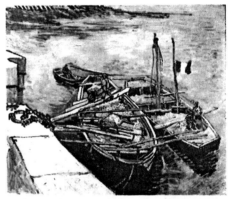

SANDBARGES UNLOADING

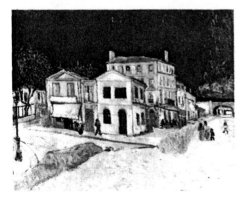

THE YELLOW HOUSE

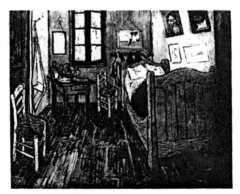

THE BEDROOM

Plate 10

TREE WITH IVY AND STONE BENCH

THE CORPSE

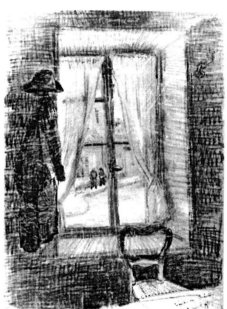

THE WINDOW AT BATAILLE'S

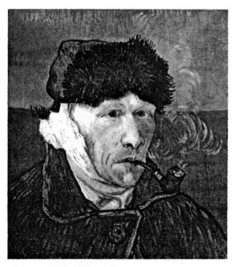

SELF-PORTRAIT WITH BANDAGED EAR

Plate 11

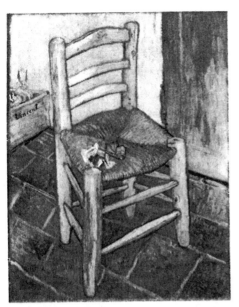

VINCENT'S CHAIR

THE REAPER *(after Millet)*

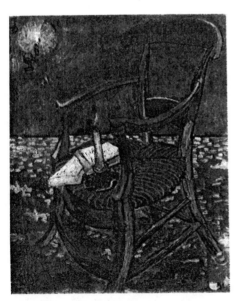

GAUGUIN'S CHAIR

HAYSTACKS IN PROVENCE

Plate 12

MAN WITH BANDAGE OVER LEFT EYE

THE ONE-EYED MAN

THE GOOD SAMARITAN (*after Delacroix*)

Plate 13

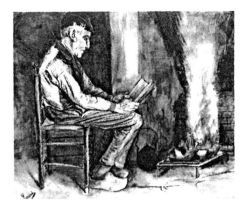

PEASANT READING BY THE FIREPLACE

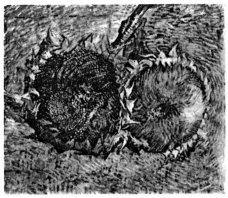

TWO SUNFLOWERS

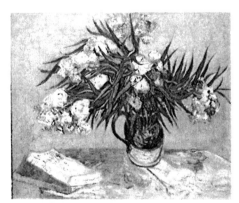

OLEANDERS

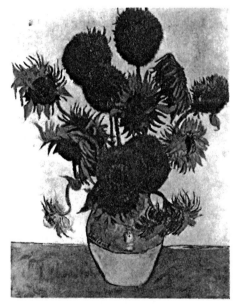

SUNFLOWERS

Plate 14

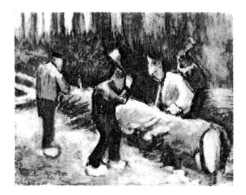

THE WOODCUTTERS

BABY IN CRADLE

THE GARDEN OF SAINT-PAUL'S HOSPITAL

SIEN SUCKLING HER CHILD

Plate 15

THE CRADLE

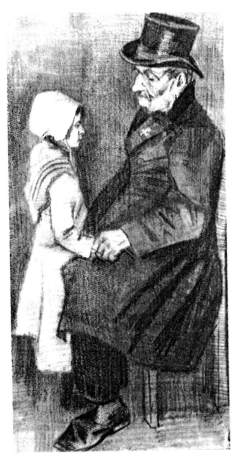

OLD MAN WITH A CHILD

Plate 16

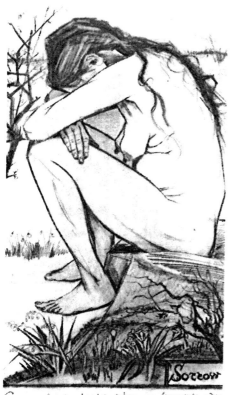

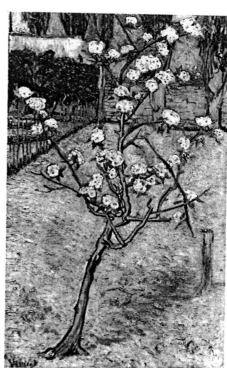

THE BLOSSOMING PEAR TREE

SORROW

Plate 17

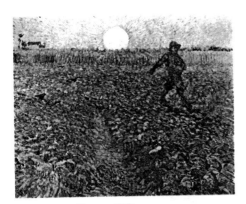

THE SOWER (*June 1888*)

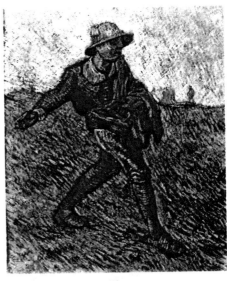

THE SOWER (*after Millet*)

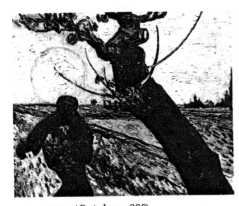

THE SOWER (*October 1888*)

Plate 18

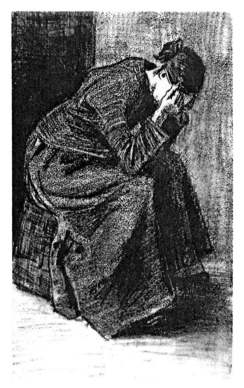

WOMAN WEEPING

WOMAN WITH DARK CAP

HEAD OF WOMAN: FULL FACE

Plate 19

HEAD OF WOMAN: NEARLY FULL FACE

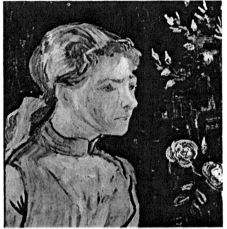

ADELINE RAVOUX

NUDE WOMAN RECLINING

AN OLD ARLESIAN WOMAN

Plate 20

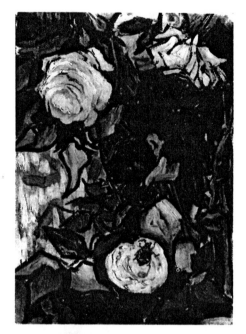

ROSES AND A BEETLE

Tombstone of the first Vincent van Gogh, Zundert

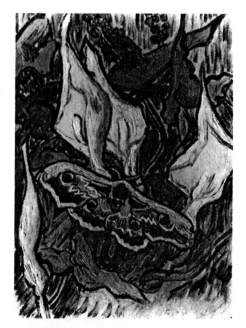

DEATH'S-HEAD MOTH

THE BIBLE AND THE JOY OF LIFE

Plate 21

BEARERS OF THE BURDEN

PEASANT BURNING WEEDS

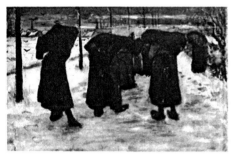

MINERS' WIVES CARRYING SACKS OF COAL

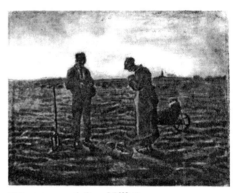

THE ANGELUS *(after Millet)*

Plate 22

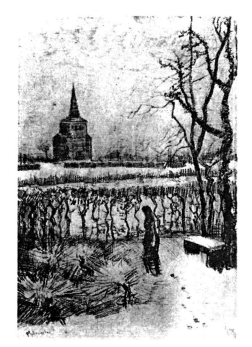

THE VICARAGE GARDEN IN WINTER

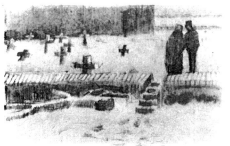

THE CHURCHYARD AND OLD TOWER
AT NUENEN

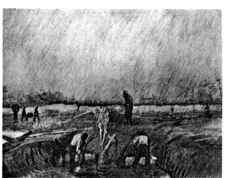

THE GRAVEYARD

GRAVEYARD SKETCH

LES ALYSCAMPS

Plate 23

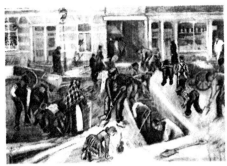

DIGGERS IN A TRENCH

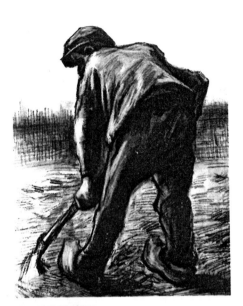

PEASANT DIGGING

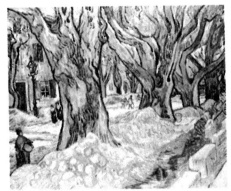

THE ROAD MENDERS

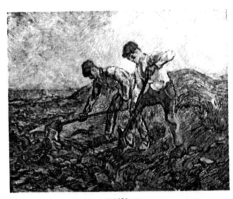

THE DIGGERS (*after Millet*)

MONTMARTRE QUARRY

Plate 24

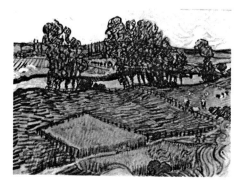

VIEW ACROSS THE OISE

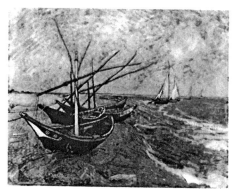

BOATS ON THE BEACH

LA CRAU SEEN FROM MONTMAJOUR

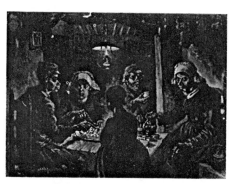

THE POTATO EATERS

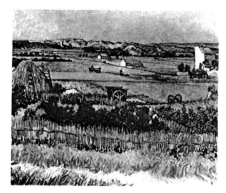

THE HARVEST

STUDY FOR THE POTATO EATERS

Plate 25

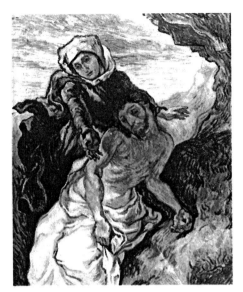

THE PIETÀ (*after Delacroix*)

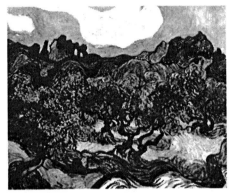

LANDSCAPE WITH OLIVE TREES

THATCHED ROOF WITH MAN ON TOP

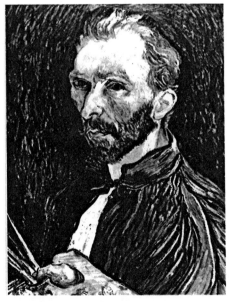

SELF-PORTRAIT

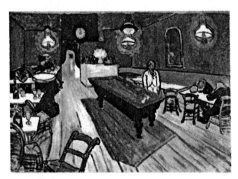

THE NIGHT CAFÉ

Plate 26

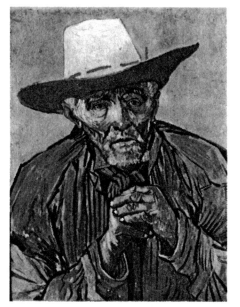

PATIENCE ESCALIER

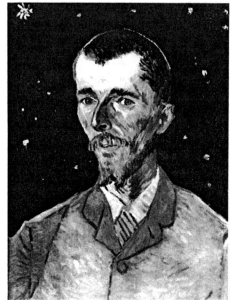

EUGÈNE BOCH

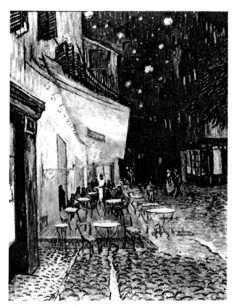

THE CAFÉ TERRACE AT NIGHT

OUR ARTIST'S CHRISTMAS ENTERTAINMENT:
ARRIVAL OF THE VISITORS
by A. Boyd Houghton

Plate 27

ROAD TO LOOSDUINEN

WINDMILLS AT DORDRECHT

HUTS AT SAINTES-MARIES

ENCLOSED FIELD (*oil*)

BIRDS' NESTS

ENCLOSED FIELD (*drawing*)

Plate 28

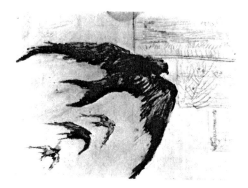

FLYING SWALLOWS

WHEATFIELD WITH REAPER

MEMORIES OF THE NORTH:
HUT WITH CYPRESSES

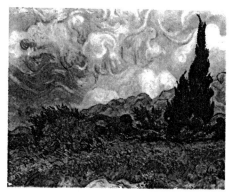

WHEATFIELD WITH CYPRESSES

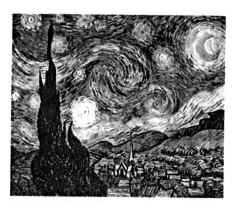

THE STARRY NIGHT

Plate 29

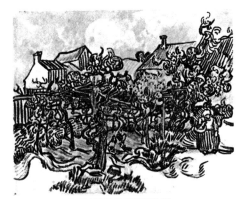

VINEYARD WITH PEASANT WOMAN

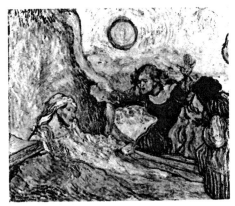

THE RAISING OF LAZARUS (*after Rembrandt*)

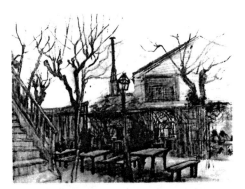

THE COUNTRY INN

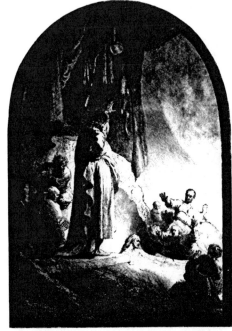

THE RAISING OF LAZARUS *by Rembrandt*

THE ANGEL

Plate 30

CHRIST ON THE SEA OF GALILEE *by Delacroix*

BRANCH OF PERIWINKLE

BOATS ON THE SEA

CAMILLE ROULIN

THE EVENING (*after Millet*)

Plate 31

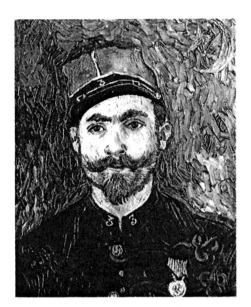

THE ZOUAVE LIEUTENANT MILLIET

MADONNA AND CHILD WITH TWO SAINTS
by Girolamo Dai Libri

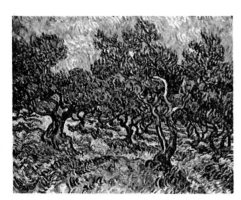

OLIVE ORCHARD

THE TOWN HALL OF AUVERS

Plate 32

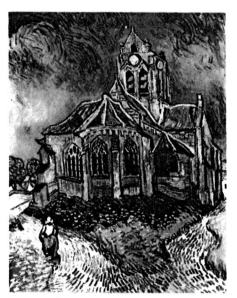

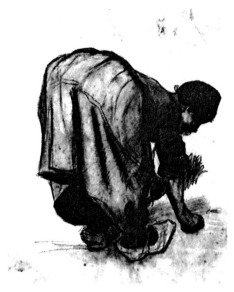

THE CHURCH AT AUVERS

PEASANT WOMAN STOOPING

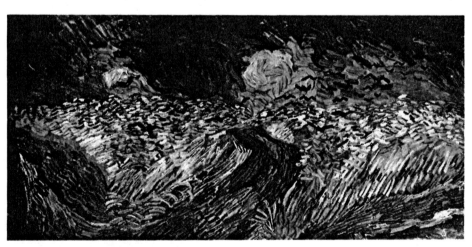

CROWS OVER THE WHEATFIELD

As he described it several years later: "You understand that I, who have learned other languages, might have managed to master that miserable little bit of Latin, etc.—which I declared, however, to be too much for me. This was a fake, because I then preferred not to explain to my protectors that the whole university, the theological faculty at least, is, in my eyes, an inexpressible mess, a breeding place of Pharisaism." [21] It seems as if he infiltrated the ranks of the theologians in order to get evidence against them rather than become one of them. The theologians' demand that he learn Greek and Latin was proof that they were more interested in sugar-coated niceties than in caring for the poor peasants. Instead of relieving suffering, as Christ dictated, he found well-fed Dutch ministers catering to well-fed Dutch merchants. Success as a theology student meant that he would become one of these contemporary Pharisees. While failure served his self-destructive urges, it was justified—indeed, it was required—by his role as the Savior who scorned them.

Vincent's Protestant father spent his life ministering to the poor peasants of southern Catholic Holland. As a Protestant missionary, Vincent repeated this role with a vengeance in caring for the poor miners of southern Catholic Belgium. In doing this he acted out an identification with his father; but, as an eccentric exile, he also caricatured his father's role and caused his parents to suffer as he felt they had made him suffer. He could do this without guilt, for he was convinced that Christ would have acted in the same way.

Vincent's identification with Christ (overlapping and fusing with his identification with his father) became most obvious there in the Belgian Borinage. Exhibiting a Christlike combination of meekness and grandeur, he made himself a "crown of the thorns of life" [22] (to use his own phrase) in a masochistic enticement of God and man. He lived in poverty, dressed in rags, and ate only the simplest fare. According to Mrs. van Gogh-Bonger, "Religion gave way more and more to practical work—such as nursing the sick and the wounded; he gave away all his possessions, clothes, money, even his bed. He no longer lived in a boarding house, but in a small miner's hut where even the barest necessities were wanting. In this way he tried to follow Jesus's teachings literally." [23]

A local baker, interviewed years later, recalled that Vincent had made shirts out of sacking: "My kind-hearted mother said to him: Monsieur Vincent, why do you deprive yourself of all your clothes like this—you who are descended from such a noble family of Dutch

pastors? He answered: I am a friend of the poor like Jesus was. . . . The humanity of our friend continued to grow day by day, and yet the persecutions he suffered grew, too. And still the reproaches and insults and stoning by the members of the Consistory, though he always remained in the deepest abasement!" [24] The baker had intuitively recognized Vincent's portrayal of a martyred Jesus. Another acquaintance reported that she had tried to dissuade Vincent from leaving her comfortable home to sleep on a miserable pallet in a hovel. He answered, "Esther, one should do like the good God; from time to time one should go and live among His own." Humbling himself by dressing in rags and covering his face with coal dust, Vincent defied the tradition of Dutch cleanliness. But to him cleanliness was not next to Godliness, as a good Dutch mother might suggest, but a show of vanity that was foreign to Christ.

Vincent had tried to find his way out of the morass of depression by following in the footsteps of his father and the other van Gogh ministers. Unsatisfied, he turned to the life of a poor evangelist—alienated, ascetic, and martyred, but this, too, failed him, depression returned, and he bitterly rejected church religion. He could not find a solution to his conflicts and a pattern for self-realization in the Dutch Reformed Church; this religion of his family and country was out of keeping with his special needs.

Because Vincent's parents were so intimately tied to the Dutch church, he no doubt regarded church and parents as one. He had always felt rejected by his mother, and he in turn rejected her. His father thereupon assumed the role of good mother in his mental economy. When, as an adult, he rejected his father, he simultaneously rejected the church. When he suggested that contemporary Christianity was a cruel religion that increased suffering rather than one that comforted and inspired serenity, a religion of "cynicism and skepticism and humbug," [25] he was also expressing feelings about his parents.

The Calvinism of the van Goghs stressed the strict, powerful Father God who demanded compliance under pain of punishment. Such a religion may help the guilt-ridden sinner who is able to handle problems through compulsive, ritualistic acts of atonement. It did not help Vincent, who not only felt like a sinner but—perhaps even more—like a despised freak, and who yearned for a loving mother rather than a strict father who would keep him in line.

He could not find in the church figures of his day the ideal whom he sought, a benevolent ideal who would be a model for the development of an identity in which he would feel proud rather than good.

Fear, however, was the chief reason that Vincent abandoned the church. He acknowledged later on that for many years he had had "a horror of all religious exaggeration," [26] including "the Christian idea of self-sacrifice, martyrdom and death," an idea implanted in him early in life. He did not wish to abandon religion but to seek a less threatening and more comforting one. His arguments against Christianity were part of a losing battle to eliminate the self-destructive thoughts that had become irrevocably entwined with the religion of his childhood. These thoughts were brewing underneath and were eventually to burst into the open and be acted upon. He adored Christ, he said, but despised Christianity. Christ had an affirmative meaning for him, representing the ideal of the beloved favorite child whom Vincent longed to be. On the other hand, Christianity—Protestantism in particular—resembled the treacherous forces that caused Christ to suffer and die.

Still another factor, mentioned earlier, entered into Vincent's decision to abandon the church and to turn to art—his halting speech, a serious handicap for a preacher. In contrast, Vincent's intense fascination in looking and his great ability in registering visual impressions and expressing them in writing and drawing could not be put to use in the ministry.

When Vincent was working as a teacher and an evangelist in England and in the Borinage, his religiosity was marked by extreme devotion to duty and self-denial, not by the inspired states that characterize such great mystics as Saint John of the Cross and his own artistic life later on. The church's demands and the gratifications it offered were too much at odds with Vincent's needs and talents to have permitted him to become an inspired preacher. Disparities such as this impeded a peaceful integration of positive elements in his makeup, an integration that is required for the spontaneous emergence of an inspired state.

Vincent's abandonment of the church was facilitated by the historical currents of the period. There was widespread breakdown of religious belief in nineteenth-century Europe, a trend that started with the French Revolution. Because of the increasing complexity of man's view of the world, secularism was winning out over the dogmatic and mystical doctrines of the church. Such doctrines may

be discarded by the intellect; but when they have been taught early in life, they persist in the unconscious and may re-emerge in forms that have no apparent connection with their origin. So it was with Vincent van Gogh.

It is clear that religious ideation did not disappear when Vincent discarded the church, but was to prove significant for his personal development as well as for the history of art. The Christ role, for instance, enabled him to carry on an intimate relationship with women that might otherwise have been forbidden. Vincent divided women into asexual *mater dolorosas* and sexual Mary Magdalenes. Shame and guilt forced him to free mothers and mother substitutes from any taint of forbidden sexual interest. Besides he found that good asexual women—like his mother, Ursula, and Kee—wanted nothing to do with him. As a result he turned to prostitutes, to Sien in particular, who became his Mary Magdalene.

Pastor van Gogh's condemnation of this relationship with Sien showed Vincent that his father was ignorant of the true meaning of Christ and Christianity: "I think it so rotten that Father stoops to such considerations as something not being in keeping with 'the dignity of his calling.' My opinion is that one might expect Father to cooperate as soon as the question of saving a poor woman arises. . . . By not doing so, Father commits an enormous error; it is inhuman for anyone to do such a thing; double so, however, if he is a servant of the Gospel. . . . Oh, I know very well that nearly all clergymen would use the same language as Father—and for this reason I reckon the whole lot of them among the most ungodly men in society." [27] Soon after, he accused the average clergyman of narrow-mindedness, hypocrisy, and "everlasting Pharisaism." [28] He expressed his unity with Jesus by recalling the latter's angry words, "The harlots go [into the kingdom of God] *before you*." [29]

Vincent's effort to convert Sien into a latter-day Mary Magdalene was an attempt to turn Sien into a good woman like his mother, Ursula, and Kee, but a good woman who would accept him rather than reject him as they had. Out of his desperate wish to save her, his perception was distorted into wistful fantasy: "It is wonderful how pure she is, notwithstanding her depravity. As if, far deep in the ruin of her soul and heart and mind, something had been saved. And in those rare moments her expression is like that of a 'Mater Dolorosa' by Delacroix. . . ." [30] The birth of

Sien's child reminded him of "the eternal poetry of the Christmas night with the baby in the stable." [31] The prostitute was magically transformed into the mother of God!

Disillusioned about his "cherished ideals" of the church, Vincent wrote, "Whatever may be said of the art world, it is not rotten." [32] And when he turned from the church to art, he merely diverted his religious ideation and his religious feelings into a different mode. "Painting is *a faith*," [33] he announced.

In discounting the importance of technique in art, he wrote to van Rappard that art is not created by hands alone, but by "something which wells up from a deeper source in our souls; and that with regard to adroitness and technical skill in art I see something that reminds me of what in religion may be called self-righteousness." [34]

Paintings took the place of sermons. Indeed, in a letter from The Hague early in 1882, they were the only worthwhile sermons: "I never heard a good sermon on resignation, nor can I imagine a good one, except that picture by Mauve and the work of Millet." [35] He reiterated the idea in Drenthe one and a half years later: "Millet has a gospel, and I ask you, isn't there a difference between a drawing of his and a nice sermon? The sermon becomes black by comparison, even when the sermon is good in itself. . . ." [36]

Not only was art a religion and a work of art a sermon to Vincent, but Christ was the greatest and most creative of artists: "He lived serenely, *as a greater artist than all other artists*, despising marble and clay as well as color, working in living flesh." [37] Vincent's identification with Christ enabled him to carry on as an artist convinced that he too was great, an extraordinary being who tolerated the blows and cruelty of life on earth knowing that he would eventually be venerated as mankind's favorite. Day by day failure and rejection would not slow him down; he would devote the same religious fervor to art that he had formerly invested in missionary work.

The story of Christ put its mark on Vincent's life as an artist. Like Christ, Vincent began the work for which he is remembered late in life, continued it for only a few years, and died young. His very emergence as an artist from his self-entombment in the Borinage was a resurrection: "Well, even in that deep misery I felt my energy revive, and I said to myself: In spite of everything I shall rise again, I will take up my pencil, which I have forsaken in great discouragement, and I will go on with my drawing, and from that

moment everything has seemed transformed for me. . . ." [38] With himself in mind, he told Theo that "one's real life begins at thirty," that artists do not find themselves until then—the same age that Jesus began his work; "I cannot repeat to you often enough, boy, that when one is thirty, one is just *beginning*." [39]

Like Christ, Vincent had only a few years in which to accomplish his mission. This was no accident, for he made it come true. Indeed, he predicted it. At the age of thirty, he wrote: "Not only did I begin drawing relatively late in life, but it may also be that I shall not live for so many years . . . between six and ten, for instance." "This is the way I regard myself," he continued, "as having to accomplish something with heart and love in it within a few years, doing this with energy. . . . *Something must be done* in those few years, this thought dominates all my plans for my work." [40]

When Vincent was a Christ-like evangelist, his father and the Dutch theologians became the hidebound Pharisees; when he became an artist, the academicians of art and the art dealers took over the role. In the manifesto of 1880 that announced his intention to become an artist, Vincent wrote, "I must tell you that with evangelists it is the same as with artists. There is an old academic school, often detestable, tyrannical, the accumulation of horrors, men who wear as a cuirass a steel armour of prejudices and conventions." [41] In 1881, he reiterated the idea in a letter to van Rappard: "You—and others, too—even if you really and truly attend the lessons at the academy, you will of course never be in my eyes an 'academician' in the despicable sense of the word. Of course I do not take you for one of those arrogant fellows whom one might call the Pharisees of art. . . ." [42]

Vincent expected martyrdom in the name of art but in the style of Christ. But this sacrifice was not meant to be the end of life but the prelude to rebirth: "I reasoned like this, 'Life means painting to me and not so much preserving my constitution.' Sometimes the mysterious words, 'Whosoever shall lose his life shall find it' are as clear as daylight." [43] He repeated the same thought in a letter to Theo: In choosing between creative art and preserving his health, he chose art, for art would live after him; then he added, " 'Whosoever will save his life will lose it, but whosoever will lose life for something more lofty shall find it.' " [44]

7 From darkness to light

VINCENT ARRIVED in Antwerp on November 27, 1885, never to return to his native land. Away from his mother and sisters, he felt free of a heavy burden. He was "more estranged from them than if they were strangers," [1] he complained, and he adamantly refused to write to his mother. He felt the same alienation from his country: "But there—the family stranger than strangers is one fact —and being through with Holland is a second fact. *It is quite a relief.*" [2]

The land of Rubens was ideal for making the transition from Holland to France and from Dutch art to French art, and he remained there for three mònths. He rented a cheap room above a paint dealer's shop, and his prodigious energy was immediately channeled into art. "I feel a power within me to do something," he said, "I see that my work holds its own against other work. . . ." [3] He knew himself well enough by now, however, to predict the outcome of his stay, for in the very first letter from Antwerp, he wrote: "[I]t will probably prove to be like everything, everywhere, namely disillusioning. . . ." [4]

In Nuenen, the human body to him was only a vehicle for the spirit; no sooner had he arrived in Antwerp than this attitude

changed. Now he could model "for the sake of modeling, because it is so infinitely beautiful in itself." [5] Away from his mother and the oppressive morality of a Dutch village, exposed to Rubens' lush baroque nudes, he became fascinated with the sensual aspects of the female form. "The women's figures I see here among the people make a tremendous impression on me," he wrote, "much more to paint them than to possess them, though indeed I should like both." [6] He soon painted the portrait of a girl from a local café in which he "tried to express something voluptuous and at the same time sad" (*Head of Woman: Nearly Full Face*).

Theo sent his brother a sum each month that was adequate for food and lodging, but Vincent spent so much on paints, canvases, and models that little remained. As a result, many of the letters to Theo from Antwerp are filled with complaints about his impoverished state. "It is hard, terribly hard to keep on working when one does not sell, and when one literally has to pay for one's colors out of what would not be too much for eating, drinking, and lodgings, however strictly calculated." [7] His sole meal was breakfast, supplemented in the evening by coffee and bread; in February he noted that he had not had more than six or seven hot dinners since leaving the parsonage in Nuenen the preceding May.[8] Not surprisingly, he complained of faintness, weakness, loss of weight, and digestive trouble.[9] He also had serious problems with his teeth. At least ten of them were lost or would be lost; as a result, his face had a "sunken look," and chewing became so painful that he swallowed food as quickly as possible.[10]

In February, "literally worn out and overworked," [11] he became ill and feared he was developing typhoid fever. Tralbaut has discovered that a Dr. Cavenaille treated Vincent with castor oil and alum sitz baths, and that the doctor supposedly told his own family that Vincent had contracted syphilis.[12] Neither the symptoms that Vincent described nor the medications the doctor prescribed, however, are suggestive of syphilis, and diagnostic procedures before the introduction of the Wasserman test in 1906 were unreliable.

Partly to insure himself a ready supply of models, Vincent entered the Antwerp Academy of Art on January 18, 1886. A fellow student described him as a strange fellow, dressed in a blue blouse similar to those worn by Flemish cattle dealers, wearing a fur cap on his head, and using a crude board for a palette—"an unpolished, nervous, restless man who crashed like a bombshell into the Antwerp academy." [13] He painted "feverishly, furiously, with a rapidity

that stupefied his fellow students. He laid his paint on so thickly that his colors literally dripped from his canvas on to the floor." He attended the night classes of the Academy and also joined two night drawing clubs. The clubs gave him the opportunity to draw from the nude female, which was practically forbidden in the Academy. He accepted the necessity of drawing from plaster casts, even though he had indignantly refused to use them a few years before when Mauve had suggested it. All this kept him busy from morning until midnight. "[T]imes are not cheerful *unless one finds satisfaction in one's work*," [14] he wrote. To keep them "cheerful," he worked with a vengeance.

Soon, however, he was embroiled in arguments with his teachers, mercilessly criticizing them for their method of working from the outline, rather than modeling with the brush.[15] His arguments convinced some of his fellow students, but when this undermining of the school's authority caused an instructor to become indignant, Vincent was nonplussed. After all, he explained, he had voiced his complaints outside the class. The instructors, in their turn, ridiculed his own work. He was not yet ready for oils, he was told, and needed to spend another year in the drawing class. Indeed, the Academy's examining board—without one dissenting voice—finally voted to demote him. "Thus at the age of thirty-three, when he had already created such masterpieces as *The Potato Eaters*," writes M. E. Tralbaut, "Vincent was sent back to the class for beginners between thirteen and fifteen years old!" [16] Fortunately, he had already left town.

Vincent's half-starved condition was not solely rooted in the need to divert limited resources into materials and models. Nor were his problems at the Academy due simply to his integrity as an artist. They were also manifestations—as in Amsterdam and the Borinage, where he had no such excuses—of an ascetic masochistic state in which he sought suffering, humiliation, and martyrdom.

Not long before leaving Nuenen, Vincent had been struck by a passage in Zola's newly published *Germinal*, a book that dealt with the struggle of coal miners against their employers. The passage concerned Mr. Hennebeau, the unhappy manager of a voracious company, who was being attacked by the miners. He was especially miserable, however, for he had just discovered that his wife had been unfaithful. He wished he could give up his heavy responsibilities, trade places with the miners, and enjoy their "easy indulgence." "He also wanted to starve," Vincent quoted from the book,

"to enjoy an empty belly, his stomach twisted by cramps that staggered his brain by fits of dizziness; perhaps that would have killed the eternal pain." When he got to Antwerp Vincent acted out what Mr. Hennebeau only fantasied: he *did* starve, his stomach *did* cramp, and his brain *was* staggered by faintness. In doing so Vincent also wished to kill an eternal pain, the pain of anxiety and depression that welled up from unknown sources within him. As a martyr suffering for the cause of art, he could explain this suffering on rational grounds, put it to use in his work, and use it as a plea for help.

To Vincent, Theo often played the sadist to his own masochistic role, although Theo—like so many caught up in victim-persecutor dialogues—must have experienced it in reverse. Vincent claimed that Theo—who was himself in debt—was not doing right by him and did not understand him. On receiving a check for 150 francs for January that had been delayed, Vincent was indignant: "Am I less than your creditors?—who must wait, *they* or *I*???" [17] In spite of continued support, he was convinced Theo did not care about him: "But I believe you have so accustomed yourself to thinking it all right that I am always being put back that you forget too easily how I have not had my due for so many years." If Theo wanted him to progress with his work, Vincent asserted, it was only fair that he should also endure poverty and want. In view of the large sums Theo was sending his ungrateful brother, no doubt he was doing just that.

Vincent's complaints and reproaches were part of a continued attempt to arouse Theo's sympathy as well as to punish him for some old or transferred resentment. The highly charged ambivalent feelings that were originally directed toward his dead father and his discarded mother were now directed toward his brother—their chief successor. Vincent's behavior punished him for their failures and pressured him to become a better parent. When Vincent told Theo that Delacroix would have died ten years earlier if it had not been for the care of his mistress, he was hinting that Theo should carry on a similar supportive role. [18]

Vincent's stay in Antwerp coincided with a serious financial crisis in Europe, and the art business was at a standstill. One dealer, for instance, told him that not a single customer had entered his shop in two weeks. For Vincent, such an environment only mirrored feelings he had about himself; in the same letter in which he wrote, "I am but a ruin compared to what I might have been," he also

observed that "many thousands and thousands are wandering about, desolate. . . . great misery is a fact that weighs the scales." [19] The anger he had formerly directed against his father's church was turned to the big companies that oppressed the working man, a sufferer whose misfortunes paralleled his own. "[I]t is possible," he wrote, "that we shall witness the beginning of the end of a society" [20]; but, he predicted, a tremendous revolution would rejuvenate it. If he had been a more outgoing man, he might have led a political revolution. Instead, he was on his way to becoming a leader of a revolution in art.

Even before leaving Holland, Vincent had taken an interest in Rubens' mastery of color. Now, in Rubens' city, the colors brightened in his own work, work that consisted mainly of portraits, town views, and still lifes. Some have claimed that Rubens was responsible for the change, but this is not wholly accurate; Vincent had already been searching for the technical means to brighten his paintings and had recognized Rubens as one who could help him.

"And although the quality of the color is not everything in a picture," he wrote, "it is what gives it life." [21] He criticized the academic artists whose "correct" colors resulted in "dead" pictures. Learning from Delacroix, Rubens, and others, he struggled to find lively combinations of pigments. He further enlivened his work with a technique he learned from Géricault, Delacroix, and Millet: painting from the center rather than from the contour. By "modeling" in this way he found that "the figures have backs even when one sees them from the front, there is airiness around the figures—*outside the paint.*" [22] He contrasted the results of this method with the work of the teachers of the Antwerp Academy who started with the contour and used flesh colors: "[H]ow flat, how dead, and how dry-balled [in Dutch, droogklooterig] the results of that system are. . . . It is correct, it is whatever you like, but it is *dead.*" [23]

Much of Vincent's constant striving to put life into his pictures was motivated by a preoccupation with death, and he attempted to transform painful thoughts about death into representations that exuded life. Putting life into pictures was, in part, Vincent's way of disavowing both his murderous and self-destructive urges.

While his preoccupation with death had older and deeper roots, it was especially strong following the unexpected death of his father in March 1885. Although he did not write about it, anyone as sensi-

tive as Vincent would have wondered if his angry attacks and eccentric behavior had killed his father—as, indeed, they may have. Shortly before leaving Nuenen, as we have seen, Vincent also became obsessed with a guilt-laden fear that his mother was on the verge of death, even though she appeared to be healthy and content. It is not far-fetched, therefore, to understand the starvation to which he subjected himself in Antwerp as a gamble with death. If he died, he would atone for his guilt; but if he won the gamble and lived, the punitive voice inside him would know he had tried.

Painting the human figure became his chief interest in Antwerp; "[P]ainted portraits," he wrote, "have a life of their own, coming straight from the painter's soul. . . ." [24] But putting life into the human form did not come easily to Vincent. Due to a painful self-consciousness, he felt "stiff and awkward," [25] and his portrayals of human figures reflected this self-image in spite of his excellence as a draftsman. In his attempt to overcome the problem, he attempted "to keep the faces animated" by talking to his models as they posed.[26] Vibrant color effects, fast firm strokes, lively brush work, and effective modeling, however, were the most effective means of achieving his goal.

Vincent now set his heart on going to Paris. Since he was no longer "absolutely green," he felt he would be accepted there. His confidence in his work continued to increase: "Drawing in itself, the technique of it, comes easily enough to me. I am beginning to do it like writing, with the same ease." [27] Now, he aimed at "originality and broadness of conception" and was ready to profit from the new movement in Paris. He counted on France to be a friendlier and brighter land that would accept and encourage originality and alleviate his longstanding misery.

Besides, Theo would be there to care for him, talk to him about life and art, and be an outlet for his passions. With Theo, he would rid himself once and for all of the pain of feeling like a melancholic outsider. "I am not an adventurer by choice but by fate," he noted, "and feeling nowhere so much a stranger as in my family and country." [28]

Having decided to go, he tried to obtain permission from Theo, whose financial assistance was essential. One request followed another. He assured Theo that he would work harder and would be willing to live in a garret.[29] He even hinted that Theo's presence

would help preserve his health, but the latter was in no hurry to
have his excitable brother come to Paris and ignored his pleas.
Finally, Vincent could stand the suspense no longer, and early in
March 1885 he took off for Paris without his brother's leave.

Vincent believed that the French were "more roughly, more
warmly alive" than the Dutch.[30] In contrast to Dutch rigidity,
France epitomized social, sexual, and artistic freedom; there, with-
out fear of reprisal, he could be himself while discovering himself.
There, he hoped to find other replacements for his parents among
creative Frenchmen and adapt their ways of living and creating to
his own resources.

"Just as in literature the French are irrevocably the masters,"
he wrote, "they are the same in painting too." [31] Long before com-
ing to Paris he had become steeped in the writings of Michelet,
Balzac, Hugo, the Goncourt brothers, and Zola. In 1883 Vincent
had expressed special admiration for Michelet's literary style, one
that he could readily adapt to his own art: "Michelet feels strongly,
and he smears what he feels onto paper without caring in the least
how he does it, and without giving the slightest thought to technical
or conventional forms—just throwing it into any form that can be
understood by those who want to understand it." [32] As we have
seen, Vincent worshipped Jean François Millet, whose works he
copied more than those of any other artist, and Eugène Delacroix,
who taught him revolutionary ways of handling color. But Vincent
had also been a devotee of other French masters, including Corot,
Courbet, Daubigny, Daumier, and Manet as well as such artists as
L. A. Lhermitte, Jules Breton, and Paul Gustave Doré.

Vincent—a rebel with a mission, a latent revolutionary—saw
France as the home of revolution. When he lived in The Hague,
he had compared the constitution that grew out of the French Revo-
lution with the Gospel of Christ.[33] In one of his verbal battles with
Theo, he had said that he would be on the side of the revolution-
aries, with Theo opposing him as a "soldier of the government." [34]
The revolutionary ideas of French writers and French artists fur-
nished him an intellectual and artistic framework to which he at-
tached his own rebellious and creative ideas.

In going to France Vincent followed the path of many creative
Dutchmen. Johan Barthold Jongkind was a recent member of this
group. He, too, was an unhappy disturbed man, an alcoholic, who

sought solace there. The French understood Jongkind, Theo once remarked, whereas the Dutch did not.[35] More important, Jongkind was the link between Dutch landscape painting and French Impressionism. Another Dutchman, Vincent van Gogh, who also had a solid grounding in Dutch art, became one of the chief links between the Impressionists and those, like the Fauves and the Abstract Expressionists, who were to follow.

Perhaps, too, in going to Paris Vincent was defying the values of his parents—part of his continuing, if unsuccessful, attempt to free himself from their psychological yoke. They had brought him up on a story about a great uncle who, "infected with French ideas," turned to drink, no doubt because "Dutch" and "French" were opposing ideas in the black-and-white language of the Dutch Calvinistic unconscious.[36] To a Calvinistic moralist, "French ideas" were a terrible threat, but to a young man who wished to liberate himself they had special appeal.

When Vincent burst in on him early in March 1886, Theo lived in a small apartment on the Rue de Laval (now the Rue Victor Massi), one block south of the Place Pigalle—the heart of Montmartre. The two were forced to share these tiny quarters. Theo was then manager of a branch of Boussod, Valadon and Company, successor to Goupil and Company. His gallery, located at 9 Boulevard Montmartre, was a center for the Impressionists, whom he defended against the criticisms of his employers. Among his paintings were works by Monet, Degas, Sisley, Pissarro, Raffaëli, Signac, and Seurat. Degas exhibited nowhere else.

Vincent immediately enrolled in the studio of Fernand Cormon, not far away on the Boulevard Clichy. His Dutch friend Breitner had studied there not long before, and the studio attracted the most talented students in Paris. Cormon was a conventional painter of no particular distinction, but as a teacher he gave his students considerable freedom. Vincent spent four hours each morning in the studio, drawing from nude models and plaster casts. In the afternoon he studied the masterpieces in the Louvre and the Luxembourg Palace.

Three or four months after Vincent began his studies at Cormon's, the studio was closed for a short time due to student agitation. Although Dr. Tralbaut believes he made great progress there,[37] Vincent, disappointed with the instruction, did not return when it was reopened.

The decision to leave Cormon's was facilitated by the fact that he and Theo moved in June from their cramped quarters to a large apartment at 54 Rue Lepic, on the hill north of the Place Pigalle. There was a separate bedroom for each, a living room, and a small studio for Vincent. A cook was hired to prepare the meals.

In leaving Cormon Vincent was repeating past performance. He had forced Mauve to abandon him and had quit the Antwerp Academy, because, like almost all real-life relations, they did not live up to his expectations. In terms of progress in art, these experiences (at least those with Mauve and Cormon) were profitable, but he saw to it that he did not remain long enough to become indoctrinated into ways that did not suit him. He resented having his creative self disrupted by conventional teachers just as he resented having his personality influenced by conventional parents. The relief he felt on leaving Cormon's seems similar to the relief he felt when he left his family and his country. Like the rebellion of a late adolescent, this behavior helped him to become an individual in his own right rather than remain bound to his artistic fathers and their artistic styles. His earlier rebellion against his parents was not altogether successful: no matter how far he fled, he forever wished to return to a state of bliss with them. In art, however, his rebellion succeeded in producing a new vision of the world.

Through Theo's gallery and Cormon's studio, Vincent was exposed to the work of the most creative contemporary artists in Europe, and he became acquainted with many of them. Only two years before, he knew almost nothing about the French Impressionists and cared even less: "And from what you told me about 'impressionism,' " he wrote to Theo, "I have understood that it is different from what I thought, but it's not quite clear to me what one has to understand from it. But for my part, I find in Israëls, for instance, such an enormous amount that is great that I am little curious or desirous for other or newer things." [38] When first exposed to them in Paris, he was still not impressed: "[W]hen one sees them for the first time one is bitterly, bitterly disappointed, and thinks them slovenly, ugly, badly painted, badly drawn, bad in color, everything that's miserable." [39] In spite of himself, Vincent still clung to Dutch tradition, and it was not easy to adjust his sights, "dominated as I was by the ideas of Mauve and Israëls and other clever painters." Before long, however, his ideas changed: "[N]ow I have seen them, and though *not* being one of the club yet I have admired certain impressionists' pictures—*Degas* nude figure —*Claude Monet* landscape." [40] He met Pissarro, Signac, Redon, and

Guillaumin and admired their works as well. He did not actually meet Seurat until his last days in Paris but was influenced by his Pointillist technique.[41] He also met younger painters at Cormon's studio who would soon become famous, including Paul Gauguin, Henri de Toulouse-Lautrec, Louis Anquetin, Suzanne Valadon, and Emile Bernard. Together with Vincent, the latter formed a group that they dubbed the *Impressionistes du Petit Boulevard,* named from their joint exhibition in "Le Tambourin," a café on the Boulevard de Clichy. This was to distinguish them from the *Impressionistes du Grand Boulevard*—Monet, Degas, Pissarro, Sisley, and Seurat—who exhibited in Theo's galleries on the Boulevard Montmartre.

Emile Bernard, the most enduring friend he met in Paris, was only eighteen years old when Vincent went to Cormon's studio; Vincent was thirty-three. Like van Rappard, Bernard was the son of a wealthy family, and he was talented both as a painter and a writer. As a collaborator of Gauguin in the Symbolist movement at Pont-Aven in Brittany, Bernard contributed to the development of Gauguin's style. When Vincent came to the studio, Cormon had just banned Bernard for painting red and green stripes on the non-descript screen used as a backdrop for the models. They met the following year at Tanguy's paint shop, and soon were companions on painting expeditions in the outskirts of Paris. Vincent often visited Bernard in Asnières, where Bernard had a garden studio on the grounds of his parents' villa, and where Vincent had a violent quarrel with Bernard's father defending his friend's artistic career. With the possible exception of unrecorded meetings in Paris during the last two months of Vincent's life, they did not see each other after Vincent left Paris early in 1888, but their correspondence continued to the end of 1889.

Bernard recalled that when he first encountered Vincent in Tanguy's shop, the latter, looking as if he were wasting away, almost frightened him. Later on Bernard felt more sympathetic: "Red-haired with a goatee, rough moustache, shaven skull, eagle eye and incisive mouth as if he were about to speak; medium height, stocky without being in the least fat, lively gestures, jerky step, such was van Gogh, with his everlasting pipe, canvas, engraving or sketch. He was vehement in speech, interminable in explaining and developing his ideas, but not very ready to argue." [42] Gauguin

has also described Vincent's appearance while walking on the Rue Lepic during the winter of 1886–1887: "Among [the pedestrians] is a fantastically dressed, shivering man who is hurrying along to reach the outer boulevards. He is wrapped in a sheepskin coat with a cap that is undoubtedly of rabbit-fur and he has a bristling red beard. He looks like a cattle drover." [43] A. S. Hartrick, another artist who met Vincent in Paris, added: "I can affirm that in my eyes van Gogh was a weedy little man with pinched features, red hair and a beard and a light blue eye. He had an extraordinary way of pouring out sentences in Dutch, English and French, then glancing back over his shoulder and hissing through his teeth. In fact when thus excited he looked more than a little mad; at other times he was apt to be morose, as if suspicious." [44] Vincent himself wrote that he was "making swift progress toward growing into a little old man, you know, with wrinkles, and a tough beard and a number of false teeth and so on"; and at times he felt "old and broken." [45]

Julien Tanguy—better known as Père Tanguy—was another rebel to whom Vincent attached himself. The sixty-one-year-old man, who had served two years on a prison ship for radical activity, ran a paint shop that served as a meeting place for such artists as Monet, Renoir, and Cézanne; Vincent's single meeting with Cézanne supposedly took place there. Vincent became a frequent visitor to the shop and painted three portraits of Tanguy; the latter, in turn, gave him paints on credit and put his canvases in the shop window. Tanguy seems to have sold one of Vincent's paintings for twenty francs—at a time when Cézanne's were selling from 80 to 150 francs and Monet had received as much as 2,000 francs for one of his. Their friendship prospered until Madame Tanguy, objecting to her husband's generosity, stirred up trouble between them. "[H]is old witch of a wife got wind of what was going on and opposed it," Vincent wrote. "So I gave it to [her] and said it was *her* fault if I did not buy anything more from them." [46] All the same, Vincent was confident that he could prevail over her: "Old Tanguy is sensible enough to hold his tongue, and all the same he will do what I want of him." The argument with the "old witch" continued by mail when Vincent was in Arles. There, when Tanguy again requested payment, he felt it was an unfair demand and attributed it to Tanguy's wife, "who is poisonous." [47] Tanguy was a martyr for putting up with her, he remarked; he would be right a hundred times over if he killed "the lady."

Three other women found their way into the meager corres-
pondence from Paris. One of them was Agostina Segatori, the
proprietress of "Le Tambourin." Vincent was fond of her, and they
apparently were intimate. When the café went into bankruptcy,
however, they argued over the return of the paintings Vincent had
left there. According to Bernard, Vincent—in a huff—finally carted
off his treasures in a wheelbarrow. On leaving her, Vincent wrote:
"I still have some affection for her and I hope she still has some for
me too. But just now she is in a bad way; she is neither a free agent
nor a mistress in her own house, and worst of all she is ill and in
pain." [48] The situation was not unlike the partings from Sien and
Margot Begeman. Vincent had excused them on similar grounds:
both were ill and dominated by someone else—Sien by her vicious
mother and Margot by her selfish family.

Vincent was also involved in the problems of another ailing
woman, known only as "S." Theo had brought her into the apart-
ment on the Rue Lepic, but she caused so much difficulty in the
household that he finally issued an edict: "either she gets out or I
get out." [49] Vincent, however, warned him that "by treating her
harshly you would immediately drive her to suicide or insanity,
and the repercussions on you would be sad indeed and leave you
a broken man." S., Vincent observed, was "seriously deranged"
and "not cured yet by a long shot." Andries Bonger, a friend of
Theo who was also sleeping in the apartment at the time, added,
"Morally she is seriously ill." Vincent volunteered to save the day:
"I am ready to take S. off your hands, i.e., preferably *without* having
to marry her, but if worst comes to worst *even* agreeing to a mar-
riage of convenience." Considering Vincent's past patterns,
his offer is not surprising: his offers to marry Sien and Mar-
got had also been more on the basis of pity than love. His assertion
that Theo's mistreatment would "drive her to suicide or insanity"
and would leave him "a broken man" suggests that this compassion
for suffering women was based on a fear of destroying them and
then being punished for it. When the woman was the aggressor,
however, like Madame Tanguy, his thoughts could turn to des-
truction without regret.

The compulsion to help suffering women is also revealed in a
story told by Gauguin in *Avant et Après*.[50] Out of pity, a Paris
shopkeeper had given Vincent a paltry five francs for a picture.
A wretched streetwalker smiled at him, hoping for a client. Vincent
gave her the money and dashed off "with an empty stomach, as
though ashamed of his generosity."

Vincent also befriended a different kind of woman—the Countess de la Boissière, who lived part of the year in Asnières. He gave her "two little pictures" [51] in 1887 and sent her two more from Arles in 1888. She was, Vincent noted, "far from young, but she is a countess first and then *a lady*, the daughter the same." Although the countess seems like a strange friend for a rebel who identified himself with peasants and laborers, it appears that he was attracted by the close relationship between the countess and her daughter, just as he had admired a similar relationship between Ursula and her mother years before. Family solidarity and affection, for which he himself longed, always fascinated him. Perhaps his friendship with the countess permitted him to share a small part of it.

Living with Theo, his chief correspondent, Vincent wrote few letters from Paris; hence only a brief sketch can be drawn of his emotional life there. Theo wrote to his mother in the summer of 1886 that Vincent had recovered his health, his spirits had improved, and he made many friends. Vincent himself observed that "the French air clears up the brain and does good—a world of good." [52] These statements may have been true, but they were not the whole truth. He had not been there long when Andries Bonger confided to his own parents, "The man [Vincent] hasn't the slightest notion of social behavior. He is always quarreling with everybody." [53] In June he wrote, "[Theo] has many cares. Moreover, his brother is making life a burden to him, and reproaches him with all kinds of things of which he is quite innocent."

Difficult as the situation may have been before, Vincent's irritability increased during the winter of 1886–1887. Theo complained about him to Wil, "My home life is almost unbearable. No one wants to come and see me any more because it always ends in quarrels, and besides, he is so untidy that the room looks far from attractive. I wish he would go and live by himself." In spite of Theo's protestations and Wil's advice that he "leave Vincent for God's sake," the two remained together.

The extent to which Vincent was overtly depressed in Paris is uncertain, although shortly after leaving he wrote, "In Paris one is always as sad as a cab horse." [54] One reported episode, perhaps apocryphal, suggests the possibility of a depressive spell: An English art dealer named Alexander Reid, who also shared the apartment with the two brothers for a while, became melancholic after being rejected by his sweetheart. Vincent responded to Reid's suffering by suggesting suicide *à deux.* "This appeared to Reid as altogether too drastic a solution, and as Vincent continued with his gruesome

preparations Reid decided to make himself scarce." [55] If true, Vincent may have been depressed and regarded such action as a companionable way out. It may have been an exhibitionistic attempt to obtain Reid's approval through self-sacrifice. Or, perhaps, he wished to warn Reid that he should not try to outdo him when it came to misery. In any case depression did not stop him from producing a large body of art—a point that needs to be reemphasized with each new phase of his artistic career.

During his two years in Paris, Vincent turned out more oils than drawings for the first time. De la Faille lists about 200 oils, 10 watercolors, and 40 drawings. The ideas he expressed about the use of color in his letters from Nuenen made a hesitant appearance in the last paintings from Nuenen and in those from Antwerp. In Paris, however, his paintings finally caught up with these written descriptions of his artistic aspirations. The somber chiaroscuro of the North disappeared and a vibrant luminosity took its place. He came ready and willing to be converted to the French way, and—in part, at least—he was. Here he found the techniques that put life into his work, if not into life itself. Seeing himself as a deteriorating "little old man," he tried to make pictures "in which there will be some youth and freshness, even though my own youth is one of the things I have lost." [56]

Unable to hire models after leaving Cormon's studio, Vincent first turned to painting flowers, although he claimed that the figure was still his chief interest. Before long, however, he was depicting the Montmartre district, repeating in a higher key the views he had done of the Schenkweg in The Hague. Some were from his studio window, while others (according to Tralbaut) were from the Place du Calvaire, an alcove off the southern side of the famous Place du Tertre high on the Butte of Montmartre that affords the best view of the whole city.[57] As in The Hague, he painted street scenes, old buildings, and factories. The windmills that adorned the Butte must have reminded him of home, and he depicted many of them, too. In 1887 he produced colorful views of the outskirts of Paris and nearby towns like Asnières, boats and bridges on the Seine, wheatfields, and still lifes of flowers and books. The still lifes included a group of sunflowers that prepared the way for the more brilliant versions from Arles.

In Paris, too, he produced about twenty-five self-portraits, many more than at any other time, ranging from simple pencil sketches to iridescent oils. As a group they are remarkable for the tremen-

dous variation he bestowed on his physiognomy. The shape of his head varies from oval to triangular to long and narrow. His nose varies in length, width, and shape, ranging from aquiline to bulbous to straight. His appearance is sometimes distorted by placing his eyes asymetrically in his skull. On occasion he has the dress and the mien of a gentleman, on another those of a peasant. In some he appears small and retiring, in others strong and audacious; in some contemplative, in others a man of action. Sometimes he is coarse and ugly, only to be refined and dignified at other times. Such variations in appearance reflect the multitude of contradictory images he had of himself and of the way he wished to reveal himself to the world. In his self-portraits he objectified these images, perhaps hoping to facilitate the choice of a final version from among them. If so, he did not succeed, for subsequent self-portraits after leaving Paris have the same diversity in appearance.

Vincent's work in Paris was greatly influenced by the Impressionists, and some of his paintings—presumably the earlier ones—resemble those of Pissarro and Sisley. For a while he was so intent on learning the secrets of shimmering color that he adopted their fine brushwork, and revealed a delicate touch that hid his own ebullience. Because the Impressionists avoided stirring up deep feelings in the beholder, however, they could be no more than a helpful adjunct in the full artistic development of such a passionate man. Having assimilated and digested those aspects of Impressionism that suited him, his later work continued to use Impressionistic techniques but was easily distinguished by its emotional intensity and rough modeling.

Vincent also admired the Pointillists,[58] especially Georges Seurat, and he adapted Seurat's technique of juxtaposing dots of pure color on a white background. But he could scarcely have followed Seurat's neat scientific approach, one totally at odds with his own inclinations. Besides, his need to put life into his pictures would not permit the rigidity and the stillness of Seurat's canvases; there had been too much of that in his own Dutch works. By executing the Pointillist technique rapidly and instinctively, however, he obtained a luminescent effect that suited his needs.

The lessons he learned from Adolphe Monticelli and Japanese prints put him on more compatible ground from the standpoint of his emotions and his view of himself as a peasant painter. From Monticelli he learned to obtain luminosity with heavy vigorous strokes and thick pure colors. From Japanese prints he learned to

use broad surfaces of bright colors. Printed from wood blocks, these prints gave a peculiar light effect; he obtained similar light effects by making his painted surfaces thick and rough in the style of Monticelli. In combining these devices he found techniques through which he could express himself in his own idiom. Nor did the influence of Monticelli and Japanese prints cease when he left Paris, but continued and came to full fruition in Arles.

In a letter written in English to H. M. Levens, an English painter he had met in Antwerp, Vincent explained that his goal was "to render intense colour and not a grey harmony." [59] "But I have made a series of colour studies in painting," he explained, "simply flowers, red poppies, blue corn flowers and myosotys, white and rose roses, yellow chrysanthemums—seeking oppositions of blue with orange, red and green, yellow and violet seeking *les tons rompus et neutres* [broken and neutral tones] to harmonise brutal extremes." These experiments in color, aided by his studies of artists from the past and the present, were extended to portraits and landscapes. An intense, colorful man, stranded in a conflict between the "brutal extremes" of sadism and masochism that might momentarily erupt into violence, Vincent tried to harmonize brutal extremes of color in his art.

Paris was abandoned as abruptly as it was invaded. Theo described the background of the departure: "In Paris, he saw a mass of things he would have liked to paint, but he was always deprived of the opportunity. The models would not pose for him; he was forbidden to work in the streets, and because of his violent temper there were continual incidents. . . . He became completely unapproachable and in the end he became heartily sick of Paris." The rejection by models, which in Nuenen Vincent could attribute to gossip and a prejudiced priest, was obviously of his own making here. "When I left Paris," he wrote later on, "I was seriously ill, sick at heart and in body, and nearly an alcoholic." [60] Driven by depression he was forced once again to continue on his martyred trek; before completing his second year there, toward the end of winter, he headed for an early spring in sunny Provence.

8 The yellow house

VINCENT ARRIVED in Arles on February 20, 1888. Located on the Rhone, this ancient city had been an important outpost of the Roman Empire, the home of Constantine, and a kingdom of its own during the Middle Ages, but had long since contented itself with being a small-town agricultural center of the rich delta surrounding it. Fed up with Paris, he found Provence a natural attraction, the nearest place where his increasing fascination with bright light and vivid colors could find a responsive environment. The comparative solitude of a small town was also welcome, as he again felt the need to isolate himself from those who stirred up his anxieties.

But why Arles? Why not the Haute Provence of Cézanne—the area around Aix-en-Provence, or the Côte d'Azur of Renoir—between Marseilles and the Italian border? Or Marseilles itself, where his idol Monticelli painted? Some evidence suggests that Toulouse-Lautrec praised Arles and encouraged Vincent to go there, hoping to be rid of a nuisance.[1] Perhaps Daudet's influence was important: Vincent had read *Tartarin of Tarascon* and, like many others, was fascinated with its romanticized version of the

area as a land of friendly, gay, handsome people. Here was a place where Vincent imagined that his melancholy would be converted into joy, and where he would find colorful subjects for his canvases. Perhaps, too, as Dr. van Gogh has suggested, Vincent had been influenced in his youth by the description of the pretty girls of Arles in Multatuli's Dutch classic, *Max Havelaar*.[2]

Vincent arranged for lodgings in the Hotel-Restaurant Carrel, a small hostel just inside the Porte de la Cavalerie, the northern entrance to the town. He soon became acquainted with Arles and its environs and found the country, the sun, the colors, and the people to his liking. The air did him good, he wrote, and the "magnificent natural surroundings" restored his morale.[3] It was, indeed, Daudet's Provence: "But here's to the country of good old Tartarin, I am enjoying myself in it more and more and it is going to be a second fatherland." [4] The Dutch, he observed, were blind and stupid for not going to sunny places like this. The heat was dry and clean, and "life here was more satisfying than in many other spots." He liked the countryside because of "the color and the logical design." "Essentially the color is exquisite here," he wrote to Wil. "When the green is fresh, it is a rich green, the like of which we seldom see in the North, quiet. When it gets scorched and dusty, it does not lose its beauty, but then the landscape gets tones of gold of various tints. . . . And this combined with the blue—from the deepest royal blue of the water to the blue of the blue forget-me-nots, cobalt, particularly clear bright blue—green-blue and violet-blue." [5]

The people of Arles were "picturesque too," he insisted, "and whereas in our country a beggar looks more like a hideous phantom, he becomes a caricature here." [6] Like Multatuli, Vincent thought the women were beautiful, and he once described Arles as "that coquettish little town of the pretty women." [7] "Color plays such a tremendous part in the beauty of the women here," he explained. "I do not say their shape is not beautiful, but that is not their special charm. That lies in the grand lines of the costume, vivid in color and admirably worn, in the *tone* of the flesh rather than the shape" [8]

Once established in Arles he made friends, he went to bull-fights in the Roman arena,[9] and he visited the local houses of prostitution. Filled with enthusiasm, his senses became keener and his hand more agile.[10] His energy seemed inexhaustible, and the work that he turned out was prodigious, even in terms of sheer quantity. He found no end of "very beautiful and interesting sub-

jects," and he acquired "a lover's insight or a lover's blindness for work." [11] By September he was able to write, "I am beginning to feel that I am quite a different creature from what I was when I came here. I have no doubts, no hesitation in attacking things, and this may increase." [12] He observed that his work prevented him from becoming melancholic. "If I were to think of and dwell on disastrous possibilities, I could do nothing," he added. "I throw myself headlong into my work, and come up again with my studies." [13] Painting diverted his mind from his inner torments—"like rabbit hunting for the cracked-brained: they do it to distract themselves." But hard work was also part and parcel of his Dutch character; it proved that he was "neither a slacker nor a good-for-nothing," [14] a point of view far more Dutch than Provençal.

As could be predicted, however, this involvement was not enough to maintain his serenity. He rationalized that the strain of work—"the mental labor of balancing six essential colors" [15]—caused him to turn to alcohol and tobacco: "After that the only thing to bring ease and distraction . . . is to stun oneself with a lot of drinking or heavy smoking." A later explanation, however, was closer to the point: "[I]f the storm within gets too loud, I take a glass too much to stun myself." [16]

There were also the familiar complaints—complaints about his health, his need for money, his isolation, and the injustices that others heaped upon him. He lost his appetite, and his stomach was "terribly weak," due, he surmised, to drinking too much bad wine in Paris. "And so it comes about by eating hardly any solid food and hardly drinking I am pretty weak. . . ." [17] At the same time, he explained that the "real reason" for his poor health was that he could *"never"* get the food he asked for, ignoring the fact that he guaranteed his own deprivation. He complained, for instance, that he spent whole days in the country with only a little bread and milk because it was too far to go back to town, while it escaped his attention that he could have taken sufficient food with him. Not for the first time, he spent all his money on materials and had nothing left to eat. A "wild" urge to frame his pictures, for example, caused him to order too many for his budget; as a result, he lived for four days "mainly on 23 cups of coffee, with bread which I still have to pay for." [18] For a moment in August, aided by the heat, he was "feeling very, very well" and his digestion was "nearly all right again." But no sooner had he said this than he returned to his woes: "I do not have strength enough left to go on like this for

long. . . . I am going to pieces and killing myself." [19] He grumbled that the region was devoid of other painters, yet he had gone there to be sheltered from them. Like work and alcohol, these external difficulties distracted him from the more serious internal misery that was never far from the surface.

As usual, his moods fluctuated. On May 29 he wrote that he suffered "from unaccountable but involuntary emotions or from dullness on some days." [20] Two months later he said that he "hadn't advanced one inch in the heart of the people," that "many days pass without speaking a word to anyone, only to ask for dinner or coffee." "But up to now," he added, "the loneliness has not worried me much because I have found the brighter sun and its effect on nature so absorbing." [21] In August and September his life was "disturbed and restless" and the isolation was "pretty serious." [22] But, he explained to Bernard, this was to be expected, for exile is the lot of the artist.[23]

Vincent also complained that the innkeeper of the Hotel-Restaurant Carrel was a swindler. When Vincent decided to move from the hotel to save expenses, the man demanded additional money and refused to permit him to move his belongings elsewhere. Vincent brought the case to the local magistrate and won; the innkeeper was reprimanded.[24]

In May Vincent rented the right wing of a complex of two houses, a narrow two-storied dwelling on the Place Lamartine, known ever since through his letters and paintings as the Yellow House. "It is painted yellow outside, white-washed inside, on the sunny side." [25] The nearest privy, though dirty, was in an adjacent hotel. It took a while before he furnished the house to his satisfaction, and he did not move into it until September 18. In the meantime he slept at the Café Alcazar, the model for Vincent's paintings of *The Night Café,* and ate at the Café de la Gare, run by Monsieur and Madame Ginoux. The Yellow House was to be more than a simple dwelling; it was to be the center for Vincent's long-cherished society of artists; Theo, Gauguin, and Bernard were to be among its members.[26] In addition to providing opportunities for artistic and economic collaboration, the members were to love each other like comrades.[27]

Vincent's idea of forming this society was based on the desire to establish a group of "brothers" who would work together like monks for the common good and for the good of art. The first plan, conceived in 1882, was to organize a group that would make prints

"for the people," without expectations of personal gain. "So what is needed," he wrote, "is courage and self-sacrifice and risking something, not for gain, but because it is useful and good." [28] The later version that he proposed for Provence, the "Society of Impressionists," was to be "something of the same nature as the Society of the Twelve English Pre-Raphaelites." [29] If Vincent's Christ identification is kept in mind, one may see more than coincidence that the poverty-stricken Vincent purchased twelve chairs for his little Yellow House—with no apparent use for them.[30]

Vincent himself equated this Society with the twelve Apostles. In discussing Theo's potential role in the group in a letter of September 1888, he called him a "dealer apostle." Then he added, "I shall urge every man who comes within my reach to produce, and I will set them an example myself." [31] He repeated the same idea early in 1889, a month after the ear mutilation: "Indeed, as long as this world lasts, so long will there be artists and picture dealers, especially those who, like you, are at the same time apostles." [32]

Although he complained bitterly of his isolation, Vincent did not lack companions in Arles, suggesting that his misery was provoked more by inner feelings of desolation and abandonment than by the actual circumstances of his life. During his first month there, for instance, he was visited by two amateur artists, "a grocer who sells painting materials as well, and a justice of the peace who looks pleasant and intelligent." [33] He also met Mourier Petersen, Dodge MacKnight, and Eugène Boch. He saw Petersen—a young, good-natured Danish artist with a nervous disorder—every day for several months. MacKnight, a Yankee, was "a dry sort of person not too sympathetic." [34] When MacKnight, who might as well have been a Dutch Calvinist, converted his landlord to Christianity, Vincent cynically expressed his disapproval.[35] Boch, a thirty-three-year-old Belgian artist with "a touch of distinction," [36] was a more likeable fellow; his art, Vincent wrote, was Impressionistic, but lacked power. No doubt encouraged by Vincent, he left in September for the Borinage.

In August Vincent also made friends with Milliet, a second lieutenant of Zouaves, an infantry unit stationed in Algeria. Milliet, a twenty-five-year-old, was "a good-looking boy, very unconcerned and easy-going in his behavior, and he would suit me damned well for the picture of a lover." [37] He became a faithful friend and, like Boch, posed for a portrait. Vincent envied his ability to conquer the women of Arles; he made love so easily, Vincent noted, that he

nearly despised love itself.[38] Milliet left to rejoin his regiment on November 1, 1888.

Vincent found still another model in August—the postman (or, rather postal official) Joseph Roulin, and the two soon became close friends. Roulin was a Provençal version of Père Tanguy: "I am now at work with another model, a *postman* in a blue uniform trimmed with gold, a big bearded face, very like Socrates. A violent Republican like Tanguy. A man more interesting than most." [39] A drinker, he loved to talk about politics, and Vincent dubbed him "the trumpet of revolutionary France"; "his exaltation is so natural, so intelligent and he argues with such a sweep, in the style of Garibaldi. . . ." [40] Here was another new father whose ideas, enthusiasm, and lack of self-righteousness were completely different from the stern father he had rejected. By November Vincent was on such good terms with the whole Roulin family that he was able to portray every one of them: "the man, his wife, the baby, the little boy, and the son of sixteen, characters and very French, though the first has the look of a Russian." [41]

Vincent's unhappiness, of course, did not disappear after he moved into the Yellow House, and he continued to search for other means to abate it. Religious ideas became prominent again during his first month there; they were not concerned with the religion of his father but with one that was new and therapeutic—"something that would tranquilize and comfort us so that we might stop feeling guilty and wretched and could go on just as we are without losing ourselves in solitude and nothingness." [42] As part of this religious preoccupation, he thought about the heavens and eternity, and he began to paint the starry sky. At the same time he managed to make life more bearable by regarding himself as a martyr for art and describing his mental difficulties in heroic terms. In a letter to Gauguin commiserating on their shared "miseries of poverty and illness," he commented that "probably we shall be giving our lives for a generation of painters that will last a long time." [43] Soon after, he announced to Theo that he was "pretty nearly reduced to the madness of Hugo van der Goes in Emil Wauters' picture." [44] And in the following letter he added, "[T]he pains of producing pictures will have taken my whole life from me, and it will seem to me that I have not lived." [45]

Vincent added to his unhappiness and isolation by continuing to dress and behave in a way that excited the ridicule of the townspeople. The children, being franker than most, openly poked fun at him. "His appearance made a highly comical impression on us,"

one of them wrote later on. "His long smock, his gigantic hat, the man himself, continually stopping and peering at things excited our ridicule." [46] Because he ate little, he looked "perpetually under-nourished," and his eccentric appearance was accentuated by a frenzied behavior. Milliet, the young Zouave lieutenant, said that Vincent was "an odd fellow," argumentative, nervous, exceptionally sensitive, with changeable moods; he regarded himself as a great artist, and "there was no budging him" once he started to paint.[47]

The Yellow House was a lure to attract Paul Gauguin to Arles from Brittany, and Vincent took special pains to see that it was properly furnished for him. Gauguin arrived on October 29, culminating months of cajolery. In his final pleas, Vincent offered Gauguin the leadership of the new society of artists, apparently forgetting that a few months before he had offered this position to Theo. After Gauguin came, Vincent's complaints decreased. He was lavish in praising his new partner and was busier than ever painting and sharing ideas with him. The presence of an actual companion apparently reduced the need for a writing companion, for Vincent's correspondence with Theo was sparse during this period. Gauguin's recent work in Brittany had become visionary, and—although Vincent criticized it—this tendency of Gauguin gave him "the courage to imagine things"; [48] in borrowing Gauguin's imagination some of his own pictures became more visionary. This was manifest, however, even before Gauguin's visit in paintings of the Garden of Gethsemane, the starry skies, and *The Night Café* —no doubt influenced by the anticipation of seeing him.

Two months after Gauguin arrived, Vincent's enthusiasm came to an abrupt halt. He could no more succeed in a flesh and blood partnership with Gauguin than with anyone else. As always, his sensitivity made the collaboration that he so passionately envisioned impossible, although Gauguin's behavior must have further complicated the situation. On December 23 Vincent wrote: "I think myself that Gauguin was a little out of sorts with the good town of Arles, the little yellow house where we work, and especially with me." [49] That very night Vincent mutilated his ear in a state of violent excitement, an episode that caused Gauguin to flee and Vincent to be hospitalized in the Hôtel Dieu.

As various writers have observed, Daudet's idealized version of the Provence of the Rhone Valley was a will-o'-the-wisp. Prosper Mérimée, for example, wrote that it was a sad and dirty country,

and Stendhal called Arles "a hole." It is a country where the mistral—the dry cold wind that descends the Rhone Valley—is sometimes so ferocious that it is impossible to stand erect in its midst. Like the weather that suddenly changes from marvelous to monstrous, the carefree people of Provence have another side to them. A native told James Pope-Hennessy, "Foreigners think this a gentle country, but in reality it is harsh and fierce." "It is indeed a bitter and ferocious country," Pope-Hennessy adds, "full of violence and lethargy, perfidy and good nature, full of every contradiction under its burning sun." Although the people are smiling and extraordinarily amiable, they are also passionately emotional. "They are capable of considerable cruelty. When the mistral blows week after week over the fields and vineyards, curling the tips of the black cypress trees, anything may happen in the towns and villages, the isolated farms and cabanons of Provence." [50] What better place to cut off one's ear?

Vincent also observed the seamy side of the country and recognized that Daudet's view was rose-colored. He was not long in Arles before he called it "a filthy town," and later he wrote that Gauguin had good reason to call it "the dirtiest hole in the South." "The carelessness, the lazy happy-go-lucky ways of the people here are beyond belief; you have trouble getting the most trifling things," he told Theo. "I see nothing here of the Southern gaiety that Daudet talks about so much, but on the contrary all kinds of insipid airs and graces, a sordid carelessness." [51] And to Wil, in the course of extolling the virtues of the land, he added: "However, I have the impression that people are getting slack here, a little too much affected by the decadence of carelessness, indifference, whereas if they were more energetic the land would probably produce more." [52] His old criticism of the hardships inflicted on Dutch peasants did not stop him from deploring the fact that their Provençal counterparts did not work as hard.

Vincent became acquainted with the violence noted by Pope-Hennessy soon after arriving in Arles. Two Italians killed two Zouave soldiers outside a local brothel. An excited mob turned on the murderers and almost lynched them. The crowd failed, he thought, not because of reason but because the Provençal is "more energetic in good intentions than in action." [53] Vincent also complained that the people of Arles were a sickly lot, that many were "on the verge of madness or violence," and that they exploited foreigners. Though kind, they also had "the most incredible prejudices against painters and painting, or, at any rate, no clear, sane

idea of it as we have." [54] While granting that the women were charming, he qualified his praise: "But [they are] no longer what they must have been," he wrote in May, ". . . they are in their decadence." He reiterated this criticism four months later: "I think that the town of Arles used to be infinitely more glorious in the beauty of its women and the beauty of its costumes. Now everything has a sick and battered look about it." [55]

Even the landscape was not beyond criticism. Once, for example, he referred to "the scorched, trivial scenery of Provence." [56] From the beginning, he found the wind so cold and dry that it gave him gooseflesh and often made it difficult to work. In addition to the "nagging malice of the constant mistral," during the summertime he was also "devoured by mosquitoes." [57] His aggravation continued into autumn: The mistral set him on edge; his stroke was affected, giving a haggard look to his studies; and it raised so much dust that the trees were whitened from top to bottom. As winter approached, he found Arles just as cold as Holland.

Although Vincent had originally intended to stay at Arles only a short time before going on to Marseilles, he remained almost fifteen months—long enough to forever change our perception of this corner of the world by forcing us to see it through his eyes. What kept him there? He could have found the same blue sky and bright sun on the Côte d'Azur or in the region of Aix-en-Provence. And he would have found an active group of painters and a population far more interested and well-informed in art. He would also have been able to avoid the violence of the mistral near Cannes, Nice, or Menton.

It seems that in spite of—and, even more, because of—the deficits of the region, Arles had the proper combination of incentives to stimulate Vincent's creative processes and to provide for his complex psychological needs, needs that could not be filled elsewhere in Provence. He had been seeking a place that was different from the dull, dark Holland that he associated with his parents and Dutch Calvinism. On the other hand, he longed to be in an idealized Holland purged of unhappiness and hypocrisy, a Holland reborn into its Golden Age where he could become a beloved immortal like Rembrandt. In contrast to this exalted wish, he also needed to satisfy his self-depreciating masochistic impulses. The region of Arles was able to accommodate him in all these respects.

Vincent resented his family and his culture, and he wished

to remove himself from his oppressive origins both geographically and psychologically. He sought to get away from "the horrible white man [i.e., Dutchman] with his hypocrisy, his greediness, and his sterility." [58] "I profoundly despise regulations, institutions, etc.," he wrote, "in short, what I am looking for is different from dogmas which, far from settling things, only give rise to endless disputes." [59]

Arles and its people represented a different universe. The lax, uninhibited, superstitious, violent Provençals presented a striking contrast to the stern, moralistic, constrained, hard-working Calvinists who threatened him in his homeland. Among them, far from home, he could observe safely removed from the struggle: "Must I tell the truth and add that the Zouaves, the brothels, the adorable little Arlésiennes going to their first Communion, the priest in his surplice, who looks like a dangerous rhinoceros, the people drinking absinthe, all seem to be creatures from another world?" [60]

The country, however, reminded him of home: "Many subjects here are exactly like Holland in character, the difference is in the color," [61] he wrote. In contrast to the mountainous country of the Haute Provence and the rocky cliffs lining the sea of the Côte d'Azur, it was, like Holland, a vast flat delta land. Nowhere else in Provence were such stretches of flat land to be found, and Vincent commented on this aspect of the country in his first letter from Arles. The region became a second home for him, a home transformed by a golden sun and a carefree mood, where somber heaths became colorful plains. Besides, like other Dutchmen, he might not have felt comfortable amidst the high peaks and steep cliffs of the Provence to the east.[62]

The few hills in the region served as convenient points to observe the plains below. He went "fully fifty times" to the Abbey of Montmajour, an ancient ruin situated on a hill dominating the plains surrounding it, "to look at this flat landscape." [63] He noted that "the wide plain might often remind one very strongly of the Dutch scenery—here where there are hardly any mountains or rocks—if the color were not so different. . . . A vigorous sun, like sulphur, shining on it all, the great blue sky—sometimes it is as enormously gay as Holland is gloomy." [64]

Other aspects of the area also reminded Vincent of Holland. The bridge of Langlois that he immortalized in a series of paintings and drawings must have been among the first. It was a Dutch

structure crossing a canal that could have been transplanted from Holland, and it was designed by a Dutch engineer imported for the purpose. Vincent's *The Drawbridge* is, no doubt, the most colorful Dutch bridge ever created. The Provençal olive trees were "like the pollard willows of our Dutch meadows or the oak bushes of our dunes." [65] The costumes of the women of Arles—colorful full dresses with lace fichus and white starched caps—resembled the distinctive dress of Dutch country women; but, like the scenery, the Provençal version was more colorful.

When Vincent went to Saintes-Maries-de-la-Mer for a week in June 1888, he crossed the plain of the Camargue, a great swampy delta through which the two branches of the Rhone River—the *Grand Rhône* and the *Petit Rhône*—pass before emptying into the sea. So similar to the delta lying between the branches of the Rhine and the Maas, it is not surprising that it reminded him of the Dutch moor. And the flat sandy beach at Saintes-Maries, with "neither cliffs nor rocks," was "like Holland without the dunes, and bluer." [66]

The idealized Holland he saw in Provence was the one depicted by the great painters of the Golden Age: "Here," he wrote, "except for a more intense coloring, it reminds one of Holland; everything is flat, only one thinks of the Holland of Ruysdael or Hobbema or Ostade than of Holland as it is." Many places were "exactly in Ruysdael's style." A gardener's wife standing out in strong sunlight was a "perfect" Vermeer. The Crau and the Camargue reminded him of "the old Holland of Ruysdael's time." The fields were "exactly like a Salomon Konink—you know, the pupil of Rembrandt who painted vast level plains." Such landscapes revived him: "The fascination that these huge plains have for me is very strong, so that I felt no *weariness*, in spite of the really wearisome circumstances, mistral and mosquitoes." And in the autumn he wrote that nature was "soft and lovely as the combination of heavenly blues and yellows in a Van der Meer [Vermeer] of Delft." [67] Inspired by the golden sun and the golden wheat, he was catapulted into the Golden Age.

Thinking of his mother, he conjectured, "Involuntarily,—is it the effect of nature here, so like Ruysdael—I think rather often of Holland, and across the twofold remoteness of distance and time gone by, these memories have a certain sadness." [68] Through seeing this land of Provence, he hoped to see both his native land and his estranged mother in a better light. "There is a sun, a light

that for want of a better word I can only call yellow, pale sulphur yellow, pale golden citron. How lovely yellow is! And how much better I shall see the North!" [69]

Perhaps because he was shy and anxious among his own class— among ministers, art dealers, businessmen, even artists, he could be more at ease with the working class society of Arles, just as he had been with the Brabant peasants, the London slum dwellers, and the Borinage coal miners. He once suggested that he would have been better off going to the Riviera where it is more sheltered, and he warned other painters to go to Antibes, Nice, or Menton, where "it is perhaps healthier." [70] He had heard of this region since childhood, for his once-adored Uncle Vincent vacationed in Menton every year. The highbrows, like his wealthy uncle, could go to the Côte d'Azur, but the lowbrows—and those, like Vincent, who regarded themselves as lowbrows—felt more at home in the Provence of the Rhone. He put it very well himself: "I am thinking of frankly accepting my role of madman, the way Degas acted the part of a notary. . . . You talk to me of what you call 'the real South.' The reason why I shall never go there is above. I rightly leave that to men more complete, more whole than I. I am only good for something intermediate, and second rate, and self-effaced." [71] Although he depreciated it, he could feel like an equal in the second-rate environment of Arles. Indeed, the Arlésiens were no better than he even when it came to mental problems: "[E]veryone here is suffering from fever, or hallucinations, or madness. We understand each other like members of the same family." [72]

The Night Café, the one in watercolor, was painted in September 1888. A carrot-topped, crouched figure dressed in blue sits at a table on the right side. It will be recalled that Vincent himself had striking carrot-colored hair and blue eyes and wore a blue jacket. In addition, orange and blue were among his favorite color combinations, and, as in *The Pietà*, he often projected himself into his art by using this particular combination.

The man's face is bent down on the table top, pressing against his left hand, and his right hand covers the right side of his head. There is, he wrote, a "blood red and dark yellow" background behind the figure.[73] Vincent is to portray himself with a bandage around this side of his head four months later, shortly after cutting

off his ear; the background is similar to that behind the bent figure. *The Night Café* also contains contrasting reds and greens, colors that often symbolize the Christmas season. Noting that during the next year he correctly predicted that he would have an attack at Christmas, we could hazard a rash guess that Vincent is here prophesying that he will cut off his ear at Christmas. But there are other hints, tangential though they may be, of a connection between this painting and the Christmas psychosis. He writes, "If [Tersteeg, his former boss at Goupil's in The Hague] saw my picture, he would say that it was delirium tremens in full swing." Here he may be projecting his fear of becoming psychotic into someone else. Perhaps mild premonitory attacks have already given warning of the full-fledged delirium to come. He writes, "The café is a place where one can ruin one's self, go mad, or commit a crime." He describes the night café as a "low public house"—a "sort of brothel" frequented by prostitutes and pimps.[74] Is he predicting his own future? For in a short time he is to "go mad" in a brothel at night.

Whether or not *The Night Café* is a prophecy, we can study it as if it were a dream, seeking its childhood determinants in his thoughts about it rather than in the customary dream associations:

> [T]he picture is one of the ugliest I have done. . . . I have tried to express the terrible passions of humanity by means of red and green. The room is blood red and dark yellow with a green billiard table in the middle; there are four citron-yellow lamps with a glow of orange and green. Everywhere there is a clash and contrast of the most disparate reds and greens in the figures of little sleeping rough-necks, in the empty, dreary room, in violet and blue. The blood-red and the yellow-green of the billiard table, for instance, contrast with the soft tender Louis XV green of the counter, on which there is a pink nosegay. The white coat of the *patron,* awake in a corner of that furnace, turns citron-yellow, pale luminous green.[75]

The scene is "like a devil's furnace"; it concerns something reminiscent of Hell that is frightening and sinful, something that goes on at night, something involving "terrible passions." "Little sleeping roughnecks" refers to rough children; Vincent, we recall, was a roughneck in his mother's eyes. In other words, sleeping children are awakened at night to hear, perhaps dimly see, a passionate and frightening performance. Using Vincent's remarks as a framework, the specific nature of the performance is clarified if we regard the painting as a dream, with its contents translatable

as symbols. The "patron" ("fr. L. *patronis*, a father"), the head of the establishment, is surely a thin disguise for father. The long cue with billiard balls at its base is juxtaposed to his pubic region. Its tip is directed toward the "soft tender" counter behind which is a vaginal-like door opening.

Together these elements add up to a dreamlike representation of a child, resembling Vincent, who is awakened at night to hear and dimly see his parents having intercourse, and who views it as a brutal yet stimulating attack. Whether he actually sees it or only imagines it, a child often conceives of adult intercourse in this way —at least if he has been brought up by tradition to believe that genitals and sex play are shameful and sinful. Vincent, we can postulate, once had, or imagined, such a traumatic experience, and the memory of it was revived by his encounters in the sexually-provocative, violent town of Arles, a town celebrated for its *maisons de tolérance* and the bullfights that the unconscious mind sometimes equates with sexual attacks. This conception of intercourse as a frightening, brutal attack is especially vivid in children who, like Vincent, had already developed a fearful, depressing relation with their mothers.

Vincent painted *The Bedroom* shortly after painting *The Night Café*. He told Theo that the two paintings were meant to contrast with each other. The bedroom scene, illustrating his own room in the Yellow House, is meant to convey a feeling of relaxation: "This time it's just simply my bedroom, only here color is to do everything, and giving by its simplification a grander style to things, is to be suggestive here of *rest* or of sleep in general. In a word, looking at the picture ought to rest the brain, or rather the imagination." [76] This suggests that the bedroom scene is intended to deny the frightening aspects of his perception of intercourse, as depicted in *The Night Café*. There is no one in the bed, no one to carry on the ugly performance; it is day, not night. It is relaxing, not stimulating. But, most apparent in the Louvre version of this painting, there is a man and a woman on the wall above the bed, each contained in a framed picture, looking down on it. Vincent may be using a mental mechanism that is often used in dreams—the displacement of forbidden objects to a neutral location. The observer is outside the scene. He is the artist himself, attempting to master his fear by painting it. The participants are displaced from the bed, which has two pillows but no occupants, to the wall. They are merely observing. Besides, being in different frames, they are well

separated. In this way, the nightmare is contained, and fright is replaced by calm.

Vincent explains that he is trying to "express the power of darkness" in *The Night Café*. It is a night scene, illuminated by bright lights; the lights are surrounded by dazzling halos and "luminous" colors. The psychoanalyst Phyllis Greenacre, in an article called "Vision, Headache and the Halo," has described a similar visual effect in small children who have been suddenly exposed to a frightening view that dazes and bewilders them: "There is generally the sensation of lights, flashes of lightning, bright colors or of some sort of aurora. This may seem to invest the object, or objects seen, or it may be felt as occurring in the subject's own head experienced literally as seeing lights or seeing red. This is depicted in comic strips as seeing stars. The initial experience always produces the most intense emotions, whether of awe, fear, rage or horror." [77] This traumatic effect seems obvious enough in *The Night Café* and is expressed in Vincent's written description of it. Many van Gogh paintings have this same quality, and viewers sometimes react to them with giddiness, as if they had received a blow on the head. Other paintings of this period—for instance, *The Rhone River at Night,* painted in September 1888—resemble the comic strip version of seeing stars. *The Night Café* suggests that the traumatic experience was the perception of adult intercourse, perhaps fused with frightening observations of adult genital organs. If one grants that *The Rhone River at Night* may be interpreted in the same way, then the man and woman in its foreground represent the adult participants in disguise. To deny the horror of the sadistic spectacle, the couple is not locked in intercourse but locked arm in arm, strolling peacefully.

There is additional evidence in favor of this thesis. Vincent developed the same character pattern that Dr. Greenacre has described in these traumatized children: "Mastery is attempted by . . . the development of severely binding superego reaction-formations of goodness which are supplemented by or converted into lofty ideals. . . . Figuratively, the child develops a halo to which, if it remains too burdensome, he reacts either by throwing it defiantly away—conspicuously in some psychopathic and psychotic states—or by endowing someone else with it." [78] Vincent, too, developed "lofty ideals." He became the best of all possible people through his identification with Jesus. This was most obvious during the evangelical period in the Borinage. Later, he attempted to

throw away these ideals, though he never really succeeded in doing so. The figurative halo that he wore during the Borinage period became a reality in his paintings.

In discussing the first Vincent, I mentioned a recollection of childhood that came into Vincent's mind shortly after the ear mutilation and suggested that it was an innocuous substitute for a painful, repressed childhood memory. Vincent described the recollection as follows: "During my illness I saw again every room in the house at Zundert, every path, every plant in the garden, the views of the fields outside, the neighbors, the graveyard, the church, our kitchen garden at the back—as far as a magpie's nest in a tall acacia in the graveyard." [79] He begins with the rooms in the house and ends with the nest high in a tree. Birds and bird's nests interest him much as babies and their cribs, and the former symbolize the latter. (See *Birds' Nests* and *Flying Swallows*.) A high tree often signifies a forbidden observation, as Freud pointed out.* [80] If these symbolic equations are applicable, the nest high in the tree represents a child observing a forbidden act—sexual intercourse, if we follow the hypothesis. The particular room in which the act occurred is obscured by including "every room in the house," and it is separated from the observer in the tree by a series of irrelevant details; these disguises are commonly used in dreams. The graveyard, mentioned twice in Vincent's sentence, links this act of intercourse to death. But, as I suggested earlier in regard to the magpie, it also relates to another set of ideas that may have intensified Vincent's interpretation of intercourse as a brutal attack: ideas relating to his dead brother, the first Vincent, who is buried under a tall tree in this very churchyard in Zundert, ideas that caused him to look upon his parents as sadists who preferred him dead to alive.

Vincent spent less time in Arles than in The Hague, Nuenen, or Paris, yet he turned out an astonishing body of work that includes many large, intricate canvases. The de la Faille catalogue includes about 185 oils, 100 drawings, and 10 watercolors. During this period, too, his confidence in his talent was high. He predicted that his work would undoubtedly secure him "the little corner I have claimed." He believed that it would hold its own with that of Cézanne,[81] whom he greatly admired, and he told Madame

* "Moreover, as I have often been able to satisfy myself, a high tree is a symbol of observing, of scopophilia. A person sitting on a tree can see everything that is going on below him and cannot himself be seen."

Ginoux that his portrait of her would one day hang in the Louvre.

The colors he ordered when he arrived in Arles helped rid him of the darkness of Holland; "hardly one of them is to be found on the Dutch palette," [82] he remarked. The exuberant mood after his arrival was reflected in his paintings. The magnificent blossoming fruit trees were among his first canvases; they are remarkable for combining an Impressionistic style, an emotional fervor, and an absence of any manifestation of disharmony. In May he depicted the plain of La Crau with its golden wheatfields and haystacks, painted from the heights of Montmajour. During his visit to Saintes-Maries-de-la-Mer in June, he drew the fishing boats on the Mediterranean, views of the town, and the picturesque *mas* of the region—the little peasant cottages with crosses jutting forth from their ridge. Back again in Arles he painted the first of his sun-drenched sowers and, before long, the parks and flowering gardens in the town.

In June he also returned to portraying the human figure; he again affirmed, as he had in Paris, that portrait painting interested him more than landscapes: "Altogether, it is the only thing in painting that moves me deeply, and which makes me feel the infinite more than anything else." He had been less secure in depicting human beings than in depicting nature, but this only stimulated him to renewed effort and experimentation. "And I always feel confident when I am doing portraits," he now insisted, ". . . it permits me to cultivate whatever is best and most serious in me," and he strove for portraiture "with the thoughts, the soul of the model in it." [83] He used intimacy with nature as a substitute for intimacy with humans in real life, and he transposed this idea into art: his paintings of nature were substitutes for human portraits. But human beings remained at the core of his interest, and painting them was his most important way of attempting to know, control, and change both them and himself.

During this period, in addition to several self-portraits, he painted portraits of a young girl (*La Mousmé*), his mother (from a photograph), and *Patience Escalier*. Escalier was a former cowboy of the Camargue whom Vincent described as "a sort of 'man with a hoe' "; Meyer Schapiro calls the portrait of Escalier "perhaps the only great portrait of a peasant." [84] Vincent also portrayed the postal agent Roulin and the rest of the Roulin family— Madame Roulin, her adolescent son Armand, the younger son Camille, and the infant girl Marcelle.

In August he painted the first in the famous series of sun-

flowers, continuing the earlier versions from Paris. The sunflower had a special fascination for him, no doubt because its features, anthropomorphized, made it both a self-portrait and a warm benefactor. Far removed from the Dutch tulip that Vincent ridiculed, this rough-stemmed, coarse-leafed indelicate object—used for fodder and cheap fuel—is the peasant flower preeminent; from this standpoint, it was the equivalent of a peasant portrait and a self-portrait. Its bold brilliance also imitates the sun that Vincent held dear as God and loving parent. In addition, its breast-like form may have attracted this frustrated man who longed to be mothered, but of this there is no solid evidence. He himself said that the sunflower symbolized "gratitude." [85]

In September, influenced by a religious mood, he painted *The Rhone River at Night, The Café Terrace at Night,* and portraits —*Eugène Boch* and the *Zouave Lieutenant Milliet* that used the night sky as a backdrop. The idea of scintillating lights was not new to his work, as witness his early drawings of Borinage miners with lights on their hats and the glowing lanterns in *The Weavers* and *The Potato Eaters.* But now they took on a warmer, more luminescent aspect.

Shortly after Gauguin's arrival in October, Vincent again painted *The Sower;* no doubt influenced by Gauguin's attempt to divert him from his Dutch realism, it is overtly symbolic and surrealistic. The sun that forms a halo around the sower's head, the deep blue field, and the green sky produce a mysterious effect. The bright yellow paintings of the exterior of the Yellow House and of Vincent's bedroom inside it were done during the same period. With Gauguin as his companion he also painted *Les Alyscamps* and vineyards during the *vendange.*

Vincent's Chair and *Gauguin's Chair* were painted in December. Like *The Yellow House* and *The Night Café,* they contrast day and night. *Vincent's Chair* is a yellow sunlit scene, and *Gauguin's Chair* is in darker tones of red and green, illuminated by a burning gas jet. The chairs in the paintings are as empty as the Yellow House would be shortly thereafter, when Vincent was hospitalized and Gauguin fled.

In Arles, perhaps more successfully than at any other period, Vincent integrated technical abilities developed from years of practice, a broad knowledge of art and literature, and the various

aspects of his personality into the production of a highly individu-
alistic body of art. Partly due to his familiarity with the techniques
of other artists and his capacity to incorporate relevant aspects of
their work into his own, partly due to his varied moods, his pic-
tures are wide-ranging in style. Some are drawn with the detail and
accuracy of a draftsman, some are Impressionistic, some have exag-
gerated forms. Some are done with thin washes, others with heavy
impastos; some with densely packed dots or short strokes of con-
trasting colors, others with broad expanses of unbroken surfaces
of solid color. Some have a mood of peaceful relaxation, while
others are shocking displays of tormented passion.

Vincent's passionate desire to reconstruct himself and his re-
lationships in his art made him seek new techniques and new
figures with whom he could identify himself. It motivated him to
assimilate and utilize the ideas of a broad spectrum of creative
people in art and literature. But his inability to remain part of a
closely knit group, like his fear of intimacy in general, did not
allow him to adhere to one school of art any more than to remain
committed to one woman or one church; it also facilitated his fight
against self-satisfied orthodoxies. Vincent had no objection to be-
ing called an Impressionist, however, not so much because he felt
he was one but because it gave him a free hand: "That is why I
remain among the Impressionists, because it says nothing and
pledges you to nothing, and as one of them I need not spell out
my ideas." [86] Here was a way of belonging to a group while not
being bound to it.

In Arles Vincent's interest in French artists extended beyond
the Impressionists and old favorites such as Millet and Delacroix,
and included Puvis de Chavannes and Cézanne. The most direct
influence, however, came from Adolphe Monticelli, the painter
from Marseilles who died in 1886, two years before Vincent came
to Arles. Vincent saw himself as a continuation of Monticelli in
Provence, both as a human being and as an artist. He even thought
of going to Marseilles to walk the same streets Monticelli walked,
"dressed exactly like him . . . with an enormous yellow hat, a
black velvet jacket, white trousers, yellow gloves, a bamboo cane,
and with a grand southern air." [87] Monticelli was an illegitimate
child brought up far away from his parents; like Vincent, he never
succeeded in having a happy love life with a woman, and Vincent
sensed their affinity. He called Monticelli "a melancholic, some-
what resigned, unhappy man, who saw the wedding party of the

world and the lovers of his time pass by, painting and analyzing them—he, the one who had been left out of things." [88] (Perhaps Vincent did not know it, perhaps it is coincidence, but, like Vincent, Monticelli also fell in love and was turned down by his cousin, Emma Ricard, a refusal that caused him to withdraw for a while from his work and contemplate becoming a monk.) [89]

Vincent wrote that no painter was so direct a descendant from Delacroix as Monticelli, and, as Germain Bazin has observed, Monticelli was "the necessary link between Delacroix and van Gogh." [90] Vincent had been impressed by Delacroix's color theories before he became acquainted with Monticelli. But Delacroix was sophisticated, wealthy, and high-born, and his art was fit for palaces—not someone with whom Vincent could identify himself either as a person or an artist. In Monticelli, a poor outcast, Vincent found a man like himself and art that was better suited to his own personality. Monticelli's paintings were more crude, more frenzied, more tormented, and more luminescent than Delacroix's, and, as Vincent noted, he used "a terribly thick impasto" [91]—characteristics that were admirably suited to Vincent's need for self-expression. Because of this, Vincent could more easily incorporate Delacroix's ideas about bright contrasting color into his work by studying Monticelli rather than Delacroix himself.

In the area of color, Monticelli contributed two important techniques to Vincent's art. One was the ability to make his colors glow. When the critic Albert Aurier wrote that Vincent was the only painter "to perceive the chromatism of things with such intensity, with such a metallic, gemlike quality," Vincent pointed out that Monticelli, not he, should be given credit.[92] The other was the arbitrary use of color. "Surely Monticelli gives us not, neither pretends to give us, local colour or even local truth," Vincent wrote in English to John Russell. "But gives us something passionate and eternal—the rich colour and rich sun of the glorious South in a true colourist way parallel with Delacroix' conception of the South viz. that the South he represented now by contraste simultané of colours and their derivations and harmonies and not by forms and lines in themselves. . . ." [93] With this stimulation, Vincent was enabled to "use colors arbitrarily to express myself more forcibly," an ideal approach for a personality that was impelled to express itself forcibly. As he knew, this approach suited him better than that of the Impressionists: "Color expresses something in itself, not merely to convey an illusion of shimmering reflexes of light." [94]

On the other hand, Vincent did not use Monticelli's dark backgrounds; he had had enough darkness in his life and in his art. With a few exceptions, he also shunned the imaginary scenes that Monticelli favored, for he needed to keep his feet on the ground to preserve his sanity.

Both in Antwerp and Paris Vincent had been fascinated with Japanese colored woodcuts, especially those of Hokusai and Hiroshige, and collected many of them. He "copied" some of them in Paris. In this interest he followed the Impressionists: Manet, for example, had used a Japanese print in the background of a portrait of Zola about twenty years before Vincent used them in his portrait of Tanguy.

Vincent's enthusiasm ("All my work is founded on Japanese art. . . ." [95]) prepared him to see Provence in terms of the Japan he knew from these prints. No sooner had he settled in Arles than he wrote, "I feel as though I were in Japan." In June he felt he saw things "with an eye more Japanese." And in September he continued, "For my part I don't need Japanese pictures here, for I am always telling myself *that here I am in Japan.*" [96] He reinforced this illusion by painting a self-portrait with slanted eyes. But when he claimed that his life in Arles would become "more and more like a Japanese painter's, living close to nature, [97] he was simply reaffirming his peasant identity in new terms.

Apart from their aesthetic virtues, the brightly colored Japanese prints interested Vincent for the same reasons the dark English prints had interested him when he was in the North. Both were inexpensive, within reach of the common man, and dealt with nature and commonplace subjects. Their imaginative, rapid draftsmanship—exaggerated and bold, yet simplified—also appealed to him. Predictably, he ignored the rigid, stylized aspect of Japanese prints in favor of their emotional intensity, particularly as he saw it in the work of Hokusai. He was impressed by an "extreme clearness" that seemed to be as "simple as breathing," [98] and he followed their use of large flat surfaces of pure contrasting colors that were sharply defined from each other, the omission of shadows, and the silhouetting of objects on a light background; in doing this he hoped to obtain greater clarity in his own work.

Seeing and depicting the world as clear was an antidote to the underlying depressed state in which he saw it as confused and agitated. The use of pure colors and the simplification of forms are common features in peasant art, and Vincent's identification with the peasant might have led him to their use in any case, but Japanese prints helped him find his way there.

He also borrowed the Japanese technique of cutting off objects at the edge of the picture and using diagonals in the foreground, features that contributed to a feeling of intimacy while giving greater depth to objects in the distance.

Vincent's tendency to exaggerate, a tendency that at times approaches caricature, was also stimulated and encouraged by others. Camille Pissarro told him that painters "must boldly exaggerate the effects of either harmony or discord which color produces." [99] He also was aroused by the writings of Guy de Maupassant and Emile Zola, who advocated the same approach in literature. He cited, for example, de Maupassant's belief in "the artists' liberty to exaggerate, to create in his novel a nature more beautiful, more simple, more consoling. . . ." [100] His description of the two French authors followed his own attempt to allay misery by wrapping it in a colorful package: "What they absolutely insist on is something very rich and something very gay in art—even though this same Zola and Guy de Maupassant have said perhaps the most poignantly tragic things that have ever been said." [101]

Vincent's religious feelings became more intense during his stay in Provence, and he sometimes equated biblical scenes with people and places there. The hot, arid country with its bright sun, rocky land, and olive trees may have reminded him of the Holy Land, whose geography he knew so well. The poems of Walt Whitman also seem to have influenced Vincent's poetic-religious mood of September, with its speculations about death and eternity, and the pictures of starry nights. He observed that Whitman was concerned with "a world of healthy, carnal love, open-hearted and frank—of friendship—of work—under the great starlit vault of heaven a something which after all one can only call God—and eternity in its place above this world." [102] One of Whitman's collection of poems is entitled "From Noon to Starry Night," and its final stanza, "A Clear Midnight," ends with the line: "Night, sleep, death, and the stars."

All these external influences collaborated with Vincent's state of mind in producing his artistic vision of Provence. The depressed

alcoholic state of his last days in Paris cleared up after his arrival, and the world appeared in a far brighter light. Indeed his view of it soon became supercharged; he entered into "a continuous fever of work," "ideas came in swarms," and he worked with "an extraordinarily feverish energy." [103] The bright sun stimulated him: "In the South one's senses get keener, one's hand becomes more agile, one's eye more alert, one's brain clearer. . . ." Looking back, he knew that in order "to attain the high yellow note that I attained last summer [1888], I really had to be pretty well keyed up." [104] Early in autumn he noticed that he experienced things with "a terrible lucidity," and pictures came "as if in a dream." Apparently this high-pitched state continued into 1890, for Dr. Rey noticed "a productive energy intensified to a frenzy" [105] after Vincent recovered from his injury.

These observations suggest that Vincent's depression was replaced by a hyperactive, hypersensitive state similar to the manic phase of a manic-depressive psychosis. Unlike the typical manic state that is disorganized and aimless, however, Vincent's was goal-oriented and was put into the service of art rather than wasted away. It contributed to the clarity of his pictures, to their vivid colors, and to the speed in which he produced them. The Provence Vincent perceived was not the Provence seen by Provençals or ordinary tourists; Dr. Tralbaut, the van Gogh expert who has lived in the region of Arles for many years, points out that this region is not especially colorful, that one never sees the brilliant colors that Vincent imagined.[106] Rather, it was the Provence created by a hypersensitive Dutchman who wished to see—and saw—a sun-struck Holland, modified by a vision of the South as he had seen it in the art of the Impressionists and Monticelli and as he had read about it in Daudet and others, as well as by the printmakers' conception of Japan.

In combining these various elements Vincent managed to use those aspects of artistic and literary knowledge that complemented his own personal and artistic identity, discarding others that were irrelevant for his needs. While doing this, he retained in his work the same personal characteristics that entered into his northern work. His pictures were still concerned with common people, with the earth, and with the forces of nature. He still viewed himself as a rough peasant painter, and he still defied the cleanliness, the fussiness, and the niceties he had been taught as a child. He did not quarrel with those who complained that his pictures were not

neatly "finished." He regarded painting as a dirty business, and he felt that his pictures were "ugly and coarse." [107] He still preferred to use inexpensive, common materials; for example, he extolled the virtues of coarsely brayed colors and of Prussian Blue—"that vulgar blue" that "yields as much as six of ultramarine or cobalt and costs *three times less*," and he mixed it with "zinc white in its crude state." [108] Milliet observed that he attacked the canvas like a real savage, and Dr. Rey observed that his overcoat was "smeared all over with colors—he painted with his thumb and then wiped it on his coat." [109]

These attitudes and techniques, however, were not indications that he downgraded himself as an artist but evidence of his artistic integrity. He put it modestly: "However, at present the élan of my bony carcass is such that it goes straight for its goal. The result of this is a sincerity, perhaps original at times, in what I feel, if only the subject can lend something to my rash and clumsy execution." [110]

9 Vincent's ear

THE OFT-DRAMATIZED event of van Gogh cutting off a piece of his ear and giving it to a prostitute has provided a powerful stimulus for the naïve but popular notion that great artists are apt to be insane. The psychoanalyst presumes that such an incident has its roots in childhood, and that a continuum exists between early events and later ones. Like dreams, symptomatic acts such as the ear mutilation have multiple determinants in both the past and the present that contribute to their particular constellation. As we shall see in the next chapter, the crisis was probably brought about by a neurological disorder, but the disorder could not have led to this particular act without the influence of other, purely psychological elements. Complex acts that utilize memories and associations require psychological explanations regardless of diagnosis. This chapter will try to show how various aspects of Vincent's life converged in this single episode.[1]

Vincent's sister-in-law, Mrs. van Gogh-Bonger, has described its context: "The day before Christmas—Theo and I had just become engaged and intended to go to Holland together . . . a telegram arrived from Gauguin which called Theo to Arles. On the

evening of December 24 * Vincent had in a state of violent excitement . . . cut off a piece of his ear and brought it as a gift to a woman in a brothel. A big tumult ensued. Roulin the postman had seen Vincent home; the policemen had intervened, had found Vincent bleeding and unconscious in bed, and sent him to the hospital. There Theo found him in a severe crisis and stayed with him during the Christmas days. The doctor considered his condition very serious." [2] The local newspaper reported the incident as follows: "Last Sunday night at half past eleven, a painter named Vincent van Gogh, a native of Holland, appeared at the *maison de tolérance n. 1,* asked for a girl named Rachel, and handed her his ear with these words: 'Keep this object carefully.' Then he disappeared. The police, informed of these happenings which could be attributed only to an unfortunate maniac, looked the next morning for this individual, whom they found in his bed with barely a sign of life." [3]

Both Gauguin and Roberts, the policeman who received the ear from the prostitute Rachel, reported that the entire ear was severed. But Dr. Gachet, his son, the painter Signac, and Mrs. van Gogh-Bonger—all of whom had a chance to observe him during more sober times—contradict this. After a thorough examination of the evidence, Doctors Doiteau and Leroy concluded that the lower half of the left ear was excised. [4] The incision was diagonal; it began posteriorly toward the top of the ear and cut anteriorly through the tragus (the prominence in front of the external opening). Vincent's self-portraits after the episode, being mirror images, show the bandage on the right side.

The widely publicized version of the episode by Paul Gauguin, written in 1903 in *Avant et Après,* has often been discredited as an attempt by Gauguin to justify the fact that he abruptly left Vincent and Arles after the incident. . . . Gauguin was taking a walk and heard van Gogh's step behind him: "I turned about on the instant as Vincent rushed toward me, an open razor in his hand. My look at that moment must have had great power in it, for he stopped and, lowering his head, set off running toward home.

"Was I negligent on this occasion? Should I have disarmed him and tried to calm him? I have often questioned my conscience

* "December 24" is no doubt a slip, inasmuch as the telegram arrived that day. The incident had occurred on Sunday night and the Sunday before Christmas in 1888 fell on December 23.

about this, but I have never found anything to reproach myself with. Let him who will fling the stone at me." [5]

Emile Bernard, artist-friend of both Vincent and Gauguin, spoke to the latter four days after his return to Paris. Immediately thereafter Bernard wrote a detailed description of the episode as Gauguin had related it to him. The art historian John Rewald notes that there is one remarkable difference between it and Gauguin's later version: "In Bernard's report there is *no* mention of van Gogh having tried to throw himself upon Gauguin with an open razor in his hand. Indeed Bernard states clearly, repeating of course Gauguin's words, that Vincent had taken the razor *after* returning to the house, in order to mutilate himself. It may well be that Gauguin, writing his memoirs in 1903 (at a time when the strange details of this incident had already been widely reported), chose to emphasize van Gogh's aggressiveness so as to better justify his having abandoned a friend in a moment of crisis." [6]

The Dutch psychoanalyst A. J. Westerman Holstijn, in the first comprehensive psychoanalytic study of van Gogh, pointed out that two frustrations contributed to the self-mutilation: the engagement of Theo and the failure of the relationship with Gauguin.[7] This double frustration incited aggressive impulses within van Gogh which, having been unsuccessfully directed toward Gauguin, were then turned upon himself. Westerman Holstijn may have been the first to suggest that Vincent's ear was a phallic symbol and that the act represented castration. The self-punishing tendencies in this act, he added, resulted from a conflict concerning homosexual impulses. He suggested that a Dutch slang word for penis (*lul*), a word that happens to resemble the Dutch word for earlobe (*lel*), played a role in the symbolism. Daniel Schneider, another psychoanalyst, agreed that the ear is a phallic symbol. Van Gogh, Schneider, said, "lives under the constant overpowering threat and masochistic homosexual unconscious wish for castration. Finally when he slices off his ear and gives it to the prostitute who accepted Gauguin, he brings it about rather than face it any longer." [8] Jacques Schnier, a professor of art and a psychoanalyst as well, also agreed that the self-mutilation resulted from aggression being turned inward, that the ear was a phallic symbol, and that the act was a symbolic castration. Professor Schnier suggested that in giving the ear to a prostitute, Vincent fulfilled an unconscious wish to possess his mother following the fantasied

assault upon a father-substitute, Gauguin.[9] Vincent outwardly idealized Gauguin, the man toward whom the aggression was intended, though inwardly he seethed with hatred toward him. This ambivalence was derived from Vincent's earlier relationship toward his father.

As if to shame the analysts, the French art critic Frank Elgar asserted, "There is no need to invoke complex scientific ideas for an explanation of this tragedy." But in the next breath he adds: ". . . We have to imagine his state of mind when Gauguin announced his departure. In this fresh defeat he had the appalling sensation of having been outlawed by that very humanity with which he had always longed, from childhood, to be united. This inferiority complex was reinforced by one of guilt. Like Orestes turning, in his mania, upon himself, he punishes his guilt by severing his own ear. Next, in a Christian spirit of self-sacrifice he carries this fragment of himself, his own living flesh, to the most fallen of human beings." [10]

J. Olivier of Saint-Rémy-de-Provence, raised in the land in which the event occurred, proposed a refreshingly new interpretation. He suggested that the bullfights in Arles made a deep impression on Vincent and contributed to the self-mutilation. The matador is given the excised ear of the bull as an award. Upon receiving the ear, Olivier explained, the matador tours the arena, displaying the prize to the crowd of spectators; then he offers the ear to his lady or a female spectator:

> I am absolutely convinced that Van Gogh was deeply impressed by this practice. . . . Van Gogh cut off the ear, his own ear, as if he were at the same time the vanquished bull and the victorious matador. A confusion in the mind of one person between the vanquished and the vanquisher. This is often the case with all of us. It may easily have been the case with Van Gogh that same night when he was provoked to overexcitement by Gauguin, yet refused to be dominated by him. Personally, I see in it a collapse followed by a courageous and magnificent exaltation, which ends in a relief of tension and an appeasement . . .
>
> The psychiatrist sees it differently. The novelist too. This is caused by the fact that both are ignorant of the conditions which might have rendered their judgment more accurate." [11]

Olivier's criticism is correct—in part. I cannot speak for the novelist, but the psychiatrist and the psychoanalyst are prisoners of their times and tend to explain phenomena in accordance with

prevailing formulae, the present attempt being no exception. For this reason symptomatic acts and behavior patterns are sometimes explained in arbitrary and stereotyped terms. When this is the case—witness the unanimity of opinion regarding the diagnosis of Vincent's ear as a phallic symbol—relevant material from the individual's present or past life may be overlooked because it does not readily fit into popular theory and practice. If Olivier is right, however, it does not follow that the psychiatrist is wrong, for a vital role is played in our psychic processes by the phenomenon of overdetermination—the remarkable ability of the mind that permits a variety of life forces to work together in the determination of human traits and symptoms. The bullfight, which Vincent mentions in letters from Arles, may have contributed to a pattern that had been developing out of a lifetime of experience. By this token, other interpretations of the incident may be valid and at the same time compatible with Olivier's. For instance, the blood and cruelty of the bullfight might have stirred up old castration fears that were then displaced to the ear.

Another event may have also influenced Vincent's behavior. Between the end of August and the ear incident in December, Jack the Ripper had mutilated a series of prostitutes in London's East End. He typically cut the throats of his victims and removed various organs, including their ears. These crimes gave rise to emulators, and Vincent may have been one of them. As a masochist instead of a sadist, however, it is conceivable that he would reverse Jack's act by mutilating himself and bringing the ear to a prostitute.

If the news story was available, Vincent would probably have read it, for at that very time he wrote, "At times, driven by a certain mental voracity, I even read the newspapers with fury. . . ."[12] It was found that Le Forum Républicain, the Arles weekly of the period, contained only local news, and that the newspapers from Marseilles were the usual source of general information; indeed, Vincent himself referred to an article in an unnamed Marseilles paper. Accordingly, a search in the Archives Départementale of the Bouche-du-Rhône disclosed fifteen articles on Jack the Ripper in Le Petit Marseillais, a daily with a wide circulation in Arles in 1888. The first appeared on September 8 and the last on December 22, the day before the ear mutilation; the gory details are described in many of them. Of particular interest, the article of October 2 quoted a letter from the assassin announcing that "in

his next crime he would cut off the ears of his victim, and this was in fact done on one of the bodies found yesterday." Again, ten days before the self-mutilation, another assassination was reported from London, presumably committed by one of Jack's emulators, in which the woman's carotid artery was sliced with so much violence "that a piece of the right ear was removed." Reading these stories may have acted like the contemporary events (called the "day residues") that characteristically contribute to the content of dreams.

Explanations for an incident such as this need to clarify its specific details. For instance:

Why did it occur at Christmas time?

Why did he mutilate his ear?

Why did he take the ear to a prostitute? a prostitute named Rachel?

Theo, the Roulins, and Gauguin were involved in the incident: What parts did they play?

The explanation of the bullfight may have contributed to the selection of the ear, and that based on Jack the Ripper may clarify the selection of the ear and the prostitute, but they do not answer the other questions. Perhaps no other spectator in all the history of bullfighting has cut off an ear at Christmas time and presented it to a prostitute. We need to understand the particular forces that led van Gogh, out of the fusion of past experience, to do just this. Castration fears, acting out of the Oedipus complex, repressed homosexual impulses, and guilt and self-punishment are ubiquitous phenomena which may be found in almost any psychoanalytic case history or psychoanalytic study of the great. But to make some sense of this "senseless" act, we should try to find out why they led to this particular type of self-mutilation at this particular time under these particular circumstances.

At the time, Theo had just become engaged to Johanna Bonger. Vincent undoubtedly knew of the engagement then, although he did not mention it in his letters until after leaving the hospital.[13] Theo's son, Dr. V. W. van Gogh, has written: "The trouble with Gauguin in Arles started right after Vincent had heard from Theo that he intended to marry. . . . It must have passed through his mind that he would lose his support, though he never mentioned it and it never came about."[14] Vincent must

have also thought that the engagement, tying Theo forever to someone else, would destroy the possibility of achieving the all-encompassing relationship with his brother for which he longed. Christmas had formerly been the season when Vincent got together with Theo; now he learned that Theo would use the holiday to accompany Jo to Amsterdam, where they were to visit her family. In the light of his psychological and financial dependence on Theo, it can hardly be doubted that Vincent's abiding sense of loneliness and depression was seriously aggravated. The self-mutilation was, in a way, an attempt to strengthen the weakened bond with Theo (and with Jo as well), while avoiding a direct confrontation with him.

Vincent may have been unaware of his resentment, nor could he openly criticize Theo and Jo in order to cause a rupture between them. There was nothing to criticize in her, and even if there were, it would not have been in keeping with his past reactions. His own problems made him eager to bring people together, not push them apart. Indeed, he had previously encouraged Theo to carry on a relationship with a woman with much lesser assets than Jo. Besides, there were advantages in encouraging a union. Through Theo's role as mirror image, Vincent could be united with a good woman, a desire he had never been able to fill on his own.

In this way, the self-destructive act helped absorb the disappointment and solve the conflict regarding his brother's prospective marriage. A demand upon them for attention, his self-imposed illness caused both Theo and Jo to worry and care for him as if they were his parents, and forced Theo to spend the Christmas holidays with him instead of her. Ironically, Vincent later blamed Gauguin for informing Theo of the episode.

To Vincent, Joseph Roulin was the latest in a line of substitutes for his father. Disillusioned with the latter, he shied away from men who resembled him and sought heroic substitutes with revolutionary ideas, like Michelet. As an artist he turned to the older generation of painters. But these men were only ideological substitutes. Anton Mauve took on the real life task in The Hague but threw off the burden in short order. Vincent also settled for men like Père Tanguy, the paint dealer and old revolutionary of Paris. Warm, artless Roulin was Tanguy's successor in Arles.

"I have rarely seen a man of Roulin's fortitude," Vincent exclaimed, "there is something in him tremendously like Socrates, ugly as a satyr, as Michelet called him, 'until on the last day a god appeared in him that lit up the Parthenon.' " [15] Vincent wanted to replace his handsome father with an ugly Socrates, and he found such a man in Roulin—a new father who spoke the truth without fear of consequences, but accepted him as he was, demanding nothing and giving much. "Roulin, though he is not quite old enough to be like a father to me," Vincent wrote, "nevertheless has a silent gravity and a tenderness for me such as an old soldier might have for a young one." [16]

Vincent was also pleased because the Roulins were a big family, similar to his own in size. But whereas his own family, he felt, was unhappy and rejecting, the Roulins seemed the opposite. Although he made very few paintings of his own family, he made many of them. At the time of the ear incident, he was painting *The Cradle*, using Madame Roulin for his model. This was the first of five similar paintings of a mother rocking a cradle, the cradle being outside the painting. His envious identification with happy babies even affected the way he saw his subject: "I have just said to Gauguin about this picture that when he and I were talking about the fishermen of Iceland and of their mournful isolation . . .'. the idea came to me to paint a picture in such a way that sailors, who are at once children and martyrs . . . would feel the old sense of being rocked come over them and remember their own lullabies." [17] He thought of himself as he thought of the fishermen. He too was the child and the martyr who lived in mournful isolation, wanting to be rocked and loved. In painting *The Cradle*, he identified himself with the beloved child who is rocked by the full-breasted mother.

In becoming one of the Roulins, Vincent gained substitute parents, a substitute family, and a substitute childhood. He had a loving mother who did not neglect, criticize, and humiliate her child. He had a father who was not a righteous moralist, and relatives whose lives did not center around ambition, power, and money. He did not have to depend on Dutch family tradition; rather he was encouraged by a "French Revolutionary" who appreciated his own revolutionary ideas. He acquired new parents whom he did not fear, who did not intensify his guilt or shame him for his rough ways, and who paid attention to him in spite of their own tribulations.

Yet all this remained fantasy, however pleasant. He was not the beloved child; he merely identified himself with the beloved child. But Vincent's masochistic development had taught him that to injure himself—and thereby become sick, helpless, and childlike —might transform fantasy into the real thing. And, indeed, the episode seems to have had some success in this respect. While little is known of Madame Roulin's response except that she continued to be a faithful model, Monsieur Roulin helped Vincent during the night of the mutilation and devoted his spare time to caring for him afterward. In reporting Vincent's recovery to Theo, Roulin wrote, "You may rest assured that I shall do all I can to give him some distraction." When Vincent was in the hospital, Roulin went to the doctor and persuaded him to permit Vincent to go back to his pictures. He took care of the Yellow House and arranged for the rental payments. On January 8, 1889, he wrote to Wilhelmina: "[We] keep each other company all day long. . . . I go to see him as often as my work permits . . . I shall always do my utmost to deserve the esteem of my friend Vincent as well as of those who are dear to him." [18]

Gauguin, of course, played an important part in the drama of the ear, but there is considerable disagreement in the interpretation of his role. Elgar asserts that the incident resulted from the failure of Vincent's friendship with Gauguin. René Huyghe believes it was due to the collapse of his dream of a collective studio which Gauguin was to head. [19] Dr. Schneider feels that Gauguin's defeat of Vincent in their search for prostitutes precipitated the event and that the mutilation itself expressed Vincent's masochistic homosexual desire for Gauguin. Professor Schnier suggests that Gauguin represented Vincent's hated father in a reenactment of the Oedipus complex. Many writers believe that Vincent turned his aggressive impulses toward Gauguin on himself.

Man's behavior is of such complexity that there may be truth in all of these suggestions. One's motivations include the superficial factors that are well known to oneself as well as deep, troubling factors that one would vehemently deny when confronted with them. Man carries his conflicts from one period of life to the next, and each stage of development puts its mark on the next. Hate and love, masculinity and femininity, aggressivity and passivity exist side by side in the unconscious mind, each having its own

voice in the total behavior. Only a close examination, in which the searcher may get lost in a mass of details, can hope to bring forth interpretations of substance rather than ideas that simply encompass the complete gamut of psychological theory.

Vincent recognized that Gauguin was "a very great artist," but his prodigious efforts to induce Gauguin to share his life at Arles were due to more than the realistic considerations of furthering their art and of his desire for an artist-colleague. There were also deep-seated needs that grew out of the conflict of his earliest years and out of his attempt to solve them. Vincent's logic told him that it was foolish to browbeat Gauguin into coming, but his emotions demanded that he do so.

Vincent arrived in Arles February 20, 1888. Gauguin did not come until eight months later, but the campaign to entice him began in the first days of May. Vincent wrote to Theo, "I could quite well share the new studio with someone, and I should like to. Perhaps Gauguin will come South." [20] He attempted to convince himself that the two of them would live on the same money that he then spent on himself. On June 6 his impatience forced him to prod Gauguin: "Send us your answer at your earliest convenience." Soon after, he told Theo, "I am very curious to know what Gauguin is going to do. I hope that he will be able to come." His pleas continued:

"I wished I were in the same place with him, or he were here with me."

"I am very curious to know what Gauguin will do."

"Your letter brings great news, namely that Gauguin agrees to our plan. Certainly the best thing would be for him to come rushing here at once."

"I am thinking about Gauguin a lot, and I am sure that in one way or another, whether it is he who comes here or I who go to him, he and I will like practically the same subjects, and . . . I am convinced that he would fall in love with the country down here."

"Do you realize that if we get Gauguin, we are at the beginning of a very great thing, which will open a new era for us. . . . *Gauguin's fare comes before everything else,* to the detriment of your pocket and mine. *Before everything else.*"

"My whole mind, like yours, is set on Gauguin now. And like you, I hope that he will come right away."

"Since he is not coming at once, *I want all the more to try to*

have everything in good order, and in readiness for him when he does come. . . . [In enclosed letter to Gauguin:] And do come as soon as you possibly can! P.S. to Gauguin. If you are not ill, do please come at once. If you are too ill, a wire and a letter, please." [21]

When Gauguin did not reply to his entreaties, Vincent sometimes acted like a frustrated lover who denied what he longed for: "Mind, as to Gauguin we must not give up the idea of coming to his aid . . . but *we do not need him.*" On another occasion, again discouraged by lack of news, he hoped to keep his resentment under control: "Only I think that one must say nothing unpleasant to Gauguin if he does change his mind, and take it absolutely in good part." [22]

Gauguin's financial distress and poor health seem to have been the initial stimuli for Vincent's desire to bring Gauguin to his side. The first reference to Gauguin, in the fourth letter from Arles, was concerned with this misery: "I have had a letter from Gauguin telling me that he had been sick in bed for a fortnight. That he is on the rocks, as he has some pressing debts." [23] Gauguin's plight was a challenge. Vincent had always been drawn to the sick and the poor, and Gauguin had even more than that to offer him. While Vincent perceived Gauguin as a companion who would keep him out of the mire of isolation, Gauguin would serve a different function than Theo. Theo took care of Vincent, but Vincent would take care of the sick penniless Gauguin. After all, Vincent had nursed poor sick people in the Borinage, and his relation with his mother improved temporarily when he was able to nurse her after she injured her hip. An earlier wish to become a doctor was no doubt related to his interest in nursing the sick and suffering. In all of these situations he took on the role of a loving mother toward a helpless child.

Vincent's admiration and compassion did not prevent him from being suspicious of Gauguin's ambitious yet mercenary plans to be an art dealer, and he spoke contemptuously of "Gauguin and his Jewish bankers." [24] Although he longed for Gauguin, he was cynical about the project: "The society [which Gauguin desired to form] *gives its protection in exchange* for ten pictures, which the artists have to *give;* if the artists did this, this Jew Society would pocket a good 100 pictures 'to begin with.' Pretty dear, this protection by a society which doesn't even exist!" Vincent wanted to give to "poor Gauguin," but poor Gauguin wanted to

take from others! Vincent was clearsighted enough, at least at times, to realize "that Gauguin would already have left us completely in the lurch if Laval had had ever so little money. . . . Faithful he will be if it is to his advantage. . . ." Gauguin did not want to come to Arles, but he would always need his "daily bread and shelter and paints," [25] and Vincent was willing to take advantage of this to get him there.

Despite sporadic denials of his mistrust, Vincent's doubts increased one month before Gauguin arrived: "I feel instinctively that Gauguin is a calculating man who, seeing himself at the bottom of the social ladder, wants to regain a position by means which will certainly be honest, but at the same time, very politic." "Certainly," one of those reassuring words that is sometimes used to deny the opposite, was probably intended to reject the unwelcome idea that Gauguin was dishonest. But soon his suspicions of Gauguin could come into the open, for he had found a way of excusing him: "If someday he decamps from Pont-Aven . . . without paying his debts, I think in his case he would still be justified, exactly like any other creature at bay." [26] Vincent continued to tempt Gauguin to come to Arles, although he suspected that Gauguin would use or betray him after he got there.

Vincent was almost prophetic in saying of Gauguin: "If it does not suit him here, he may be forever reproaching me with, 'Why did you bring me to this rotten country?' " Indeed, Gauguin's widely publicized criticism of his would-be rescuer had been "forever reproaching" him. Vincent invited, even seduced this potential persecutor to live with him, another example of a long-established pattern in which love and suffering combined. This helped to account for the choice of Gauguin rather than Bernard, also a talented painter and a far more devoted friend. In fact, Vincent went out of his way to discourage the loyal Bernard from visiting him.

Psychoanalytic writers agree that Vincent was sexually attracted by his comrade. Rather than assert that the two engaged in overt homosexual practices, they suggest that Vincent's latent sexual interest in Gauguin stirred up enough guilt to trigger the Christmas explosion. There can be little doubt that Vincent's wish to live with Gauguin was less a wish for the business partnership of which he wrote than for a passionate love affair. Vincent wrote about Gauguin with an ardor that was far removed from business, and their discussions were as charged as lover's quarrels: "Our

arguments are *terribly electric,* sometimes we come out of them with our heads as exhausted as a used electric battery." [27] Homosexual impulses may have been coming closer to consciousness during the days preceding the self-mutilation. Writing of this period, Gauguin claimed, "On several nights I surprised him in the act of getting up and coming over to my bed." He implied that Vincent, in a trance, was going to hurt him; he ignored the other possibility.

Passages in Vincent's letters suggest that he saw Gauguin as a mixture of feminine and masculine. In decorating the Yellow House, Vincent's own room was to be simple and sturdy while Gauguin's room was to be dainty and pretty. He wrote to Theo: "If Gauguin comes, or someone else, there is his bed ready in a minute. . . . the prettier room upstairs, which I shall try to make as much as possible like the boudoir of a really artistic woman. Then there will be my own bedroom, which I want extremely simple, but with large, square furniture, the bed, chairs and table all in white deal. . . . The room you will have then, or Gauguin if he comes, will have white walls with a decoration of great yellow sunflowers . . . crammed into this tiny boudoir with its pretty bed and everything else smart." [28] Like a son long separated from his mother, anticipating the marvels that only she could concoct, he eagerly awaited Gauguin's cooking and praised it mightily when it was finally put before him: "[H]e knows how to cook *perfectly.*" [29] On the other hand he envied Gauguin's physical strength and his sexual prowess. He called Gauguin a creature with savage instincts in whom blood and sex prevailed over ambition, "very successful with the Arlésiennes." [30] In view of Vincent's own interest in Gauguin, these successes may have provoked a jealous rage that resulted in the angry attack the night before the ear episode in which, according to Gauguin, Vincent threw a glass of absinthe in his face.

Both the feminine mothering aspect and the virile male aspect of Gauguin are represented in *Gauguin's Chair,* Vincent's symbolic portrayal of his comrade. The chair's broad curving bottom appears identical to the chair of *The Cradle* that contains the curved broad-bottomed, feminine figure of Madame Roulin. But there is a contradiction. A lighted candle stands erect in the forepart of Gauguin's seat, with two modern novels beside it. If we pursue the hypothesis that these paintings represent body images (there are other aspects to them, to be sure), Gauguin's femininity as ex-

pressed in the lines of the chair becomes a cloak for a singularly potent maleness, and Gauguin becomes a woman with a penis— the common fantasy of boys who have observed that some people lack them, fear that the same terrible thing might happen to themselves, and then imagine in desperation that everybody has one. To carry this idea one step further, Gauguin, in this bisexual role, may have represented his loved-feared-hated mother—a dangerous phallic mother of the kind often uncovered during psychoanalysis in the submerged fantasies of male patients whose fears of women and their genitals beget strong homosexual predispositions.

One can conjecture about other roles that Gauguin may have played. For example, he may have been a substitute for the dead older brother. Vincent idealized Gauguin as his mother idealized the first Vincent. But now the idealization was limited to Gauguin's artistry; he knew that in other ways Gauguin was far from perfect, indeed he was bad. In this way Vincent could be the good one, reversing the childhood situation. Or, as some have suggested, Vincent may have seen Gauguin as a replacement for his father, and the mixed feelings of love, envy, and resentment that Vincent felt for his father may have been displaced to him. Out of Vincent's need to strengthen his image of himself as a man, Gauguin— who was talented, strong, and successful with women—could have served as an alter ego. These hypotheses may be reasonable enough —as hypotheses. But Vincent's attitudes and feelings about Gauguin as expressed in his letters do not offer convincing evidence. Failing additional information, we will put them in limbo.

In any case Gauguin was to have another, more relevant role in the drama. Constructed out of the hodgepodge of Vincent's impulses, fantasies, and self-protective devices, he was to play the part of Judas to Vincent's Jesus.

Rachel, the prostitute to whom Vincent brought his ear as a gift, was the last in a series of women with whom he had miserably unhappy relationships. From childhood, Vincent had been attracted to "despised" women, and his reverses with Ursula Loyer in London and Kee Vos in Holland, self-sought as they were, pushed him back to them. We do not know when he first visited prostitutes, but they formed a regular part of his life from the time he met Sien. In Arles, as one observer put it, "he was always hanging around in brothels." [31]

Prostitutes may have been inferior women from one point of view, but "they have a certain passion, a certain warmth," he wrote from Drenthe in 1883, "which is so truly human that the virtuous people might take them as an example." Prostitutes were more than sexual outlets; indeed, he suggested more than once, he had infrequent sexual relations with them. Vincent had to care for a prostitute and trust her if the relation was to be satisfactory, as he wrote to Theo: "And I tell you frankly in my opinion one must not hesitate to go to a prostitute occasionally if there is one you can trust and feel something for, as there really are many." Vincent rejected his religious and middle-class mores because they were, in part, extensions of his feared mother's coldness and rejection. "I know full well that whores, frankly speaking, are bad," he conceded, "but I feel something human in them which prevents me from feeling the slightest scruple about associating with them. . . . If our society were pure and well regulated, yes, then they would be seducers; but now, in my opinion, one may often consider them more as sisters of charity." [32]

Bernard's description of Vincent's "extreme humanity for prostitutes" suggests that he treated them as madonnas to be worshipped: "I myself have been a witness to sublime scenes of devotion on his part." Thus Vincent turned "bad" women into "good" mothers.

Like Vincent, the prostitute was an outsider in the world, and, as he explained in August 1888, this could be turned to good use: "Being a creature exiled, outcast from society, like you and me who are artists, she is certainly our friend and sister. And in this condition of being an outcast she finds—just as we ourselves do—an independence which is not without its advantages after all, when you come to think of it. So let's beware of assuming an erroneous attitude by believing that we can do her a service by means of social rehabilitation which for that matter is hardly practical and would be fatal to her." [33] In June, just a few months before butchering his ear, he had written that "the whore is like meat in a butcher's shop"; [34] when he treated his own body as "meat in a butcher's shop," he reversed their roles, identified himself with the whore, and showed his sympathy for her.

The self-mutilation was part of a pattern of self-abuse. Dr. Mendes da Costa, his teacher in Amsterdam, has described this

tendency: "Well, whenever Vincent felt that his thoughts had strayed further than they should, he took a cudgel to bed with him and belabored his back with it; and whenever he was convinced that he had forfeited the privilege of passing the night in his bed, he slunk out of the house unobserved at night, and then, when he came back and found the door double-locked, was forced to go and lie on the floor of a little wooden shed, without bed or blanket. He preferred to do this in winter, so that the punishment, which I am disposed to think arose from mental masochism, might be more severe." [35] Vincent's lifelong tendency to starve himself and to restrict his diet to the simplest of foods was another means of torturing his body. Similarly, he exposed it to the elements by divesting himself of adequate clothing. He recognized that he was "often terribly melancholic, irritable, hungering and thirsting, as it were, for sympathy, and," he added, "I often even pour oil on the fire." [36] In other words, self-torture was a bid for attention, as when he put his hand in the flame of the lamp in his final frantic attempt to woo Kee.

Mendes da Costa has also pointed to Vincent's fascination for the sick, the suffering, and the maimed: "[H]e was consumed by a desire to help the unfortunate. I had noticed that even in my own home, for not only did he show a great interest in my deaf and dumb brother, but at the same time he always spoke kindly to and about an aunt of ours who was living with us, an impecunious, slightly deformed woman who was slow-witted, and spoke with difficulty, thus provoking the mockery of many people." [37] Similarly, he liked to have injured people for models and admired the work of artists who depicted them. Drawing an old man with a bandaged head, he asserted, "There are some ruins of physiognomies which are full of expression. . . ." Indeed the physically deformed are not only interesting but beautiful: "I have had some beautiful models of late. . . . A fellow with a wheelbarrow, the same whose head you may remember I drew, but then in his Sunday * clothes and with a Sunday-clean bandage around his blind eye." He quoted Delacroix to support the idea that deficiency due to organ impairment contributed to creative activity: "I discovered painting when I no longer had any teeth or breath left." [38]

Self-mutilation has not been documented in his childhood, but Mrs. van Gogh-Bonger mentioned a type of behavior that is similar

* The ear episode occurred on Sunday.

to it—destruction of his own creative products: "[A]t the age of eight he once modeled a little clay elephant that drew his parents' attention, but he destroyed it at once when, according to his notion, such a fuss was made about it. The same fate befell a very curious drawing of a cat, which his mother always remembered." [39] Angry people may destroy objects in place of humans they wish to destroy. But Vincent destroyed objects which he created as extensions of himself. Mutilating such a "self-object" is a symbolic self-mutilation. He destroyed them apparently because praise caused him to feel shameful or guilty. Perhaps the boy perceived the "praise" as ridicule—the sort of soothing syrup that ambivalent parents pour into their offspring. Punishment might be preferable; it, at least, came from the heart.

Vincent's letters suggest another reason for his fascination and identification with mutilated people: they receive favors. In discussing the drawings of the English artist, Boyd Houghton, for instance, he calls attention to *Our Artist's Christmas Entertainment:* "[I]t represents a corridor in the office of the *Graphic* on Christmas. The artists' models come to wish them a Merry Christmas, and most probably to receive tips. Most of the models are invalids—a man on crutches leads the procession—his coattail is held by a blind man, who is carrying another man on his back who cannot walk at all—his coattail again is held by a second blind man, who is followed by a wounded man with a bandage around his head, and after him come others shuffling along." [40] Vincent himself drew the sketch of an injured man with a bandage around his head during the Christmas season of 1882. "The model who sat for this really had a head injury and bandage over his left eye." [41] It is no coincidence that Houghton's drawing of injured models was a Christmas scene and that Vincent drew his *Man with Bandage over Left Eye* and also mutilated his ear at Christmas time. In cutting his ear and then using his bandaged head for a self-portrait, he identified himself with the injured models. Houghton's models came for a Christmas gift. Vincent too desired a gift for Christmas—the gift of care, compassion, and love —and felt the need to be injured in order to get it. Vincent's version of Delacroix's *The Good Samaritan* depicting the New Testament parable, also contains a man with a bandaged head who receives attention.

One of his mother's favorite stories, recorded by Mrs. van

Gogh-Bonger, prompts a similar explanation that, at the same time, involves the ear: "As a child he was of a difficult temper, often troublesome and self-willed; his upbringing was not fitted to counterbalance these faults, as the parents were very tender-hearted, especially toward their eldest. Once Grandmother van Gogh, who had come from Breda to visit her children at Zundert, witnessed one of little Vincent's naughty fits. Having learned from experience with her own twelve babies, she took the little culprit by the arm, and, with a sound box on the ears, put him out of the room. The tender-hearted mother was so indignant at this that she did not speak to her mother-in-law for a whole day, and only the sweet-tempered character of the young father succeeded in bringing about a reconciliation."[42] True, exaggerated, or family fiction, the story reveals the image of Vincent as perceived by his mother—he was a bad boy, not because of mother but in spite of her. Perhaps her tender-heartedness on this occasion was an overreaction that helped her to ignore her anger toward her son, and her indignation toward the older woman may have been an attempt to foist it on someone else.

Bearing in mind that past experience had already led Vincent to feel he was bad, he concluded that his mother was acting in this protective way not because he was right but because he was injured. He had already postulated that a dead boy is loved more than a living boy; now he added a corollary: to be hurt (i.e., partially dead) is more apt to bring love than to be active and healthy (i.e., alive). An active boy was "rough," and we recall that Vincent's mother forced him to leave the village school because the Brabant "peasant boys" made him "too rough." In Arles, in June 1888, he accused himself of being a brute;[43] perhaps he was still listening to the accusatory voice of his mother.

The psychological situation surrounding this childhood incident in which his mother was protective may have been one of the motivating forces behind the adult self-mutilation. When he portrayed himself with injured ear, he was pleading for attention from mother (or from the world which acted as her substitute): "My ear has been injured again. Love and protect me as you did then. I am not rough; I am not a brute. I am a helpless victim." Moreover, the beauty he saw in injured people may have been partially derived from incidents of this kind, since it was a "beautiful" experience to have mother be so loving; the beauty was displaced

from the experience to the injured person. Finally, in injuring himself Vincent also proved that mother was right: He was a bad boy for doing such a destructive thing. But he was also punishing himself for his badness.

The fact that Vincent brought his ear to a prostitute suggests that the act had some kind of sexual meaning, so it is not surprising that some writers have considered the ear to be a phallic symbol. The incident occurred during an acute psychotic state in which his reality testing functions were impaired and primitive thinking processes had taken over; the use of symbols is an essential part of such a state. Because the unconscious mind tends to regard protuberances as masculine and aggressive, removing the protuberant part of the ear may have been to inform the prostitute, a substitute for his mother, that he was not an aggressive, hurtful male—the "rough" boy whom his mother disliked—but helpless, penetrable, the victim of a hurt.

On the other hand, as ear nibblers and those who enjoy having their ears nibbled know, the ear is itself an erotic organ. Psychologists and pediatricians have observed that infants obtain sensual pleasure from stimulating their ears, and that infants begin to manipulate their ear lobes before manipulating their genitals.[44] They sometimes pull rhythmically on their ear lobes while sucking at the breast or their own thumbs. Vincent may have regressed to seeking childhood pleasures with the ear because of fears of genital inadequacy. He was concerned about his potency prior to the episode, and had already rationalized this feeling in August when he exclaimed, "Why exert ourselves to pour out all our creative sap where the well-fed professional pimps and ordinary fools do better in satisfying the genital organs of the whore . . . ?" And in November he complained that he was less "gifted" than Gauguin with the women of Arles.[45] Consequently, we may look upon the gift of the ear as another, albeit psychotic, attempt by Vincent to heal his loneliness by uniting with a mothering person, while at the same time avoiding the conflict-laden genitals. In addition, since rules, commands, and their appropriate punishments first enter the mind through the ear, the ear is recognized as an important adjunct of the conscience, and conscience sometimes backfires through the ear in the form of auditory hallucinations.

From this point of view, Vincent removed his conscience in removing his ear; in this way he could "turn a deaf ear" to its cruel demands.

Lacking suitable data, such speculations are inconclusive, and it may be more profitable to discuss another idea. Pain or discomfort in an organ may justify its removal. Treatment for an uncomfortable tooth may be nothing less than its removal; indeed Vincent had his teeth removed for this very reason; why not the same for an uncomfortable ear? His ear was no doubt causing him discomfort during his psychosis—the discomfort of frightening auditory hallucinations. There is no accurate record of the symptoms of the Christmas attack, but it is likely that they followed the pattern of delirium, disorientation, and auditory and visual hallucinations that occurred in other attacks—a point to be discussed in the next chapter. A few months later, while at the sanitarium at Saint-Rémy, he wrote about some of his fellow patients: "[D]uring their attacks they have also heard strange sounds and voices as I did. . . ." Referring to a particular patient, he added, "[H]e thinks he hears voices and words in the echoes of the corridors, probably because the nerves of the ear are diseased and too sensitive, and in my case it was my sight as well as my hearing. . . ." Elsewhere he mentioned "perverted and frightful ideas about religion" and "unbearable hallucinations" that plagued him during the attack.[46] In his psychosis, the unbearable, frightening sounds could have driven him to decide that "the nerve of the ear" was itself diseased.

In removing an offending organ, Vincent followed the admonition of Jesus to his disciples: "[I]f thy hand or thy foot offend thee, cut them off, and cast them from thee: it is better for thee to enter into life halt or maimed rather than having two hands or two feet to be cast into everlasting fire. And if thine eye offend thee, pluck it out, and cast it from thee: it is better for thee to enter life with one eye, rather than to have two eyes to be cast into hell fire." It was but a small step to, "If thine ear offend thee, cut it off . . ." Vincent may have responded to this admonition not only because of his self-destructive tendencies but also because Matthew 18, in which it appears, begins with a passage that had special significance for him: "At the same time came the disciples unto Jesus, saying, 'Who is the greatest in the kingdom of heaven?'

And Jesus called a little child unto him, and set him in the midst of them. And said, 'Verily I say unto you, Except ye be converted and become as little children, ye shall not enter into the kingdom of heaven. Whosoever therefore shall humble himself as this little child, the same is greatest in the kingdom of heaven.' " The advice to remove offending organs follows a few lines later; hence to humble oneself "as this little child" may require self-mutilation.

Every time Vincent read these passages, and he read them many times, a childhood memory and a childhood pain must have been stirred. For on the tombstone of his dead brother, the "perfect" Vincent who died in his infancy, the inscription represented Luke's version of becoming "as little children":

Vincent van Gogh
1852
Let the Little Children
Come to Me
For of Such Is
the Kingdom
of God.
Luke 18, vs 16.

In cutting off his ear, then, Vincent may have been experimenting with the role of his dead infant brother, an experiment he is later to carry through to completion. He thereby not only bid for his mother's love but became deserving of "the Kingdom of God," a striving that is frequently depicted in his art.

Vincent's preoccupation with religion seemed to reach a new peak during the latter part of 1888, and Gauguin wrote that "the Bible fired his Dutch brain." [47] But the letters to Theo during this period were not, as earlier, filled with Bible quotations; instead, he denied his former religious convictions, criticized the church, and made ironic remarks about "good Christians." Despite his distrust of Christianity, however, he expressed a "terrible need of—shall I say the word—religion" and of "the need of love and religion which must appear among men as a reaction to skepticism, and to that desperate suffering that makes one despair." [48] His own despair, arising from feeling unloved and unwanted, forced thoughts of salvation and a new religion of love upon him.

The self-destructive thoughts inside him that had merged with his view of Christianity also drove him away from the religion of his birth. In a letter dated May 29, 1888, for instance, he associ-

ated Christianity with suicide—and murder: "You understand so
well that 'to prepare oneself for death,' the Christian idea (happily
for him, Christ himself, it seems to me, had no trace of it . . .) is
idle. . . . can't you see that similarly self-sacrifice, living for other
people, is a mistake if it involves suicide, for in that case you
actually turn your friends into murderers." [49] The "mistake" rep-
resented both fear and intention, for he was to make such a mis-
take in December: to sacrifice himself, kill a part of his own body,
and turn his friend Gauguin into a murderer.

There is reason to assert that the mutilation had religious
significance: As Christmas approached, Vincent's religious preoc-
cupations increased. His identification with the martyred and
humiliated Christ, which had remained more or less hidden since
his departure from the Borinage, again rose to the surface. The
protective structures that maintained reasonable control over the
religious identification were undermined, and delusional religious
ideas broke out in the open. Unfortunately there is no record of
the specific content of Vincent's hallucinations and delusions. But
there is no doubt that it included religious ideas. Upon his return
from Arles after the ear mutilation, Theo wrote: "While I was
with him, he had moments when he was well, but after a short time
he reverted to his ravings about philosophy and theology." Ber-
nard, who obtained the information from Gauguin on the latter's
return to Paris, stated: "He wants to be quartered with the other
patients [in the hospital], refuses assistance from the nurse, and
washed himself in the coal bin. One might almost think that he
pursues biblical mortifications."

As he declared afterward from the sanitarium in Saint-Rémy,
Vincent also recalled his religious preoccupations and attributed
them to his surroundings in Provence—perhaps because they re-
minded him of the Holy Land: "When I realize that here the
attacks tend to take an absurd religious turn, I should almost
venture to think that this even *necessitates* a return to the North."
He amplified the idea shortly after: "I am astonished that with my
modern ideas . . . I have attacks such as a superstitious man
might have and that I get perverted and frightful ideas about re-
ligion such as never came into my head in the North." [50]

A letter written in September also struggled with the connec-
tion between suffering and Christianity and the search for a new
religion: "[Tolstoi's] religion cannot be a cruel one which would
increase our sufferings, but on the contrary, it would be very com-

forting, and would inspire serenity and energy and courage to live and many other things. . . . Tolstoi implies that whatever happens in the way of violent revolution, there will also be a private and secret revolution in men, from which a new religion will be born, or rather something altogether new, which will have no name but which will have the same effect of comforting, of making life possible, which the Christian religion used to have. . . . In the end we shall have enough of cynicism and skepticism and humbug. . . ." [51] A few months later, however, Vincent's reason was to weaken and be defeated by an erupting unconscious; he would be driven into a psychotic state in which the ability to distinguish reality from fantasy would be lost. In contrast to his benevolent Mother God, an image of God that had developed out of powerful and sadistic parental images would emerge, sadistic conscience and forbidden impulse would be locked in combat, and his life threatened. The nothingness of isolation, like a vacuum, must be filled. A sadistic parent or a sadistic God promises more than no one at all.

We also know that Vincent was fascinated by the New Testament scene in the Garden of Gethsemane (often called the Garden of Olives) and that it was on his mind during the latter part of 1888—stimulated, no doubt, by the olive orchards and the hot sun of the Midi. The fascination was shortly to turn into a horror. Vincent had actually painted the scene in July and again in September but destroyed both paintings.[52] The following year he appears to have sensed that his paintings of olive trees and of the starry sky were "realistic" ways of portraying the scene in the Garden. They were religious paintings with "models" omitted. In this way he avoided the nightmare connected with the actual portrayal of biblical scenes. The paintings by Bernard and Gauguin of the Gethsemane scene which he called "nightmares" probably reminded him of the terrifying nightmares he experienced early in the year while recovering from his Christmas delirium. He conveyed the threat to his life and sanity that the Garden contained when he warned Bernard against painting it: "And when I compare such a thing [Gauguin's painting of three trees against a blue sky] with that nightmare of 'Christ in the Garden of Olives,' good Lord, I mourn over it, and so with the present letter I ask you again, roaring my loudest, and calling you all kinds of names

with the full power of my lungs—to be so kind as to become your own self again a little." [53]

He had already mentioned Gethsemane in an October 1888 letter to his sister Wil concerning Monticelli. Vincent felt that his own interest in color was similar to Monticelli's, but he also saw in Monticelli his own instability, excessive drinking, and self-destructive tendencies: "I think of Monticelli terribly often here. He was a strong man—a little cracked, or rather very much so—dreaming of the sun and of love and gaiety, but always harassed by poverty—of an extremely refined taste as a colorist, a thoroughbred man of a rare race, continuing the best traditions of the past. He died at Marseilles in rather sad circumstances, and probably after passing through a regular Gethsemane. Now listen, for myself I am sure that I am continuing his work here, as if I were his son or his brother." [54]

Change "Marseilles" to "Auvers" and Vincent is prophesying his own end. "Passing through a regular Gethsemane" involves having your ear cut off. Vincent no doubt was impressed by the violent act of Simon Peter in cutting off the right ear of Malchus, a servant of the high priest, who had come to seize Christ: "Then Simon Peter having a sword drew it, and smote the high priest's servant, and cut off his right ear. The servant's name was Malchus. Then said Jesus unto Peter, Put up thy sword into the sheath. . . ." (John 18: 10,11) Vincent, of course, cut off the lobe of his left ear, but when he portrayed his bandaged head for all the world to see, it became his right ear: the mirror-image. Like the dreamer, the psychotic performer may take on more than one role. In Vincent's delirium the long established self-image of Jesus might come to the surface of consciousness but, so to speak, dragging the images of Simon Peter and Malchus with it. Just as one may perceive several body images when looking in the mirror from different angles, one may look at different characters in a scene and perceive different self-images. In acting out the scene in Gethsemane Vincent may have become not only Jesus but the victim Malchus and the aggressor Simon Peter as well.

Gauguin's role may also be viewed in its relation to the Gethsemane scene. Vincent enticed Gauguin to Arles with (not "in spite of") the conviction that Gauguin was a schemer who looked on Arles as a financial stopgap. "On various occasions I have seen him do things which you and I would not let ourselves do," he wrote to Theo, "because we have consciences that feel differently

about things." [55] Gauguin would have become an incongruous member of the society of artists that Vincent hoped to establish, who were to work together for the common good and act as the Apostles of Art. In naming Theo the first "dealer-apostle" he hoped that "if we stick to it, this will help to make something more lasting than ourselves." [56] In contrast he was suspicious of his colleague: "But if Gauguin and his Jewish bankers came tomorrow and asked me for no more than 10 pictures for a society of dealers, and not a society of artists, on my word I do not know if I'd have confidence in it, though I would willingly give 50 to a society of artists." [57]

If we grant that Vincent identified himself with Jesus, that the ear mutilation was a reenactment of the Gethsemane scene, and that the Society was equated with the group of Apostles, Gauguin becomes Judas Iscariot, the Apostle who betrayed Jesus in Gethsemane for thirty pieces of silver. There was another similarity between Gauguin and Judas: until a few years before, Gauguin had been a man of finance—a successful stock-broker—while Judas was in charge of the finances of the Apostles (John 12:6 and 13:29). Vincent also felt the same ambivalence toward Gauguin that has been described in the alliance between Jesus and Judas, in which the kiss of betrayal bears witness to the fusion of loving and destructive impulses.[58] Nor was Vincent lacking in discernment in casting Gauguin in this role. The latter's behavior during their final days together and in later attempts to vindicate himself through condemning Vincent were hardly those of a friend.

Interestingly enough, Bernard, intimate of both artists and aware of the events in Arles, painted a *Christ in the Garden of Olives* (reproduced in Rewald's *Post-Impressionism*), which may be the same painting that Vincent called a "nightmare." Behind the soldiers who are about to seize Jesus appears the face of Gauguin portraying the face of Judas. Rewald remarks, "Gauguin thought he recognized himself in the figure. . . ." [59]

From the standpoint of Vincent's identification with the crucified Jesus, the Virgin Mary in her Pietà role—where she is depicted lamenting over the dead body of Christ—becomes Vincent's mother. In giving the mother surrogate, Rachel, a dead segment of his body, Vincent symbolically repeated the scene on Calvary. In the Eucharist the faithful receive the body and blood

of Jesus under the appearances of bread and wine; when Vincent presents his ear to Rachel, he in effect repeats the words of Jesus: "Take, eat: this is my body." Through the psychological mechanism known as oral incorporation, Vincent becomes one with mother.

Rachel, of course, is more easily seen as Mary Magdalene than as the Virgin Mary. From a psychoanalytic point of view, however, it makes little difference. The mother image has been split into "good" and "evil." The evil in Mary is displaced to Mary Magdalene, so that the Virgin Mary can be perceived as guiltless. But, with the psychotic collapse of defense mechanisms, the two may fuse once again.

Vincent was acquainted with the character of Rachel, an antecedent of the *mater dolorosa* in the Old Testament. She is also mentioned in the New Testament in connection with Herod's slaughter of infant boys in his attempt to kill Jesus: "A voice was heard in Ramah, wailing and loud lamentation, and great mourning, Rachel weeping for her children; she refused to be consoled because they were no more." (Matthew 2:18.) Rachel was a mother who grieved for her dead children. Similarly, I have suggested that Vincent viewed his own mother as one who grieved for the loss of the dead first Vincent. In his psychotic state, as in *The Pietà*, he symbolically presented his dead body—through identification first with the dead Vincent and secondarily with the crucified Christ— as a token. He hoped thereby that his mother would adore him as she adored the first Vincent and as Mary adored the crucified Jesus.

In a letter written by Vincent late in 1876, he expressed a longing to return home for Christmas and reminisced about past Christmases at home with his family: "Brabant is ever Brabant, and one's native country is ever one's native country." [60] Then he quoted from the same biblical comment about Rachel: "A voice was heard in Ramah . . ." Here, long before Rachel the prostitute entered the story, Vincent had associated Christmas time, Rachel, and a mother's love and grief for her children.

Vincent presented his ear to Rachel at Christmas time—perhaps as a Christmas gift. Christmas had an especially vital significance for him by reason of his identification with Jesus. During the early years of his letter writing, from 1872 to 1877, he repeatedly expressed an intense and pleasurable anticipation for Christmas, family, and native land; [61] he was able to cast aside his usual role

of outcast at this season. Christmas had an adaptive and thera-
peutic value, and seemed able to fill the task Ernest Jones has
assigned to it as a symbol of the ideal resolution of family discord
through reunion. After 1877, however, I cannot find a single Christ-
mas greeting or a single remark in anticipation of Christmas.

Fervid feelings for Christmas continued even after he threw
over his conscious preoccupation with institutional religion, but
they were expressed in different terms. Drawings "like the little old
man with his head in his hands" are intended, he said, to convey
"the peculiar sentiment of Christmas and New Year's." [62] The
thought of joyful reunion with his family was replaced by an in-
tensified masochistic identification with the maimed, the aged,
and the poor, as exemplified in the drawing of cripples receiving
tips at Christmas that interested him so much. He identified him-
self with these unfortunates in the hope of obtaining the Christmas
gifts of love and forgiveness. This is the paradox of masochism:
The masochist is convinced by reason of past experience that he
must bring hurt upon himself—in the manner of the child who
feels himself loved when sick and neglected when well.

It may not be coincidental that two of Vincent's most painful
experiences occurred at Christmas time. It was at Christmas in
1881, following the painful rebuff by Kee Vos, that he stirred up a
"violent scene with Father, and it went so far that Father told me
that I had better leave the house." [63] This performance no doubt
appeared to his father to be a sadistic attack. But in the son's eyes,
it seemed only that he had provoked his father into cruelly casting
him out of his own house. The attack of 1888, while different in
content, was another masochistic affair. He was well enough aware
of the effect on him of the Christmas season to predict a recurrent
attack the following Christmas, a prediction that was to prove true.

Vincent was aided in his struggle for acceptance by this iden-
tification with Christ. The dead Vincent, the unseen and
unchallengeable competitor for mother, was probably the live Vin-
cent's most significant foe. Only a Christ could have hoped to win
such a battle. A similar situation has been described in people
who regularly feel depressed during the Christmas season—people
with the so-called "Christmas neurosis." L. Bryce Boyer has found
that the symptoms may result from unresolved rivalries with
brothers and sisters: "In them the birth of Christ, a fantasied
competitor against whom they were unable successfully to contest,
reawakened memories of unsuccessful rivalries with siblings, real
or fantasied, in their pasts. . . . There was some indication that

they at times identified with Christ in an attempt to deny their
own inferiority and to obtain the favoritism which would be His
just due." [64] It seems that Vincent's elated state during Christmases
before 1878 was associated with an identification with the happy,
newborn Christ child, while afterward, as the result of failures in
work and love and alienation from his family, he became the Christ
who suffered and died for love.

The mutilation of Vincent's ear at Christmas may also be
seen against the background of the pagan custom of celebrating
December 25, the winter solstice in the Julian calendar, as the
birthday of the sun. The waning (or dying) sun is followed by the
waxing (or reborn) sun. The custom of a sacrificial ritual in which
the king or mock king was offered up as a sacrifice or totemistic
feast grew from this. Later, an emblem such as a boar's head was
substituted. It symbolized that death must precede rebirth—as the
sun must set before it rises.[65] So with Vincent, whose preoccupation
with rebirth is one of the most powerful themes in his letters and
art, the presentation of the mutilated ear is another offering of a
dead totem in preparation for rebirth. This may be compared to
the apparent destruction of the ear in Gethsemane: like the sun,
it seemed to have been destroyed; but it was returned "like new":
"And he touched his ear and healed him" (Luke 22:51).

There exist, therefore, several interrelated explanations for
Vincent's self-mutilation. Its occurrence at Christmas time was not
accidental; since 1878, Christmas had become a time of intensified
feelings of isolation, loneliness, and depression. Vincent's masochis-
tic fascination with bodily injury helped to protect him from these
feelings, for injury was associated with being cared for and loved.
Further, he related injury and Christmas gifts. The box on the
ears as a child, cited as the epitome of childhood relations with
mother, gave him proof that an ear injury, in particular, brings a
mother's love. Prostitutes substituted for his rejected, rejecting
mother, so it is not too surprising that he brought his Christmas
token to one of them, intending to evoke a gift of love in return.
In 1888, his brother Theo's imminent marriage increased the fear
of isolation; the mutilation alleviated the fear by bringing Theo
to him. Similarly, it stimulated the Roulins to nurse him, fulfilling
a wish that reflected an envious identification with their baby.

The mutilation also represented a symbolic death, exhibiting

Vincent in the image of his dead brother, the first Vincent—someone mother adored. As a gift, the severed ear was specifically the gift of a baby, a dead baby. Thus it was both a reliving of wishes to unite with his mother and a bitter mockery of his mother's attachment to her dead son. In the live Vincent's sardonic gesture he taunted his parents with the reminder that they turned their tragedy into his tragedy.

Perhaps the perception of parental intercourse as a stimulating but brutal attack, as suggested by *The Night Café* and his description of it, offered its own contribution: this perception may have been reactivated in his mind by watching the bullfights in the arena of Arles and reading about Jack the Ripper, as well as by his experiences with the sexually active Gauguin. In cutting off his ear, Vincent acted out the frightening childhood memory; at the same time he symbolically displayed himself to a mother-surrogate as a castrated, nonthreatening person. He was not the brute or the roughneck his mother believed him to be; rather he was the victim who needed her and deserved to be nursed by her.

From another point of view, the mutilation was related to religious thoughts and identifications that had been occupying his mind for several months. In excising an ear that was filled with tormenting hallucinations of a religious nature, it carried out the biblical injunction to remove an offending organ. This was equated with becoming a child who is worthy of the Kingdom of God, following the biblical inscription on the grave of his dead brother. The identification with the suffering Jesus gave further impetus to the mutilation and further promise of parental love. In part this related to the scene of *The Pietà,* in which the *mater dolorosa* tenderly holds the crucified figure. The ear symbolized the body of Jesus, like the Host in the church ritual. Vincent presented it to the prostitute Rachel, who had come to represent both Mary Magdalene and the *mater dolorosa.* The scheming, money-seeking Gauguin was cast in the role of Judas, who betrayed Jesus in Gethsemane. The Gethsemane scene, in which the ear of Malchus is cut off, had been prominent in Vincent's mind before the mutilation. Possibly intensified by recent exposure to ear excisions in the bullring at Arles as well as in the story of Jack the Ripper, this scene pointed the way to the choice of the ear as the specific object for mutilation.

10 Dizziness and style

VINCENT WAS ABLE to leave the hospital in Arles on January 7, 1889, two weeks after the ear mutilation. He promptly returned to his easel after recovering from his injury. As it was winter, he produced still lifes and portraits, including the self-portrait with his head bandaged, and a portrait of the interne Dr. Rey. He had another psychotic attack, however, early in February.[1] Although it lasted only a few days, his strange behavior was frightening to the superstitious people of Arles, and they began to harass him in the Yellow House. As the result of a public petition, he was incarcerated in a hospital cell late in February, even though he was sane at the time; this in turn apparently precipitated another brief spell.

The Reverend Mr. Salles, a Protestant minister who had befriended him, testified that he had been treated unjustly. As Vincent told his brother, "Anyhow, here I am, shut up in a cell all the livelong day, under lock and key and with keepers, without any guilt being proved or even open to proof. . . . So you understand what a staggering blow between the eyes it was to find so many people here cowardly enough to join together against one man,

and that man ill." [2] He had long complained of feeling like a prisoner; now he had caused the feeling to become the real thing, but could show that it was due to the weakness of others, not his own. Unknowingly, he provoked the townspeople, the same people he had recently regarded as happy and friendly, to attack him. When they did, he reproved them and got the sympathetic attention of his friends and brother. He told them about the injustice and let them get angry for him.

This episode was representative of the way Vincent set himself up as a martyr and then exploited the reaction for the benefit of his self-esteem. He was jeered and threatened by a crowd, even as Christ was jeered and threatened in Gethsemane, and Christ, too, was seized and falsely convicted.[3] As a result of this misfortune, Vincent reaffirmed what Christ had taught him long before: "[T]o suffer without complaining is the one lesson that has to be learned in this life." [4] By channeling self-defeating behavior into the Christ identification, he put himself above his tormentors. This forestalled the depression that would otherwise have followed such rejection; and intense feelings, compounded of righteousness and anger, became available for artistic purposes, rather than being wasted away in a paralyzing state of unhappiness.

Roulin left town on January 23, having been transferred to Marseilles, and his wife and family left soon after. Roulin's departure no doubt increased Vincent's isolation and loneliness, for they had become increasingly close. Vincent was deeply moved in describing Roulin's last visit: "It was touching to see him with his children this last day, especially with the quite tiny one, when he made her laugh and bounce on his knee, and sang for her." His voice, Vincent added, had the quality of "a sweet and mournful lullaby." [5] For Vincent, it was Roulin who sang the lullaby, and it was Roulin who mothered him too. This was not the first time that Vincent found a man to care for him rather than a woman. He drew and painted many women mothering their babies; but with women themselves, he either held his distance or took care of them.

On March 29 Vincent looked back on his mental state since he was hospitalized: "Sometimes moods of indescribable mental anguish, sometimes moments when the veil of time and the fatality of circumstances seem to be torn apart for an instant." [6] Soon after he wrote to Theo that he felt well "except for a certain undercurrent of vague sadness" and to the painter Paul Signac that

he suffered "inner seizures of despair of a pretty large caliber." He could not face the isolation of an artist's studio again, yet he dared not think of living with another artist; for a moment he thought of joining the Foreign Legion.[7]

After being released from forced confinement, Vincent decided to remain in the hospital until Pastor Salles could find suitable lodgings for him. Once a place was found, however, he feared that he was not fit to govern himself. He also discovered something else about himself, something he had long been denying by asserting his independence and defying authority. He found that he liked the idea of being totally dominated by someone else: "When I *have* to follow a rule, as here in the hospital, I feel at peace." [8] This search for peace, his loneliness, public resentment, and the fear of another psychotic attack led him to seek the shelter of a sanitarium for mental disorders.

At the suggestion of Pastor Salles, Theo arranged for Vincent's admission to the sanitarium of Saint-Paul-de-Mausole, twelve miles northeast of Arles. On the outskirts of Saint-Rémy-de-Provence, it adjoins the Roman ruins known as *les Antiques,* of which the most beautiful and best preserved is *le Mausolée.* Saint-Paul-de-Mausole, originally an Augustinian monastery dating back to the twelfth century, was converted into a sanitarium early in the nineteenth century. Its charming, rambling structures and parklike grounds are located at the foot of Mount Gaussier, part of a modest mountain range called the Alpilles.

Vincent entered this protected environment on May 8, 1889. Mentally alert, he discussed his situation with the director-physician, Dr. Peyron. The fifty-year-old doctor, described by a former patient as a man "with an enormous belly, half Silenus, half Falstaff," [9] is reputed to have been a stingy fellow who kept his patients on a spare regime. There were not over a dozen in the men's quarters; with thirty rooms empty, Vincent was given a separate studio. He was pleased with the surroundings, his melancholy diminished, and his stomach felt better. From his first letter from Saint-Rémy, he insisted on the need to work, and he began to paint in the garden of the sanitarium and in the surroundings. Jean François Poulet, the twenty-seven-year-old attendant who accompanied him, recalled years later that Vincent was a good fellow, although strange and silent, who forgot his suffering when

working. Vincent himself confessed that he felt alive only at his easel.[10]

He soon began to complain that the food was moldy; the poor patients, he noted, had "no other daily distraction than to stuff themselves with chick peas, beans, lentils and other groceries and merchandise from the colonies in fixed quantities and at regular hours. As the digestion of these commodities offers certain difficulties, they fill their days in a way as inoffensive as it is cheap." For several months he refused to eat this diet and subsisted on "bread and a little soup." [11]

On July 5 he received news that his sister-in-law was pregnant, and he sent off congratulations at once. Soon after, he went to Arles with his attendant to buy some canvas and visit the Pastor Salles and Dr. Rey; they were not in town, so he spent the day with his old charwoman and some former neighbors. A day or two after returning to the sanitarium, he had a severe psychotic attack; he was kept in his own room for a while, and not even allowed to use his studio. After this prohibition was lifted, he was still afraid to face other people; "I tried in vain to force myself to go downstairs," he wrote on September 10. "And yet it is nearly two months since I have been in the open air." After recovering, he again complained of "terrible fits of depression." [12] As usual, it drove him to work "with a dumb fury" and re-evoked his masochistic philosophy: "I know well that healing comes—if one is brave—from within through profound resignation to suffering and death. . . ." Living in a room with a metal door and barred windows gave him reason to reaffirm his unhappy view of himself as a prisoner. Nevertheless, he locked himself in his studio in order to eliminate the distracting influence of other patients.[13]

In spite of depression, his appetite increased, and Dr. Peyron —making an exception—permitted him to have meat and wine. Although he had recently refused to touch the regular hospital food, Vincent now accused himself of "eating and drinking like a hog." "As for eating a lot, I do—but if I were my doctor I'd forbid it," he soon added. "I don't see any advantage for myself in enormous physical strength, because it would be more logical for me to get absorbed in the thought of doing good work. . . ." [14] This suggests that his habitual ascetic eating habits were due to a fear of being destructive if he became too powerful; semi-starvation, he hoped, would weaken these guilt-laden aggressive impulses and hard work would divert them.

Vincent made a second trip to Arles in November and found Pastor Salles at home; there was no attack following this visit. As he had feared, however, he had one at Christmas time, but it only incapacitated him for about a week. Although briefly "overcome with discouragement," [15] he soon made new plans for pictures and asserted that he was in better health than he had been for two years. Early in 1890 he contemplated joining Gauguin in Brittany, in spite of the disastrous outcome of their partnership in Arles. Gauguin, however, had left Brittany for Paris, and his suggestion that they form a studio in Antwerp did not stir Vincent's enthusiasm. On February 1 he received news of the birth of his nephew and namesake, Vincent Willem. He had a brief attack on January 23 following a visit to Arles; a month later, another severe attack occurred after spending two days there that incapacitated him until the end of April. [16]

Seven attacks were specifically mentioned in his letters and in the hospital records during the time Vincent spent in Arles and Saint-Rémy. There were others, however: after the third of these recorded attacks he wrote that he had had *four "grandes crises"* and *three* fainting spells, all marked by an amnesia for the events surrounding them. [17] His own descriptions and the official register of the asylum agree that the spells were sudden in onset and gradual in disappearance. While two persisted for about two months, he recovered from the others in one or two weeks. During the stay at Saint-Rémy, three of the four episodes occurred after going to Arles, and only one of four visits there ended without incident. Two attacks occurred while he was painting, one of them during a mistral. Vincent also observed that the emotions that gripped him in the presence of nature could cause him to lose consciousness; [18] unfortunately, he did not elaborate this statement.

The attacks were ushered in by an acute state of delirium and disorientation. "I do not know where I am," he wrote, "and my mind wanders." Visual and auditory hallucinations accompanied the delirium; they seemed "real," he recalled, and frightened him "beyond measure." He also had bizarre religious ideas and delusions of being attacked or poisoned that sometimes caused him to become assaultive. [19] The attendant Poulet said that on one occasion Vincent suddenly kicked him in the belly, explaining later that he thought the police from Arles were after him; [20] this inci-

dent tends to corroborate Gauguin's often-questioned statement that Vincent had assaulted him during the Christmas attack of 1888.

Vincent also thought of committing suicide during the episodes and seems to have attempted it in both Arles and Saint-Rémy.[21] According to Paul Signac,[22] he tried to drink a bottle of essence of turpentine during their meeting in Arles in March 1889,* and he had episodes in the sanitarium in which he drank stolen kerosene and swallowed oil colors out of their tubes. On one occasion, it required Dr. Peyron, the head attendant Trabu, and Poulet to take the tubes from him.[23]

During the attacks, people seemed to be at a great distance, voices to come from afar, and things to be changing before his eyes. He did not always recognize people; they looked *"quite different from what they are in reality,"* he explained, "so much do I see in them pleasant or unpleasant resemblances to persons I knew in the past and elsewhere." [24] He complained of dizziness, although this is difficult to evaluate in view of the fact he had suffered from it for many years. In the course of recovering, his mind remained foggy for a while, nightmares replaced the terrifying hallucinations, and he complained that his eyes were "very sensitive." [25] The doctors said that his intellectual functions were unimpaired between attacks, and the content of his letters testifies to this. He was unable to paint during the acute psychotic phase of his illness; he returned to his easel only when the disorientation, the hallucinations, and the delusions disappeared. Vincent's case does not aid those who wish to prove that a psychotic man can create great pictures.

To the clinician, the presence of delirium accompanied by disorientation, hallucinations, delusions, terror, and violent behavior suggests a syndrome commonly called a "toxic psychosis." Caused by various toxic or other organic disturbances of the brain, it is differentiated from the so-called "functional" psychoses—schizophrenia and the manic-depressive states. It seems likely that Vincent's emotional problems and poor diet added their share to these primary causes, but it is unlikely that either factor in itself would cause such a disturbance.

Delirium tremens is the best known toxic psychosis. It appears when the alcoholic has been drinking heavily or after he stops

* Signac's statement to Theo that he had found Vincent "in perfect health, physically and mentally" may have been an attempt to reassure him (letter 581a).

abruptly. Although there is no substantiating evidence, the three attacks that followed Vincent's visit to Arles might have been due to resumption of heavy drinking on returning to the city, and the attack that occurred after being forcibly confined in a hospital cell in Arles might have been due to abrupt withdrawal. On the other hand, the Christmas attack in 1899 occurred in the sanitarium where, presumably, his intake of alcohol was controlled. Other factors also argued against the diagnosis of delirium tremens: While visual hallucinations are typical, auditory hallucinations are unusual; fainting spells are not observed; and the characteristic tremor of the hands that contributes to its name does not appear in descriptions of Vincent's attacks. The fact that his physicians were opposed to this diagnosis is perhaps the most damaging evidence against it; [26] in Provence, they undoubtedly would have been well-versed in this pathological manifestation of alcohol.

Absinthe poisoning is another diagnostic possibility.[27] Vincent was no stranger to absinthe. According to Gauguin, he was drinking it during their nightly visit to a bar when he threw the glass at Gauguin's head. In denying that an unnamed artist's death was due to absinthe, Vincent may have hinted at his own reason for using it: "Besides, he would drink it, not solely for pleasure, but because, being ill already, he needed it to keep himself going." [28] Introduced into France by the soldiers of the Algerian war of 1844–1847 as a remedy for fever, it had attained great popularity by the time Vincent moved there. Until it was outlawed in 1915, its consumption was highest in the Bouches-du-Rhône, the *département* in which Arles is located; compared with a national average of 0.60 liters, the average consumption there was 2.45.[29] Thujone, a constituent of the absinthe plant, is a brain toxin that made absinthe the most dangerous of all alcoholic beverages. From descriptions in the French medical literature, the typical manifestations of absinthe poisoning were epileptic convulsions and recurrent attacks of delirium. Unlike delirium tremens, however, the attacks were said to persist after the victim stopped drinking it and to be commonly accompanied by auditory hallucinations. The lack of clear-cut signs of mental deterioration between attacks (such as loss of memory or decreased intellectual functioning) may diminish the likelihood of this diagnosis.

Both Félix Rey, the interne who had not yet received his degree, and Dr. Peyron, an ex-eye doctor with no formal training in psychiatry or neurology, made a diagnosis of epilepsy. Without

evidence of an actual convulsion, this diagnosis seems remarkable for those days, even for an expert. During the 1870s and 1880s an argument was raging among neurologists concerning "masked epilepsy" and most—the celebrated Hughlings Jackson among them—had concluded that episodic abnormal mental states in epileptics occur only after fits.[30] Today, however, some episodic mental disturbances, including delirium, are generally accepted as bona fide manifestations of epilepsy. The triggering of attacks by external stimuli and the illusionary distortion that Vincent described have, in recent years, been found to be characteristic symptoms in epileptics with an abnormal focus of electrical activity in the temporal lobe of the brain. Perhaps Dr. Rey and Dr. Peyron were ahead of their times. Perhaps they were influenced by Vincent's statement that there were several epileptics in his family. Perhaps they had knowledge that the fainting attacks that Vincent mentioned were in fact convulsive seizures but did not enter it into their brief records.

All in all, the diagnosis of temporal lobe epilepsy (or "limbic seizures," as it is sometimes called) is the most likely conjecture. The cause of the abnormal electric discharge associated with this disorder is unknown. Most claim it to be purely a neurological disorder, perhaps of an hereditary nature. Some believe that overcharged emotions may in themselves be a causative factor. Further investigation, including the use of modern testing procedures, might reveal some unsuspected pathological process. But while we must be circumspect in our conclusions, it is fallacious to go as far in the opposite direction as the Dutch psychiatrist Professor G. Kraus, who, after an extensive review of the subject, suggested that Vincent's disease, like his art, was "individualistic," and therefore should be classified in a category by itself.[31] The genius is as unable to conjure up a private disease as any other mortal.

The de la Faille catalogue lists about 150 oils, 10 watercolors, and 100 drawings for the year that Vincent was in Saint-Rémy-de-Provence. These oils tend to be more somber than those from Arles, the brilliant contrasts being replaced with blended, earthy colors: "What I dream of in my best moments is not so much striking color effects as once more the half tones." [32] This change may have reflected the fact that his confinement had sobered him, or he may have been afraid of the effect of bright contrasting colors on his dangerously charged nervous system. He himself wrote of "the

great desire to begin with the same palette as in the North," and he credited the inspiration for this change to the Delacroix paintings in the museum in Montpellier [33]—paintings by the same Delacroix who had formerly inspired him to brighten his palette. This paradox is not difficult to understand. Vincent had always felt free to borrow from other artists, but these ideas had to reinforce his own needs. When these needs changed, his mind could be influenced by other aspects of an artist's work that had then become more relevant to him.

As a group, the paintings from Saint-Rémy are also more turbulent than those from Arles. Many are characterized by a linear style that conveys an impression of agitated movement, impulsively executed yet with demonic control. In spite of his mental perturbations, this control remained firm, as reflected in the accuracy with which he could reproduce the proportions of his subjects. The emphasis on line during this period resulted in a close resemblance between paintings and drawings.

During his first month in the sanitarium he began to paint subjects in the garden—flowers, ivy, trees, shrubbery, benches, stairs, and the fountain. From his iron-barred studio window he also painted the first of the series of changing views of the enclosed field; the low-lying Alpilles in the background are often pictured as writhing giants—understandable, perhaps, for a Dutchman accustomed to flat heaths, but a projection of his own turmoil as well. In June, at last able to go outside the sanitarium walls, he painted his first olive trees and *The Starry Night*. Later in the month he began to transform the dark Provençal cypresses into undulating, flame-shaped objects and, once again, painted sowers and reapers of wheat.

When he recovered from the long attack of July and August, he turned to self-portraits. While claiming to have done so for lack of other models, he was probably trying to reconstitute himself after this disorganizing experience. In the first of these portraits, he wrote, he was "thin and pale as a ghost." But about a month later, he again depicted himself as a "peasant of Zundert" and wrote, "I am plowing on my canvases as they do on their fields." He also painted portraits of the chief attendant Trabu, with "something military in his small quick black eyes," and Madame Trabu, "an unhappy resigned creature of small account." [34]

At about the same time, he made copies from the large stock of reproductions, wood engravings, and lithographs that Theo had

sent him, beginning with Delacroix's lithograph, *The Pietà*. During the attack from which he had just recovered, he had "ruined" the original lithograph, perhaps acting on his "sickly religious aberrations"; [35] now he brought it back to life. He also copied Mme. Demont-Breton's *The Man Is at Sea*, Rembrandt's *Angel* and *The Resurrection of Lazarus*, Daumier's *The Topers*, Doré's *The Prison Courtyard*, and Delacroix's *The Good Samaritan*. He made four paintings after Gauguin's *L'Arlésienne*, and he even copied his own *Bowed Man* and *The Bedroom*. Above all, he "*translated into another tongue*" [36] the peasant pictures of Millet, twenty in all, including two series called *The Workers of the Fields* and *Four Hours of the Day*. Using black-and-white reproductions as models, he improvised the color while searching for memories of the original paintings: " 'the vague consonance of colors which are at least right in feeling'—that is my own interpretation." [37] In effect, Vincent was collaborating with these artists rather than merely copying their works, in this way carrying on the partnerships that were no longer possible in person-to-person relationships. No doubt he was also using the works of others to strengthen an artistic identity that had been weakened by his illness.

During the last months of 1889, Vincent painted olive trees during the harvest, the Boulevard Victor Hugo at Saint-Rémy, and —following the Japanese printmakers—landscapes in the rain. On hearing of the birth of his nephew early in 1890, he made a magnificent picture of "big branches of white almond blossoms against a blue sky" [38] for him.

When Vincent gave his sermon in England in 1876, its central figure was a stranger or pilgrim whose life was a long walk "from earth to Heaven." Vincent too was preoccupied with both earth and heaven and his lifelong love of walking in the countryside put him on intimate terms with them.

It has been suggested earlier that his artistic fascination with the earth grew out of his frightening childhood exposure to the tombstone that bore his own name. It was also derived, however, from his view of the earth as a substitute mother. On the one hand, he felt detached and rejected by it; on the other, he fantasied it would take him in, and he would become part of it. His pictures of plants and trees clinging to rocky slopes as if fearful of losing their hold on the earth were, in essence, self-portraits. *The Roots*

was intended to represent a "convulsive, passionate clinging to the earth—torn by the storm." When he drew "little stems sturdily rooted in the ground," he was putting into visual form the conviction that "to grow, one must be rooted in the earth"; [39] when he focused his artist's eye on the trunks of strong trees, and painted them where they sink their roots and fuse with the rich earth, he too felt united with it. Lacking roots, he would wither and die. As we have seen, his interest in diggers (revealed by scores of drawings) arose in part from this passion for the earth; so did his preoccupation with the potato—the *aardappel* of his native tongue and the *pomme de terre* of his adopted tongue; he depicted it many times.

Rejected in love, Vincent turned in religious fervor to God in heaven; as he explained in his sermon, "There is joy when a man is born in the world, but there is greater joy . . . when an Angel is born in Heaven." There the stranger becomes a welcome guest; the moon, the sun, and the evening stars, he wrote later from Amsterdam, "speak of the Love of God." [40] When he gave up the religious ministry and accepted the vocation of art, his belief and interest in heaven was less audible, but no less intense, for it was projected into the skies he created. As we have seen, Christian ideas about suffering, death, and heaven appeared frequently in his letters in the fall of 1888. Hence it was no coincidence that Vincent was immersed at this time in painting starry skies; this task helped him to objectify his mystical belief in heaven and, at the same time, keep his feet on the ground. As he painted the stars of Provence, he looked to them with hope, and they beckoned to him with the promise of acceptance.

The "pilgrim" trudging toward a distant goal in the horizon often appears in Vincent's works, as in *Road to Loosduinen*. In some, the wayfarer is removed from the earthbound observer by a great expanse in the foreground, but he is far from heaven as well; in others, he approaches the distant horizon. There are as well similar landscapes in which the pilgrim is missing; here Vincent was the painter-pilgrim outside the canvas, anticipating the hard road ahead and heaven beyond. There are striking perspectives that transport the pilgrim—or the viewer—toward heaven; in describing a *Sower* of 1888, Vincent wrote that the field was "climbing toward the horizon." [41] He sometimes painted his southern landscapes from a perspective that makes them appear to have been forcibly thrust upward toward the sky. This thrust is seen, for

example, in *Enclosed Field*, a painting of the field behind the
sanitarium in Saint-Rémy. The actual topography is flatter than
it appears in the painting; indeed, a drawing of the same scene
shows he was able to depict it from a photographic point of view.
The tilted landscape is similar to some of his Dutch landscapes, but
it is also different; whereas the Dutch scenes lead the viewer to
heaven by the hand, the Saint-Rémy scene, like others from his
last year on earth, disrupts the earth's surface and catapults him
there.

Vincent used still other devices to link earth and heaven, in-
cluding innumerable church spires, tall trees, smokestacks, and
steepled buildings. In Holland, the windmill, directed heavenward
like the Christian cross, also attracted his artistic eye (*Windmills
at Dordrecht*), and he continued to portray them in Paris. Even
the crosses atop the little houses in Saintes-Maries pointed the way.

He was fascinated with birds and collected and painted their
nests—objects that reminded him he too might be free as a bird.
During a fit of depression, Vincent called himself a caged bird, a
variant on the self-image of a prisoner condemned to loneliness.
On the other hand, the soaring bird, a prominent object in many
van Gogh landscapes, was analogous to the pilgrim on his way to
heaven. (See *Birds' Nests, Flying Swallows, The Reaper, The Sower*
[June 1888], *Road to Loosduinen, Crows over the Wheatfield*.)

Pipe smoking was one of Vincent's few earthly pleasures, and
there are many pipe smokers among his works. He once wrote that
smoking by an old tree trunk and looking at the blue sky helped
him forget his cares.[42] There, like the old trunk, he was rooted in
the earth, but at the same time the smoke provided him a direct
line to heaven. He also pictures smoke pouring out of great in-
dustrial stacks and peasant cottages. (See *Self-Portrait with Band-
aged Ear, Man with Bandage over Left Eye, The Factory*, and
Peasant Reading by the Fireplace.)

During the last year of his life, he used vigorous strokes—both
sweeping arabesques and straight lines—that ascend swiftly into
the sky like Jacob's ladder, sometimes enhancing, sometimes re-
placing the perspective of earlier days. (*Vineyard with Peasant
Woman*.) Irrespective of the content associated with them, they
draw the viewer into the sky, and from this standpoint can be
viewed as early examples of abstract Expressionism. They are
usually combined with other devices; in *Memories of the North:
Hut with Cypresses*, for example, the terrain is thrust upward as in

Enclosed Field, the peak of the house is elevated, and the flame-shaped cypresses touch the very top of the firmament, all reinforcing the vertical thrust of the pen lines themselves.

The pilgrim of Vincent's sermon also reminds us that Bunyan's *Pilgrim's Progress* was a favorite book of his. Like Vincent, its hero, Christian, fled in sorrow from the family and neighbors who thought him mad. He walked toward the light in the distance, a light that crowned the gate to heaven, as Vincent went to the light of the Midi. Like Vincent, he fell into the Slough of Despair. Like Vincent, he was not led astray by Mr. Worldly Wiseman or by Sloth, Simple, Presumption, Formalism, and Hypocrisy, and, like Vincent, he remained the most humble of men. He was arrested by the townspeople of Vanity Fair because he refused to conform to their standards, as Vincent was arrested by the townspeople of Arles. He strode across the River of Death and ran up the hill toward heaven, as Vincent was to kill himself in Auvers, on the Oise River.

Vincent closed his sermon with a description of a landscape by an English artist, Boughton, called *A Pilgrim's Progress:* "Our life is a pilgrim's progress. I once saw a very beautiful picture; it was a landscape at evening. In the distance on the righthand side a row of hills appearing blue in the evening mist. Above those hills the splendour of the sunset, the gray clouds with their linings of silver and gold and purple. The landscape is a plain or heath covered with grass and its yellow leaves, for it was in Autumn."

Compare this English landscape with *Wheatfield with Cypresses,* one of several similar landscapes Vincent painted while a patient at Saint-Paul-de-Mausole in Saint-Rémy. The blue hills in the background rise abruptly toward the right side, and the sky is filled with clouds. In the foreground the plain is covered with long yellow stalks of wheat, ready for the autumn harvest. Vincent's model for the painting was the hills behind the sanitarium, part of the low rugged Alpilles, where no sharp rise like this can be seen.

Many van Gogh landscapes similarly contact the heavens by carrying the eye upward toward the right side. In his earlier work this was accomplished by means of perspective; in some of his latter work by means of line. (See *Landscape with Pollard Willows, Pollard Willows by the Side of the Road, The Road to Loosduinen, The Stairs, Enclosed Field* [oil], *Vineyard with Peasant Woman.*)

Vincent went on in his sermon to explain the meaning of the

Boughton painting: "Through the landscape a road leads to a high mountain far, far away, on the top of that mountain a city whereon the setting sun casts a glory." Christian trudged wearily for a long while, and finally asked the Angel of God " '[W]ill the journey take all day long?' And the answer is, 'From morn till night, my friend.' And the pilgrim goes on sorrowful yet always rejoicing—sorrowful because it is so far off and the road so long. Hopeful as he looks up to the eternal city far away, resplendent in the evening glow. . . ."

The eternal city of heaven is not to be seen in Vincent's *Wheatfield with Cypresses*. But perhaps it shows up in another landscape of the Alpilles—*The Starry Night*, in deep blues. In fact Vincent paired *The Starry Night* with *Wheatfield with Cypresses* (or another landscape just like it): he suggested that the two be shown together at an exhibition of the Independents.[43] The rising hills of *Wheatfield with Cypresses* are repeated in this night scene. A mysterious town that glows in the darkness nestles high in them. Although purely imaginary content is rare in Vincent's art, such a town is not to be found in the Alpilles. Perhaps it is the pilgrim's goal, "the eternal city far away, resplendent in the evening glow."

With this in mind, *Wheatfield with Reaper*, *Wheatfield with Cypresses*, and *The Starry Night*—three landscapes from 1889— form a sequence that depicts the sermon theme of going from earth to heaven, "from morn till night." The little reaper of the first landscape, Vincent's symbol of "almost smiling" death, is starting on his long journey. The mountains are the same in all three, but with each painting the eye is led higher and higher into them as the day advances into night. The cypresses are absent in the first landscape, they come into view on the right side in the second, and they shift to the left in the third. The sorrowful, toiling reaper ascends the mountains and finally arrives at night in the eternal city of heaven. These pictures help us see that Vincent's assertion that his art was intended to express "serious sorrow" was only part of the story; it also expresses eternal joy.

Vincent's perspectives are often dizzying and distorted. Meyer Schapiro has noted, for example, the "dizzying succession of parallel and converging lines" in *The Bridge of Trinquetaille* and the "rapid convergences" in *The Bedroom*.[44] The expansion of the

foreground and the contraction of the background in the latter has been cited as evidence of Vincent's abnormal perception of space, due to mania or a poison (such as absinthe) that affects the nervous system.[45] Yet in drawings executed at the same time, these deviations are absent,[46] indicating that they were not forced on him by mental illness but were purposefully introduced to achieve a desired effect. As we have seen, "distortion" was equally deliberate in *The Enclosed Field.* The flamboyant linear style characteristic of Saint-Rémy was another way in which he purposefully distorted his subjects: "The 'Olives' with a white cloud and a background of mountains [*Landscape with Olive Trees*], as well as the 'Moonrise' and the night effect, are exaggerations from the point of view of arrangement," he wrote, "their lines are warped as in old wood." [47] The exaggeration of perspective and the curving linear style imparted the sense of movement to Vincent's work that he had always desired. Referring to *The Bedroom,* for example, Schapiro writes of "the spontaneous intensification of movement in his rendering of things. . . . [B]y projecting movement into nature, he is relieved of tension and wins a real peace." [48] Perhaps this enabled Vincent to believe that this bedroom scene was "suggestive of *rest* or of sleep." [49]

Lines came to resemble vectors possessing force and direction—outward projections of his highly charged inner life.[50] The concentric circles, the spirals, and the arabesques seen, for example, in his cypresses, his olives, and *The Starry Night* evoke a feeling of dizziness in some sensitive individuals. It may not be coincidental that Vincent himself had long suffered from dizziness, and that this dizziness was often evoked by heights. Concerning a caricature of Gauguin's showing him sitting on a ledge over the sea, he noted, "I have always had an unutterable horror of sitting like that on precipitous cliffs verging on the sea, as I suffer from vertigo." [51] This problem was so severe that during his stay in Paris he could never get used to climbing stairs; there, too, he complained of "fits of dizziness in a horrible nightmare." He was distressed when painting the heaths of Drenthe at midday: "Painting it in that blazing light and rendering the plains vanishing into infinity makes one dizzy." [52] The dizziness reappeared when he was painting the plains of Provence, no doubt when looking down on them from the ruins of Montmajour.

Fear of heights associated with dizziness might impede the work of a landscape painter. But Vincent took adversity as a chal-

lenge, and—like depression—the symptom no doubt stimulated his creative functions. In attempting to master the fear and attenuate the dizziness, I suggest, he made pictures from high places, drew dizzying perspectives, and discovered for art the use of swirling line patterns. Instead of passively experiencing the symptom, he actively depicted it. Professor A. M. Hammacher expresses the belief that Vincent, who painted many pictures from windows, felt a strong need to use this safe enclosure because it made him dizzy to work in the open air.[53] The window may have acted like a protective barrier on the edge of a dizzying cliff. The perspective frame that he used during most of his artistic life, composed of criss-crossing wires in a wooden frame, no doubt served the same function.

Though we can only speculate, it seems possible that Vincent's dizziness and fear of heights had their source in the traumatic events of his childhood. His earliest relations with a depressed mother who was unable to cuddle him securely may have given rise to a feeling of instability in space. Thus sensitized, his frightening perception of parental intercourse as a brutal attack would have reinforced the problem. During the last two years of his life it may have been further aggravated by the neurological disturbance responsible for his attacks as well as by malnutrition and alcohol; perhaps as a consequence, his dizziness received its most direct artistic expression during that period.

When, during his first months in Saint-Rémy, Vincent expressed the wish to return to the colors he had used in the North, he was, no doubt, reflecting a deeper wish to return to Holland. By September 1889, however, the idea became more explicit: "I have a terrible desire coming over me to see my friends and to see the northern countryside again." [54] In April 1890 his homesickness was reflected in the group of paintings and drawings depicting thatched-roofed huts and peasants with wooden shoes that he called "memories of the North" and in a revised version of *The Potato Eaters* drawn in his new linear style. He wrote to his mother that he had some pictures that "remain just as if they were painted say in Zundert, or Calmpthout [another Brabant village]. . . . It would have been simpler if I had stayed quietly in North Brabant"; and he told Theo that his present studies were links "with our distant memories of our youth in Holland." [55]

On April 29, Vincent complained that he was "sadder and more wretched" than he could say.[56] No doubt his unhappiness was aggravated by Dr. Peyron's seeming neglect during the attack from which he had just recovered, although Vincent's bitterness about it did not come into the open until he was far away in Auvers: "[O]ld Peyron didn't pay the slightest attention to it, leaving me to vegetate with all the rest, all deeply tainted." [57] Work, however, was still his salvation. In May, he wrote that he had more ideas in his head than he could carry out and that his brush strokes came "like a machine." [58]

Burdened by homesickness and loneliness, he resolved to depart: "My surroundings here begin to weigh on me more than I can say . . . I need air, I feel overwhelmed with boredom and grief." He requested Theo to ask Dr. Peyron to let him go. As soon as the arrangements were made, he painted four of his greatest still lifes—two of roses and two of irises. In one of the paintings of irises, he sought a "soft and harmonious" combination of colors and in the other, "tremendously disparate complementaries." [59] He had expressed the desire not long before to give up the striking color contrasts of the latter, but, characteristically, he was not obsessively bound by his artistic resolutions. Perhaps this deviation from his recent works was made easier by the fact that for the moment, knowing he was to leave within the week, he was feeling more confident of himself and working "with a calm and steady enthusiasm."

On May 16, one year and one week after he arrived, he headed north.

11 Vincent's eye

VINCENT'S ARTISTIC accomplishments, a remarkable achieve-
ment by a man with so little formal schooling in art, were
made possible by a training that was begun in childhood. It was
not the planned training of the 1880s, but a spontaneous, partly
unconscious "learning" that arose out of the pressure of inner needs
and was fostered by his cultural milieu. An important part of this
learning process was the result of an intense fascination with look-
ing.

The reader of *The Complete Letters* soon became aware that
Vincent's eyes were incessantly surveying his environment. Letters
written to Theo long before he decided to become an artist are
filled with word pictures of people and places. Sheer visual fasci-
nation was a vital impetus that helped push Vincent into art.
It was because of this long period of intensive looking that
he was able to say only one year after embarking on his life as
an artist that his eye was "well-trained and steady." [1] The eye
of the painter, like the ear of the musician, is his basic tool.
It is through being able to recall, assemble, and modify what
he sees that the artist projects images onto canvas. Indeed, the

artist may think of himself as a hypertrophied eye, like the mysterious, hovering eye-persons of Odilon Redon or the more humorous one of Paul Klee. Cézanne described Monet as "only an eye—but what an eye!" Vincent himself, in describing a portrait of his idol Millet, noted the "intense look of a painter—how beautiful it is—also that piercing gleam like in a cock's eye." [2]

Vincent, too, had "the intense look." During his bookselling days in Dordrecht an acquaintance noted his "small, narrowed peering eyes," just as later on in Arles an observer said he was "continually stopping and peering at things." [3] Gazing was the pleasure Vincent could gratify most readily. When he was hospitalized in The Hague and forbidden to get out of bed, for instance, he could not stop breaking the rules in order to look at the "splendid" view from the window of the ward. He went to dances in Antwerp, not to dance but to look: "I still go often to those popular balls, to see the heads of the women and the heads of the sailors and soldiers. . . . one can amuse oneself a whole evening, at least I do, by watching these people enjoy themselves." [4] And of the Provençal scenery he exclaimed, "I cannot tell you often enough, I am ravished, ravished by what I see." During the periods in Provence when he was forced to stay indoors, he found he could draw upon his store of visual memories, much as one might look at home movies.[5] This was especially helpful during winter when the weather would not let him work outside.

Fixing on paper or canvas what he gazed at was a natural consequence to Vincent: "It is splendid to look at something and admire it, to think about it and keep hold of it and then to say, I am going to draw it and work at it until I have it fixed on paper." He also used the art of others as a substitute form of looking. When he was in England, long before he became an artist, he went every week to *The Graphic* and *The London News* to see the new issues. "The impressions I got on the spot," he recalled some ten years later, "were so strong that notwithstanding all that has happened to me since, the drawings are clear in my mind." Painting was an extension of seeing: "I love to paint, to see people and things and everything that makes our life—artificial—if you like." [6]

Vincent was also a voracious reader, often completing a book a night. Having "an irresistible passion for books," he read books of special interest many times—the Bible, Dickens' Christmas stories, *Uncle Tom's Cabin,* and Michelet's writings, for instance. Books not only gave him new ideas and reawakened old feelings

but also stirred up visual impressions. "[T]he love of books," he said, "is as sacred as the love of Rembrandt—I even think the two complement each other." [7] Long years of reading contributed to the "sureness of eye" of which he spoke. Looking at people and the environment, looking at books, and looking at paintings were different aspects of a driving impulse toward visual activity. His ability "to acquire power to read a book in a short time without difficulty, and to keep a strong impression of it" was part of the process that helped his artist's eye become "well-trained and steady." [8] Equating looking at books with looking at art, he wrote, "In reading books as looking at pictures, one must admire what is admirable, without doubt, without hesitation, sure of one's ground."

When he read a book, he sometimes saw pictures rather than words. For instance, he found passages in Zola "superbly painted or drawn," and a passage from one of Theo's letters was "palpable and visible" to him. On reading Victor Hugo's '93, he wrote, "It is painted—I mean written—like a Decamps or Jules Dupré." On another occasion he said that if he should hear some music "I should be watching the musicians rather than listening." [9]

The artist, according to E. H. Gombrich, is "the man who has learned to look critically, to probe his perceptions by trying alternate interpretations in play and in earnest." [10] Vincent also stressed the need for practice, recognizing with Gombrich that a learning process is involved. "[T]he way to get bolder and more daring in the future," he wrote, "is to continue quietly observing as faithfully as possible now." He was intensely motivated by inner pressures to look and to interpret what he saw. As a result, he "learned to look critically." [11]

Vincent's passion to look could be considered the result of a powerful constitutional drive to use his eyes. The psychoanalyst Phyllis Greenacre, for example, has suggested that the extraordinarily sensitive sensory equipment of artists (and not only painters) is the result of a genetic mutation.[12] Aldous Huxley, among others, has agreed with this point of view. On the other hand, Dr. Greenacre has also observed that various portions of the perceptual apparatus in the neurotic and the psychotic—whether or not they are artistic—may be hypersensitive, and traces the roots of this hypersensitivity to childhood conflict.[13] May not the sensitivity of the artist have similar roots? There is no sharp dividing line between the artist and the neurotic, as Freud pointed out long

ago. Perhaps the deification of the artist—an ancient tendency of civilized and not-quite-civilized man—still influences our most modern thinkers. The change from "god-given" to "constitution-ally endowed" may be more an expression of scientific sophistica-tion than of a change in basic conviction.

This is no attempt to deny the importance of constitutional endowment but rather to suggest that such a complex psychological situation as artistic creativity requires a complex explanation. The psychoanalyst is not equipped to prove or disprove the significance of heredity in relation to creativity. It is clear, however, that psy-chological forces played an important role in the development of Vincent's intense visual activity. On the basis of his observations Vincent himself came to a similar conclusion concerning one aspect of vision, the reaction to color: "[A]ll the impressionists are . . . somewhat neurotic. This renders us very sensitive to color and to its special language, the effect of complementary colors, of their contrast and harmony." [14]

Visual activity was one of the devices that Vincent used to make his loneliness tolerable. Vision is one means by which the outsider can carry on a relationship with other people, even though it is at a distance and largely in fantasy. Vincent depicts this outsider-onlooker role in his drawing of an outdoor café (*The Country Inn*) in which a man, walled off by the table and trees in front of him and the staircase behind him, gazes at several couples. Vincent's visual interests complemented his interest in nature. He used various aspects of nature as substitutes for human relationships, and these relationships were also carried on mainly through the eyes.

Like others who have strong depressive tendencies, he was especially sensitive to feeling unloved and hated. Such people often have a highly developed perceptual sense; they seem to have built-in radar screens that detect possible dangers in the environ-ment, dangers which they fear will overcome them at any moment. Vincent's eyes were his chief means of relaying the information to his mind. Convinced that others wanted to hurt him, he kept track of their behavior with his eyes, like a spy searching for troop movements in the ranks of the enemy. What in its inception, how-ever, was developed as a means of self-protection ultimately be-came a means of understanding people's nature that was useful in his work as an artist. As he wrote to his Dutch friend van Rappard, "You know that I am in the habit of observing very accurately the

physical exteriors of people in order to get at their real mental makeup." [15]

Many passages from Vincent's letters suggest that looking also represented a hungry devouring state. He had more pleasure nurturing himself through his eyes than through his mouth. His eating habits were ascetic, but he was ravenous in what he took in through his eyes. For example, he had "devoured" two chapters of a new book, adding, "Someone says instead of eating enough . . . I keep myself going on coffee and alcohol, and reading."

By his actions, Vincent denied the angry cannibalistic impulses he feared; it was his eye that was voracious, not his mouth. Through gazing, visual gratification became a substitute for oral gratification. His eye swallowed its surroundings as if they were both food and friends. This applied especially to looking at paintings. He once remarked, *"How rich in beauty art is; if one can only remember what one has seen, one is never empty or truly lonely, never alone,"* [16] and he heartily endorsed Delacroix's statement that "painting is a feast for the eyes."

Perhaps the rejection that Vincent experienced with his mother was connected with problems related to feeding and cuddling. His mother did not actually abandon him; she was still there to be seen. As a result, a shift of interest from unsatisfied mouth-skin-body sensations to visual sensations may have occurred, as if the situation became frozen at the time before eating. He went on and on, gazing expectantly at his mother from a distance, anticipating being fed and held. But this gaze, because it was frustrated in its goal, became a hungry gaze. It is an old idea that such frustration leads to wish-fulfilling hallucinations. Such visual imagery, however, is ordinarily a precursor to the real goal and not the goal in itself. Out of frustration, Vincent made the goal the imagery rather than the final intimate union with mother.

While depression caused him to turn to fantasy, frustration and fear of his angry cannibalistic impulses may have caused him to shift from mouth to vision. In this way visual imagery came to play an important role in his mental life. Some clinical data suggests a connection between such ravenous use of the eye and depression. The English pediatrician-psychoanalyst D. W. Winnicott observed visual states akin to Vincent's in depressed children.[17] The eyes of these unhappy children became fixed for long periods on near objects; later they became "slave drivers to their eyes" and developed a tremendous reading urge.

Vincent himself observed the child's pleasure in gazing—a baby, for instance, "looking for hours at the shuttle [of a loom] flying to and fro." [18] He equated the warm rays of the morning sun with a mother's warmth: "[I] think I see something deeper, more infinite, and more eternal than an Ocean in the expression of the eyes of a little baby when he wakes in the morning and coos or laughs because he sees the sun shining in his cradle." [19] This child, an extension of himself, is content and immortal because the mother-breast-face sun sends out its nourishing rays.

"[O]ld cab horses have large beautiful eyes," Vincent once wrote, "as heart-broken as Christians sometimes have." [20] Round large bulging eyes have long been empirically associated with a melancholic gaze, and Vincent drew many of them, such as those in *The Potato Eaters*. They beg, "Please don't hurt me. Please help me and love me!" And, like a hungry open mouth, they also ask to be fed. Carrying on such a relationship through the eyes was a compromise solution in his attempt to solve the conflict between the fear of a dangerous mother and the desire for intimacy with her.

Parallel to the unfounded suggestion that Vincent's steep perspectives were provoked by mania or a poison affecting the nervous system, eye specialists have theorized that his brightly colored vision of Provence and his halo effects were the result of an ocular disturbance such as nearsightedness, glaucoma, or cataracts. Such ideas can scarcely be convincing to anyone who views his artistic development as a whole. He not only had control over the exaggerated, dazzling effects he produced, but they were carefully planned, gradually evolving out of a synthesis of personal characteristics with his broad knowledge of artistic styles. They were not at the whim of some eye or brain disorder.

Vincent's fascination with looking had its own problems. Gazing in itself gave rise to fear when there were insufficient barriers between him and people in whose presence he felt uncomfortable. In such situations he protected himself by refusing to look. His sister Elizabeth said that as a child he kept his eyes half-closed when eating with his family. Someone has also remarked that he stared straight ahead while walking, refusing to recognize anyone in the street.[21]

Anxiety in looking became especially intense during his stay

in the sanitarium at Saint-Rémy. After he was sufficiently recovered to walk about the town, he wrote, "The mere sight of people and things had such an effect on me that I thought I was going to faint and I felt very ill." Seven months later, while discussing a painting that he wished to copy, he said, "You know I think 'The Virgin' so dazzling, *I have not dared* look at her." [22] On the other hand he did not fear confronting the sun—the most dangerous and, for him, the most prized visual object of all. This confrontation began in bleak Holland, not in sunny Provence, and it was of sufficient intensity to produce a painful inflammation of the eyes.

The childhood device of keeping his eyes half-closed in order to isolate himself from his family seems to have been transformed into a technique that he used in developing his artistic style. He first mentioned it in 1883 while in The Hague: "[N]ow that I let myself go a little, and look more through the eyelashes, instead of staring at the joints and analyzing the structure of things, it leads me more directly to seeing things more like patches of color in mutual contrast." Commenting on some studies he had made, he observed "something of that mysteriousness one gets by looking at nature through the eyelashes, so that the outlines are simplified to blots of color." [23] He found the method helpful in painting *The Potato Eaters*: "[W]hen seen through the eyelashes in the light of the lamp, all this proves to be *very dark gray.* . . . But when starting the picture, I tried to paint them that way, with yellow ocher, red-ocher and white, for instance. But that was *much too light* and decidedly wrong." [24]

His friend Kerssemakers related that on a walk with him, "he suddenly stood stock-still before a glorious sunset, and using his two hands as if to screen it off a little, and with his eyes half-closed, he exclaimed, '. . . Take care you never forget to half-shut your eyes when you are painting in the open air. Once in a while those clodhoppers in Nuenen say that I am mad when they see me shuffling about on the moor . . . screwing my eyes half-shut, holding up my hands to my eyes, now in this way, now in that, in order to screen things off.' " [25] "To screen things off," which—by a magical reversal—began as a defensive attempt to become invisible, became a way of seeing things in new ways. I do not know if this technique was used by other painters as it is today; even if he had heard about it from others, however, such instruction would only have encouraged his use of an old and practiced habit.

Vincent was well prepared for his task as an artist not only

because of the education he acquired during a lifetime of intensive looking but also because his visual interest had always been directed toward his predecessors in art. The development of his style is a good example of Gombrich's thesis that evolution in art is not simply the result of cultural change, as some art historians have maintained, but the result of a special kind of history—the history of technique. Art develops through the accretion of techniques from one generation to the next. Through this accretion artists "learn to look" and to see things that have never been seen before. The ability of the artist to visualize the world in terms of paintings, old and new, and to make these views part of his personal vision is necessary to the continued evolution of creative art.

Aided by an excellent visual memory, Vincent acquired a broad knowledge of painters and this knowledge became part of his visual perceptions. To cite a few of numerous examples, he saw "van Goyenesque effects" and "an effect exactly like Ruysdael's bleaching fields" in the Drenthe countryside. He observed "a Rembrandtesque effect" when looking at the Nuenen weavers by lamplight; and when his interest turned to Japanese art, a boat on the Rhone river was "pure Hokusai." He found figures on the beach at Saintes-Maries "like Cimabue." [26] Finally, he incorporated this way of seeing into his own style.

Why did Vincent so readily see actual surroundings as if they were paintings? Being born into a country with a four-hundred-year tradition that accepted art as an integral part of life and into a family that prized art seems likely to have encouraged such a disposition, and the dark, wet, flat monotonous Dutch countryside may also have contributed to it. Vincent equated this bleak environment with loneliness and depression, and it often provoked a melancholic state in him. Seeing it glorified through the eyes of a revered artist, however, transformed the scene into an aesthetic experience that alleviated boredom and depression. The fear that grew out of the very intensity of his gaze may have reinforced his perception of the world in this "as-if" way. Similar to keeping his eyes half-closed, seeing the object or person as a painting made it less real and less threatening.

A strong sense of shame also played a key role in the development of Vincent's dependence on visual experience. The intensity of the feeling of shame is related to the factors that develop the child's self-image. Childhood situations that convince him of his own inferiority—whether physical or psychological, general or

specific—lower his threshold for feeling shame. Shame is the emotion above all that relates to vision, for it is based on the feeling that one is seen as an inferior or despised person—ugly, dirty, repulsive, and helpless. To avoid being regarded in this way he wishes to disappear from sight; etymologically, the root word of shame means being covered up.

The attempt to avoid feeling shame contributed to Vincent's self-isolation, for in isolation he became invisible. Using the magical thinking that equates not-seeing with not-being-seen, Vincent turned his head away or closed his eyes in an attempt to avoid the discomfort. He also feared direct contact with revered elders. In London, for instance, he occasionally met Mathijs Maris, one of the best known Dutch painters of his time and one whom Vincent greatly admired; Vincent found that he "was too bashful to speak out freely to him." [27] A similar reaction occured when he saw Boughton, the artist who painted *The Pilgrim's Progress*, the painting mentioned in Vincent's sermon: "I dared not speak to Boughton because his presence overawed me." In the winter of 1880 he walked many miles from the Belgian Borinage to Courrières, in northwestern France, in the hope of seeing Jules Breton, then a well-known artist and poet who followed the realistic manner of Courbet and Millet. After a difficult week on the road he arrived at Breton's studio and observed its chilly "Methodist" exterior. In spite of all his exertions, he lacked the courage to confront the master. Elsewhere in the town he tried to satisfy himself by less embarrassing means: he found a picture that *might* have been painted by Breton. [28]

As an artist, Vincent became an eye. And as an eye, he said, in effect, "I can see you but you can't see me." When he painted his self-portrait, he said, "I am seen, but seen on my own terms. I can make myself either repulsive or attractive. It is up to me, not to you to decide." When he painted the portrait of a model he said, "It is the other who is exposed, not I," while at the same time revealing himself in it.

The transformation of the visual core of shame, the pain of being looked at, into the awe of looking was especially important in his artistic development. Awe signifies a sense of being overwhelmed by the greatness and majesty of a person or object; feelings of reverence, wonder, or fear often accompany it. Shame and awe are related. Both are concerned with contrasts between superior and inferior and with vision, although in shame one is observed

while in awe one is the observer. Vincent often described the intense awe that he felt in the presence of idealized figures and in the presence of nature, making explicit what one might surmise from his paintings. In the presence of an object of awe, he continued to feel small and inferior while the object of awe was felt as big and powerful, but he no longer experienced the shame of scorn and the terror of abandonment that would result from it. In their place he felt a reverence, a oneness, and a "consolation," as he put it, in the presence of a powerful image.

Awe, however, was not a completely satisfying substitute for shame. For he remained weak, inferior, and helpless in relation to the awesome object. Besides, the awe was sometimes accompanied by fear. The ability to see the object as a painting rather than the real thing was a further step in the transformation of shame. By visually containing the object within the bounds of a canvas and a frame, Vincent could then master the residue of shame and fear inherent in awe, transforming it into an aesthetic reaction. Now he could say, "I have nothing to fear. It is not I but you who is small and helpless. But I do not take advantage of my power. Rather, I admire you and want to be your friend."

One more step in this process remained for Vincent. The aesthetic reaction felt in looking made it easier to put the object on canvas and produce the same reaction in others. By becoming the painter himself rather than merely looking through the eyes of the painter, by the transformation from passivity to activity, further control was wrested from the object. He became the master, and the object was contained for eternity. By simplifying and modifying the picture, he became bigger in relationship to it, and the transformation was completed.

12 "The doctrine of Christ" in pictures

THE IDENTIFICATION with Christ was one of the dynamic forces that motivated Vincent to become an original and productive artist. As Christ, he felt justified in attacking the academicians and in becoming a martyr for art. Art utilized his suffering by glorifying it in the image of Christ. He could shed useless tradition, learn new ideas and techniques from the other outsiders, and feel assured that he was destined to create a new tradition. The shame he felt about being a lowly outsider was hidden by a sense of greatness that enabled him to produce artistic miracles. As Christ, he was permitted—or even forced—to press on defiantly in the face of the threatening world, confident that the future would vindicate him.

Vincent's Christ identification contributed not only to the intensity of his artistic drive but also to the content and style of his art. In spite of this, however, he painted few biblical scenes. He could only be called a religious painter in consideration of the religious ideation that was expressed in nonreligious form in his pictures. Among the works from the North, there is not a single overtly religious portrayal, except for the small and incidental Christ figures in *The Bearers of the Burden* and *The Potato Eaters*.

The few biblical scenes among his works all come from Provence. Two were painted in Arles, both depictions of Christ in the Garden of Olives,[1] and he destroyed them both. The others, all copies, were painted a year later when he was incarcerated in the sanitarium at Saint-Rémy. They included *The Pietà* and *The Good Samaritan*, both after Delacroix, *The Angel*, and *The Raising of Lazarus*, after Rembrandt. The subject matter of all of these paintings had a deeply personal meaning for him. The paintings after Delacroix deal with Vincent's favorite theme—the plea for love and attention through sickness, injury, or death. *The Pietà* depicts a mother's love for a dead son, and *The Good Samaritan* shows a wounded man who has been nursed, bandaged, and helped on his way. *The Angel* is based on a copy of *The Angel Raphael*, ascribed, probably incorrectly, to Rembrandt.[2] Raphael is the guardian angel of humanity, protector of the young and innocent, especially of pilgrims —like Vincent. We are not certain, however, that Vincent knew the actual subject of the painting although he made inquiries about it. We do know that he considered the portrait to be "luminous and comforting." [3] *The Raising of Lazarus*, of course, is concerned with rebirth, another of Vincent's central themes.

Vincent made some significant modifications in Rembrandt's etching, *The Raising of Lazarus*. In the original etching the figure of Christ, in the foreground, looks down on Lazarus. Vincent eliminates Christ, restricting his version to a closeup of the prostrate body of Lazarus—who now resembles Vincent—and the onlookers. Compared with the original, where the scene is viewed from afar, the artist, Vincent, stands at the side of the missing Christ—"the greatest of all artists"—and sees the scene more or less through his eyes. In Rembrandt's etching an erect male figure towers above the onlookers behind Lazarus; the diminutive woman beneath him is relatively obscure. In Vincent's version, the man has been eliminated and the woman—now larger, older, and more frantic—hovers alone over the prostrate form. The change converts the woman into a near *mater dolorosa* and the painting into a near Pietà. Simplifying the etching focuses the attention on the relationship between the helpless man and the concerned woman.

With these exceptions, Vincent shunned religious subjects. He attempted to explain this by falling back on his long and intense exposure to the art of the Netherlands: "Those Dutchmen had hardly any imagination or fantasy, but their good taste and knowledge of composition was enormous. They have not painted Jesus

Christ, the Good God and so on. . . ." [4] He might have added that Dutch Calvinism made it so.

From the fourteenth to the sixteenth centuries, the art of the Catholic Netherlands was mainly religious in content. But with the advent of the Calvinists during the Protestant Reformation, paintings were banned from the church and the portrayal of holy subjects was frowned upon. Protestant iconoclasts mutilated church art wherever they could lay their hands on it. As a result, biblical heroes and religious events gradually vanished. In appeasing the Dutch Reformed Church, most artists had eliminated religious themes from their works by the seventeenth century and sought inspiration in the common objects around them. And so the art of this great period consisted of portraits, still lifes, genre paintings, landscapes, and architectural pieces.

Rembrandt was the chief exception. But even Rembrandt's religious portrayals remained close to the earth, in contrast to the Catholic art of Italy, Spain, and Flanders. Rembrandt used Bible subjects more to portray character than to illustrate religious events. According to the art historian Wilenski, for instance, Rembrandt's works "are not religious art in the sense of art called forth by the service of the Church. . . . He is generally said to have thought of the Bible stories in terms of daily life." [5] Vincent himself remarked that of all the Dutch painters, Rembrandt "is the only one, the exception, who has done Christs, etc. And in his case it is hardly like anything whatever done by the other religious painters; it is metaphysical magic." [6]

In diverting his religious preoccupations from New Testament religion to art as religion, disguised New Testament ideation is to be found in many of Vincent's works. This pattern of transformation had long since been established by the pressure of the church on his Dutch predecessors. When religious portraiture was rejected by the Reformation, it went underground. Religious ideas were hidden within still lifes, landscapes, and genre painting. The apple, for instance, represented original sin, the walnut the divine nature of Christ, the butterfly the soul, and the fleur-de-lis the Virgin Mary. Originally used as incidental elaborations in religious art, they made their appearance as independent, symbolic still lifes by the end of the fifteenth century. Whether in a nation or an individual, deeply imbedded religious ideas cannot be rooted out by edict. They persist in disguise.

But there was more than Dutch tradition to account for Vin-

cent's avoidance of mystical religious portraiture. The personal fears that drove him from Christianity made him oppose art that was not consonant with reason. In 1885, for instance, he complained of a "mystic Christ" in a painting by Uhde, and added that he preferred the "thoroughly logical, sensible and honest" art of Lhermitte and Raffaëli.[7] In 1888 he criticized the symbolic, esoteric art being popularized by Odilon Redon. This may seem a strange position for one whose life was so prone to bizarre behavior, but fear that he might lose control of his behavior seems to have been responsible for his distaste for such art. His reluctance to portray Bible scenes sprang in part from a concern that "frightful ideas," mainly self-destructive in nature, might break into consciousness, and that he might act on them. In the religion of art, Vincent rejected a sadistic Christian God and found his way to a safer, kindly God—Mother Nature. Rather than paint the Christ of the Bible he painted "the doctrine of Christ,"[8] a phrase Vincent applied to Millet's landscapes.

During 1888 and 1889 Vincent objected to the visionary religious scenes that his friends Gauguin and Bernard were painting in Brittany, and he advised Bernard to stay with reality. Soon after confessing that he had a "horror of all religious exaggeration," he complained that their "Christs in the Garden" had gotten on his nerves and called them "a sort of dream or nightmare."[9] Yet he was attracted to this very scene and had painted it twice in 1888. When he destroyed these paintings, it was as if he were destroying a frightening nightmare that threatened to turn into a reality. Indeed, it did so a few months later when he mutilated his ear.

Vincent's copies of Delacroix's and Rembrandt's religious scenes were far from imitations. But the fact that another artist stood between himself and the Bible may have been a safeguard. Furthermore, Vincent did not perceive Delacroix and Rembrandt as visionary religious painters. They painted the real thing, not an imagined scene. Regarding Delacroix, he wrote, "And then do you know why the pictures of Eug. Delacroix . . . have such a hold on one? Because when [he] did a 'Gethsemane', he had gone to see first-hand what an olive grove was. . . ."[10] He repeated the same judgment about Rembrandt: "Rembrandt did not invent anything, that angel, that strange Christ, the fact is that he knew them. . . . Now there is a great distance between Delacroix's and Rembrandt's method and that of all the rest of religious painting."[11]

We have seen that Vincent had a powerful attachment to men who sowed the fields. He had already drawn at least five sowers before he left the Borinage during the first months of his career as an artist, ". . . and I will take it up again," he wrote about the sower. "I am entirely absorbed in that figure." [12] His interest was partly derived from his idol Millet and "the doctrine of Christ" that Millet painted. He copied *The Sower* of Millet both in the North and the South and used the same figure in other landscapes.

Even as a youth anticipating a religious life, Vincent regarded himself as a sower who followed in Christ's footsteps. In 1877, for instance, he had written: "I suppose that for a 'sower of God's word,' as I hope to be, as well as for a sower of the seeds in the fields, each day will bring enough of its own evil, and the earth will produce many thorns and thistles." [13] When Vincent became an artist (and turned Christ into an artist), he transferred the idea of the sower to art. As he wrote to Bernard in June 1888, "Though this great artist—Christ—disdained writing books on ideas, he surely disdained the spoken word much less—particularly the parable. (What a sower, what a harvest, what a fig tree, etc.) . . . These spoken words . . . are the very highest summit reached by art. They make us see the art of creating life, the art of being immortal and alive at the same time. They are connected with painting." [14] Equating himself with Christ and Christ with art, his paintings became visual rather than spoken parables and his sowers portraits of Christ as well as self-portraits.

At the time Vincent was equating Christ, sower, and art in this letter, he was also painting and drawing sowers and included sketches of a sower in letters to Bernard and the English painter Russell.[15] In them, the sower strides diagonally across a plowed field with the sun behind his head. If the viewer places himself in front of the sower, the sun becomes a halo and the figure becomes a haloed Christ-sower; the figurative meaning of the "sower of the word" is translated back into the literal meaning, a device sometimes used in dreams. Another van Gogh *Sower*, painted the following October, requires less imagination. For here, the sower's head is surrounded by the golden sun just as the head of Christ is surrounded by a golden halo in church paintings.* (See *The Sower*, June 1888, and *The Sower*, October 1888.)

* This *Sower* is appropriately used on the front cover of a paperback book on the parables: Joachim Jeramias, *Les Paraboles de Jésus*, Ed. Xavier Mappus, Le Puy, 1962.

During the same summer in which he painted these sowers, Vincent visited Saintes-Maries-de-la-Mer, a fishing town on the Mediterranean, and admired the fishing boats there—"little green, red, blue boats, so pretty in shape and color that they make one think of flowers." "A single man is their whole crew," he wrote. "They are off when there is no wind, and make for the shore where there is a bit too much of it." [16] He viewed them metaphorically: "We are at present sailing the high seas in our wretched little boats, all alone on the great waves of our time." [17] Painting them helped to control the lonely, threatening world that the scene symbolized.

These boats also made him think of Delacroix's painting, *Christ on the Sea of Galilee,* illustrating Mark 4:39 in which Christ calms the waters. Vincent referred to this painting on his return to Arles from Saintes-Maries: "Ah, that lovely picture by Eug. Delacroix: 'Christ in the Boat on the Sea (sic) of Gennesaret [Galilee]! He—with his pale citron-colored aureole—luminously asleep against that patch of dramatic violet, somber blue, blood red, the group of mortally frightened disciples—on that terrible emerald sea, rising up to the very height of the frame. Oh! that sublimely brilliant conception." [18] Vincent's seascapes from Saintes-Maries were undoubtedly influenced by Delacroix's painting, and they resemble it in concept and in color. As Vincent painted them, the pretty little boats of Saintes-Maries that "hardly venture on the high seas" are in turbulent waters: witness the somber hues, the feeling of violent motion, and the height of the waves. In spite of this turbulence, however, the little boats that are only supposed to sail "where there is no wind" remain calm and peaceful. (See *Boats on the Sea.*)

Vincent drew three seascapes, he wrote, "just by letting my pen go," [19] a painter's pre-Freudian version of free association. Perhaps Vincent was saying, in effect, that these pictures represented ideas from the hidden resources of his mind that were pressing toward consciousness and that finally emerged spontaneously through his hand. In view of his identification with Christ and his strong preoccupation with the New Testament at the time, it is likely that the visit to Saintes-Maries and his view of the fishing boats on the sea aroused thoughts of the New Testament scene of Christ calming the waters and of Delacroix's painting that illustrated it. Vincent's knowledge of the Holy Land no doubt caused him to compare Saintes-Maries with the locale of the event at

Galilee. The little Provençal fishing port was to Provence what the fishing villages of Galilee were to the Holy Land. Much of Christ's ministry was carried on in these villages, and the color of fishing life in Christian lore is thought to have come from it.*

Vincent's interest in this scene was not new. He had discussed it in 1876 when he delivered his sermon. In a passage comparing life to a rough sea voyage, he wrote, "[V]ery soon the waves become higher, the wind more violent, we are at sea almost before we are aware of it. . . . Does not everyone of you feel with me the storms of life, or their forebodings or their recollections?" In answer, he reassured the congregation by referring to this scene in which Jesus calms the winds and delivers the boats to safety. He returned to it again in 1877, stimulated by a stormy day in Amsterdam that he called "beautiful and inspiring." [20] He reminded Theo that Peter became frightened while walking on the water and began to sink, but Jesus responded, "O thou of little faith, wherefore didst thou doubt?"

Vincent's early years had left him lacking the faith and trust that is essential to an optimistic view of the world, a lack that left him vulnerable to frightening preoccupations with life and death. In identifying himself with Christ, the beloved child, he hoped to grasp the faith that had eluded him in his own childhood. His strong, though precarious faith in a loving God made both life and art possible. His interest in the stormy sea had some of its roots in this biblical passage in which faith overcame fear.

He reenacted this scene, playing the role of Christ, by painting the stormy sea under difficult conditions. He mastered his fear of the storm and, indeed, the storm itself by getting it down on canvas. He may have had this in mind when, early in his struggle to become a painter, he affirmed his belief in the quotation, "I will grow larger in the storm." He sought this growth when he painted the sea near The Hague in 1882: "All during the week we have had a great deal of wind, storm, and rain, and I went to Scheveningen several times to see it. I brought two marines home from there. One of them is slightly sprinkled with sand—but the second, made during a real storm, during which the sea came quite close to the dunes, was so covered with a thick layer of sand that I was obliged to scrape it off twice. The wind blew so hard that I could scarcely

* Saintes-Maries is named after two Saint Marys—one of them Mary Jacob, the sister of the Virgin Mary—who, the story goes, were abandoned at sea in a small boat and found their way to this harbor. Their tombs have long been the object of a yearly religious pilgrimage.

stay on my feet, and could hardly see for the sand that was flying around. However, I tried to get it fixed by going to a little inn behind the dunes, and there scraped it off and immediately painted it on again, returning to the beach now and then for a fresh impression." [21]

Vincent painted *The Cradle* for the martyred sailors "alone on the sad sea." [22] In reflecting about it, the sea became a reflection of his own inner world, a world that grew out of childhood despair —a vast and empty, albeit dangerous and enveloping space that lacked love and intimacy. He transformed and tamed this barren space by incorporating within it a revised view of himself as a beloved Christ who was in full control of its dangers.

Vincent repeatedly compared the flat fields of grain with the sea, and sometimes he equated landscapes with seascapes. In describing the fields of Drenthe, for instance, he wrote: "There was not a vista of the sea in the background, but only the sea of young grain, the sea of furrows instead of the sea of waves." [23] Later, he wrote that the plains of Provence were "as beautiful and as infinite as the sea." [24] The landscape of the nearby Crau, a vast plain that he called "infinity-eternity," caused Vincent to ask a fellow, "Does it amaze you that I think this as beautiful as the sea?" He was pleased to hear the fellow reply, "I myself think it even more beautiful than the ocean; because it is inhabited." [25]

He repeated the scene of Jesus taming the storm when he faced the violent winds of the mistral in Provence, planted his easel in the ground, and painted the turbulent sea of wheat. It was as if he were telling the winds that he, too, was not afraid, that he could tame them even as Jesus had done. "I painted it with the mistral raging," he wrote Bernard in June 1888. "My easel was fixed in the ground with iron stakes. . . ." In August he again noted that he had been painting in a "very ill-natured, nagging wind—le mistral." [26] This time, however, he put his canvas flat on the ground and worked on his knees.

Vincent equated sea and field as well as sower and Christ. So it is not surprising that his *Sowers* of 1888 were land versions of Delacroix's *Christ on the Sea of Galilee,* that preoccupied him at the time. In July or August 1888, he wrote that he was working on a sower "done completely differently. The sky is yellow and green, the ground violet and orange. There is certainly a picture of this kind to be painted of this splendid subject, and I hope it will be done someday, either by me or someone else." He wanted

to combine Delacroix's painting and *The Sower* of Millet: " 'The Christ in the Boat' by Eugène Delacroix and Millet's 'The Sower' are absolutely different in execution. 'The Christ in the Boat'— I am speaking of the sketch in blue and green with touches of violet, red and a little citron-yellow for the nimbus, the halo— speaks a symbolic language through color alone. Millet's 'Sower' is a colorless *gray*, like Israël's pictures. Now, could you paint the Sower in color, with a simultaneous contrast, for instance, of yellow and violet . . . yes or no? Why, *yes*. Well, do it then." [27] He followed his own advice.

He best succeeded in combining the form of Millet's *Sower* with Delacroix's color and style in *The Sower*, October, 1888: "A green-yellow sky with pink clouds. The field violet, the sower and the tree Prussian blue." [28] But he was not satisfied to let the color alone symbolize the halo, for it is also directly represented as the sun, "an immense citron-yellow disk," encircling the sower's head like Christ's "citron-yellow" halo in Delacroix's painting. *The Sower*, October 1888, also shares some of the other formal characteristics of Delacroix's seascape. The placement of the haloed head of the sower is similar to that of the haloed head of Christ. So is the diagonal placement of the wheatfield and that of Delacroix's boat. Even the branches of Vincent's tree seem to repeat the pattern of the raised arms of the excited fisherman.

The association between *The Sower* and the *Christ on the Sea of Galilee* coincides with the associations of the parable of the sower and the biblical passage of Christ calming the waters, one that Vincent knew so well. The parable was spoken by Christ from a boat at sea (Mark 4:1–9), and the passage in which Christ performs the miracle during the storm follows a few lines later (Mark 4:35–41). Vincent wrote about Delacroix's *Christ on the Sea of Galilee* and Millet's *The Sower* just after he had returned to Arles from Saintes-Maries where he painted the fishing boats in the manner of Delacroix; his remarks suggest that he was continuing the same Christian theme when he painted the sowers in Arles. Further, his associations went directly from sea to sower in a letter of this period addressed to the Englishman Russell: "I have been to the seaside for a week and very likely am going thither again soon. . . . Am working at a Sower: the great field all violet, the sky and sun very yellow, it is a hard subject to treat." [29]

The religious significance of other van Gogh pictures may be inferred from the artist's own reflections. Take the newborn baby

lying in a cradle that he drew after Sien's return from the hospital. At the time that he drew it, *Baby in Cradle* reminded him of "the eternal poetry of the Christmas night with the baby in the stable . . . a light in the darkness, a brightness in the dark night." [30] Considering that the infant is equated with the Christ child, the whiteness of the pillow surrounding his head, standing in contrast to the dark surroundings, represents his halo. It may be compared to the white cloth that serves as a halo for the Christ child in El Greco's *Adoration*. Perhaps other van Gogh representations of mother and child were also partly inspired by this holy scene. The lantern above the head of the sleeping infant in *The Evening* blazes like a ball of yellow fire. It is the sun-halo brought indoors for this night scene; with its help, Vincent returned to "the eternal poetry of the Christmas night."

Vincent thought that sad women, who attracted him so much, had "the Dolorosa expression." [31] The label "Sorrow" that he inscribed on the sketches of Sien was his English version of *Dolorosa*. When he drew and painted these sad faces, as he did so many times, he was also portraying the loving mother of the crucified Christ, the *mater dolorosa*. She was the ideal whom he sought in life, in art, and in death.

Subjects as outwardly diverse as an old cab horse and Dr. Gachet also had one source in the martyred Christ theme. In discussing a poem that conveyed to him "the exaggerated leanness of the mystic Christs," he wrote that "the anguished look of the martyr is, like the eye of the cab horse, sorrowful." [32] Dr. Gachet's portrait, Vincent wrote, revealed the "heart-broken expression of our times," [33] but it also reminded him of Gauguin's portrayal of Christ's Agony in the Garden of Olives. To Vincent, it was a modern, secular version of the Agony. He saw both himself and Christ in the old horse as well as the old doctor.

Because Vincent's worship of nature was a retreat from frightening Christianity, landscape painting became a retreat from visionary religious portrayal. But—like so many old Dutch paintings—it was also a disguised representation of Christian belief itself. He expressed a religious message when he depicted trees, fields, flowers, birds, and the sea; the sky, too, with its sun, moon, stars, and clouds. Christ's death and resurrection were portrayed in the death and rebirth of trees and plants, the reaping and sowing of the fields, and the sunset and sunrise; his ascent into heaven was symbolized in the flight of birds, the clouds in the

sky, and trees reaching for infinity. In discarding the "cynicism and scepticism and humbug" of contemporary Christianity, he turned to the Japanese artist who "studies a single blade of grass." "Come now," he went on, "isn't it almost a true religion which these simple Japanese teach us, who live in nature as though they themselves were flowers?" [34] The single stem of a flower and the single stalks of wheat he painted under Japanese influence seem to have had a similar meaning to him. (See *Branch of Periwinkle*.)

Vincent worshipped the sun. He called it "the good god sun" and asserted, "Oh! those who don't believe in this sun are real infidels." [35] In a landscape from Saint-Rémy, the sun, "surrounded by a great yellow halo," rises over a wheatfield. "Here," he wrote, "I have tried to express calmness, a great peace." With pictures like this, he added, "it was not necessary to portray the characters of the Sermon on the Mount in order to produce a gentle and consoling motif." [36] The haloed sun often reigned over Vincent's earth during the day. And the stars took its place at night. When he felt a "terrible need . . . for religion," he wrote, "then I go out at night to paint the stars" [37]; they reminded him of the night in Bethlehem.

The sun halos of his sowers and the haloed suns rising over wheatfields are only a fraction of the halo effects that abound in Vincent's art and contribute to its characteristic style. The identification with a haloed Christ no doubt played a part in this. His striking red hair may have strengthened this self-image, and the frightening childhood view of sexual intercourse, as suggested earlier, may have led directly to experiencing dazzling halo effects. In essence, then, Vincent's pictorial halos mirrored his own view of himself, and from this standpoint were abbreviated self-portraits.

He himself regarded the halo as a contribution to art: "As for stippling and making halos and other things, I think they are real discoveries but we must see that this technique does not become a universal dogma anymore than any other." [38] He portrayed an overtly religious halo only once, however, and that in the copy of *The Angel Raphael*. The sunburst pattern in this halo is almost a replica of the halo over the baby in *The Evening*—a painting reminiscent of Vincent's word picture of "the eternal poetry of the Christmas night with the baby in the stable . . . a light in the darkness." Several of his self-portraits, including the one that re-

sembles the red-headed Christ in *The Pietà,* are surrounded by halos composed of concentric rings, each ring a series of short vigorous strokes. Similar halos surround the head in other portraits, including *Camille Roulin* and *The Zouave Lieutenant Milliet.* Halos are also produced by means of glowing lights and contrasts between black and white tones. The halo of the steam in *The Potato Eaters* and the halo formed by the white pillow in the sketch of Sien's baby are other examples.

Halo effects are often displaced from the head or the sun to other contexts. For example, sunbursts are used as technical devices in depicting shrubs and trees, and concentric halos surround the eyes in the peasant portrait, *Patience Escalier,* intensifying the facial expression. They are also seen in the startling celestial display in *Road with Cypress and Star* and in the lighting effects of the oil version of *The Night Café.*

Vincent's fatal attraction toward heaven during the year before he killed himself contributed to an increasing tendency toward vertical movement in his pictures. Perhaps this tendency led to a transition from concentric halos to the arabesque forms and twisted spirals characteristic of this period. In them the ring structure is unraveled and the halo drawn upward in a curving pattern.

More significant to his art as a whole, he tried to achieve the effect of a halo through color alone: "I want to paint men and women with that something of the eternal which the halo used to symbolize, and which we seek to convey by the actual radiance and vibration of our coloring." [39]

Vincent's preoccupation with the Garden of Olives, the scene of Christ's Agony and the betrayal of Judas, played a special role in the art of 1888 and 1889. Except for the two canvases of the scene that he destroyed, his deep attachment to it was displaced to landscapes. Take, for instance, the painting *The Garden of Saint-Paul's Hospital* in which "the nearest tree is an enormous trunk, struck by lightning and sawed off," a "somber giant—like a defeated proud man." He was trying, he wrote, "to give an impression of anguish without aiming straight at the historic Garden of Gethsemane." [40] In effect, he painted it as a substitute for the paintings of Gethsemane that he had destroyed the year before.

Van Gogh olive trees are among the most distinctive visions

in art. They originated out of his love for the land of Provence as well as out of his fascination with the Garden on the Mount of Olives. By the simple ruse of eliminating the biblical figures—Christ, the disciples, the angel, Judas, and the soldiers—and using real olive trees as models, he was able to paint a symbolic version of Christ's Agony in the Garden without feeling compelled to destroy it. These Provençal olive trees were acceptable, whereas the fantasied olive trees of Gethsemane and the fantasied biblical figures were too frightening; he had to avoid putting them on canvas or destroy the canvas when he did. In substituting the gnarled olive tree for the Garden of Gethsemane and bringing it into the fold of modern art, Vincent rediscovered an old Christian symbol: it had long before been used to denote the Garden. (See *Olive Orchard* and *Landscape with Olive Trees.*)

Vincent's letters reveal the relationship between his olive orchards and this biblical scene. He introduced the olive trees of Provence into his letters in July 1888, just after reporting his first personal experience in painting Christ in the Garden: "I have scraped off a big painted study, an olive garden, with a figure of Christ in blue and orange, and an angel in yellow. Red earth, hills green and blue, olive trees with violet and carmine trunks, and green-gray and blue foliage. A citron-yellow sky. I scraped it off because I tell myself that I must not do figures of that importance without models." [41] In the next letter, he briefly mentioned the olive trees at Montmajour, the ancient abbey near Arles.

They reappeared in September, as an association to the Gethsemane scene: "For the second time, I have scraped off a study of Christ with the angel in the Garden of Olives. You see, I can see real olive trees here, but I cannot or rather I will not paint it anymore without models: but I have the thing in my head with the colors, a starry night, the figure of Christ in blue, all the strongest blues, and the angel blended citron-yellow. And every shade of violet, from a blood-red purple to ashen, in the landscape." [42] After this, the Gethsemane theme again disappeared from his letters, although it reemerged at Christmas time in the act of mutilating his ear.

He returned to olive trees the following April, shortly before he had himself incarcerated in the sanitarium at Saint-Rémy. But now he isolated them from the biblical scene, although the underlying identity of the two may be inferred from their associative connections. First, he derided the "papier-mâché Christs that they

serve up to you in Duval establishments called Protestant, Roman Catholic or something or other churches." Then, like the associations of a patient in psychoanalysis, he switched abruptly: "Oh, my dear Theo, if you saw the olives just now. . . . [T]he tender beauty, the distinction! . . . [T]he rustle of an olive grove has something very secret in it, and immensely old. It is too beautiful for me to dare to paint it or be able to imagine it." [43]

He did "dare to paint it" in June, however, aided by the security of the asylum. Even in the act of severing the bond between olive trees and the destroyed canvases of Christ in the Garden of Olives, he betrayed the underlying relationship: "Finally I have a landscape with olive trees and also a new study of a starry sky. . . . [T]hese two studies are parallel in feeling . . . not a return to romantic or religious ideas, no." [44] He denied the religious content of both paintings—evidence, at least, that he considered it. But the fact that he regarded the paintings "parallel studies" suggests that they represented two aspects of the paintings he destroyed in 1888. The painting of the olive trees may be compared to the *Christ in the Garden of Olives* of July, a daytime scene with a "citron-yellow sky." The painting of the starry sky may be compared with the nighttime *Christ in the Garden of Olives* of September, with its own starry night.

Though Vincent had an aversion to mystical religious paintings, he admired the New Testament works of Delacroix. "Because when Eug. Delacroix did a 'Gethsemane,' " Vincent wrote, "he had gone to see firsthand what an olive grove was, and the same for the sea whipped by a strong mistral. . . ." [45] The realism of Delacroix (and Rembrandt as well) made it possible for him to tolerate the frightening aspects of these biblical events and, at the same time, to reap the benefits of Christ's consolation. From the standpoint of his own art, however, Vincent found it safer to restrict himself to olive trees, without the presence of biblical figures. Nevertheless, the trees themselves represented figures, as Vincent revealed in November: "And I am not an admirer of Gauguin's *Christ in the Garden of Olives*. . . . [Bernard] has probably never seen an olive tree. . . . No, I have never taken any stock in their biblical interpretations. . . . If I stay here, I shall not try to paint a *Christ in the Garden of Olives*, but the gleaning of the olives as you still see it, giving nevertheless the exact proportions of the human figure in it. . . ." [46]

Vincent revealed the bond between the biblical scene and olive trees in this statement, although he never openly acknowl-

edged it. Discussing his "discovery" of the olive tree with an artist friend, he said that he preferred that "others who are better and more powerful than I reveal their symbolic language." [47] Yet in the next letter to Theo, he came close to doing so: "[T]his month I have been working in the olive groves, because their Christs in the Garden, with nothing really observed, have gotten on my nerves. Of course with me there is no question of doing anything from the Bible. . . . Bernard's [religious canvases are] a sort of dream or nightmare. . . . [I]t gives me a painful feeling of collapse instead of progress. Well, to shake it off, I have been knocking about the orchards . . . which along with the three studies of olives that you have, at least constitute an attack on the problem." [48]

Vincent's olive trees may have expressed still another religious meaning. Though twisted and tormented, they are striving toward heaven, and they are often depicted with two outstretched branches. Considering that they were avowedly modeled after the human figure, a tortured one at that, they are reminiscent of the crucified Christ and of the Cross that symbolizes him. The tree and the Cross have long been equated, as both the New Testament and psychoanalytic literature attest, and it is not surprising that Vincent, too, might have equated them. The *Landscape with Olive Trees*, the one with the cloud formation that resembles mother and child, contains these semistylized, agonizing trees. If they did indeed represent the Cross for Vincent, then the erupting earth and mountains in it represent the tremor that shook the earth during the crucifixion.

Vincent seems to have portrayed in his own expressionistic idiom an idea similar to an Italian Renaissance work of Girolama Dai Libri, *Madonna and Child with Two Saints*. A Cross and a tree with two branches face each other, one being equated with the other. In the heaven above, the Madonna holding the Christ child is enclosed in a cloud. Vincent would have avoided painting a visionary scene like this, although it portrayed a motif that was dear to him. Perhaps he portrayed the same motif in his landscape by omitting the cross and the mother and child in the sky, but retaining the realistic tree and the clouds that resembled them.

The tree trunk of *The Sower* of October 1888 bifurcates into two main branches, both of them cropped at the top. This configuration may represent another tree-cross. If so, the haloed sower-Christ has been displaced from his original position as a crucified figure, a variety of displacement that sometimes is used in dreams.

13 Crows over the wheatfield

WHEN VINCENT came north from Saint-Rémy in May 1890, he stopped off in Paris for three days, where he saw his sister-in-law Jo and his nephew for the first time. He looked healthy and cheerful but complained that the noise and bustle of the city was "bad on his head." [1] He left for Auvers-sur-Oise on May 21.*

Twenty miles northwest of Paris, Auvers is a picturesque town on the banks of the Oise River that has been frequented by artists since 1860, when Daubigny settled there. Its main street lies near the river, and the rest of the town extends up the terraced hillside disappearing into the plains high above. On arriving there, Vincent praised its beauty, giving special attention to the "moss-covered thatched roofs which are superb." During his first weeks in Auvers, his health improved, and he felt "calm and normal." [2] Lodgings in an inn had been obtained for six francs per day, but thinking the price too high, Vincent moved to a room in Gustave Ravoux's café, located on the main street, that cost only 3 francs 50 centimes. There may have been another reason for his choice. Knowingly or

* Dr. Jan Hulsker believes that he left Paris on May 20.

unknowingly, he selected a place to spend the last two months of his life that was almost identical in its relationship to the town hall facing it as the house in which he was born and reared in Zundert.

Vincent was attracted to Auvers by the presence of Dr. Paul-Ferdinand Gachet, a sixty-one-year-old practioner of medicine with a bent for homeopathy, whom Theo had met through Camille Pissarro. Dr. Gachet's office was in Paris, but he went there only' three days a week, spending the rest of his time in Auvers, where he painted and etched, and cared for an occasional villager. He loved animals and possessed "8 cats, 8 dogs, besides chickens, rabbits, ducks, pigeons, etc., in great numbers" [3] and a goat called Henrietta that he took for strolls. He was also a talented amateur artist, using the pseudonym of Paul van Ryssel, and one of the first admirers of the Impressionists. Of Flemish origin, he spoke Vincent's native tongue and was knowledgeable about the Northern masters. He had known Vincent's old favorites, Monticelli and Bruyas, when he was a medical student in Montpellier and later had friendly relationships with Daumier, Cézanne, Courbet, Pissarro, Guillaumin, Renoir, Manet, Monet, and Sisley; in the seventies Cézanne had been his neighbor, patient, and friend. An advocate of free love, and—like Tanguy, Roulin, and Vincent himself—a socialist, he seemed the ideal physician-companion for Vincent.[4]

Vincent wrote from Auvers that "to be back among painters and interested in all the struggle and discussions and especially in the labor of the little self-contained world of painters" [5] had a favorable effect on him. But, except for Gachet, he did not go out of his way to make close relationships with the painters there— perhaps because, as he wrote, he now felt powerless to form the union of artists he so cherished. The few artists whom he mentioned did not seem especially significant to him. One was Anton Hirschig, a young Dutchman, who also lived in Ravoux's café; not enthusiastic about his paintings, Vincent recommended that he leave Auvers to work with Gauguin, who had by then returned to Brittany. Vincent also referred to an Australian painter named Walpole Brooke, merely noting that Brooke had lived in Auvers for "some months and we've sometimes gone out together." He also mentioned a colony of American artists; they lived next door to him, but he had "not yet seen what they are doing." Another artist named Louis Dumoulin (Vincent wrote "Desmoulins"), who interested Vincent

because he had painted in Japan, returned to Auvers during Vincent's stay.[6] Vincent expressed the wish to meet him and, according to Dumoulin's later testimony, he did [7]; Vincent, however, did not mention it in his letters.

Neither did he mention his acquaintance with two brothers, Gaston and René Secrétan, who were living in their wealthy father's country house nearby. Nineteen-year-old Gaston liked to paint and enjoyed discussing art with Vincent. Intuitively sensing his masochistic nature, the brothers and their companions delighted in provoking him. "One day," René related, "he blazed up and tried to kill everbody because someone had put salt in his coffee. Another time, he almost fainted when the fellows put a dead snake into his painting materials." More often, however, Vincent kept his anger to himself when they tricked him.[8]

No doubt Vincent also had friendly contacts with the Ravoux family and other townspeople, for some of them posed for him, but he wrote almost nothing about them. Only with Dr. Gachet did he acknowledge a close bond: "Now nothing, but absolutely nothing, is keeping us here but Gachet—but he will remain a friend, I should think." They became intimates almost immediately, and Vincent planned to spend one or two days a week painting in Gachet's garden. He wrote to his mother that the doctor was sympathetic and that he could go to his house "as I want." "I feel that he understands us perfectly," he told Theo, "and that he will work with you and me to the best of his power, without any reserve, for the love of art for art's sake." He had Sunday dinners with the Gachet family, although he complained that too many courses were served. He found in Gachet a knowledgeable person who appreciated his work: "This gentleman knows a good deal about painting, and he greatly likes mine; he encourages me very much, and two or three times a week he comes and visits me for a few hours to see what I am doing." [9]

Vincent also saw another side to the doctor. In the first letter from Auvers, he referred to his eccentric behavior and "grief-hardened face." Describing Gachet as "a very nervous man himself and very queer in his behavior," Vincent explained that the death of his wife "some years ago" had "greatly contributed to his becoming a broken man"; in fact, she had died about fifteen years before. Apparently trying to forestall disillusionment with someone he desperately needed, he expressed the opinion that "his experience as a doctor must keep him balanced enough to combat the nervous

trouble from which he certainly seems to be suffering at least as seriously as I." Finally, however, the disillusionment could not be contained: "I think we must not count on Dr. Gachet *at all.* First of all, he is sicker than I am, I think, or shall we say just as much, so that's that. Now when one blind man leads another blind man, don't they both fall into the ditch?" He saw in Gachet someone who resembled him and therefore could not help him.[10]

"Altogether father Gachet is very, yes very like you and me," Vincent wrote to Theo. Not only did Gachet share Vincent's interests in art and politics, but as he wrote to Wil, Gachet was "something like another brother, so much do we resemble each other physically and also mentally." [11] Both had red hair, blue eyes, and a large forehead; both dressed strangely, constantly smoked a pipe, and had weak digestions; and both, as Vincent saw it, were neurotic, eccentric, and melancholic. Paul Gachet's son has strongly denied "the curious and bizarre judgments" that Vincent made of his father, and it is possible that—given a certain resemblance—Vincent unconsciously projected his own thoughts into his benefactor.[12] Perhaps the remark he made to Wil concerning Gachet gives us a clue, for it repeated the description of Delacroix's portrait of Bruyas that he had sent Theo in 1888: "as like you and me as another brother." * If Vincent unconsciously perceived the portrait as an image of the dead older brother with whom he had identified himself, as I have suggested, he may have also perceived Gachet in this way. He idealized Bruyas, whom he had never seen. But the close contact with Gachet may have stimulated the buried resentment he had held toward his dead competitor, and Gachet became an older brother with the same imperfections that cursed Vincent himself.

Vincent's resentful feelings against Gachet were not far from the surface, if we are to believe a story told by the doctor's son. When Vincent visited Gachet's house, he admired a painting by Guillaumin depicting a bare-breasted woman lying on a bed.[13] He complained bitterly because the picture was unframed and demanded that the situation be remedied. Gachet requested a local craftsman to carry out the task but the latter failed to act with dispatch. Returning to find the painting still neglected, Vincent exploded with rage. Gachet felt that Vincent was reaching for a

* In the same letter to Theo (564) noting the resemblance between Gachet and themselves, Vincent remarked that Gachet knew Bruyas and shared Vincent's ideas about him.

weapon in his coat pocket, whereupon he gave the younger man a powerful look. With this, Vincent's anger disappeared, he lowered his head and departed. This story almost duplicates that of Gauguin when he claimed that Vincent threatened him with a razor prior to the ear mutilation. There is no evidence, however, that this outbreak of violence was part of another psychotic attack.

Gachet's son has stated that his father preferred to put his money into extra paintings rather than into accessories; as a result, he had many unframed pictures, including two masterpieces by Cézanne. Why, then, did Vincent explode about this particular work? If he equated Gachet with his older brother, he may have perceived the well-endowed woman in the painting as the good, nurturing mother whom he longed for, but who belonged to his other brother. This would mean that a surrogate of the envied brother—whose death was responsible for his mother's suffering—now seemed to neglect her. Such a situation could well provoke a spasm of rage, momentarily brushing aside the shame and guilt that usually kept his real feelings hidden.

Vincent's agitation seems to have had an increasingly important influence in the pictures from Auvers, which included about 70 oils, 30 watercolors and drawings, and one etching. Like a horse nearing the barn, he drove himself faster than ever. The spirals of Saint-Rémy almost disappeared, and short, frenzied strokes—not new to his work—became more prominent. They give an impression of shimmering mosaics, or, like the spirals, form continuous patterns of movement.

The first painting that Vincent described from Auvers was a study of one of the old thatch-roofed houses which, he observed, were getting rare.[14] He persisted in painting these houses to the end, no doubt continuing the "memories of the North" he had begun in Saint-Rémy. By recreating scenes that resembled his childhood environment, he was probably acting out frustrated wishes to return home. Two other buildings that he depicted in Auvers—the town hall and the church—may have been part of the same reconstruction, for their counterparts in Zundert played an important visual role during his childhood. *The Town Hall of Auvers* is remarkably similar to the view from the house in Zundert he had left about twenty-five years before, and *The Church at*

Auvers no doubt reawakened memories of the church in Zundert where his father preached and the first Vincent was buried.

While Vincent did not link these two churches in his letters, he did note that the painting of the church in Auvers was intended to be "nearly the same thing as the studies I did in Nuenen of the old [church] tower and the cemetery" [15]—studies we have earlier traced to the influence of the Zundert church and cemetery. The cemetery of the Nuenen studies, however, is not present in the Auvers rendition. Perhaps this is explained by the fact that the cemetery looks down on the rear of the church, the side depicted in the painting. This suggests that he was symbolically looking at the Zundert church from his envied brother's burial place; soon, he was to have himself buried in this same cemetery. We can compare this view of the church with such paintings as *The Cradle* and *The Resurrection of Lazarus,* in which, I have suggested, Vincent also placed himself outside the canvas.

The Church at Auvers may have had another, complementary symbolic meaning for Vincent. Standing at the left of the church's rear—an exaggerated rear at that, reminiscent of the large posteriors of women he so often drew in Nuenen (see *Peasant Woman Stooping*)—is the back of a buxom woman. As we have seen, Vincent equated people and objects and often combined them in the same picture. This suggests that he equated the church with the woman. To carry this approach a step further, the church, with its spacious, protective interior, may have symbolized for Vincent— as it does for many devout people—a loving mother. In distorting it, he was applying the same principle to the church that he once voiced about the female body. When the teacher in an Antwerp drawing class criticized him for accentuating the hips in his sketch of a model of Venus de Milo, he retorted, "God damn you! A woman must have hips and buttocks and a pelvis in which she can hold a child!" [16] The extraordinary view of the church in Auvers may have been still another expression of his wish to have been born of a protective and nurturing mother. It is a theme he repeated with monotonous regularity, but with infinite variety.

At Auvers he no longer painted the night sky with its twinkling stars, but the deep mysterious blue of *The Starry Night* became even more conspicuous in Auvers. It often occupied the troubled skies of his landscapes as well as the sky of *The Church at Auvers.* This somber blue is not a solid mass, but a mosaic of short strokes

interspersed with lighter blues and whites. Foreboding, it also scintillates, suggesting that the skies will open in a promise of better times to come.

These same blues take over the whole in a portrait of the inn-keeper's daughter, Adeline Ravoux, "in blue against a blue background." [17] This is one of a dozen portraits Vincent executed in Auvers: others included the melancholic portraits of Dr. Gachet, Gachet's daughter Marguerite at the piano, young children, and a peasant girl with a big yellow hat. He also painted still lifes of flowers, rich undergrowth in a grove of poplars, tree-lined streets, and town gardens.

Probably the most characteristic works from Auvers are the sweeping landscapes; Vincent called them "fields seen from a height." [18] There are almost thirty of them; some are very wide in relation to their height, adding to the impression of a vast expanse of land; Professor Hammacher suggests that this new format was derived from Puvis de Chavannes.[19] Three of these wide canvases depict "vast fields of wheat under troubled skies"—a reflection of his despair; yet soon after, he made "an immense plain with wheat-fields against the hills, boundless as a sea, delicate yellow, delicate soft green . . . checkered at regular intervals with the green of flowering potato plants, everything under a sky of delicate blue, white, pink, violet tones." [20] More than ever before, these land-scapes show fields divided into the discrete plots that, I have suggested, evolved from his earlier fascination with cemeteries.

In spite of the accessibility of Theo in nearby Paris, the brothers saw each other only twice during the seventy days Vincent spent in Auvers. On Sunday, June 8, Theo and his family had a "peacefully quiet" day with Vincent at Dr. Gachet's house.[21] Early in July, Vincent returned the visit to Paris, where he met many of his old friends and had lunch with Toulouse-Lautrec. Theo was preoccupied with his family's health and financial problems, and he and Vincent were tense and irritable; an argument ensued, and Vincent abruptly left for Auvers. "Back here," Vincent wrote in reply to a friendly letter from Jo, "I still felt grieved and continued to feel the storm which threatens you weighing on me too." He was not reassured by her kind words, for he added, "[M]y life is also threatened at the very root, and my steps are also wavering." [22]

Vincent repeatedly begged Theo to spend his vacation in

Auvers instead of the customary journey to Holland, insisting that their mother would understand.[23] Ignoring the suggestion, Theo and his family left for Holland on July 15. Theo returned to Paris after about eight days, leaving Jo and the baby to divide the time between Mrs. van Gogh and Jo's family.

On the afternoon of Sunday, July 27—shortly after Theo returned—Vincent shot himself with a revolver. The regional newspaper, *L'Echo Pontoisien*, reported that the incident occurred "in the fields";[24] he stumbled back to the inn when night was falling. M. Ravoux called Dr. Mazery, a local physician, but Vincent asked that Dr. Gachet also come.[25] The two doctors decided that the bullet was inaccessible, and Dr. Gachet applied a dressing to the wound, which was "level with the edge of the left ribs, a little in front of the axillary line." Vincent was not in serious pain, his mind was clear, and he proceeded to smoke his pipe throughout the night. Because he refused to give Dr. Gachet his brother's home address, Gachet had Hirschig deliver a letter the following morning to the gallery in Montmartre. When Theo finally arrived at the bedside, Vincent said, "Do not cry, I did it for the good of everybody." He died peacefully in Theo's arms at one o'clock in the morning of Tuesday, July 29. He was four months past his thirty-seventh birthday.

Considering Vincent's life of suffering and his glorification of death, suicide was not an unexpected end. Convinced of the possibility of a "smiling death," he could say, "Death holds no terror for me," a phrase he would have not used about life. In describing *The Reaper* of Saint-Rémy, he wrote that there was "nothing sad in this death," that it "goes its way in broad daylight with a sun flooding everything with a light of pure gold." [26] Vincent shot himself on a Sunday—the day long ago dedicated to the sun's worship—in the middle of the summer. Our imagination suggests that he did it in the heat of the afternoon sun in an open field like the one pictured in *The Reaper;* the actual facts of the location are unknown, however, although several contradictory claims have been made.

Vincent mentioned suicide frequently enough, but always to condemn it or to deny the impulse to do it. In 1881, for example, he noted that "I really don't think I am a man with such inclinations," and in the following year he voiced his approval of Millet's

statement that suicide is the act of a dishonest man. In 1883, he described it as "horrid." [27] In these years he was not yet ready to kill himself. He regarded life as a necessary preparation for death, both from the standpoint of a need to "lead the Christ life" and a need to produce pictures that would insure his immortality. "*I want to be somebody in my time, to be active,*" he wrote, "so that *when* one dies one can think, I go where all those go who were daring go." [28] Later in life, however, his attitude was less moralistic; in 1887, for example, he wrote, "It's better to have a gay life of it than to commit suicide"; and in 1889, on the verge of acknowledging the impulse that his earlier thought had been staving off, he said that he took the remedy prescribed by Charles Dickens to prevent suicide—a glass of wine, bread with cheese, and a pipe of tobacco.[29]

What finally swung the scales so that the wish to die outbalanced his drive for self-preservation? As in the case of the ear mutilation, we would expect that various factors contributed to the wish, but the most distressing of them concerned his relationship with Theo. For he was then threatened with the loss of this brother, who, as he had said, was his only "real friend." Ever since being dismissed from his job as an evangelist in the Borinage, his dependency on Theo was a matter of life or death: "[I]f I should have to keep out of your way, . . ." he wrote at that time, "I might wish I had not much longer to live." He reiterated the idea later on, ". . . my life or death depends on your help." When Theo had difficulty in raising money for him. Vincent responded that reducing the payments "would be like choking or drowning me." [30] In 1890 this life-saving dependency on Theo was threatened from several sources. In coming north, Vincent was directly confronted with Theo's anxiety over the welfare of his new family, especially intense at the time due to the child's poor health. In spite of reassurances of continued support, Vincent must have recognized that Theo had to divert both affection and funds to the two newcomers. He must have also recognized that he had the status of weekend guest rather than that of a regular member of the family and that he could no longer force himself into Theo's apartment as a full-time partner as he had in 1886.

Theo was also deeply involved in problems with his employers, who disapproved of his interest in the Impressionists and refused to pay him an adequate wage. "Ought I to live without a thought for the morrow," Theo wrote on June 30, "and when I work all

day long not earn enough to protect that good Jo from worries over money matters, as those rats Boussod & Valadon are treating me as though I had just entered their business, and are keeping me on a short allowance?" He threatened to resign and open his own business if they refused his demands: apparently he requested a showdown with them, for on July 14 he noted that, "although eight days are past now, these gentlemen have not said a word about what they intend to do with me." Although Vincent had encouraged Theo to quit his job long before, he no doubt had mixed feelings when it became a real possibility, knowing that Theo would lack the resources to help him. In killing himself, Vincent was removing a painful burden from his brother's back. The last words of his last letter, the one found on his body, dared Theo to quit: "[Y]ou can still choose your side, I think, acting with humanity, but what do you want?" [31]

Theo had been in poor health for a long time, and this also threatened the relationship. For months Vincent had been worrying about it, although he tried to hide his anxiety with expressions of hope and reassurance. As Jo observed on May 17, Vincent looked far healthier than the brother who was responsible for his sustenance. Little is known of the nature of Theo's illness, but there can be no doubt of its seriousness. Following Vincent's death, his health deteriorated rapidly. The disease, combined with psychological stress, led to a mental breakdown. He finally developed urinary retention and died on January 25, 1891, six months after his brother.

Resentment toward those one loves and is dependent on is prominent among those who commit suicide. Vincent half-recognized this when he wrote that killing oneself turns one's friends into murderers. Largely repressed because it was inimical to his conscience, resentment toward Theo—his closest friend—was probably a powerful motivating force in his own suicide. The parents' perception of Theo as a handsome, refined model child no doubt accentuated Vincent's feelings of being ugly and bad and turned Theo into a new edition of the perfect first Vincent, another competitor with whom he was unable to compete. The fact that Theo had the wife and child that Vincent so devoutly desired for himself would have stirred up these old feelings of jealousy and resentment and, as a consequence, he would have felt more guilty than ever, especially at a time when Theo was having serious difficulties of his own.

To minimize his resentment, Vincent seems to have removed himself from the competition—during his youth by becoming Theo's benefactor, and later by turning Theo into his own benefactor. Nevertheless, the jealousy occasionally emerged; for example, when he described Theo as the one who was worthy of being comforted by their mother, he added, "I almost envy you." At a time when he was openly bitter, he expressed it with irony: "You are quite the plush gentleman, and I am a black sheep." [32] The anger that accompanied this envy was usually absent in his letters, but exceptions occurred between 1883 and 1885. Disappointed by Theo's defense of their parents and his refusal to join him as a brother artist, Vincent insulted, castigated, and threatened him in one letter after the other. He accused him of falseness in having to maintain a social position, of being *cruel* in your worldly wisdom," of not having exerted himself enough to sell a single picture, of not understanding him, and of being "too high and mighty to take the slightest notice . . . of my work." [33]

These attacks disappeared from Vincent's letters after he left Nuenen, but the resentment reappeared in other forms. Take, for example, the incident in 1886 when he suddenly thrust himself on Theo in Paris even though Theo had strongly objected to his coming; and after living with his brother for a while, he is reported to have had repeated outbursts of anger against him. A slip that Vincent made in Arles may have been a more disguised reflection of his hostility: Just as he had finished the beautiful painting of two pear trees, he received notice of the death of Mauve, his first teacher. "Only something—I don't know what—seized me and brought a lump to my throat," he wrote, "and I wrote on my picture SOUVENIR DE MAUVE VINCENT THEO." [34] In the painting, however, Theo's name is not to be found. Such a lapse is hardly evidence of untainted love. Then, too, Vincent made portraits of many people, including his mother, his father, and his sister Wil.* But Theo, toward whom he claimed to be the closest and whom he owed the most, is not to be found among them.† In Auvers, he proposed to paint portraits of Theo, Jo, and the baby, but failed to carry out his announced intent. If, as Vincent had postulated, portraits were ways of achieving immortality, denying Theo a portrait could have been a symbolic attempt to prevent

* Those of his parents and Wil are from photographs.
† A recently "discovered" portrait of Theo by Vincent van Gogh is, according to Dr. van Gogh, neither by Vincent nor a portrait of Theo.

him from sharing his own immortality. The older brother might be worthy of the kingdom of heaven, as his tombstone implied, but Vincent was in a position to exclude the younger brother who had replaced him as Vincent's rival.

In leaving Provence for the north, Vincent was headed toward Holland, responding to the gnawing homesickness that tormented him during his years of self-imposed exile. To return there, however, would have been useless, for he knew he would not find the home he longed for. "In the fullness of artistic life," he once wrote, "there is, and remains . . . that nostalgic longing for the truly ideal life that can never become true." [35] Killing himself, however, was a symbolic way of going to this ideal home. As the pilgrim in the sermon of his youth and as a martyred Christ as well, he would become a welcome guest in the eternal city of heaven. In 1883, Vincent had correctly predicted, "[M]y body will hold out a certain number of years—take, for instance, from six to ten." [36] In dying in his mid-thirties, he was following the example of Christ.

As mentioned earlier, however, he had a strong aversion to old age, and for a man who felt he was aged beyond his years, killing himself was insurance against it. As the years passed, he grew increasingly afraid that aging would result in loss of the skill and creativity that alone made his life worth living. By September 1888, at the height of his accomplishments, he wrote: "I also feel the possibility of going to seed and of seeing the day of one's capacity for artistic creation pass, just as a man loses his virility in the course of life." [37] In Auvers, his loss of confidence in the ability of Dr. Gachet to help him and the possibility of a recurrence of his psychotic attacks added to the fear of aging, and he worried he might not be able to continue: "I am trying not to lose my skill. It is the absolute truth, however, that it is difficult to acquire a certain facility in production, and by ceasing to work, I shall lose it more quickly and more easily than the pains it has cost to acquire it. And the prospect grows darker, I see no happy future at all." [38] He meant, of course, a happy future on earth, for he never foreclosed the idea of a happy future elsewhere.

While afraid of failure, the threat of success may have been even more alarming. Concluding that he had "a horror of success," Vincent quoted Carlyle: " 'You know the glowworms in Brazil that shine so that in the evenings ladies stick them into their hair with

pins; well, fame is a fine thing, but look you, to the artist it is what the hairpin is to the insects.' " [39] On another occasion he compared fame to "ramming the live end of your cigar into your mouth." [40]

While he received no widespread acclaim during his lifetime, even the recognition that began to come during the last years of his life disquieted him and may have contributed to his decision to kill himself. During his stay in Paris from 1886 to 1888 some of his peers, including Toulouse-Lautrec, defended and praised his work. His pictures were exhibited in the Restaurant la Fourche, the Cabaret du Tambourin, Tanguy's paint shop, and in Martin's and Thomas's galleries, and, later, at the exhibitions of *Les Indépendants*.[41] Except for a paltry twenty francs he received from Tanguy for a portrait, however, these showings apparently did not attract a single purchaser or rate him a single review in newspapers or magazines.[42]

The situation began to change during the last year of his life. His paintings were displayed in Brussels early in 1890 at the exhibition of *Les Vingt*, a fine Belgian art society that rivaled the best in Paris for modern art, and Anna Boch, the sister of Vincent's friend Eugène Boch and an artist in her own right, purchased one of his paintings for four hundred Belgian francs,[43] a good price for the period. His name also began to appear in public print, first on August 17, 1889, in one of a series of articles on Impressionists by J. J. Isaäcson, in *De Portefeuille*, an Amsterdam weekly. Isaäcson, a Dutch artist and critic who was acquainted with Theo, wrote a glowing description in which he claimed that Vincent was destined for posterity. Even before its publication, Vincent warned the author, "As it is possible that in your next article you will put in a few words about me, I will repeat my scruples, so that you will not go beyond a few words, because it is *absolutely* certain that I shall never do important things." [44] Later, he told Theo that the statements were "extremely exaggerated" [45] and that he would have preferred that Isaäcson had said nothing about him.

In January 1890, Albert Aurier, a brilliant young French critic, wrote the highly favorable article on Vincent in *Le Mercure de France*, the first devoted entirely to him. In his prompt response to Aurier, Vincent again complained that the praise was exaggerated, adding that "my back is not broad enough to carry such an undertaking." [46] In a letter to his mother and Wil, he wrote: "As soon as I read that my work was having some success, and read the article in question, I feared at once that I will suffer for it; this is how things

nearly always go in a painter's life: success is about the worst thing that can happen." [47] He exposed more of his feelings in another letter to Wil: "But when I had read that article I felt almost mournful, for I thought: I ought to be like that, and I feel so inferior. And pride, like drink, is intoxicating, when one is praised, and drunk the praise up. It makes one sad, or rather . . . the best work one can do is what is done in the privacy of one's home without praise." [48] As a self-conscious masochist who felt ugly and repulsive, the exposure of fame was intolerable; and as a guilt-ridden man, he could not enjoy the glory of success when he was convinced he deserved the pain of punishment. The reinforcement of these influences by a Dutch rearing that taught him to forgo self-aggrandizement made fame and fortune anathema to him.

No wonder that in dying he could feel content, leaving behind his fears, depression, distrust, shame, guilt, and resentment and enter into a joyous life in "the eternal city far away." His was a "lust for death" more than a "lust for life."

Crows over the Wheatfield is one of the works from Vincent's last month of life. Some claim it is his last work, although this does not appear to be true. Writers usually assume it is a gloomy and terrifying warning of his impending suicide. Meyer Schapiro described the scene as "a field opening out from the foreground by way of three diverging paths. . . . [T]he lines, like rushing streams, converge toward the foreground from the horizon, as if space had suddenly lost its focus and all things turned aggressively upon the beholder. . . . [T]he great shining sun has broken up into a dark scattered mass. . . . [The crows unite] in one transverse movement the contrary directions of the human paths and the symbols of death. . . . It is as if [the artist] . . . saw an ominous fate approaching. The painter-spectator has become the object. . . ." [49] The black birds, the wheat ready for the harvest, and the ominous atmosphere suggest impending death. This death is directed at the artist himself, who is outside the painting at the convergence of the three paths.

Professor Schapiro noted that the mood of despair in the painting was also present in the letter in which Vincent mentions it. But the despair is the voice of Christ. Vincent began the letter by telling his sister-in-law that a letter she had sent him was "like a gospel, a deliverance from the anguish which has been caused by

the hours I had shared with you." [50] Christ was delivered from
his anguish—the Agony in the Garden—by the Crucifixion. So we
may guess that the painting depicts Vincent's own fantasied Cruci-
fixion in the image of Christ. The two lateral paths represent the
horizontal arms of the Cross and the central path the upper por-
tion of the vertical axis of the Cross. The unseen head of the
painter-Christ, lying at the convergence of the horizontal and verti-
cal axis outside the painting, is looking toward heaven. Vincent
had put himself in a similar position outside the canvas in earlier
works, for instance in *The Cradle,* where the beloved child-artist
is in an unseen cradle, and in his modified version of Rembrandt's
The Raising of Lazarus. The "broken-up sun" noted by Professor
Schapiro is Vincent's "good god sun," the God who had momen-
tarily abandoned him.

Seen in this light, *Crows over the Wheatfield* recalls that
moment during the Crucifixion in which "there was darkness over
all the land," and Christ cried out, "My God, my God, why hast
thou forsaken me?" The painting remains a gloomy warning of
impending doom. But as a Crucifixion, it served a more important,
wish-fulfilling function for Vincent. It heralded the joyful rebirth
and the welcomed ascension into heaven of God's favorite child.
Like the gloomy aspects of the sermon themes, it was tolerable—
indeed, it was welcomed—because of Vincent's conviction that only
through suffering would he finally be beloved of God.

The painting seems not only to converge onto the spectator but
to draw him into the sky as well. Students have debated whether
the crows are flying toward the observer or toward the sky. Seen as a
crucifixion, this apparent confusion is clarified. For the focus in this
painful yet hopeful event must remain divided between the death
of the martyr on the cross and the everlasting joy that awaits him
and all who believe in him. The crows descend to seal his fate, but
they also accompany him to his eternity in heaven.

At last Vincent has made up for his mother's neglect. In dying
as God's favorite child, he has finally outdone the first Vincent.

Notes

Numbers that appear alone in the *Notes* indicate specific letters in van Gogh's correspondence. These numbers are those used in the publication of the original letters as well as in the translated versions. The original version—in Dutch, French, and English—is included in *Verzamelde Brieven van Vincent van Gogh,* in four volumes, 1952–1954, reissued in 1955, Wereld-Bibliotheek, Amsterdam. Most of the translations in the present book are from the American edition: *The Complete Letters of Vincent van Gogh,* in three volumes, Greenwich, Connecticut: New York Graphic Society, 1958. In many instances, however, they have been modified or changed, often at the suggestion of Dr. Jacob Spanjaard.

The date and place of origin of each letter can be approximately determined from the list that follows.

LETTERS FROM VINCENT TO THEO VAN GOGH
(plus descriptions of Vincent by others)

Letter		
1–8	The Hague	August 1872–May 1873
9–26	London	June 1873–May 1875
27–59	Paris	May 1875–March 1876

Letter

60–83	England	April 1876–December 1876
84–94a	Dordrecht	January 1877–April 1877
95–122a	Amsterdam	May 1877–July 1878
123–143a	Etten, The Borinage, Brussels	July 1878–April 1881
144–165b	Etten	April 1881–December 1881
166–322a	The Hague	December 1881–September 1883
323–343	Drenthe	September 1883–November 1883
344–435c	Nuenen	December 1883–November 1885
436–458a	Antwerp	November 1885–February 1886
456–462a	Paris	March 1886–February 1888
463–590b	Arles	February 1888–May 1889
591–634a	Saint-Rémy	May 1889–May 1890
635–652	Auvers-sur-Oise	May 1890–July 1890

LETTERS FROM VINCENT TO ANTHON VAN RAPPARD

R1–R6	Etten	October 1881–November 1881
R7–R38	The Hague	December 1881–July 1883
R39–R58	Nuenen	January 1884–September 1885

LETTERS FROM VINCENT TO HIS SISTER WILHELMINA

W1	Paris	1887
W2–W12	Arles	March 1888–May 1889
W13–W20	Saint-Rémy	July 1889–February 1890
W21–W23	Auvers-sur-Oise	June 1890

LETTERS FROM VINCENT TO EMILE BERNARD

B1(1)	Paris	1887
B2(2)–B19a	Arles	March 1888–November 1888
B20(20)–B21(21)	Saint-Rémy	October 1889–December 1889

LETTER FROM VINCENT TO PAUL GAUGUIN

B22	Arles	October 1888

LETTERS FROM THEO VAN GOGH TO VINCENT

T1a–T41	Paris	July 1887–July 1890

Preface
[1] 169

Chapter 1
[1] 79 [2] 329, 518
[3] Frank Elgar, *Van Gogh: A Study of His Life and Work* (New York: Frederick A. Praeger, 1958), p. 17.
[4] 180 [5] 218, W20 [6] 136 [7] W23 [8] 195 [9] 220 [10] 268a
[11] 319 [12] 392 [13] 418 [14] 392, 591 [15] 431 [16] 503 [17] 590
[18] 607 [19] 541 [20] 617 [21] 649 [22] 132 [23] 542 [24] 133
[25] 435c [26] 20 [27] 158 [28] 216 [29] 133 [30] 450 [31] 262
[32] 299 [33] 543 [34] 556 [35] 552 [36] 220 [37] 430 [38] 472 [39] 410
[40] 534 [41] 533 [42] 592 [43] W11 [44] 625 [45] 629 [46] 644
[47] 645 [48] W4 [49] 531 [50] 73 [51] 91 [52] 103 [53] 518 [54] 576
[55] 193, 120 [56] 435c [57] 133 [58] 431, 451 [59] W1 [60] 20 [61] 25
[62] 248 [63] R33 [64] 220, 252, R29, R30 [65] 252 [66] 506 [67] 604
[68] 126, 127 [69] 357 [70] 221 [71] 392 [72] B21(21) [73] 558a
[74] 242 [75] 218 [76] 82a [77] 195 [78] 199 [79] 489 [80] 343
[81] 514 [82] B21(21) [83] 242 [84] 334 [85] W16 [86] B10(18), 509
[87] 76 [88] 541 [89] 574
[90] "In a more general sense, the butterfly may symbolize the resurrection of all men. This meaning is derived from the three stages in its life as represented by the caterpillar, the chrysalis, and the butterfly, which are clearly symbols of life, death, and resurrection."—George Ferguson, *Signs and Symbols in Christian Art* (New York: Oxford University Press, 1945), p. 7.
[91] B8(11) [92] B8(11) [93] W2 [94] 112

Chapter 2
[1] Joseph Campbell, *The Masks of God: Primitive Mythology* (New York: The Viking Press, 1959), p. 54, p. 56.
[2] 320 [3] 28 [4] 78 [5] 36a [6] 288 [7] 321 [8] 329 [9] 197
[10] R30 [11] 274 [12] 305 [13] 133
[14] Sigmund Freud, *The Standard Edition of the Complete Psychological Works of Sigmund Freud.* Vol. XIX, *Resistance to Psychoanalysis,* 1924 [1925] (London: The Hogarth Press, 1961), pp. 211–222.
[15] 219 [16] 232 [17] 133
[18] E. H. Gombrich, *Art and Illusion: A Study in the Psychology of Pictorial Representation* (New York: Pantheon Books, 1960), p. 313.
[19] 514 [20] 470 [21] 133: "So instead of giving in to despair, I chose

the part of active melancholy. . . . I prefer the melancholy which hopes and aspires and seeks to that which despairs instagnation and woe." [22] 301 [23] 324

[24] Bernhard Berliner, "Psychodynamics of the Depressive Character," *Psychoanalytic Forum*, I (1966), pp. 244–264.

[25] Albert J. Lubin, *ibid.*, pp. 254–256.

[26] Johanna van Gogh-Bonger, "Memoir of Vincent van Gogh," *The Complete Letters of Vincent van Gogh*, Vol. I, American edition (Greenwich, Connecticut: New York Graphic Society, 1958), p. xxviii.

[27] 315 [28] 344 [29] 347 [30] 350a [31] 443 [32] 449 [33] 546, 557 [34] 571

[35] Charles Mauron, "Vincent et Théo," *L'Arc*, Cahiers Méditerranéens, No. 8 (Autumn 1959).

[36] 208 [37] 400

Chapter 3

[1] 288

[2] Elizabeth H. du Quesne-van Gogh, *Persoonlijke Herinneringen aan Vincent van Gogh* (Baarn, 1910).

[3] 100 [4] 247 [5] 133 [6] 292 [7] 390 [8] 91

[9] Johanna van Gogh-Bonger, "Memoir of Vincent van Gogh," *The Complete Letters of Vincent van Gogh*, Vol. I, American edition (Greenwich, Connecticut: New York Graphic Society, 1958); p. xxii.

[10] 15 [11] W13

[12] Van Gogh-Bonger, *op. cit.*, p. xxiv; 156

[13] 94a [14] 92 [15] W4 [16] 344 [17] 358 [18] 72, 94 [19] 89 [20] 122a [21] 429 [22] 126a [23] 128 [24] 143a [25] 132

[26] Erik H. Erikson, "The Problem of Ego Identity," *Journal of the American Psychoanalytic Association*, IV (1956), pp. 66–67.

[27] Max Weber, *The Sociology of Religion* (Boston: Beacon Press, 1963).

[28] 435c [29] 348, 345a [30] 358 [31] 379 [32] 345a [33] 347

[34] Jos de Gruyter, *De Haagse School*, 2 vols. (Rotterdam: Lemniscant, 1968–1969).

[35] 400 [36] 347, 393 [37] 390, 326 [38] 406 [39] 400 [40] 400 [41] 133 [42] 133

Chapter 4

[1] Johanna von Gogh-Bonger, "Memoir of Vincent van Gogh," *The Complete Letters of Vincent van Gogh*, Vol. I, American edition (Greenwich, Connecticut: New York Graphic Society, 1958), p. xxxi.

[2] 110 [3] 153 [4] 154 [5] 155 [6] 158 [7] 193 [8] 164 [9] 358 [10] R21 [11] 198, 201, 201 [12] 342, R8 [13] 206 [14] 193 [15] 189, 190

[16] 234; 212, 312 [17] 212 [18] 208 [19] 241, 263 [20] 280 [21] 296
[22] 307, 308 [23] 297 [24] 194 [25] 256 [26] 219 [27] 195 [28] 272
[29] 309 [30] 309 [31] 318 [32] 332 [33] 339 [34] 339a [35] 343
[36] 345, 345a [37] 351 [38] 350a, 358 [39] 361, 386a, 388, 362 [40] 358
[41] 362 [42] 352: "Mother hurt her leg . . . a fracture of the thigh
bone, near the pelvis and the hip joint."
[43] Johanna van Gogh-Bonger, op. cit., p. xxxvi.
[44] 378 [45] 377 [46] 380 [47] 382 [48] 392 [49] R44 [50] 346
[51] 404 [52] R57 [53] 94a [54] 143a [55] 190 [56] 190, 230, W1 [57] 322a
[58] 195 [59] 452 [60] 435b [61] 94a [62] 442 [63] 427 [64] 458a
[65] 427 [66] 408 [67] 94a, 435a, 458a [68] 218 [69] 429 [70] 418
[71] 345 [72] 204
[73] Like Vincent, both Peter Bruegel the Elder—known as the Peasant
Bruegel—and Hieronymus Bosch, were born in North Brabant and
portrayed the poor peasant, the persecuted, the ugly, the crippled, the
mutilated, and the aged. There is no proof, however, that either Bruegel
or Bosch significantly influenced van Gogh; perhaps the similarity in sub-
ject matter was derived from frightening impressions of sensitive children
to suffering people in an oppressed land.
[74] 195 [75] 268 [76] R8 [77] 332 [78] 438 [79] R8, 417 [80] 343
[81] 247 [82] 453, 264 [83] 117 [84] 218 [85] 276 [86] 299 [87] R28
[88] 370, 371 [89] 383 [90] 372 [91] 408 [92] 433 [93] 416 [94] 427
[95] 429 [96] 427 [97] 428 [98] 429 [99] 434 [100] 184, 408 [101] 444
[102] 435

Chapter 5
[1] 347, 388a, [2] 341 [3] Information about Cor van Gogh obtained
from Dr. V. W. van Gogh. [4] 155 [5] 161 [6] 187 [7] 408 [8] 432
[9] 433 [10] 440 [11] 451 [12] 476 [13] W9 [14] W18
[15] Johanna van Gogh-Bonger, "Memoir of Vincent van Gogh," *The
Complete Letters of Vincent van Gogh,* Vol. I, American edition (Green-
wich, Connecticut: New York Graphic Society, 1958), p. xxiii.
[16] 77, 248
[17] Charles Mauron, "Notes sur la structure de l'inconscient chez Vincent
van Gogh," *Psyché,* VIII (1953), pp. 24–31, 124–143, 203–209.
[18] Sigmund Freud, *The Standard Edition of the Complete Psychological
Works of Sigmund Freud,* Vol. XXIII, *Construction in Analysis, 1937*
(London: The Hogarth Press, 1961).
[19] Sigmund Freud, *The Origins of Psycho-Analysis: Letters to Wilhelm
Fliess, Drafts and Notes: 1887–1902* (London: Imago Publishing Co.,
1954), pp. 255–269.
[20] Erik H. Erikson, "The Problem of Ego Identity," Journal of the
American Psychoanalytic Association, IV (1956), p. 87.

[21] W1 [22] W9; Marc Edo Tralbaut, *8 X Vincent van Gogh; Vincent van Gogh et les Femmes* (Antwerp: Pierre Peré, 1962), pp. 16–28. [23] 155 [24] 158 [25] 262 [26] 164 [27] 201

[28] A. M. Hammacher, *Van Gogh's Life in His Drawings* (London: Marlborough Fine Art Ltd., 1962), p. 27.

[29] 442 [30] 442 [31] 605 [32] 257 [33] 143a [34] R16

[35] Albert C. Cain and Barbara S. Cain, "On Replacing a Child," *Journal of the American Academy of Child Psychiatry*, III(1964), pp. 443–456.

[36] 91 [37] 122a [38] 315 [39] 325 [40] 326 [41] 358 [42] 411 [43] 97 [44] 226 [45] R40 [46] 408

[47] F34, F84, F87, F88, F1230, F1231 recto, F1231 verso, F1236 recto, F1237, SD 1687, SD 1686. SD 1686 is a drawing of a funeral procession. From Jacob Bart de la Faille, *The Works of Vincent van Gogh: His Paintings and Drawings* (New York: Reynal & Co., 1970).

[48] 129, 126 [49] 236, 553b, 380, 610 [50] 108 [51] 189 [52] 268 [53] 331 [54] R28

[55] A similar, though opposite, transformation occurred in the dream of a man whose older and favored brother died and was glorified by the mother. As a result, the live brother, like Vincent, felt that only suffering and death would bring him love. After a prolonged bachelorhood, he finally married. The first argument with his wife caused him to feel crushed and abandoned. This incident provoked a dream in which the beautiful lot that he had purchased to build a home shrank in size and was transformed into a graveyard plot. It was a way of saying to his wife-mother, "If I were my dead brother, you would love me."

From the standpoint of the development of creativity, Vincent's history parallels that of Heinrich Schliemann, the "father" of modern archaeology and the discoverer of Troy. Schliemann, whose father was also a minister, was born a few days after the death of an older brother, and was named for him. The brother was buried in a nearby cemetery, and the boy delighted in exploring it. Schliemann's overpowering interest in excavating ancient objects may have its roots in this childhood situation. See William G. Niederland, "An Analytic Inquiry into the Life and Work of Heinrich Schliemann," *Drives, Affects, Behavior*, II (New York: International Universities Press, 1965), pp. 369–396.

[56] 142, W1 [57] 564 [58] 570 [59] 573 [60] 613

[61] O. Rank, "Der Doppelgänger. Eine Psychoanalytische Studie," *Imago*, III (1914), pp. 97–164.

[62] 506 [63] R30 [64] 262 [65] 227 [66] R44 [67] W22 [68] 398 [69] Meyer Schapiro, *Vincent van Gogh* (New York: Harry N. Abrams, 1950), p. 40.

[70] 403 [71] 435, 597 [72] W14 [73] 604

[74] Bertram D. Lewin, *The Psychoanalysis of Elation* (New York: W. W. Norton, 1950), pp. 150–155.

[75] Martin Grotjahn, "Ego Identity and the Fear of Death and Dying."
The Journal of the Hillside Hospital, IX (1960), pp. 147–155.
[76] Schapiro, *op. cit.*, p. 108.

Chapter 6
[1] Johanna van Gogh-Bonger, "Memoir of Vincent van Gogh," *The Complete Letters of Vincent van Gogh*, Vol. I, American edition (Greenwich, Connecticut: New York Graphic Society, 1958) p. xxv.
[2] 20. Quotation from Jules Michelet, *L'Amour*.
[3] 20 [4] 26 [5] 39b [6] 82a [7] 55
[8] Albert J. Lubin, "A Boy's View of Jesus," *The Psychoanalytic Study of the Child*, XIV (New York: International Universities Press, 1959), pp. 155–168; also Albert J. Lubin, "A Psychoanalytic View of Religion," *Clinical Psychiatry and Religion*, edited by E. M. Pattison (Boston: Little, Brown, 1969), pp. 49–76.
[9] 39b [10] 93 [11] 109 [12] 112 [13] 127
[14] From Vincent's Sermon, 1876.
[15] A. J. Westerman Holstijn, "The Psychological Development of Vincent van Gogh," *American Imago*, VIII (1951), pp. 239–273.
[16] 39 [17] 74 [18] 70 [19] 94, 88 [20] 122a [21] 326 [22] 112
[23] 123, introductory paragraph to section entitled "Etten-Borinage-Brussels" *The Complete Letters of Vincent van Gogh*, Vol. I (Greenwich, Connecticut: New York Graphic Society, 1958), p. 172.
[24] 143a [25] 542 [26] 605 [27] 288 [28] 306 [29] 326 [30] 314
[31] 213 [32] 336 [33] 398 [34] R43 [35] 181 [36] 326 [37] B8(II)
[38] 136 [39] 335, 339 [40] 309 [41] 133 [42] R3 [43] R34 [44] 310

Chapter 7
[1] 440 [2] 443 [3] 438 [4] 436 [5] 442 [6] 442 [7] 438 [8] 442, 449
[9] 442, 444, 448, 449, 452 [10] 450, 449 [11] 449
[12] Marc Edo Tralbaut, *Vincent van Gogh* (New York: The Viking Press, 1969) pp. 177–178. Dr. Marcus A. Krupp advised me on the historical aspects of the diagnosis and treatment of syphilis.
[13] 458a [14] 451 [15] 446, 447, 450
[16] Tralbaut, *op. cit.*, p. 184.
[17] 443 [18] 448 [19] 453 [20] 450 [21] 441 [22] 447 [23] 452
[24] 439 [25] 448 [26] 439 [27] 449 [28] 459a [29] 451, 452 [30] 489
[31] W4 [32] 266 [33] R35 [34] 379 [35] T16 [36] 159
[37] Tralbaut, *op. cit.*, p. 196.
[38] 371 [39] W4 [40] 459a [41] 544a
[42] Tralbaut, *op. cit.*, p. 200.
[43] Van Wyck Brooks, ed., *Paul Gauguin's Intimate Journals* (Bloomington, Indiana: Indiana University Press, 1958), p. 55.

[44] A. S. Hartrick, *A Painter's Pilgrimage through Fifty Years* (Cambridge, 1939).

[45] W1 [46] 461 [47] 505 [48] 462 [49] 460

[50] Translated as *Paul Gauguin's Intimate Journals, op. cit.*, p. 56.

[51] 489 [52] 459a [53] 462a [54] 466

[55] T. J. Honeyman, "Van Gogh: A Link with Glasgow," *The Scottish Art Review*, II (1948), as cited in John Rewald, *Post-Impressionism from Van Gogh to Gauguin* (New York: Museum of Modern Art, 1956), p. 26.

[56] W1

[57] Tralbaut, *op. cit.*, p. 199.

[58] Dr. Hammacher [*Van Gogh's Life in His Drawings* (London: Marlborough Fine Art Ltd., 1962), pp. 90–93,] believes that the work Signac did before he became a Pointillist greatly influenced the development of Vincent's art in Paris.

[59] 459a [60] 544a

Chapter 8

[1] Marc Edo Tralbaut, *Vincent van Gogh* (New York: The Viking Press, 1969), p. 217.

[2] A 11; Multatuli (Eduard Douwes Dekker), *Max Havelaar or The Coffee Auctions of the Dutch Trading Company* (New York: London House & Maxwell, 1967), pp. 156–157. An example of Multatuli's view of the women of Arles: "I don't say: there I saw a woman who was as beautiful as this or that. No, they were all so beautiful, and so it was impossible to fall in love there for good and all, because the very next woman always puts the previous one right out of your mind. . . ."

[3] 474, 481 [4] 552 [5] W4 [6] W3 [7] B5(5) [8] 542 [9] 474 [10] B17(14) [11] 496, 541 [12] 539 [13] 489, 513 [14] 543 [15] 507 [16] 513 [17] 474, 478, 480 [18] 509, 546 [19] 519, 520, 523 [20] 492 [21] 508 [22] 530 [23] B14(9) [24] 479, 484, 485, 487 [25] 480 [26] 493 [27] B11(13) [28] 249 [29] 498 [30] 534 [31] 544 [32] 574 [33] 467 [34] 468, 482, 490, 498 [35] 514 [36] 505 [37] 541a [38] 539 [39] 516 [40] 573, 550 [41] 560 [42] 543 [43] 544a in Dutch edition, 553a in American edition.

[44] 556 [45] 557 [46] 590b

[47] Tralbaut, *op. cit.*, p. 240.

[48] 544, 493, 562 [49] 565

[50] James Pope-Hennessy, *Aspects of Provence* (Boston: Little, Brown, 1952), p. 149, 13.

[51] 502, 482, 576 [52] W4 [53] 469 [54] 576, 577 [55] 482, 542 [56] 558b [57] 509 [58] B5(5) [59] B18(15) [60] 470 [61] 488 [62] 463 [63] 509 [64] W5 [65] 587 [66] 499 [67] 502, 496, 521, 509, 496, 539 [68] 512 [69] 522 [70] 532, 577 [71] 581 [72] 576 [73] 533 [74] 534 [75] 533 [76] 544

[77] Phyllis Greenacre, "Vision, Headache, and the Halo," *The Psycho-analytic Quarterly*, XVI (1947), pp. 171–194. Reprinted in her *Trauma, Growth, and Personality* (New York: W. W. Norton, 1952), pp. 132–148.
[78] *Ibid.*
[79] 573
[80] Sigmund Freud, *The Standard Edition of the Complete Psychological Works of Sigmund Freud*, Vol. XVII, *From the History of an Infantile Neurosis*, 1918 (London: Hogarth Press, 1955), p. 43.
[81] 497 [82] 476 [83] 516, 517, 531
[84] 520; Meyer Schapiro, *Vincent van Gogh* (New York: Harry N. Abrams, 1950), p. 64.
[85] 626a [86] 539 [87] W18 [88] 626a
[89] Henry Braun, "La Vie de Monticelli," *Catalogue of Exposition*, Galerie Lucien Blanc, Aix-en-Provence, 1959.
[90] 626a. Germain Bazin, quoted in Preface by Pierre Ripert to *Catalogue of Exposition, op. cit.*
[91] 626 [92] 626a [93] 477a [94] 429 [95] 510 [96] 469, 500, W7 [97] 540 [98] 533, 542 [99] 500 [100] 470 [101] W3 [102] 105, 113, 165b, W8 [103] 474, 535, 544a [104] B17(14), 581 [105] 543, 590b
[106] Tralbaut, *op. cit.*, p. 228.
[107] 539, 544a [108] 532, 541a
[109) Tralbaut, *op. cit.*, p. 240; 590b
[110] 544a

Chapter 9
[1] This chapter has been revised and enlarged from my previous article, "Vincent van Gogh's Ear," *The Psychoanalytic Quarterly*, XXX (1961), pp. 351–384.
[2] Johanna van Gogh-Bonger, "Memoir of Vincent van Gogh," *The Complete Letters of Vincent van Gogh*, Vol. I, American edition (Greenwich, Connecticut: New York Graphic Society, 1958), p. xlv.
[3] *Le Forum Républicain*, Dec. 30, 1888.
[4] Victor Doiteau and Edgar Leroy, "Vincent van Gogh et le drame de l'oreille coupée," *Aesculape*, XXXVI (1936), pp. 169–192.
[5] Gauguin, *Avant et Après*, p. 34.
[6] John Rewald, *Post-Impressionism from Van Gogh to Gauguin* (New York: Museum of Modern Art, 1956), p. 268.
[7] A. J. Westerman Holstijn, "The Psychological Development of Vincent van Gogh," *American Imago*, VIII (1951), pp. 239–273.
[8] Daniel E. Schneider, *The Psychoanalyst and the Artist* (New York: International Universities Press, 1950), pp. 227–239.
[9] Jacques Schnier, "The Blazing Sun: A Psychoanalytic Approach to Van Gogh," *American Imago*, VII (1950), pp. 143–162.

[10] Frank Elgar, *Van Gogh: A Study of his Life and Work* (New York: Frederick A. Praeger, 1958), pp. 202–203.

[11] A13 [12] W4 [13] 570

[14] V. W. van Gogh, "Some Additional Notes to the Memoir of Vincent van Gogh," in *The Complete Letters of Vincent van Gogh*, Vol. I, American edition (Greenwich, Connecticut: New York Graphic Society, 1958), p. lviii.

[15] 572 [16] 583 [17] 574 [18] W10

[19] René Huyghe, *Van Gogh* (New York: Crown, 1958), p. 80.

[20] 480 [21] 493, 494a, 497, 501a, 504, 507, 521, 544, 547, 549 [22] 514, 541 [23] 466 [24] 498 [25] 535 [26] 538 [27] 564 [28] 534 [29] 561 [30] B19a, 560 [31] 590b [32] 326, 173, 326 [33] B14(9) [34] B9(12) [35] 122a [36] 212 [37] 122a [38] 264, R37, 604

[39] van Gogh-Bonger, *op. cit.*, p. xx.

[40] R32 [41] 256

[42] van Gogh-Bonger, *op. cit.*, p. xx.

[43] B9(12)

[44] Peter H. Knapp, "The Ear, Listening and Hearing," *Journal of the American Psychoanalytic Association*, I (1953), pp. 672–689.

Psychologists and pediatricians have long observed that infants obtain sensual pleasure from stimulating their ears. See Karl Abraham, "The Ear and Auditory Passage as Erotogenic Zones" (1913), *Selected Papers on Psychoanalysis* (New York: Basic Books, 1953), pp. 244–247; and Milton I. Levine, "Pediatric Observation on Masturbation in Children," *The Psychoanalytic Study of the Child*, VI (New York: International Universities Press, 1951), pp. 117–124.

[45] B14(9), 560 [46] 592, 607, 574

[47] Gauguin, *op. cit.*, p. 31.

[48] 506, 543 [49] 492 [50] 605, 607 [51] 542 [52] 505, B19(17) [53] B21(21)

[54] W8. Evidence indicates that van Gogh's appraisal of Monticelli was incorrect; see Alfred Werner, "Monticelli: Logical Colorist," *Arts*, XXXIV (Oct. 1959), pp. 44–47.

[55] 571 [56] 544 [57] 498

[58] Sidney Tarachow, "Judas, the Beloved Executioner," *The Psychoanalytic Quarterly*, XXIX (1960), pp. 528–544.

[59] Rewald, *op. cit.*, p. 363.

[60] 82a [61] 3, 13, 39, 49, 77, 82a, 113, 115, 116 [62] 253 [63] 166

[64] L. Bryce Boyer, "Christmas 'Neurosis,'" *Journal of the American Psychoanalytic Association*, III (1956), pp. 467–488.

[65] Ernest Jones, "The Significance of Christmas," *Essays in Applied Psycho-Analysis*, II (London: Hogarth Press, 1951), pp. 212–224.

Chapter 10

[1] 576 [2] 579

[3] Johanna van Gogh-Bonger, "Memoir of Vincent van Gogh," *The Complete Letters of Vincent van Gogh*, Vol. I, American edition (Greenwich, Connecticut: New York Graphic Society, 1958), "If the police," ([Vincent] says), "had protected my liberty by preventing the children and even grownups from crowding around my house and climbing the windows. . . . I should have more easily retained my self-possession." p. xlvii.

[4] 579 [5] 573 [6] 582 [7] 583, 583b, 585, 587 [8] 589

[9] Victor Doiteau and Edgar Leroy, *La Folie de Vincent van Gogh* (Paris: Editions Aesculape, 1928), p. 53.

[10] Marc Edo Tralbaut, *Vincent van Gogh* (New York: Viking Press, 1969), p. 288; W14.

[11] 592, 605 [12] 599, 600, 601, 605, 611 [13] 604, 605, 606 [14] 605, 607 [15] 614, 620, 622 [16] 624, 625, 626, 628, 629, 634a [17] W11 [18] 626a [19] 625, 592, 576, 605

[20] Tralbaut, *op. cit.*, p. 288.

[21] 602a [22] 590a

[23] Tralbaut, *op. cit.*, p. 291.

[24] W15, 592, W15 [25] 605, 628, W13, 602a, 613, 571 [26] W15

[27] See Dr. Magnan, "Des principaux signes cliniques de l'absinthisme," *Revue d'Hygiène*, XII (1890), pp. 909–923; Dr. Lagrand, "Absinthism in France," *Quarterly Journal of Inebriety;* XXVI (1904), pp. 155–158; and Emma E. Walker, "The Effects of Absinthe," *Medical Record*, LXX (1906), pp. 568–572.

[28] 588

[29] Henri Schmidt, "L'Absinthe: l'aliénation mentale et la criminalité," *Annals d'Hygiène Publique et Médecine Légale*, 4 série, XXIII (1915), pp. 121–133.

[30] John Hughlings Jackson, "On Post-Epileptic States" (1888–1889), *Selected Writings of John Hughlings Jackson*, (London: Hodder and Stoughton, Ltd., 1931), I, pp. 366–384.

[31] G. Kraus, "Vincent van Gogh en de Psychiatrie," *Psychiatrische en Neurologische Bladen*, No. 5 (Sept.–Oct. 1941), cited in A16.

[32] 604 [33] 601, 604 [34] 604, 612, 605 [35] 605 [36] 613 [37] 607 [38] 627 [39] 195, 228, 336 [40] 101a [41] 501 [42] 193 [43] 593

[44] Meyer Schapiro, *Vincent van Gogh* (New York: Harry N. Abrams, 1950), pp. 76, 78.

[45] Roland Fischer, "The Biological Fabric of Time," *Annals of the New York Academy of Sciences*, CXXXVIII (1967), pp. 440–488.

[46] Sketches in letters B22 and 554.

[47] 607 (Vincent was discussing *Landscape with Olives*.)

[48] Schapiro, *op. cit.*, p. 78.

[49] 554
[50] I was helped in formulating these ideas by a paper by Stanley Steinberg, "Motion and Balance in an Artist's Work," presented to the San Francisco Psychoanalytic Society and Institute (November 1966), unpublished.
[51] B18(15) [52] W4, 325
[53] A. M. Hammacher, *Van Gogh's Life in His Drawings; Van Gogh's Relationship with Signac* (London: Marlborough Fine Art Ltd., 1962), p. 30.
[54] 601, 605 [55] 616, 617 [56] 629 [57] 648 [58] 630 [59] 631, 633

Chapter *11*

[1] 157 [2] 248 [3] 94a, 590b [4] 207, 442 [5] 539, 560, 623 [6] 185, R20, 605 [7] 143a, 133 [8] 148 [9] 212, 247, 576
[10] E. H. Gombrich, *Art and Illusion: A Study in the Psychology of Pictorial Representation* (New York: Pantheon Books, 1960), p. 313.
[11] 205
[12] Phyllis Greenacre, "The Childhood of the Artist," *The Psychoanalytic Study of the Child*, XII (New York: International Universities Press, 1957), pp. 47–72.
[13] Phyllis Greenacre, "The Predisposition to Anxiety," *The Psychoanalytic Quarterly*, Part I, X (1941), pp. 69–94; Part II, X (1941), pp. 610–638. Reprinted in *Trauma, Growth, and Personality* (New York: W. W. Norton, 1952), pp. 27–82.
[14] W20
[15] R5 [16] 126
[17] D. W. Winnicott, "Ocular Psychoneurosis of Childhood," in *Collected Papers* (New York: Basic Books, 1958), pp. 85–90.
[18] 355 [19] 242 [20] 591 [21] A. Wilson in P. Trevor-Roper, *The World Through Blunted Sight* (Indianapolis: Bobbs-Merrill, 1970), p. 36; Frederick W. Maire, "Van Gogh's Suicide," *Journal of the American Medical Association*, CCXVII (1971), pp. 938–939; Oscar Ward, in a letter to the Editor, *Journal of the American Medical Association*, CCXVIII (1971), pp. 595–596. 165b [22] 594, 625 [23] 309 [24] 405 [25] 435c [26] 331, 367, 516, 501a
[27] Johanna van Gogh-Bonger, "Memoir of Vincent van Gogh," *The Complete Letters of Vincent van Gogh*, Vol. I, American edition (Greenwich, Connecticut: New York Graphic Society, 1958), p. xxiv.
[28] 332, 136

Chapter *12*

[1] 505, 540, B19
[2] Jacob Bart de La Faille, *The Works of Vincent van Gogh: His Paintings and Drawings* (New York: Reynal & Co., 1970), p. 250.

[3] 602 [4] B12(10)
[5] R. H. Wilenski, *Dutch Painting* (New York: The Beechurst Press, 1955), p. 101.
[6] B12(10) [7] 414, 416 [8] B8(11) [9] 605, 615 [10] 605 [11] B12 (10)
[12] 135 [13] 93 [14] B8(11) [15] B7(7), 501a [16] B6(6) [17] B11(13)
[18] B8(11) [19] 500 [20] 99 [21] 226 [22] 574 [23] 340 [24] 509
[25] B10(18) [26] B7(7), W5 [27] 503 [28] 558a [29] 501a [30] 213
[31] 262 [32] B4(4) [33] 643 [34] 542 [35] 520 [36] B21(21) [37] 543
[38] 528 [39] 531 [40] B21(21) [41] 505 [42] 540 [43] 587 [44] 595
[45] 605 [46] 614 [47] 614a [48] 615

Chapter 13

[1] W21 [2] W21, 640a [3] 641a
[4] Victor Doiteau, "La curieuse figure du Dr. Gachet," *Aesculape*, XIII (1923), pp. 169–173, 211–216, 250–254, and XIV (1924), pp. 7–11.
[5] 639 [6] 642, 644, 651, 646, 640, 638
[7] Marc Edo Tralbaut, *Vincent van Gogh* (New York: Viking Press, 1969), p. 310.
[8] Victor Doiteau, "Deux copains de van Gogh, inconnus, les frères Gaston et René Secrétan, Vincent tel qu'ils l'ont vu," *Aesculape*, XL (1957), pp. 39–61.
[9] 638, W22, 639, 638, 640a [10] 635, W22, 648, 638 [11] 638, W22
[12] Paul Gachet, *Le Docteur Gachet et Murer* (Paris: Editions des Musées Nationaux, 1956).
[13] Guillaumin's painting, *Woman on Bed*, is now in the Gachet collection of the Louvre.
[14] 636 [15] W22 [16] 458a [17] 644 [18] 641, W23
[19] A. M. Hammacher, *The Ten Creative Years of Vincent van Gogh* (New York: Harry N. Abrams, 1968), p. 175.
[20] 649, 650
[21] Johanna van Gogh-Bonger, "Memoir of Vincent van Gogh," *The Complete Letters of Vincent van Gogh*, Vol. I, American edition (Greenwich, Connecticut: New York Graphic Society, 1958), p. lii.
[22] 649 [23] 637, 644, 646, 648
[24] *L'Echo Pontoisien*, Aug. 7, 1890.
[25] Victor Doiteau and Edgard Leroy, *La Folie de Vincent van Gogh* (Paris: Editions Aesculape, 1928), pp. 92–93; Paul Gachet, "Les médecins de Théodore et de Vincent van Gogh," *Aesculape*, XL (1957), pp. 4–38.
[26] 604 [27] 154, 212, 268 [28] 448 [29] 462, W11 [30] 302, 132, 193, 288 [31] T39, 595, 598, 599, 602, 603, 604 [32] 77, 386a [33] 347, 350, 358, 362 [34] 472, 638 [35] 489 [36] 309 [37] 530 [38] 648 [39] 524
[40] 531 [41] A. M. Hammacher, "Van Gogh and the Words" in Jacob Bart de la Faille, *The Works of Vincent van Gogh: His Paintings and Drawings* (New York: Reynal & Co., 1970), p. 14.

[42] 506. The only other pictures Vincent sold before 1889 were eighteen ink drawings to his uncle C. M. in 1882 for fifty guilders, and a self-portrait to the London Art firm of Sulley and Lori in 1888. (For the latter, see Marc Edo Tralbaut, *op. cit.*, p. 300.)

[43] It has usually been assumed that the painting was *The Red Vineyard*, but the editors of the de la Faille catalogue believe it may have been one of the *Sunflowers*.

[44] 614a [45] 611 [46] 626a [47] 629a [48] W20

[49] Meyer Schapiro, "On a Painting of Van Gogh," *View*, I (1952), pp. 9–14. Also in D. Wolberg, S. Burton, and J. Tarburton, eds., *Exploring the Arts* (New York: Visual Arts Press, 1969), pp. 154–166).

[50] 649

Selected references

Andriesse, Emmy: *de Wereld van van Gogh/le Monde de van Gogh/the World of van Gogh*. The Hague: Daamen n.v.; Bruge: Desclée de Bouwer; Paris: Laurent Tisné; Milan: Libritalia; second printing, 1957. An interesting collection of photographs of the regions and people that van Gogh painted.

Cooper, Douglas: *Drawings and Watercolours by Vincent van Gogh*. New York: The Macmillan Company; Holbein-Verlag, Basel, 1955. Fine reproductions of watercolors.

de la Faille, Jacob Bart: *The Works of Vincent van Gogh: His Paintings and Drawings*. New York: Reynal & Co., 1970. This large volume contains reproductions of all of the known works. It has been revised from the original French edition of 1928, in four volumes, and from the Hyperion edition (oils only) of 1939 by a committee of Dutch experts.

Rewald, John: *Post-Impressionism from Van Gogh to Gauguin*. New York: The Museum of Modern Art, 1956. A detailed and accurate account of van Gogh's stay in France, 1886–1890, seen in relation to the other artists of the period.

Schapiro, Meyer: *Van Gogh*. New York: Harry N. Abrams, Inc., 1950. Schapiro's analyses of the colored reproductions are masterpieces.

Szymańska, Anna: *Unbekannte Jugendzeichnungen Vincent van Goghs*. Berlin: Henschelverlag, 1968. A recently discovered group of pictures Vincent drew in 1873 and 1874—long before he became an artist—for the young daughter of H. G. Tersteeg.

Tralbaut, Marc Edo: *Vincent van Gogh*. New York: Viking Press, 1969. This is the most comprehensive biography of van Gogh's life, with excellent reproductions.

Index

262 Index